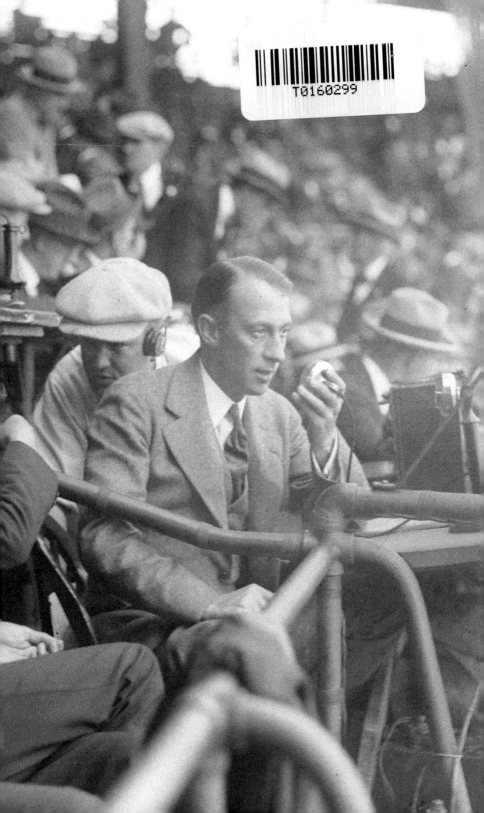

MEMORIES FROM THE MICROPHONE

MEMORIES FROM THE MICROPHONE

A Century of Baseball Broadcasting

CURT SMITH

Foreword by Brooks Robinson

Cover Design: Elina Diaz
Cover Photo/illustration: Graham McNamee of W.E.A.E broadcasting World
Series, 10/5/24. , 1924. [October 5] Photograph. https://www.loc.gov/
item/2016838543/.
Interior photos: National Baseball Hall of Fame and Museum
Layout & Design: Elina Diaz

For permission requests, please contact the publisher at:
Mango Publishing Group
2850 S Douglas Road, 2nd Floor
Coral Gables, FL 33134 USA
info@mango.bz

For special orders, quantity sales, course adoptions and corporate sales, please
email the publisher at sales@mango.bz. For trade and wholesale sales, please
contact Ingram Publisher Services at customer.service@ingramcontent.com or
+1.800.509.4887.

Memories from the Microphone: A Century of Baseball Broadcasting

Library of Congress Cataloging-in-Publication number: 2021937677
ISBN: (print) 978-1-64250-675-4 , (ebook) 978-1-64250-676-1
BISAC category code: SPO003030, SPORTS & RECREATION / Baseball /
History

Printed in the United States of America

To Cooperstown

Contents

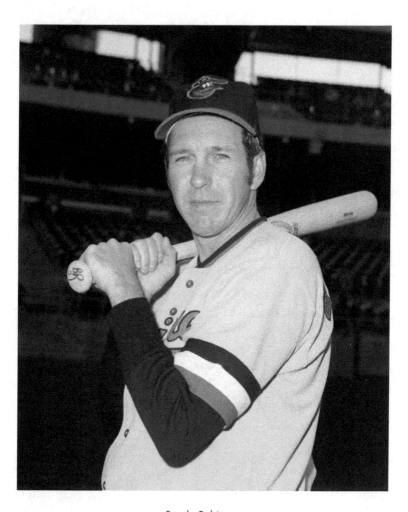

Brooks Robinson

FOREWORD

Playing for the Orioles for twenty-three seasons, I didn't think about managing or coaching or broadcasting.

I was focused on playing—on being part of a team that won two World Series and four American League pennants. I think our 1969, 1970, and 1971 teams were as good as any teams that have ever played the game.

So when I retired in 1977, I just assumed that I would leave the game. It was a great time; I had a lot of fun and got to play with some of the greatest athletes the game has known.

But in 1978, WMAR-TV in Baltimore approached me and wanted to know if I wanted to be a part of their broadcast team. Back then, games weren't on every day. WMAR televised about sixty games a year—fifty on the road and ten at home.

I thought about it, and after talking with my wife, Connie, we decided that I'd give it a try. It turned out to be pretty special, because it was like going to where you've always gone, seeing the guys and being at the games—not just shutting everything down in retirement.

Most of all, it was fun.

Of course, I found out I needed a little work to be competent at it. So I hired a speech therapist to help me. That first year, she'd tape the games and we'd go over a few things on the tapes, figuring out where I'd made mistakes with words—some of which I'm sure I picked up growing up in Arkansas. But the reason I went to her was so she could critique me and let me know what I could do better.

It was like anything else: You work at it if you want to be
good at it.

I got to work with some super people: Chuck Thompson, who
won the Hall of Fame's 1993 Ford C. Frick Award; Bill O'Donnell;
Scott Garceau, who is doing Orioles games now; and Jon Miller,
who won the 2010 Frick Award.

Jon and I had a great time; we jogged together on the road,
and I remember this one time when we were staying at a hotel
in downtown Detroit. We were getting ready to go jogging when
I looked out the window and saw they were having a big race in
town. I called up Jon and said: "Let's go join them!"

Well, we went down and fell in with the group. But the race
organizers weren't real happy with us because we didn't register, so
we didn't have numbers. But we had some fun!

I found out that there are quite a few things that announcers
who've played the game can add to a broadcast. I remember one
day in 1980 when we were playing Detroit. The Tigers pitcher was
Milt Wilcox, whom I had gotten a hit off of back in Game Two of
the 1970 World Series when he was with the Reds.

The first two times up, Eddie Murray just missed hitting it out
of the park. I said, "The way he's swinging at Wilcox, he's going to
hit one out."

Well, it was just the luck of the draw, but the next time up,
Eddie hit one out. And people remembered that.

Most nights, it was my job to go down on the field before the
game and talk to our pitching coach, Ray Miller, to see how they
were going to pitch to the opposing hitters. Ray was terrific; he
helped me out a great deal.

I wasn't the best interviewer, but I kept a notebook on each
team, and I would read all the newspapers when we went into
towns to get the best information I could. Connie would keep the
Baltimore papers at home.

I'd call her up and ask her, "Are you saving the papers for me?"

And she'd reply, "I think you care more about the papers than you do me!" But she was very supportive of my career, and I feel very fortunate about that.

When you're a broadcaster with connections to a team that wins a World Series, it's not quite as special as when you're a player—but it's close. In 1983, I got to be part of the Orioles' victory parade. Seeing them win that World Series after having lost the World Series four years earlier in 1979 was a treat.

I remember when they beat the White Sox in Game Four of the 1983 ALCS. I was announcing that game, and Tito Landrum hit a home run in the top of the tenth to break a scoreless tie, eventually giving the Orioles the win. Just to know that the next game was going to be in the World Series—and then to beat the Phillies—was something special. I was lucky to be a part of it.

It was all part of the Oriole Way, which is how the team operated from top to bottom. Of course, if you're around this game long enough, you look back and wish you had done this or done that. But being a part of those teams—on the field and as a broadcaster—was something I'll never forget.

I retired from the booth after the 1993 season; I was ready to do something else. But those sixteen years on television gave me a chance to continue to be a part of the game that I love.

I was privileged to play with the greatest athletes and coaches as well as with some of the greatest sports announcers when my playing career was through. Those broadcasters helped continue and strengthen the connection between the game and the fans—a bond that has made baseball the National Pastime.

Brooks Robinson

PREFACE AND ACKNOWLEDGMENTS

The poet Walt Whitman wrote, "Where is what I started for so long ago? And why is it yet unfound?" Many of us started to listen to baseball broadcasts when we were young. Irrespective of age, it has kept us from growing old.

Memories from the Microphone is the first book to evoke a century that began on August 5, 1921, in a makeshift KDKA Pittsburgh studio heard by only a tiny number of households equipped with receiving sets. It tells how largely unknown figures became household names, defining events that helped create a community of the caring—our National Game, heard on radio across the entire country, then seen on television, and now accessed via the Internet, available *everywhere.*

The book unfolds chronologically. It is statistical, since baseball is, but more anecdotal, since tales told well illuminate the game. "On the field, not a lot sometimes happens," mused the great Orioles announcer, Chuck Thompson, adding that the best announcers rarely let you notice. This work relates baseball's birth on radio and TV, how the vocation and effect have changed, and how broadcasting's art form has helped baseball remain what Doris Kearns Goodwin calls the "most timeless of all sports."

Memories tells only part of baseball's verbal history: It is not a substitute but rather a complement to a trip to Cooperstown. This is more of a representative than a comprehensive look. Some Voices have been discussed in a section or two or appear occasionally. Some had long careers with effects so lasting that they appear throughout this volume. Other worthy profiles have unfortunately had to be abridged due to space. I have tried to keep

omissions to a minimum, like errors behind a pitcher or clouds on a sunny day.

Here are Voices known in every precinct—Mel Allen, Red Barber, Harry Caray, Vin Scully—and dozens of other noted men and women of the microphone. Here are events that changed our lives: from the advent of sound ferried through the air to baseball broadcast around the globe. Here is "heavenly rhetoric," in Shakespeare's phrase—rhetoric that is by turn loud, soft, gentle, riotous, short-sighted, and visionary from each major league and every region.

To clarify text, first names and nicknames after first usage let a reader follow a trend, club, or broadcaster's plot. A capitalized *V* in Voice indicates a big-league announcer: a club's *lead* Voice is specified. Nicknames are used for color. Jay Hanna Dean was "Dizzy" or "Ol' Diz;" Bob Prince was "Gunner;" and Phil Rizzuto was "Scooter." The Yankees are the Bombers; the Giants became the 'Jints; the Dodgers are the Bums or Brooks; and the White Sox are the Pale Hose. The Stadium denotes Yankee Stadium. The Peacock Network is NBC. The Red Sox are the Olde Towne Team. Since the early 1900s, Washington has used the names Senators, Nationals, and Nats interchangeably. Baseball language is used extensively to engage the reader and expand his or her big-league world.

I have tried to give fair space to each club while also respecting facts: the New York Yankees, for instance, have played a much larger role in broadcasting's evolution than the single-season Seattle Pilots. Reliving their stories, I am struck by how many of baseball's great Voices climbing the radio/TV stairway developed an identity: showman, cynic, huckster, comedian, and/or essence of the home team on the air. *Memories from the Microphone* is their book, and yours.

This book is a communal work. I especially want to thank Brooks
Robinson, Orioles Hall of Fame third baseman, a fine former O's
broadcaster, and an even better human being, for his gracious
foreword to this book. For decades, he has been an inspiration
to millions of Americans on and off the field. His message here
shows why.

Let me also thank a dear friend, the National Baseball Hall
of Fame and Museum, with a staff worthy of its name: Kelliann
Bogan, Photo Archivist/Director of Digital Assets; Sean Gahagan,
VP Retail Merchandising and Licensing; John Horne, Coordinator
of Rights and Reproductions; Cassidy Lent, Manager of Reference
Services; Scot Mondore, Director of Licensing and Sales; Craig
Muder, Director of Communications; and Jon Shestakofsky, VP
Communications and Education. Senior Library Associate Bill
Francis's incalculable aid makes research there a delight.

In addition, I'd like to thank Mango Publishing's terrific staff
for making this centenary book possible: Chris McKenney, founder
and Chief Executive Officer; Brenda Knight, associate publisher;
Jane Kinney Denning, acquisitions editor; Robin Miller, editorial
coordinator; Lisa McGuinness, creative director; and Elina Diaz,
senior designer. Valerie Tomaselli, President of MTM Publishing,
was especially invaluable, helping balance draft, deadline, and
message to secure a finished product.

Other thanks are deserved too. My wife Sarah facilitated
text and editing. Bill Nowlin has made the Society of American
Baseball Research (SABR) the go-to source for baseball analysis.
David J. Halberstam, whose website *Sports Broadcast Journal* is an
invaluable blend of fact and opinion, helped forge Chapter 10 on
SuperStations. Educator and Hispanic radio/TV authority Jorge
Iber was especially helpful with Chapter 11, "Opening Doors."
Peter King of CBS Radio News is a fount of everything Metsian.
I am grateful to my agent, Robert Wilson; Gannett News Service's

Mike Murphy; and former Hall of Fame Library Director
Jim Gates.

I have been fortunate to write about and to know many of
the broadcasters in this book. Many of the quotes and stories
herein are taken from talks we have had over the years. I thank
them for befriending tens of millions of American lives, when we
were young.

I first visited Cooperstown when I was twelve and have made
about seventy-five treks to visit and, above all, research. It has a
grand wearability—unmatched, in my view, even by a prior life as
a White House speechwriter. Here, in this idyllic town, the Hall of
Fame plays a score of nostalgia, hope, and myth.

Dick Enberg, a fine and poetic man, often said, "If you have
baseball in your soul, it doesn't go away. It's there forever." Finally,
I thank the reader for having baseball in *your* soul from each first
pitch to final out.

Curt Smith, 2021

Chapter 1

1921: PRESENT AT THE CREATION

An old British Broadcasting Company radio series, *Listen with Mother*, began each program by asking, "Are you sitting comfortably? Then I'll begin." On Friday, August 5, 1921, baseball on the air began commercially, if not always comfortably, over America's first licensed radio station, Pittsburgh's KDKA. This year hails a century of the Pastime ferried to the republic through the air by the wireless, as it was first known, and later television.

Since baseball has long seemed wed to both, it is natural to assume that it must have long been in harmony with each. In fact, Harold Arlin was winging it that August afternoon at Forbes Field in suburban Pittsburgh as he described the first Major League Baseball game ever broadcast, play-by-play carried by a microphone—inventing an art form as he spoke.

After that game's final pitch—Pittsburgh 8, Philadelphia 5—Arlin's voice was critiqued by a listener as "clear, crisp, resonant, and appealing." In time, as "The Voice of America," it made him what the *London Times* called "the best-known American voice in Europe"—indeed, "the world's most popular radio announcer." He also invented the celebrity interview in the 1920s, emerging for a while as a celebrity himself.

Such a future would have seemed more improbable than the sheer fact of radio—sound, through the air!—when Arlin, twenty-five, and several other Westinghouse Electric and Manufacturing

engineers visited the company's **KDKA** rooftop East Pittsburgh studio in 1920. "What's that?" Harold had said several days earlier, eyeing the shack studio from outside the plant. Inside, he now saw a microphone about which the same question could be posed. "It looked like a tomato can with a felt lining. We called it a mushophone."

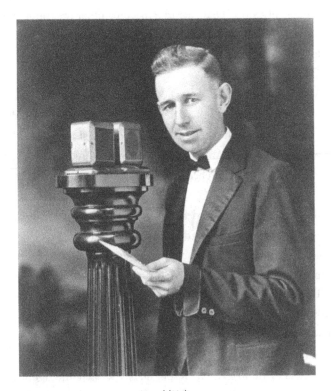

Harold Arlin

Earlier that day, Tuesday, November 2, **KDKA** received a broadcast license as the first commercial radio station: thus, becoming eligible to broadcast. Moreover, it had a lot to announce. Since the date was Election Day, KDKA's on-air debut reported Warren Harding's presidential landslide over James M. Cox.

According to the *New York Times*, "curiosity led Arlin" to apply for
the on-air job. He was hired, instantly—in another precedent,
popularly known as the world's first radio announcer.

Arlin was born in La Harpe, Illinois, raised in Carthage,
Missouri, and schooled at the University of Kansas. In an
exquisitely small field, he was starting at the top. In 1921, Harold
did Davis Cup tennis, aired West Virginia–Pittsburgh football, and
gave baseball scores. That August 5, needing other programming,
he drove to the city's Oakland section, bought a seat at Forbes
Field, put a scorecard on a wooden plank, and converted a
telephone to a microphone.

What did the pathfinder sound like that afternoon? KDKA
then had only one-hundred-watt power v. today's fifty thousand.
Few people had wireless. The transmitter did or didn't work. The
crowd often drowned Arlin out. No one knew who listened or how
long. The game itself lurched: third inning, Phillies, 4-2, on Cy
Williams' homer; Pirates, 5-4; the Phils tied at five; eighth-inning
singles gave Pittsburgh the decision. Thirteen runs on twenty-one
hits careened around the yard, including two Pirates doubles and a
triple. The game took one hour and fifty-seven minutes—about the
time it takes to play six innings now.

Ironically, Cox's 1920 running mate was Franklin D. Roosevelt,
the 1933–1945 president who coined the famed Fireside Chats, his
messenger radio and its baseball premiere his kind of game: "lots
of action for my money." Forbes was also his kind of place, letting
"outfielders scramble and men run the bases." Left and right field
originally loomed 360 and 376 feet from the plate respectively;
center was a gargantuan 462 feet away. The plot lay adjacent to
the Cathedral of Learning and scenic Schenley Park—to *Sports
Illustrated (SI)*, "the loveliest setting of any major league field."

"There was a lot to describe," said Arlin. Even so, at first, "our
guys at KDKA didn't think that baseball would last on radio. I did
it sort of as a one-off project," recalling that "no one told me I had

to talk between pitches." As station wattage leaped, so did Harold's marquee. His news show on the station—another first—starred such nabobs as French general Ferdinand Foch, British statesman David Lloyd George, movie star Lillian Gish, and then-Secretary of Commerce Herbert Hoover.

One 1920s day, a rather eminent baseball player in Pittsburgh for an exhibition game agreed to appear on air. At the William Penn Hotel studio, Babe Ruth even found a speech written for him. Introduced by Arlin, the man George Will called "the first national superstar, the man who gave us that category," found himself unable to say a word.

Desperate, Harold took the speech and started reading it as if he were Babe Ruth. As he did, the Bambino silently leaned against the wall, sweating and smoking one cigarette after another. "We pull it off," Arlin said; letters to KDKA hailed Babe's calm, assured voice. Harold's task became to find time to broadcast as much baseball as he would like, airing the Pirates sporadically through 1924, both pleasance and pioneer.

"I was [later] a foreman by day," he said, "and I'd do KDKA at night." In 1923, Arlin made the first shortwave broadcast to Great Britain, South Africa, and Australia. In 1925, Westinghouse transferred him to a personnel job in Mansfield, Ohio. A writer said: "To thousands, he seems almost a member of the family." By now, more than one million Americans owned a receiver. "TV leaves nothing to the imagination," Harold said much later. His medium, on the other hand, left all.

On Election Day 1952, KDKA asked Arlin to reminisce about Harding-Cox and report that night's Dwight Eisenhower-Adlai Stevenson result. Twenty years later, the Pirates held a day in Harold's honor. Voice Bob Prince had him broadcast an inning to many listeners grown old. Aptly, grandson Steve Arlin pitched for the San Diego Padres, that day's Pittsburgh rival. Yet it is an

incident from a quarter-century earlier that best showed Harold's mix of modesty and steel.

In 1947, many in Mansfield wanted to name its high school football stadium "Arlin Field." For more than an hour, the school board, which he served as president, argued the merits. Harold was strongly and futilely against. Years later, the board's vote still upset him because it was "one of the few times in my life that no one would listen to me." The once "Voice of America" died March 14, 1986, at ninety, in Bakersfield, California. The National Baseball Hall of Fame and Museum's obituary, like most, praised "the man who started play-by-play."

Chapter 2

1920S: THE INVENTORS

The Greek philosopher Heraclitus said, "Everything flows and nothing stays." He would have understood the 1920s—the "Roarin' Twenties"—which found America quite changed at decade's end from its start. The 1930 US Census reported that more people lived in cities than on farms. Technology put more washing machines in homes and more kinds of cars on the road. Prohibition began in 1920, auguring an age of speakeasies full of flappers and bootleggers. President Harding touted the law while swilling bourbon with Babe Ruth in the Oval Office when the Yankees visited Washington. Defining change, the Nineteenth Amendment gave women the right to vote.

Hollywood fulfilled Thomas Edison's dream of fusing film with sound, the screen no longer silent, even as many actors failed to transition. Similarly, early baseball Voices showed varied skill in adding sound to sight. The disparity showed as early as 1921, with KDKA ferrying radio's first World Series—Yankee-Giants— from the Polo Grounds, Grantland Rice announcing. Meanwhile, Tommy Cowan re-created—as we shall see, re-invented— summaries of the game from another site for WJZ Newark, New Jersey, and WBZ Springfield, Massachusetts. Coverage was local, not national.

The written word was national, holding an iron grip on America's mind and manner. In 1922, Rice—the *New York Herald*

Tribune's "Grannie"—"for the first time carried the Classic directly…to great crowds [estimated at five million] throughout the eastern part of the country," said the *New York Times*. Tens of millions read his syndicated column "The Sportlight" and knew his greatest quote: "For when the One Great Scorer comes to mark against your name, he writes—not that you won or lost—but HOW you played the Game." Rice was a man of print.

Since the first Series in 1903, he and other scribes had expressed why America prized the Pastime. His byline joined Damon Runyon's, who penned "The Ruth is mighty and shall prevail," and Ring Lardner's "Alibi Ike" and "You Know Me Al" series in the *Saturday Evening Post.* John Kieran wrote the first "Sports of the Times" column. At twenty-one, Fred Lieb became a longtime *The Sporting News* (*TSN*) correspondent, covered each World Series between 1911 and 1958, and christened Yankee Stadium "The House That Ruth Built."

Baseball's geometry of the mind helped the perfect reading sport become a perfect listening pleasure. "Remember how remarkable sound must have seemed," said Dick Enberg, airing baseball intermittently for nineteen years between 1969 and 2016. In 1895, Guglielmo Marconi sent and received his first radio signal in Italy. Seventeen years later, the *RMS Olympic* telegraphed an operator: "*RMS Titanic* ran into iceberg. Sinking fast." For three days, RCA Radio's David Sarnoff updated "reporters and friends." In 1926, he founded the National Broadcasting Company. CBS and ABC were born in 1927 and 1943, respectively.

Early-century America worshiped the reinvented man, F. Scott Fitzgerald's *The Great Gatsby* etching a green light at the end of a lost love's deck: "the orgiastic future…so close that he could hardly fail to grasp it." Jay Gatsby could easily have aspired to be Graham McNamee. By 1922, eyeing *his* future, the aspiring broadcaster had studied voice as a boy, sung in churches, and arriving that year from Minneapolis with his mother, given a concert at Aeolian Hall

in New York. Next year, Graham began as a professional singer. "The reviews were good," Thomas F. Moore later wrote in *SI*, "but concert and church work was scarce."

In May 1923, McNamee entered the AT&T building on lower Broadway on lunch break from jury duty. In a WEAF audition, said Moore, "They grabbed him for his voice." That fall he became the World Series "color man" or "analyst," heard via AT&T as far north as Boston and as far south as Washington. In 1922, writer William O. McGeehan had been Rice's aide. Radio now crossed from sight to sound. Grannie left, bored, radio not his métier, and returned full-time to print. McGeehan replaced him, then quit during Game Three. This left his partner in a pickle, since McNamee knew little of baseball beyond three outs per half-inning. How far could his tenor take him? As far as invention could travel.

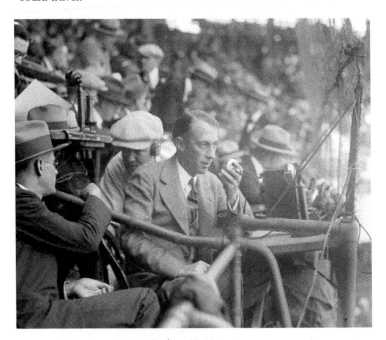

Graham McNamee

The Classic ended on Monday, October 15. In the next four days,
WEAF received 1,700 letters gushing over Graham—"amazing,"
said future Cardinals Voice Jack Buck, "since few families owned
a radio [under three million] and fewer knew how to reach
the station." McNamee aired political, economic, and social
events—both national and global—including the 1924 103-ballot
Democratic National Convention—working sixteen hours a day
for fifteen straight days. Each broadcast started, "How do you do,
ladies and gentlemen of the radio audience?" and ended, "Graham
McNamee speaking. Good night, all"—radio's first great name.

"McNamee also aired almost a dozen sports," said Mel Allen,
arguably baseball's all-time most recognizable voice, in 1985.
"The early days meant network radio," especially the Pastime's,
its regular season heard only in America's northeast quadrant.
Eventually Graham did twelve straight World Series, airing
NBC's first Rose Bowl on January 1, 1927. "The first great ad-lib
personality," said NBC announcer George Hicks. "You wouldn't
knock Laurence Olivier for taking liberties with a part. Graham
was in the same class—an artist" who was a novice, saying of a
pitch, "The next ball is a strike."

The public didn't care, Moore writing, "He made every word
sound earthshaking." Resenting his prestige, some reporters
simply shook. In 1929, one said, "McNamee, will you pipe
down?!" Graham's last Classic was 1934: the event "to be opened
by the umpire who will howl 'play ball,'" he said. Next year,
Commissioner Kenesaw Mountain Landis eyed McNamee's
drinking, divorce, and growing arrogance and dispatched him from
the Series. Baseball's great artist never called another game.

In 1933, thirty-three million American families owned a radio
for Graham's penultimate Classic. Ring Lardner was unstirred,
saying, "There was a double-header yesterday—the game that was

played and the one McNamee announced." Graham had done
most baseball far from the site, trying to give tuners-in the sense that
they were with him "at the spot." In truth, being "far from" was
the puzzle.

By the 1930s, most local teams aired their *home* schedule *live*.
Costly line charges precluded away coverage. How could you air
baseball without *being* there? As McNamee had already learned,
wireless telegraphy could make scales fall from a listener's eyes.
From 1929 to 1943, Charles Carroll, a.k.a. "Pat" Flanagan,
showed how Western Union's Simplex Machine could invent and
enable the re-creation, siring "play-by-play within three seconds of
the time it occurs," wrote *TSN*. An operator at the park sent data
to a Voice hundreds of miles away in the studio. The announcer
got the message: B1L. It meant ball one low. Next: S2C. Strike two
called. You could paint—re-create—a game you never saw.

One day, Flanagan did a game by Simplex, urging, "If you
want these out-of-town-games regularly, write and tell us." The
next day, nine thousand did. "[Harold] Arlin invented baseball
on radio," said longtime Chicago Voice Jack Brickhouse. "Pat
invented re-creations." A stick whacking wood mimicked bat
hitting ball. The soundtrack simulated a heckler, a hot dog vendor,
applause from a fictive fan. By 1936, thirteen big-league clubs
re-created. Only New York's three teams—the Dodgers, Giants,
and Yankees—abstained. In 1934, they had signed a five-year
radio ban, afraid people would not pay to see what they could
hear for free.

The most famed practitioner of the art was a future American
president. Ronald Reagan's father named the boy "Dutch" for his
chubby countenance. At WHO Des Moines, his first major gig,
it became Reagan's lifelong moniker. (Another was the "Gipper,"
after doomed Notre Dame football player George Gipp in the film
Knute Rockne, All American.) Crucially, Dutch's was the only one of

four Des Moines stations doing the Cubs to re-create, not air live, from Wrigley Field or another National League (NL) park, Reagan getting code in studio from the road or Wrigley before reporting a game unseen.

One day the wire broke. The Gipper paused but didn't panic, knowing "that if we switched to music, the listener would turn to a station doing the game live." Instantly, he recalled the one thing *not* to make next morning's box score: foul balls. A batter can hit two million fouls and still have two strikes. Thus, for seven minutes, Dutch set a record for balls hit outside the lines, having the Cubs' Augie Galan foul to the left, right, or out of the park—anywhere. In addition, the St. Louis pitcher kept calling time to tie his shoes or tug at the resin bag. A tornado neared. Both skippers were ejected. None of it happened, but at home, who knew?

Finally, the wire revived, Dutch laughing. It read: "Galan popped out on first ball pitched." In 1937, Reagan signed a film contract with Warner Bros., evolving into its famed King of the Bs. "A 'B' movie was a film they didn't necessarily want good," he mused. "They wanted it Tuesday." Years later, the president said, "Making things up, mixing fact and fiction. [Pause] What great preparation for politics." He was always proud of doing Cubs play-by-play, since Chicago was daily baseball broadcasting's cradle.

On April 23, 1924, *Chicago Daily News* reporter Hal Totten invented daily play-by-play: the first Voice to do the first game for the first station to air an entire home schedule: WMAQ Chicago, Cubs 12, Cardinals 1. He added the White Sox in 1926, finding such work "a great way to see games free." Competing stations also aired the teams, paying no fee for the right. Totten observed, "[Cubs owner Philip] Wrigley made Chicago radio baseball's Mecca. 'The more outlets,' he said, 'the more we'll own the city.'"

Soon, Voices like Totten, WBBM's Flanagan and Truman Bradley, and WGN's Bob Elson and Quin Ryan did the White Sox and Cubs. In 1934, Hal took each club to WCFL. Nationally, Totten did the 1926-1929 World Series, a listener hearing his "foot on the slab" and "pretty husky fellow" and high voice signing-off "G-bye now." He did four NBC Series, two All-Star Games, and Mutual Broadcasting System's (MBS) 1945–1950 *Game of the Day*. In 1962, the Southern Association president dissolved the seventy-seven-year-old minor league. Hal then returned to writing, dying in 1985.

Flanagan died in 1963, a decade after Pittsburgh became the last club to adopt all-live road coverage. His first year, the 1929 Cubs won the pennant before facing Philadelphia in the Series. Down, two sets to one, Chicago next day led, 8-0, in the seventh inning as the Athletics' Mule Haas flew to center field, Hack Wilson thinking it a breeze. "He's over, getting under it," Flanagan began. "Wait, it looks like Hack's lost it [in the sun]! He has…the ball falls! [Joe] Boley scores, and Max Bishop! And here comes Haas! An inside-the-park homer!" The inning reversed the Series, Philly winning, 10-8.

Three years later, the Cubbies won another flag in an every-third-year pennant cycle lasting through 1938. That September 28, Chicago trailed Pittsburgh by a half-game as the ninth inning began tied at five at Wrigley Field: it was dusk, with no lights, so the game was to be called if no one scored. The Pirates and first two Cubs quietly made outs, Gabby Hartnett then batting. "This is it! The Cubs have to score," Flanagan pressed. Moments later: "A long drive to deep left-center! Lloyd Waner going back! Gone! Gone! Cubs win!" They clinched the pennant October 1, then, like 1932, braved a World Series sweep by the Yankees.

"Win a World Series [v. New York]?" Pat answered a reporter. "I'd settle for a Series game!" He settled for airing three Series and the first All-Star Game in 1933 at the White Sox's Comiskey

Park, named for owner Charles Comiskey. By 1943, a cancer-stricken Flanagan would have been content with health. He retired to the Cubs' longtime spring training site, Catalina Island, twenty-three miles from the Southern California coast. In 1988, Jack Brickhouse, Chicago *his* kind of radio/TV town for forty years, began reminiscing about Pat's creation. "He wouldn't like radio now," with ingenuity having yielded to technology, progress *sans* charm.

Another Chicago Depression Voice heightened, if not coined, variety. Quin Ryan detailed the famed Dempsey-Tunney "Long Count" fight, another sort of combat—the 1925 Scopes "Monkey Trial"—each major party's 1928 convention, and Red Grange scoring four touchdowns in twelve minutes for Illinois v. Michigan in 1924. Listening at eight, Brickhouse recalled someone calling WGN to urge Ryan's firing: "He obviously doesn't know a touchdown from a first down. No man can score that often in that short a time."

Quin gave WGN great return on his time's investment. One day he aired the Kentucky Derby or Memorial Day 500, later the Indianapolis 500. The next, he used the name "Uncle Quin" on such children's programs as *Little Orphan Annie* and reported live the sinking of the Lincoln Park excursion steamer *Favorite* off Oak Street Beach, the Chicago Stock Yards fire, Notre Dame football coach Knute Rockne's funeral—and baseball, including first-year Mutual's 1935 All-Star Game.

Ryan was on play-by-play for 1938's ninth-inning late-afternoon blast that Pat Flanagan described. "It's official now," Quin said. "There won't be another inning. National League President Ford Frick is in the press box, and the umpires have passed up the word. It's now or never. Gabby swings—he hits it! It's a long, long drive—way, way back into left-center! Lloyd Waner

is racing back! It's going, it's going! It might be, it may be! It is!
Home run! The Cubs win it, 6 to 5!"

In the Series, NBC's play-by-play man was the sole Voice to
air each Chicago and St. Louis club. Born in 1904 in Brooklyn,
Johnny O'Hara was schooled at New York University, became an
extra-first-grade radio operator, and for seven years in his twenties
boarded ships, visited three continents, and missed the game.
"It killed me to read the scores," O'Hara said, returning home.
His new calling started when a regular radio host got plastered.
Subbing, he joined WCFL, added vaudeville, and aired both
1927–1933 Second City teams and a hot stove show, moaning,
"Al Capone gets paid by the bullet. How come I can't get paid by
the word?"

After calling CBS's 1933 All-Star Game and Mutual's 1937
Series, O'Hara moved to KWK St. Louis, adding that city's
1940 Mid-Summer Classic. "Chicago likes his style," wrote
TSN. "St. Louis just had more money." A 1943 KWK ad read
of him, "Knows baseball from A to Z. St. Louis's most popular
announcer"—indeed, he was *TSN*'s "Announcer of the Year."
That season the irascible former Cardinals pitcher, Dizzy Dean,
to whom we will return, aired the Browns. "Try confronting *that!*"
said St. Louis *Post-Dispatch* columnist Bob Broeg. O'Hara didn't,
joining Diz on the Browns and Redbirds. Both clubs, but neither
Voice, made the 1944 All-St. Louis Series.

Dean and O'Hara worked several more years together. By
1949, Johnny alone covered "all home games, sponsor undecided,"
said *TSN*'s preview issue, for the hapless Browns. Retiring, the
happy wanderer taught radio code to Army and Air Force
instructors, built a portable radio station, and entered his last port
in 1963, knowing that being at sea, as Leonard Bernstein said of
music, "didn't have to pass the censor of the brain before it could
reach the heart."

In an age of great railroad lore caught by music—"The Wreck
of the Old 97," "The Ballad of John Henry," and "This Train Is
Bound for Glory"—"The Wabash Cannonball" towered. First sung
in 1882, it was recorded by the Carter family in 1929 and famously
sung by Dean, who regularly warbled the tune on TV's 1950s and
1960s *Game of the Week.*

"The Cannonball" crossed farm, small town, and river in a
then more rural America, thrilled children gathered at the nearest
crossway, and devoured huge swathes of land on The Great Rock
Island Railroad route. It began in one baseball chapel, St. Louis,
and ended in another, where Detroit Tigers radio began April 19,
1927, on WWJ (née 8MK): "Good afternoon, boys and girls, this is
[Edwin] Ty Tyson speaking to you from [then] Navin Field."

Through 1942, wrote the *Detroit Free Press*'s Bob Latshaw,
"There wasn't an afternoon that anyone could escape Tyson."
Ty called Lynwood Rowe "Schoolboy" or "Schoolhouse" for
having played on a men's team as a fifteen-year-old. Chasing flies,
Leon "Goose" Goslin swayed his arms. Hank Greenberg became
"Hancus Pancus." Short foul lines flanked a vast center field. Right
field's twenty-five-foot overhang turned pop-ups into homers.
Steep-rowed seats enclosed the haunt. Later, *SI* cooed: "Owners
claim Briggs Stadium is the best park in baseball; contented Detroit
fans admit it probably is."

Wooden Bennett Park, an early-century site at the juncture of
Michigan Avenue and Trumbull Street—"The Corner," coined
future Voice Ernie Harwell—was rebuilt in concrete in 1912,
renamed for owner Frank Navin, and rebaptized in 1938 for
new owner Walter Briggs and in 1961–1999 as Tiger Stadium,
Harwell saying, "Farewell, old friend," upon its close. Voices forged
a similar continuum; Ernie was preceded or flanked by others,
including Paul Carey, Ray Lane, George Kell, Mel Ott, Van
Patrick, Harry Heilmann, and Tyson.

Ty graduated from Penn State, was a World War I doughboy, and joined WWJ as a weatherman and reporter. By 1933, a radio annual read: "[Ty's] technique is deliberate and sure, flavored with a dry humor which has made him a favorite with listeners." Next year Tyson aired the earliest surviving regular-season entirely recorded game: September 20, 1934, v. the visiting Yankees. That July 13, Babe Ruth had hit No. 700, yelling, "I want that ball!" as Ty hummed, "It's going, it's going, and it's a home run!" The man who nabbed it got a better seat, twenty dollars, and an autographed ball.

The Tigers had last waved a flag a quarter-century earlier. In 1934, Detroit again made the Series, Judge Landis dubbing Tyson "[too] partisan for NBC or CBS." Drafting a six-hundred-thousand-name petition, listeners convinced him to let Ty broadcast locally. "It showed how popular he was," said Harwell. Tyson was even more beloved in 1935. Most Valuable Player (MVP) Greenberg had 168 RBI as the "Tiges," Ernie's byword, won another pennant. Detroit had lost four straight World Series. Perhaps this year would break the spell.

Airing the 1935 Classic for NBC, Ty was commandeered by Landis to broadcast for "people who work and love baseball"—the average American, he said. In Game Six, Detroit up, three sets to two, the score tied at three in the ninth, Mickey Cochrane singled and took second base on an out. Goslin faced the Cubs' Larry French, Ty shouting to be heard. "Plenty of racket out there," he said. "A drive up the middle! And the winning run will score!" Even Grantland Rice hailed Detroit, relief repeated across the land: "The leaning tower can crumble and find its level with the Pisan Plain," the Tigers a champion at last.

WWJ had done Series "summaries" since 1920, but pre-1934 sponsors were still considered too commercial. Now, money talking,

change began. "This is brought to you by the R.J. Reynolds
Tobacco Company" commenced a broadcast, which ended by
again noting R.J. Reynolds—two ads per sponsor. Firms could
spend two-way. In addition, from 1933 to 1946, four-time AL
batting titlist Harry Heilmann called the Tigers on the Michigan
Radio Network, its flagship WXYZ Detroit. The statewide network
was created by George W. Trendle, who also conceived *The Lone
Ranger* series, carried on ABC Radio and later TV, with Clayton
Moore as the Ranger.

Generations grew up gripped by the white hat and horse, silver
bullets, and valiance of the series. Trendle used *The Lone Ranger*
to lift an age. Heilmann's network helped link a state. "It was
unique," mused Harwell, a Michigander from 1960 till his 2010
death. Tyson reached greater Detroit. WXYZ fed the rest. For
nearly a decade, each aired the same daily game. Then, in 1942,
the networks fused. "Harry knew the new owners and had a bigger
name," said Tyson, removed until he rejoined the team's first TV
booth in 1947.

In 1951, cancer took Heilmann's life on the eve of the All-Star
Game in Detroit. Ty then returned to radio. A year later, Van
Patrick became the Bengals' radio/TV Voice, his megaphone
reaching each outlet of the old regional network. As for Tyson,
Harwell invited him to Father's Day at Tiger Stadium in 1965,
three years before Ty's death. He addressed the crowd, described
an inning, and touched an audience he still termed his "boys and
girls." Said Ernie: "The reaction was overwhelming. One of the
most popular broadcasts we ever had." Class, after all, tells.

Let us conclude with two inventors who helped their regional
franchises find resonance in pre-Depression America, extending
their community to small towns and farms far from Boston and St.
Louis. At one end, the post–World War I Red Sox were the hero of

any dog that was under. By contrast, from 1926 to 1934, Cardinals General Manager (GM) Branch Rickey's brainchild—the farm system—built five pennants and three world titles. Strangely, it was a non-Redbirds Series in which France Laux first showed how minimalism could evoke maximum effect.

Ninety minutes before the start of the October 5, 1927, Yankees-Pirates Classic opener, KVOO Tulsa lacked "a guy to locally broadcast [re-create]," said station director Fred Yates. Someone mentioned Laux's name: born in 1897 in Guthrie, Oklahoma, *bona fides* including Oklahoma City College, US Army World War I, and part-time football referee—above all, a resident of Bristow, barely thirty miles away.

Yates jumped in his car, sped to Bristow, and improbably found Laux driving down the street. "Can you broadcast baseball?" Yates shouted, pointing France's car to the shoulder. Laux said, "Never done it. Why?" Explaining, Yates and his passenger arrived in the Tulsa studio just as Pittsburgh's Ray Kremer threw the first pitch to Earle Combs.

France aired the Yankees sweep, added college football, and got a thirty-day trial with fifty-thousand-watt KMOX St. Louis. He spent 1929–1942 with the lordly Cardinals and lowly Browns, adding 1945 and 1948–1953, respectively. "Forget the booth," Laux said. "I sat in the boxes," calling baseball's then-southern- and westernmost big-league club with precision, aided by KMOX, whose power made him shine.

Until 1958, when the Dodgers and Giants left New York for California, the recently renamed Busch Stadium was America's baseball locus below the Potomac and beyond the Mississippi: on weekends, full of pilgrims drinking draught beer in its stands. "Their spiritual following was enormous," said Broeg, an influential post-war voice. Laux became an avatar in many Southern, Appalachian, and Midwest burgs. "Before the late-'50s

move," said Broeg, "St. Louis had more than half the country
to itself."

In 1931, the Cardinals tuned up for a World Series with Connie
Mack's Athletics, their heart a 1904 leap-year baby who, said the
St. Louis *Globe-Democrat*'s Bob Burnes, "loved auto racing before
auto racing was cool." Twenty-seven-year-old rookie Johnny
Leonard Roosevelt "Pepper" Martin began the Classic unknown.
He left it with a .500 average and a name, "The Wild Horse of
the Osage." Would fame spoil him? Not likely, said Burnes, Pepper
"carrying spare car parts in a wardrobe trunk" and grease covering
his face, hands, and hair.

"Young man, I'd rather trade places with you than any other
man in the country," Commissioner Landis, a former federal judge,
told him after the Series.

"Well, that'll do fine, Judge," Pepper said, "if we can trade
salaries"—his $4,500 for Landis's $60,000.

In 1933, Frankie Frisch, already a legend as "The Fordham Flash,"
a then rare major leaguer to attend college, became a player/
manager for the Cardinals. "A man is up to bat four times a day
as a rule," he said. "Why can't he hustle?" Martin agreed, stealing
twenty-six bases and the key to a skipper's sanity. Once, Stan
Musial lost a fly that conked him on the coconut. Retrieving it,
Martin asked about his friend. "I'm OK," Stan said. Pepper: "Then
you won't mind if I laugh."

Frisch's mind often fixed on the son of a migratory cotton
picker, born in a sharecropper's cabin, whose schooling ended in
second grade—"and I wasn't so good in first grade, either." In
1933, Dizzy Dean began his first of four straight years of winning
twenty or more games. By 1934, Ol' Diz vowed that "me 'n'
[younger brother] Paul will win forty-five." They won forty-nine,

the older *frère* taking thirty—the last NL pitcher to win that many to this day.

Laux dubbed Diz and his Running Redbirds, a.k.a. the St. Louis Swifties, "the Gas House Gang." Drama critic Lloyd Lewis wrote, "[It] redramatized for the public that old traditional story about the talent of common men"—the honorific "Gas House" bred by Willard Mullin's 1934 cartoon showing gas tanks on the shabby side of railroad tracks with several players hoisting clubs, not bats, on their shoulders entering the posh part of town.

Using current cant, that Series busted norms. Diz fouled behind the plate in a scoreless Game Seven, Cochrane, catching for the Tigers, letting it reach the seats. Dean then blooped past third base, making second when Goose Goslin paused. Momentarily, Frisch hit a three-run double, Diz telling Cochrane, "You're beat now," to cap a seven-run third. Later Landis ordered the Cards from the field for twenty minutes after Detroiters pelted Joe Medwick with food and bottles for roughly sliding into third baseman Marv Owen. Justice was delayed, not deferred: St. Louis, 11-0.

In the 1934 All-Star Game, France voiced Carl Hubbell striking out five straight batters. That October, he, Flanagan, and Ted Husing split the first sponsored Series, Motor Auto Co. giving CBS and NBC $500,000 each. Two years later, Tony Lazzeri smashed a Classic slam in Game Two. "He jogs in and stabs the plate for the fourth run on that hit!" Laux pealed. "This has been quite an inning for the Yanks!" Game Six launched quite a streak. "A ground ball to [Lou] Gehrig. Scoops it up! Touches the bag for the third out—and the 1936 World Series is over!"—their first of four straight titles.

In 1937, Laux became the first *The Sporting News* staff-chosen "Announcer of the Year" for "outstanding service to radio and baseball…and being chosen oftener than any other announcer to report Series and All-Star Games." His network *adieu* was 1941: "And there goes a drive going out to right field! Looks like

it's going to be a home run…for [Pittsburgh's] Arky Vaughan!"
Ted Williams' ninth-inning *voila* wrote a 7-5 AL lulu. Exclusive
sponsor Gillette Co., exerting its power to dictate announcers, then
dropped Laux like a wind-blown pop.

"Competition killed him," said Broeg. Nationally, his flat
metallic tone "wasn't hip enough." Laux moseyed back to St.
Louis, where mid-1940s Dean, Harry Caray, and Gabby Street
emerged. The AL Browns moved to Baltimore in 1954. France
bought a bowling house, became American Bowling Congress
secretary, and died in 1978, two years after his wife of forty-
seven years. He was eighty, life, as he admitted, having moved on
well before.

In 1925, eighteen members of the Baseball Writers' Association
of America (BBWAA), including Boston native Fred Hoey,
covered the Red Sox for nine local papers. Hoey wrote 1909–1946
schoolboy and big-league sports for the *Journal*, *Herald*, and *American*,
and anchored baseball's first and largest early radio network. An
arrangement of twenty-two affiliates, the Yankee (later Colonial)
Network was named for the region's history, not Bronx Bombers
dynasty. "Fred also did the [then-Boston] Braves. But it's the
Sox who mattered," said Ken Coleman, their Voice for much of
1966–1989. Fred was known, he said, as "The Man Who Does
the Games."

To be literal, Ben Alexander and Charles Donelan, not Hoey,
called the first Boston baseball, sporadically airing the 1925 Braves.
By 1927, Hoey aired each club's home games live, already known
for his work in print. Yankee head John Shepard III pledged
to cover each major regional sports event with "a recognized
authority." Til Ferdenzi had heard Hoey before attending Boston
College, then working for the New York *Journal-American* and NBC

Sports. Not "trained," Til said, "Fred had a dry, biting voice," his
teams biting deep into Boston's two-headed baseball Janus.

The Sox and Braves routinely moored the 1920s and '30s
second division. Fred's fortitude was repaid in 1931 when both
clubs hailed Hoey as "the first to work on a network giving the
play-by-play," said *TSN*. "He has one of the biggest daily followings
of any announcer because of the large number of stations."
Baseball's first Radio Appreciation Day gave a mélange of gifts to
the man who "keeps the mailman loaded down."

By season's end, Hoey had aired a record number of hours:
1,920, including that year's 320, such a workload "a severe strain
not merely on [my] eyes, but on the nerves." Fred especially tried
to ease the latter. "He liked the sauce, or so I've heard," said
Coleman. In 1933, CBS awarded his first network gig: Series
Games One and Five. At forty-eight, Hoey reached the booth
smashed before the opener. He soon left the air, Fred blaming "a
bad cold" and swearing never to work again without lozenges.

Unhorsed, he came home sober, his reputation intact. "In
Boston, where people knew about his drinking, all was forgiven,"
said Coleman. "There'd been thousands of letters to papers saying,
'How dare you hurt our Fred?' No criticism, since he was looked
on as the first guy to do baseball on radio. That was *something*
then." Ned Martin, the Sox 1961–1992 announcer who grew up
in Philadelphia, said, "I never met Fred, but I feel like I *know* him,
because people still swear *by* him."

It is hard now to re-create the wireless's impact. A garage owner
in suburban Walpole increased volume, Til said, "to blast it around
town." Stores put ostrich-legged speakers on the sidewalk, play-by-
play invading the street. Drivers fender-bended, halting to hear the
groundbreaker. In 1933, total attendance at decrepit Fenway Park
trailed 2019's first *six* home games. Late that year, the Sox got a
new owner, Tom Yawkey, who revived the park, then team.

On April 18, 1938, the Sox opened v. New York at home, Hoey
predicting that Jimmie Foxx, "in great condition," would have
"a terrific year." He did, hitting fifty homers. Audio recalls Fred's
staccato and detail. Rudy Vallee had just cut a record. Gehrig,
in his 1,966th straight game, had batted .345 in Florida and now
hit a drive barely foul—"fortunately," said Hoey. Boston's Ben
Chapman hit to left field. "It may be a home run! It may be in there!
Well, well, well! The ol' ballgame is tied up!"—final, Sox, 8-4.

 To Fred, a foul stirred "some very lively ducking." A "dandy
hit" U-turned the game. Hoey read "birthdays and births today"
and telegrams from Manchester, Bar Harbor, and "boys at the
vets"—a veterans' hospital. During one break, he pimped for
Socony Oil's "drain out winter service." In another, Hoey said
"to appreciate baseball, you have to see it. To get Kellogg's
Corn Flakes, you have to taste it." Weary, Fred flubbed, "Homer
hit a Foxx!"

 Since 1919, the Red Sox only twice had placed even fourth
until 1938, when they finished second. One day player/manager
Joe Cronin slashed a bases-loaded liner off Indians third baseman
Odell Hale's head to shortstop Billy Knickerbocker, who tossed to
second baseman Roy Hughes, who threw to first for a triple play.
In 1937, Bobby Doerr had joined the Sox, later regretting "Mr.
Yawkey's trying to buy a pennant." He later forged it from within.
By then, "The Man Who Does the Games" no longer did.

 Hoey could not believe he was gone, until he was. After all,
he knew the six-state Sox network, with its covered bridges and
autumn splendor. He knew how to message—"Mention Fred," said
Coleman, "and people recall Kentucky Club tobacco and Mobil's
Flying Red Horse." He was old-shoe, his phrase "He throws to first
and gets his man" later used by Ken "subconsciously." Above all,
Hoey built a style later adopted by future Red Sox Voices: respect

and subtlety over stomp and shtick. None of this mattered to The Men Who *Sold* the Games.

In 1937, John Shepard III sacked Hoey. Earlier that year, Franklin Roosevelt had thrown out the first ball at the All-Star Game in Washington. FDR now said that Fred should remain, prompting letters and telegrams to flood the Sox office. It went to his head, affecting balance, said reporter and broadcaster Leo Egan, especially when Fred got a raise. A year later, he sought another, Shepard this time dropping the guillotine for good. Again, the public "hooted and threatened a boycott," said Egan. Socony Oil and General Mills ignored it, wanting *their* Voice, not Kentucky Club's and the Flying Red Horse's.

"Radio was changing," Coleman said. "Fred paused a lot," lacking gloss. "Plus, the booze's effect never really left." Childless, unmarried, Hoey began his final decade. "On the air he *was* Boston baseball," mused Ken, "and it was not the same without him"—or McNamee or Totten or Laux or Ty: Depression Originals all. On November 17, 1949, Fred died at sixty-four, recently retired from the Boston *American*, in his gas-filled home in suburban Winthrop, of "accidental…asphyxiation," said the *Boston Daily Globe*. "He was generally credited with building up baseball broadcasting to the lofty spot it holds."

Chapter 3

1930s: To Broadcast or Not

In 2020–2021, the Coronavirus took more than 600,000 American lives, shut the nation down for a goodly portion of the year, and forced a madding crowd of companies and educators to work by Zoom—an online school for the eye. Ninety years earlier, the leading radio Voices of the time taught at a school for the ear.

Perhaps inevitably, since even the piety of language can be reduced to cash, baseball warred in radio's first decade over whether airing its product by wireless would help or hurt attendance. "At first," wrote James Walker of Saint Xavier University, "half of baseball's mostly East Coast barons viewed radio as a fifth estate thief, robbing them of…customers at the gate." Such fear was rational. Drawing from a dense populace that used the streetcar and subway to reach a park, teams like the Athletics and Phillies fussed that would-be patrons might find it easier—worse, more enjoyable—to stay home and tune in.

Antipodally, owners primarily in the Midwest, especially Chicago, thought radio a "promotional tool" to sell the Pastime in mid-America, said Walker, especially among the young. It "reach[ed] across the region's vast farm fields" into one small town after another, convincing legions to troop to the big city to see "what they could only hear through the ether." For a club like St. Louis, radio became an ambassador, the Redbirds network one day topping 120 affiliates. Raised in Iowa, Bob Feller said, "By the time

I got to Sportsman's Park, France Laux had made me feel like I was home."

This early schism pit urban v. rural, close-packed v. diffuse, and shoreline v. heartland America. It bred fear of a "slippery slope" that might harm club rights, leading enough owners to cashier a total radio ban when the idea first arose. "If the League could dictate [1930s] radio rights, what other team rights might be at stake?" Walker said, one size not fitting all. Some clubs regularly broadcast. Others did Opening Day, then turned to soap opera and news. Proving film mogul Adolph Zukor's truism that "the public is never wrong," the general population was more unified. It wanted each game aired.

In 1932, *TSN* polled readers about live radio baseball. Almost 260,000 voted—almost five times its circulation—people everywhere, Robert Creamer later wrote, pining for America's "favorite *divertissement*" to utilize the wireless. Yet improbably, in 1934, eight of sixteen big-league teams acted to thwart that wish by banning radio. According to writer Chuck Hildebrandt, "The Indians ended up *dropping* radio" before renewing it. Such Luddite resistance met oblivion, each non–New York club re-upping. Deeming it overly mercenary, no early franchise even charged for rights.

Gradually, local radio neutralized regular season's absence on the four national networks: CBS; NBC's "Red" for music and comedy and "Blue" for public affairs; and the Mutual Broadcasting System (MBS). On May 24, 1935, Franklin Roosevelt threw a White House switch to set another precedent—baseball's first big-league night game. By coincidence, it matched the Phillies at the Reds in the first game on nascent Mutual—Red Barber, announcing. He then returned to his second year as Voice of the Reds on giant five-hundred thousand-watt flagship WLW Cincinnati, radio not yet regulated. "Millions came to the park

each year," said Ronald Reagan. "Others couldn't or didn't,"
announcers their eyes and ears.

To a greater or lesser sum, we are each the product of a time and
place. Cleveland's Tom Manning, a baseball man, was shaped by
a baseball year. Born in 1899, he learned later about that year's
20-134 Cleveland Spiders, making the awful 1962 New York Mets
seem awesome. Said Manning, "That's some record to uphold."

Major Tom thrice won the National Amateur Baseball
Federation as player, coach, or manager, perhaps to avenge 1899.
Whatever he said was said volubly, the newsboy winning a 1918
Cleveland Press contest to measure the "loudest voice." Manning
stood behind home plate at twenty-one-thousand-seat League
Park, using a megaphone to bellow pitcher-catcher batteries. In
1929, he began reading radio scores, blowing the transmitter,
his idiosyncrasy at one with the yard's two flagpoles and 290-
foot right-field line. It helped convince WTAM to make him the
Indians' first Voice.

In 1931, Manning did his first of seven World Series on NBC,
emerging a luminary. Lou Gehrig was an Everest, dinging twice in
1936's Game Four: "There it goes, a long smash deep into center
field!" Tom began. "Way up! Going, going, going! A home run!" In
1930, Lou's Yankees had traded popular Mark Koenig to Detroit.
Later released, Koenig in August 1932 joined the Cubs, who,
making the World Series v. the Bombers, voted in advance to give
Mark only half of his postseason player's share. In Game Three,
Babe Ruth at bat, teammates cried, "Cheapskates" at the Cubs as
the Cubs threw liniment and profanity at Ruth.

Did Babe point that day to center field at Wrigley Field, raising
two fingers to predict a homer? Most historically shake their head.
Manning's NBC take then differed. "Now he is pointing out at
center field, and he's yelling at the Cubs that the next pitch is going

into center field!" Tom reported. "Here's the pitch. It's going! Babe
Ruth connects, and here it goes! The ball is going, going, going—
high into the center-field stands, into the scoreboard! And it's a
home run! It's gone! Whoopee! Listen to that crowd!"

Manning aired every 1933–1937 Presidential opener—FDR
flinging each's first pitch with his unorthodox, overhanded lob—
and at least eight other sports, air crashes, floods, and national
conventions, working from a plane, tugboat, and submarine. *TSN*
touted the Megaphone Man's "uncanny ability to shoot from the
hip at a microphone," his staccato also buoying eight straight All-
Star Games on NBC or Mutual from 1933 to 1940. In 1938, *TSN*
named him "Announcer of the Year." Tom seemed indispensable.
More accurately, he was indelible.

At his peak, Gillette then ironically dumped NBC and its
Redhead, Manning, for Mutual and red-haired Barber. Tom
drifted to Cleveland TV sports, joining Indians lead Voice
Jimmy Dudley on 1956 radio. Hearing loss and jet travel spurred
retirement. On Manning's death in 1969, the Cleveland City
Council named him one "of the ten most important men" in
Cleveland history. No one sought a recount.

Try picturing baseball broadcasting today without the player-
turned-announcer. You can't. At first re-creating in an auto
showroom, Jack Graney traced a historical arc. A Canadian in
America's game, jagged tone in a silken craft, he became the first
athlete-turned-mic man, doing the Indians every season but one for
twenty-one years.

"Graney made me know that I wanted to announce," said
then-Clevelander Jack Buck, hearing him from tiny League Park
and vast Municipal Stadium but knowing little of John Gladstone
Graney's past. One nickname was "Glad." The other was "Three
and Two Jack," surfacing in his first 1908 spring training. Player/

manager Nap Lajoie entered the cage as Graney began to throw
"the fastest ball I had ever pitched," knocking Nap out and sending
Glad to the minors.

By 1910, the Ontario native had returned to start a 1,402-game
career: first to bat v. Ruth (1914), wear a uniform number (1), and
try to save a mate in the clubhouse who later died of a thrown
pitch. In 1920, Carl Mays beaned Ray Chapman, fracturing
the shortstop's skull. Next day, "viewing his friend's body at the
hospital," wrote David Jones, Jack "broke down and had to be
forcibly removed from the room." That fall, Cleveland won its
first Series—and Bill Wambsganss completed the only-ever Classic
triple play. In 1922, Graney left baseball to "make some money,"
lost most in the Depression, and "to divert myself, bought a radio."

By and by, Jack was *on* the wireless, the 1932 Indians switching
to new flagship WHK. Raspy but genial, Graney persuaded Judge
Kenesaw Mountain Landis in 1935 that he was not "too partial"
to be the first ex-jock to air a Series or All-Star Game. Banging a
desk meant a re-created foul. A pitch cued "a strike through the
center." A hurler tossed "a sad iron fastball." Daily, Glad held a
lit, but unsmoked, cigarette in the booth. "It'd burn my hands,
but I couldn't puff and talk," managing to talk through Bob
Feller's fifteen Ks in his first big start and each of a record twelve
one-hitters.

In the 1940 opener at Chicago, "[Ray] Mack is on…one knee,
scrapes it up with his glove hand, flips it over to [Hal] Trosky at
first," Jack exulted. "A close decision, and he's out! Bob Feller has
his first *no-hit* game!" A year later, Joe DiMaggio's record fifty-six-
game hit streak ended July 17 before baseball's then-largest night
crowd, 67,468, at Cleveland. In the eighth, he lashed to shortstop.
"[Lou] Boudreau has it. Throw to second, on to first! Double play!
The streak may be over!" Graney said. It was, Joe straightway
hitting in seventeen straight additional games.

In 1946, new boss Bill Veeck closed League Park: too small
for his imagined hordes. The '48ers won the flag and beat Boston
in the Series. In 1950, WERE became the new flagship. Retiring
in 1953, Jack was honored at Municipal with a day. He did TV,
moved with wife Pauline to Missouri, and prized symmetry. As a
boy, Buck fell asleep to Graney. Glad now heard him daily over
KMOX. In 1978, Jack Graney fell asleep, for good, at ninety-one.

As the wireless grew through the 1930s, unanimity was more easily
mouthed than gained. For instance, Landis ordered a moratorium
on more radio, even suggesting that clubs charge a fee on existing
coverage. It failed for the same reason that each league's owners
spurned a total ban: "team autonomy was paramount," wrote
James Walker.

By 1938, all big-league cities but New York heard virtually
every home game—adding road re-creation, if feasible. Next year,
every franchise signed the Major League Broadcasting Agreement,
which defined "broadcasting" to include telephone, not just radio;
said clubs could broadcast only between 550 and 1600 AM and
not on a shortwave or other "high frequency" outlet; kept a team
from airing games on any station within fifty miles of another
park and in two-team cities when the other was playing at home;
and made the Yankees and Giants "two-team territory" but the
Dodgers, twenty miles from Yankee Stadium in the borough of
Brooklyn but technically in New York, just "one."

Since owners agreed on little, such unanimity underscored
radio's hold. Team rights had still not been sold when in 1937, the
Giants' Leo Bondy told other owners of a station's $100,000 offer
for home exclusivity. He declined, but many were scandalized or
intrigued. They were stunned when, in 1938, the NL and Brooklyn
Trust Company "tore up the pea patch," quoting Barber, asking

then-Reds chief executive and GM Larry MacPhail to save the
Dodgers franchise as Executive VP.

Previously, said Yankees Voice Mel Allen, Brooklyn had been
"so fouled up internally—ownership, money problems—that they
just went along with what the other two New York clubs did."
Deeming it inane to ignore the wireless, MacPhail, green with
envy, now began grasping green, his initial acts as subtle as a horn.
First, the new Dodgers don immediately ended the ban, putting all
154 Brooklyn games on 1939 wireless: live at home; away, by wire.
Second, the visionary committed to bringing the 1934–1938 Reds'
radio Cortez to Ebbets Field.

"MacPhail believed in [radio's] promotional power. He became
sold on it," said Barber. Each grasped how radio "made a game
played by two teams [into] a contest involving personalities who
had families, troubles, blue or brown eyes." When WOR 710 AM
began airing each inning of the Dodgers, it jolted the Yanks and
'Jints from hibernation, flagship WABC airing at home when
possible and "re-creating away wherever it had space," Red sniffed.
"No way could they let Brooklyn have exclusivity." Already, a
certain individuality was seen to separate Brooklyn from the
other boroughs.

In 1934, Washington Senators (a.k.a. Nationals) owner Clark
Griffith hired the "Rembrandt of the Re-Creation." Arch
McDonald brought a Tennessee drawl, pick-pocket's brass,
showman's gift, and love of the limelight, baseball, and radio.
Born in 1901 in Hot Springs, Arkansas, moving to Chattanooga
as a child, he welded grit and dash and anything to stay afloat as a
crop hand, butcher, fight referee, refrigerator salesman, soda jerk,
and patent medicine man. Baseball's future impresario screamed
common man.

In 1932, Arch began with the Class-A Chattanooga Lookouts of owner Joe Engel, the "Barnum of the Bushes." Fueled by Engel-led write-ins, he beat major league Voices to become *TSN*'s first "Announcer of the Year." Half a century later, the *Washington Post*'s Shirley Povich was still amazed. "A fan vote, yes [57,960 total], but over *big*-league guys?" Each team has a scouting system. The Nats scouted Voices, too, Griffith hoping to exploit a 1933 pennant by putting games on radio, only to have the second division roil his club all but three of the next twenty-three years.

McDonald arrived in the capital in Roosevelt's first full presidential year, FDR using the radio—"My friends"…"you and I"…"we neighbors"—language as conversation. Arch also did, chanting "right down Broadway" (strike) and "ducks on the pond" ("runners") and "there she goes, Mrs. Murphy!" (Nats home run). A play that disproportionately benefited the Senators—a homer, grand throw, or catch—might lead him to sing a country ballad hymned by, among others, singing cowboy Gene Autry, "They Cut Down the Old Pine Tree."

During Arch's suzerainty, McDonald was a Southern man in a Southern town. It took John F. Kennedy's 1961 arrival as president to break Dixie's grip on local culture. Arch's style overlaid re-creation, joining the sound of infield chatter, crowd murmuration, and pencil against hollow wood miming bat against ball. For a while, he re-created by an open window of a People's Drugstore on G Street three blocks from the White House. Outside, hundreds jammed a sidewalk, "roaring for blocks on end," said Allen.

One day, McDonald said, "The Senators are going to win this game, or I'm Scarlett O'Hara!" When they lost, he did next day's game sitting in the display window of his sponsor's drugstore, wrote Warren Corbett, "wearing a full skirt and petticoats styled after the heroine of *Gone with the Wind*." The *Star*'s Morris Siegel mused, "He'd draw more people than the Senators." Later, the

drugstore built a basement studio, Arch in a glass booth, encircled
by a 350-seat bleacher section, audience cheering all around.

If Cecil Travis doubled, McDonald twice hit a gong. A Mickey
Vernon homer earned a ring for every base. Ratings evinced Arch's
spell as an amateur theater actor, charity banquet emcee, and
comedic contrast to WJSV (later WTOP) "morning personality"
and later TV star Arthur Godfrey. In 1936, they bet on whose
listeners would give more Christmas gifts to needy children. The
loser was McDonald, appearing at the children's Christmas show
to perform "The Dance of the Dying Swan" in a ballerina's tutu.
Joe Engel would have cheered.

General Mills was a Senators sponsor, among many, "and liked
games done in a particular style," said Allen. A home run became:
"It's into Wheatiesville!" The dugout greeted him at home:
"Wheaties—go get 'em!" In 1939, it paid $400,000 for Yanks
radio rights. In turn, McDonald was hired as America's highest-
paid sportscaster at $27,800 per annum, reportedly more than Joe
DiMaggio, said the *Washington Post*, to air the Yankees and Giants
at home, neither there on the same day. Each's road schedule was
blacked out but later re-created.

A *TIME* magazine story profiled the debut of baseball radio in
New York, naming the "big, bearlike" McDonald an "Ambassador
of Sports." Arch's pickle was cultural, a rub some foresaw.
Patronized, he was a fish out of water. "People thought him too
rural," wrote Corbett. "After calling a pitch, he waited silently
for the next one." Under hiring roulette, Arch was to be replaced
in DC by Allen until one day early in 1939, Mel said, "the man
who to Washington had always meant to *throw* the pitch entered
Griffith's office": Walter Johnson, 417-279 in 1907–1927.

Seeing the Big Train, Clark's bell went off: Walter, on Senators
radio! Later, Allen mused, "It's a thrill to lose out to Washington's

biggest hero." Mel had recently joined CBS, outlet WABC the
Yankees flagship. That May, McDonald's Bombers sidekick began
an Ivory soap spot. "And now, ladies," said Garnett Marks, coyly,
"I want you to get up close to your radio set. I want to talk to you
about Ovary soap." Misspeaking, he laughed, tried again to say
"Ivory," chuckled, and was fired, public letters and stories dubbing
him lewd. At that point, Allen became McDonald's aide.

After one year, Arch sailed home down the Potomac, having
nicknamed DiMaggio "The Yankee Clipper" after the first
transatlantic airliner, the Pan Am Yankee Clipper. He won his
second "Announcer of the Year" award in 1942, often working
in pre–air conditioning undies. Named best Voice again in 1945,
McDonald did Mutual's World Series a year later. It went badly,
Variety saying, "The World Series is over, but as far as radio, the
sour taste lingers on." That fall, Arch ran for Congress, losing in
Maryland's suburban Montgomery County and before long his
preeminence in Washington.

For the Arkansan, post-war TV loomed less as opportunity than
a threat. In 1948, Bob Wolff became WTTG Channel 5 anchor.
Next year, McDonald added video to WWDC Radio. By 1952,
Wolff moored the Nationals booth. "He [Arch] was bigger locally
[in Redskins football, Maryland basketball, and boxing], but Bob
got bigger nationally," said the *Star*'s Siegel. Finally, the Brooklyn
Dodgers Radio Network entered DC, Nat Allbright re-creating the
integrated team, its ratings often topping the Nats'. Griffith's first
Black player debuted in 1954, too late to outlast the Dodgers.

In 1956, *TSN* deemed McDonald the longest-serving baseball
Voice since 1932. Not impressed was National Bohemian Beer,
removing him from baseball radio/TV in late 1956. "He never
saw another [baseball] game," said Siegel. Instead, Arch had a
heart attack in 1960, defying his doctor by returning to work and
"doing the things I like to do. I'll eat anything that doesn't eat me."
That October 16, the Voice of the Redskins aired a road game

at Yankee Stadium, where the New York football Giants played. On the train headed home, Arch fell from his chair while playing bridge and was pronounced dead by a doctor. He was fifty-nine.

In late 1960, the same-age Senators fled to Minnesota as the renamed Twins. By then, they had not won a World Series since 1924—and would not until 2019, under a different DC franchise, as any true citizen of the capital knows. To paraphrase Bill Veeck in another context, Arch made each game a carnival, each day a Mardi Gras, and every fan a king. He received the National Baseball Hall of Fame and Museum's 1999 Ford C. Frick Award for "broadcast excellence." No one was reported to have sung "They Cut Down the Old Pine Tree."

In 1928, a five-foot-six, three-hundred-pound son of a Jewish immigrant tailor attended a boxing match in downtown Cincinnati covered by 250-watt WFBE, then-weakest of the five stations heard in Ohio's second-largest city. The tiny outlet had forged a niche by covering what *Media Heritage* called "sports, amateur acts and nearly anyone else who strolled into their basement studios"—McDonald redux—"in the…Parkview Hotel." That night, the ring mic man failed to show, Harry Hartman "[taking] a swing" in reserve.

Hartman was unschooled, earthy, and had a voice to sear the ear, yet boasted a cult fandom from a WFBE series when, in 1930, he touted to Reds owner Sid Weil the need for personality on the air. Soon Harry waddled into a chair behind the backstop at then-Redland (later, Crosley) Field, stripped to his briefs, and fashioned a rapid cant that became his schtick: half-character and half-cartoon. Given the station's power, many expected a peewee audience. His creative and vivid personal vocabulary—rich with words like *socko* and *blammo* and *belto* and *whammo*—proved them wrong by cementing his brand with listeners.

Later renamed WCPO, the station was among the first to air baseball's entire 154-game schedule, becoming 162 upon the early 1960s expansion. "Hartman was a character who, for a lot of people, as Dizzy Dean said, 'learned 'em baseball,'" said former Hall of Fame historian Lee Allen. "His dictionary wasn't thick, but his delivery won you over." Like Tom Manning, Harry doubled on radio and public address, sitting between two mics, addressing them in order, and between pitches cracking jokes.

In 1948, Mel Allen birthed "Going, Going, Gone!" upon a homer. Hartman was said locally to have coined the phrase, since he and bandleader Zeke Moffitt released a song with the title, "Bam! It's Going, Going, Gone!" around the time Harry was named the *Sporting News* 1936 "Announcer of the Year." Cincinnati "had no one to compare him with," said Barber, until he became that barometer on spiring WLW in 1934. Four years later, both aired the All-Star Game at Crosley: Harry on WCPO, Red on NBC. Sadly, WCPO dropped the Reds in 1943. By then, Hartman had moved into sales, having brilliantly sold himself.

In 1938, future Hall of Fame pitcher Waite Hoyt retired at thirty-eight, turning to play-by-play, where his past speaking tense was ageless. The usual mic man says, "A liner back to the pitcher! He throws to first, trying for a double play. The runner is out!" Waite never thought of himself as usual: "There was a liner to the mound!" he insisted. "The pitcher threw to first base. The runner dove back. He was out!"

Invariably, the 1942–1965 Voice of the Reds cited "accuracy" to explain his speech. "As I speak to you, what happened a moment ago is gone." Hoyt became among the first fine athletes-turned-announcers, making Cooperstown as a player (1969) and nominated as a Voice (Frick Award finalist). "Schoolboy" Hoyt grew up in Brooklyn, pitching for Erasmus Hall High School. In

1914, his father Addison, a noted minstrel, vaudevillian, and show
business manager, drove to the Giants office, signed his fifteen-
year-old son's contract, and agreed for a mere five-dollar bonus to
be put in the bank—the team wanting to curb Hoyt's ego and pop
wanting him to toe the line.

Writer Will Wedge named Waite "The Aristocrat of Baseball"
for his cool and panache, but at first, Hoyt mimed a commoner,
pitching for an industrial team. By 1919, he made the champion
Red Sox, joining fellow left-hander George Herman Ruth. Next
year, Babe's circus invaded New York. Waite followed in 1921,
helping the Bronx Bombers make their first World Series. "The
secret to success," he would say, "is getting a job with the Yankees."
He did a job on the Giants in 1921's last best-of-nine Series,
the Yanks losing but Hoyt hurling twenty-seven innings with no
earned runs.

Already Hoyt was enamored by what he read about radio. A
Brooklyn neighbor invited him to hear for himself. "I went in and
in the front room, a converted bedroom, sat the first radio I had
ever seen," Waite said. Equipment covered the wall, set to receive
and send signals tuned to KDKA, Hoyt "completely flabbergasted
at the thought of sounds coming from the box"—natural for a
man who later composed, danced, and sang at the Palace Theater,
appearing with Jack Benny, George Burns, and Jimmy Durante:
good company, like the Yanks.

In 1927, the Bombers earned the sobriquet "Murderers' Row,"
Ruth and Gehrig skying sixty homers and 173 RBI, respectively.
Hoyt finished 22-7, claiming famously, "It's great to be young and
a Yankee." New York clinched the pennant September 13, giving
him the rest of the month off. Waite used it for his first gig before
a mic, NBC having him talk on WEAF New York each Monday
about baseball. "Time wasn't a factor," Hoyt said, exceeding the
allotted fifteen minutes "with no repercussion" and appearing
regularly on the wireless as the Yanks swept two Series in a row.

In 1929, Babe married a second time, to Claire Hodgson, at
five in the morning. "The only time we can miss crowds," she
said. Ruth stories have since segued into myth. Writers then often
shielded Yanks beside the Babe, Hoyt later drinking so heavily that
he entered a hospital to dry out. Papers explained it by dubbing
Waite amnesiac, leading Ruth to telegram, "Read about your
case of amnesia. Must be a new brand." Released in 1930, the
Aristocrat was signed by five other big-league teams, twice by
Brooklyn, before retiring in 1938 with a record-tying six Series
victories, a 237-182 record, and hope for a life beyond the stage.

By then, his father-in-law had helped Hoyt enter the mortuary
and funeral business, leading writer John Kieran to dub him "The
Merry Mortician" and Waite to say, "I'm knocking 'em dead on
Sixth Avenue [theater] while my partner is laying 'em dead in
Westchester." Brown and Williamson Tobacco Company made
Waite a cast member with actors, actresses, and a thirty-six-piece
orchestra on WMCA's daily 210-minute *Grandstand and Bandstand*.
For a fifteen-minute WNEW program, Hoyt was "writing pages on
Honus Wagner and only getting time to complete half of them. I
learned, but there was nobody to school me."
　　Waite faced a belief that ex-players lacked adequate
vocabulary—read: education—for play-by-play as opposed to
"color," General Mills even canceling an audition. Umpire George
Moriarty knew better. Arguing a call, Hoyt told him, "You're out
of your element. You should be a traffic cop so you could stand
in the middle of the street with a badge on your chest and insult
people with impunity." By 1940, Barber, ensconced in Brooklyn,
felt that while "Waite'd never done baseball, I thought he would
take to it naturally," making him a pre/post-game host.
　　In late 1941, any station could air a team, Cincinnati's WKRC
seeking to compete with WLW and WSAI. Hoyt's agency, William

Morris, asked about play-by-play. WKRC doubted "my ability to
ad-lib and speak extemporaneously," he said later. Other angst was
legitimate, Waite having to learn to score a game and condense
what he knew while convincing execs that an elitist voice and
education—he lacked both—were effete. In turn, Hoyt worried
about Cincinnati's image as sedate and slow. How would the night
owl thrive? He didn't know, Waite said, yet found a happiness "that
I'd never known."

Hoyt voiced 1946–1951 by himself. In 1952, he pioneered
the NL's first radio/TV simulcast—both media at once. "I did
everything, even Burger Beer ads," he said, trying to weave hopeful
but credible prose. "It wasn't easy. In 1945 through 1955, the Reds
were second division each year." Other teams had stars, he jibed.
What did Cincinnati have? Stories so human and told so well that,
while other stations in a rain delay returned to the studio for music,
listeners remained with Hoyt to hear.

In bars and homes and stores, they heard Waite talk for an hour
or two about Ty Cobb, Tris Speaker, and Ruth—no one knew
Babe more. On August 16, 1948, airing the Reds, Hoyt learned
of Ruth's death from cancer. After the game, he paid a two-hour
tribute to the Babe on the air, without a note. Waite's best yarn
referenced third baseman, Joe Dugan, helping carry Ruth's coffin
from St. Patrick's Cathedral in New York on a steamy day. "Lord,"
moaned Joe, "I'd give my right arm for a beer." Hoyt murmured,
"So would the Babe."

Waite might have sacrificed other limbs for a respectable club. Out
of nowhere, the 1961 Reds arose. Vada Pinson batted .343. Frank
Robinson's thirty-seven home runs and 124 RBI earned a Most
Valuable Player award. On September 26, the Reds flew home
after clinching a tie for their first post-1940 pennant. Downtown

speakers blasted Dodgers play-by-play. LA was eliminated
that night.

Hoyt aired radio's 1953 and second 1960 All-Star Games. In
1961, he was busted back to the wireless by NBC on the Series,
deeming him not TV-ready. The Yanks led the opener, 2-0, when
Cincinnati's Dick Gernert lined to third. "A ball that [Clete]
Boyer stopped!" said Hoyt. "There was a great stop by the third
baseman. He dove to his left, stopped the ball, jumped to his feet,
and threw Gernert out!" The next day's set pivoted in the fifth,
Yankees catcher Elston Howard missing a pitch. "[Elio] Chacon
suddenly storms home, and he's safe!" The Reds won, 6-2.

Tied at a game, the Series moved to the NL's tiniest park:
center field 387 feet from the plate and capacity a mere 30,274. All
knew how baseball's most recognizable player, the Yankees' Mickey
Mantle, had braved a late-year hip infection. During Game Three,
blood seeped through his uniform. In the ninth inning, Mantle
knelt in the on-deck circle. As Mick watched, Hoyt's partner Bob
Wolff cried, "There's ball hit out in right field, and there goes the
home run for Roger Maris—his first hit of the Series!" It swung
the game, 3-2.

A day later, Mantle left after two at-bats. In the third inning,
Yankees pitcher Whitey Ford got "Chacon [to] hit a squibber...
to the second baseman [Bobby] Richardson, who...threw him
out," Hoyt said, breaking Ruth's Series streak of twenty-nine and
two-third scoreless innings in 1916 and 1918: New York, 7-0. Next
day Cincinnati was sent packing, 13-5. The secret to success still
involved the Yankees.

In 1965, Waite released a record, *The Best of Waite Hoyt in the
Rain*, then another, *Waite Hoyt Talks Babe Ruth*. In September, the
Reds held Waite Hoyt Day. "The big adventure is over," he said,
retiring to join Burger Beer's publicity office. Hoyt died of heart
trouble in 1984, at eighty-four. Today, replica microphones hailing

him and later Reds Voices Marty Brennaman and Joe Nuxhall
hang below the radio booth at Cincinnati's Great American Ball
Park, where Waite's tense evokes William Faulkner's requiem: "The
past is never dead. It is not even past."

The *Sporting News* 1959 preview issue showed White Sox radio
Voice Bob Elson's photo: like the run, field, and pitch mode of the
Pale Hose, as they were called, slightly out of date. Bob was still
styled "The Old Commander" for US Great Lakes Naval Training
Center war-time service. In 1943, he had even been given leave
to call a Series. "Franklin Roosevelt asked that he announce [for
Mutual]," Jack Brickhouse said. "Only time a president used rank
to get a uniformed baseball guy home."

To many, by the 1930s, Bob had succeeded Graham McNamee,
Jack mused, as "the most imitated, creative announcer who ever
lived." He called twelve World Series and nine All-Star Games
through 1943, all but one on Mutual—twenty-one of baseball's
two peaks. Elson was also huge beyond the game, his weekly
network series as measured as the time. Ultimately, World War II
ended, currents changed, and he seemed less salient. Yet his life
was integral in taking radio from early steps to a presence in almost
every home.

A March 1904 baby, Bob came from a five-child Chicago
family reliant on its grocery business, his voice intervening as a
career, so wowing nuns at a local church that he won an audition
for the Paulist Choir. Making it, Elson competitively toured five
years in Europe, taught not to shout for fear it might hurt the voice.
He graduated from DePaul Academy, entered Loyola, transferred
to Northwestern, but didn't graduate, finding radio too fetching. In
1928, Bob visited St. Louis to see pool whiz Willie Hoppe, where
his career took a carom.

At the Chase Hotel, Elson readied for a KWK station tour but, finding it to be an announcing contest, decided to audition. He read a script, won a listener vote, and worked until Chicago papers, reporting it, made WGN Radio tender an offer to come home. On the eve of turning twenty-five, Bob debuted in 1929 on news, live music remotes, and network lead-ins, especially the *Amos 'n' Andy Show*—everything but sports. Quin Ryan, once editor of WGN's boss, the *Chicago Tribune,* called baseball and other games but liked writing and station politics more.

Such leverage let Bob become the 1931–1942 Cubs *and* Sox Voice of WGN's home schedule. To a baseball lover, five Chicago outlets carrying it filled radio's cradle. "There were no soap operas in those days, so women had to listen to baseball or shut the radio off," Elson said. Commissioner Landis helped him become baseball's pre-war network prism, the commissioner's office "down the street" from WGN. They often lunched, as in 1930, when Landis began tapping Series Voices: McNamee at NBC and Ted Husing at CBS.

That season, baseball for the first time sold exclusive rights to Ford Motor Company for $100,000. Another precedent was The Commander's on-field radio interview with A's manager Connie Mack. "Judge Landis said it was OK to run a wire from the booth. At first players were antsy," Bob said. "Before long, they got the swing." Elson also interviewed at the Series and 1933's first All-Star Game at Comiskey Park. "We have a sellout," recently retired manager John McGraw told CBS, "a fine day, and I hope the best team wins."

The AL did, 4-2, Ruth belting the Classic's first homer and Bob saying, "Babe must have asked God for timing." Landis also chose All-Star Voices, only a 1936 illness breaking Elson's 1933–1942 streak. "The Judge would say, 'Stick to baseball. There's going to be a lot of Hollywood people in the park, and I don't want to hear a thing about them. I don't care if Harpo Marx slides into second

base…it better not be mentioned in the broadcast.'" With Bob, it was more rewarding to remember what was.

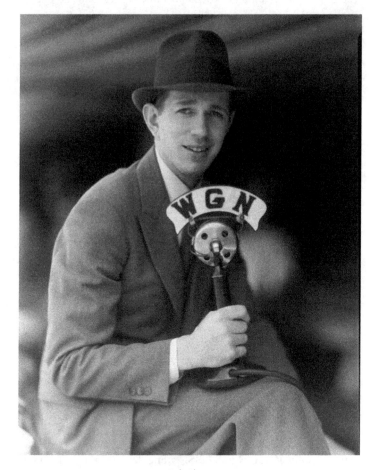

Bob Elson

Elson voiced the 1932 World Series where Babe Ruth did or did not prophesy his home run against the Cubs. "I was there!" Bob said. "He pointed to the bleachers." In 1935, Mutual's first Classic began with a bang: Barber and Elson on play-by-play. "Like a good

marriage, it clicked," the Commander said. In 1937, "Yankees 1,
Giants 0… And there's a long one! …Joe DiMaggio has hit a home
run over the roof!" In 1939, Gillette paid higher rights for Series
exclusivity, ending multi-network coverage and pairing Barber and
Elson for the first of four more times through 1943.

Elson's vitae included Chicago Cardinals football and Black
Hawks hockey, boxing, horse racing, and college football. He also
interviewed big-wigs at Chicago's Ambassador East Hotel—his
1942–1945 service as a lieutenant, senior grade, drew celebs to US
bases around the world—and on the 1946–1948 series *Bob Elson
On Board the Century* for the New York Central Railroad's *Twentieth
Century Limited*, mid-century America carted from Grand Central
Station to Chicago's Union Station and back.

Elson interviewed Eleanor Roosevelt, Richard Nixon, John F.
Kennedy, and Marilyn Monroe: like Bob, newsmakers of their
time. Even reclusive Joe D. spoke, if not architect Frank Lloyd
Wright. Elson: "Mr. Wright, I've always had a great appreciation
for your work." Wright: "In that case, young man, I've done
enough for you already." Peaking in the 1940s, Bob did voice-overs
for weekly newsreels and the first yearly 1943–1948 Series official
highlight film. If not ubiquitous, nationally known he was.

By the 1950s, the passenger train's heyday past, Elson took his
show to the Pump Room in the Ambassador East on each non-
baseball weekday afternoon, studying an answer before posing the
next query—rare even for a medium of conversation. The 1930
Mack interview baptized his *Man in the Dugout*, heard before and/
or after each game: a feature that can hardly be exaggerated, since
big-league clubs have employed such shows for years, selling ad
time, humanizing the club, and raising a player's profile.

By 1942, Bob had married, later to have three children. In
October 1945, discharged from the navy, he continued to arrange
for entertainers to tour military hospitals and service bases. After

Mutual's 1943 Series—Bob in uniform behind a mic—he may
have despaired of one-upping himself. *You* try. Of greater concern
was deciding for which post-war team he would call balls and
strikes in Chicago, its broadcast world turned upside down.

Regard Elson was a giant question mark. Ready to pop a cork,
the 1947–1948 White Sox and Cubs meant to air all games on
radio and add TV when possible. The Cubs had just won the
1945 pennant, Bob thinking it a fluke and the Sox a better bet to
compete. Meanwhile, Jack Brickhouse had grown up in Peoria,
believing that Bob would play anywhere, by 1940, such loyalty
ensuring his niche as Elson's protégé in everything but name.
A telegram from Bob read: "Have recommended you for our
announcers' staff and sports assistant. Expect a call… Remember, if
asked, you have a thorough knowledge of baseball."

Hired, Brickhouse introduced Les Brown's band, continued
"Man on the Street" interviews begun in Peoria, became Notre
Dame's play-by-play man—a religion in Chicago—and helped
Bob air *their* sport. In mid-1942, Jack replaced navy-bound Elson
as WGN's big-league Voice, doing the Cubs through 1943 and
the Pale Hose through 1945. Next year, Bob returned to Sox
WJJD, Brickhouse spending 1947 on experimental television and
returning a year later to both teams' WGN seventy-seven-game
TV home slate—154 games of his catchphrase, "Hey-hey!"—the
extrovert's face and voice in every crevice of the city.

In 1952, the Commander sailed to WCFL. The Sox highwater
mark was 1959, the first time in fifty years that a non-Comiskey
(Bill Veeck) owned the park. After eight Yankees flags that decade,
the Hose portended a new day in one eleven-run inning of one hit,
ten walks, a hit batsman, and error. Taking the lead in July, they
broke their attendance mark (1,423,144) and clinched the pennant
September 22, 4-2, at Cleveland. "Vic Power stepping in," said

secondary Voice Don Wells. "A ground ball up the middle! Luis [Aparicio] up with the ball, steps on the bag, fires to first for a double play! And the White Sox have won the American League [AL] pennant!"—a forty-year wait ended.

At Midway Airport, fifty thousand had gathered to greet the champion White Sox as the plane arrived after two in the morning. Veeck was shocked to find that on the final out Mayor Richard Daley had activated air raid sirens, their cry presaging Bob's. Each 1947–1965 Series club's Voice aired half of each game. "With the Sox in, it couldn't be Allen," said NBC's Lindsey Nelson of the usual AL suspect. "The problem was that [NBC 1952–1963 sports head] Tom Gallery and Bob had loathed each other as kids" on the same block in Chicago.

Gallery chose Brickhouse to represent the Sox on NBC TV. Elson's network snub was "the biggest hurt of my career," Bob lamented, re-creating the Classic locally on WCFL. He spent his last Hose decade reading box scores, calling his broker, and playing gin rummy, of which he was a master. In 1969, Richard Nixon hailed baseball's centennial at the White House. When an aide introduced Elson, the president nodded, fondly. "Oh, I know Bob," he said. "I even knew him back when the White Sox had a good team."

Axed in 1970, Elson lasted one season in Oakland. Without Chicago as a canvas, the artist was lost, dead of a failing heart in 1981, at seventy-six. Referencing Allen and Barber making Cooperstown in 1978, Brickhouse said, "If Bob had lived in New York, he'd have been the first inducted into the Hall of Fame." The Commander joined them there in 1979, the final baseball port of his long and fine career.

In 1944, WIND's Ralph Bertram Puckett, a.k.a. Bert Wilson, had begun blowing for the Cubs. Outside the park, people trekked from

provinces to Wrigley Field. Ivy draped the outfield wall. Afterward,
a banner flew a white "W" (on blue backdrop) or blue "L" (on
white), Wilson baying, "I don't care *who* wins as long as it's the
Cubs!" He knew the odds. The native Ohioan had moved to Iowa,
learned the trumpet, announced and sung on his state university's
campus station, and at twenty began in commercial radio, no
local outlet having baseball. Bert convinced a station to air it, even
sitting atop a house near the center-field fence to make play-by-play
more aerial.

By 1943, Wilson did hockey, basketball, roller derby, football,
the Indianapolis 500, and Double-A baseball. When the Cubs' Pat
Flanagan needed an aide, Bert auditioned. "Despite laryngitis,"
WIND said, "he...talk[ed] his way in," earning Pat's post on his
retirement. From 1944 to 1955, the ultimate evangelist quaffed
beer ("practicing what he preached," said '60s Voice Milo
Hamilton) while working solo. He did play-by-play, ads, "and
anecdotes—what we call color," said the Phillies' Byrum Saam,
feeling that "if Bert was paid by the syllable, he'd have owned the
Wrigley Building."

Once he and Brickhouse, out to dinner, became ensnared in
a giant traffic jam. "Didn't go anywhere for hours," Jack said.
Ultimately, an unknown driver "about eighteen cars away started
honking SOS on his car horn." Wilson, a ham radio operator,
reciprocated in code, downtown soon "a carnival of noise. But
that was Bert—he did *everything* with gusto." To WGN sports editor
Jack Rosenberg, the Midwest Cheering School of Brickhouse,
Hamilton, and Harry Caray, among others, started here.

"Bert was always charged up for his games," said Rosenberg.
"Understand that Chicago's broadcasting is a little different than
other cities. We don't *want* our radio-TV guys to kneel in a chapel
and sit on their hands," the Windy City expecting Voices to
animate: "Be exuberant, go get 'em, Cubs." Bert freely conceded

that "he listened to Bob Elson and copied him," Brickhouse said, "but was more excitable and always at the park. You could have buried him at Wrigley Field," like his teams.

Bert's first season at Wrigley parodied Cubdom, a 1-13 start almost making him rethink his trumpet. In 1945, MVP Phil Cavarretta hit a league-high .355, Stan Hack scored 110 runs, and the Cubs won the pennant before a seven-game Series loss. Partial redemption in the form of Ernie Banks arrived in 1953 from the Kansas City Monarchs, clubbing his first of 512 homers. "What wrists," Wilson observed. A year later, he said, "I think we may have a really good team this year."

The only team the 1954 Cubs beat was last-place Pittsburgh. The next year marked the end for what Brickhouse termed, "Sober or not, the quintessential Cubs fan." At Wrigley Field, hearts broke each year. Bert's heart stopped on November 5, 1955; Wilson was forty-four years old. Not "[caring] who wins," he would have in the 2016 World Series—since finally, "It's the Cubs."

Chapter 4

1940S: BASEBALL'S OLIVIER AND GIELGUD

"Talking great announcers, you start with them," Vin Scully said of Mel Allen and Red Barber. The 1940s were the first of several decades in which they towered: sportscasting's Laurence Olivier and John Gielgud, respectively. In 1978, they became the Baseball Hall of Fame and Museum's first broadcast honorees: the only year that more than one Voice won the Ford C. Frick Award for broadcast excellence because, to tell the truth, the committee couldn't make up its mind.

Like Millay, Red was a poet. Like Sinatra, Mel was a balladeer. Both became a World Series rite on network radio and TV. Much later, another Frick honoree dubbed baseball conversation "quirky," said Bob Costas. "Tell me about the guy sitting down at the end of the dugout. Does he come from some tiny little town in Arkansas? Is he a character?" Red and Mel understood. Listening, most of America barbed, beamed, above all, cared.

Their World Series dominance began in 1935: Red, on play-by-play, feeling it criminal to be prejudicial. In 1938, Mel debuted on Fall Classic color, deeming passion intrinsic to the game. Their first joint Series was in 1940. At one point, either or both voiced balls and strikes seventeen times in eighteen years, Allen more often because his Yanks owned October. Each cloistered us in a home,

bar, or eatery—or later by transistor radio smuggled into school, the score passed like code from one ear to another. Even teachers craved what they told us to ignore.

To many, Allen became the Bombers, baseball's greatest dynasty: a paladin or nonstop talker, contingent on your take. He was the ultimate sponsor's dream: home runs, a.k.a. "Ballantine Blasts" or "White Owl Wallops," after his signature "Going, going, gone!" Red obsessed more on the purity of his prose, huffing, "To care, to root, are not the rights of the professional announcer"—and was as good as his word. Mel differed: "Of course, I wanted the Yankees." With due respect, it wasn't hard to tell.

Red Barber

Mel Allen

One Depression day, *New York World-Telegram* cartoonist Willard
Mullin took a taxi back to his office after another Dodgers defeat.
The driver asked, "What did our bums do today?" Inspired by the
moniker, Mullin later drew the endearing, ill-shaven hobo who
became the "Brooklyn Bum." The 1930s Dodgers had roiled the
second division. In 1941, they lost a heartbreak Series, then won
104 games to barely lose a pennant. Nine times in 1946–1956,
Brooklyn lost a regular-season, playoff, or Series title on the last
day: the Bums beloved not despite but because of *why* and *how*

they lost. At the mic was a man who was born in Columbus, Mississippi, in 1908.

In 1930, as biographer Warren Corbett wrote, while Red "was working his way through the University of Florida as a waiter and boarding-house manager, one of his housemates, Ralph Fulghum, asked him to read a research paper on the university radio station." He started the broadcast intending to be an English teacher. He finished, dazzled by the wireless, dropped out of school, and as station Voice and director, began "looking for [commercial radio] jobs." In 1934, Cincinnati majority owner Powel Crosley hired vice president and GM Larry MacPhail, who put the Reds on behemoth WLW Radio, Barber their young Voice.

Most early announcers re-created noise to feign being at the park. Barber put a mic *next* to the telegraph to amplify the dot-dash. On May 24, 1935, he called Mutual's first game in the major leagues' night debut—at Crosley Field. In 1938, the Reds' Johnny Vander Meer no-hit Boston. Four days later, he threw another no-no, Barber voicing back-to-back. More precedent: On August 26, 1939, now-Brooklyn Voice Red aired the big-league TV baptism from Ebbets Field to the few sets aware of New York's W2XBS (now WNBC).

TSN declared the ball nearly invisible, unlike players, umpires, and Red. Barber vended General Mills, Ivory Soap, and Mobil Gas in the stands with no monitor and two cameras, "guessing from which light was on where it pointed." His TV stay was brief, for radio was Red's leather. By now, about everyone had a wireless: Robert Creamer wrote that you could walk down a street, windows open, and not miss a pitch. A distant cousin of writer Sidney Lanier, Red flattered by talking up, not down: listening to him an exercise in self-improvement.

The mound became "a pulpit" and the sky, "a beautiful robin-egg blue with, as the boys say, very few clouds in the form of

angels." Due to Barber, wrote broadcaster and media critic David
J. Halberstam, "and radio's importance then, we remember the
messenger as distinctly as the message"; the Dodgers were our
team, bub, and don't you forget it—and Brooklyn's "cathedral of
the underdog" was Ebbets Field.

Ebbets was built in 1913, fifteen years after the independent city of
Brooklyn had been incorporated into New York. Dodgers regulars
and reserves walked or took the subway to work. "Everyone in the
park knew everybody else," said longtime shortstop Harold "Pee
Wee" Reese. Brooklyn's largest bar had a 31,901-stool capacity,
often filled. Gladys Goodding—"one more D than in God"—
played the organ, greeting umpires with *Three Blind Mice*. Housewife
Hilda Chester rang a cowbell like a weapon. The Dodger Sym-
phony used a trumpet, a trombone, snare and bass drums, and
cymbals to daunt the enemy. The borough was still sensitive
to condescension.

In 1941, it and Red had a lot to cheer. Brooklyn lauded
him with a Day, and Barber read a script for the New York
Philharmonic "Symphony in D for the Dodgers." Brooklyn then
launched the Subway Series. In Game Four, the Bums led in the
ninth, 4-3. With two out, Hugh Casey threw what Red styled "the
craziest curve I ever saw." Tommy Henrich missed it, the umpire
roaring, "Strike three!"—series tied, except for catcher Mickey
Owen's passed ball: Yanks win, 7-4. "Anything can happen at
Ebbets Field," Barber said, "and usually does."

An example: A 1945 group led by Branch Rickey and Walter
O'Malley bought 50 percent of the Ebbets estate—the Dodgers.
That fall, Rickey broke the color line by signing a Black player,
Jackie Robinson. Less a career than a cause relied on his success.
He spent 1946 at Triple-A outlet Montreal. On April 15, 1947,
Jackie debuted in Flatbush, Red aware that his language would be

scrutinized. Some teammates petitioned for Robinson's demotion, but Barber and Kentuckian Reese refused to sign. For both, decency helped overcome.

That October, NBC telecast its first Series to DC, New York, Philadelphia, and Schenectady, New York. In Game Four, Yanks up 2-1, starter Bill Bevens forged eight walks and no hits in eight and two-thirds innings. Most Voices then ignored an at-work no-hitter as if jinxing it by noting it. Allen heeded the rite in the game's first half. Inheriting the mic, Barber junked it, revealing Brooklyn's line score—one run, two errors, no hits. Mel gasped.

In the Bums' last home at-bat, Carl Furillo walked. Pinch-runner Al Gionfriddo then stole second base. Pete Reiser was passed on a 3-1 count: the winning run on Bevens' tenth walk. Cookie Lavagetto then pinch-hit. "Swung on, there's a drive hit out toward the right-field corner!" Barber said. "It's off the wall for a base hit! Here comes the tying run, and here comes the winning [3-2] run!"—on the Brooks' sole hit.

Back in the Bronx, Game Six scripted an apex of Red's career: Joe DiMaggio up with two out and on, Dodgers up, 8-5. "Outfield deep, around toward left, the infield over-shifted," Barber said. "Belted! It's a long one! Deep into left-center! Back goes Gionfriddo! Back, back, back, back, back, back! He makes a one-handed catch against the bullpen! Oh, doctor!" No. 5 kicked dirt near second base, rare emotion from a stoic.

Next day the Yankees won the Series, 5-2. "We'll have to wait a while," rued Reese, not sure when that would be.

In 1948, Barber nearly died of a hemorrhaged ulcer, fueling change. In Atlanta, Georgian Voice Ernie Harwell was so superb that his Class-AA Crackers put a radio in the dugout. Rickey asked their owner, Earl Mann, to release him, offering a reserve catcher in exchange. At thirty, Ernie swelled New York's radio/TV colony

of Red, Alabama's Allen, and Russ Hodges of rural Tennessee.
"It's how we grew up," Barber said of Southern Voices drawn to
Gotham, "telling stories to be entertained."

Print could be still life. Radio supplied sequential imagery set to
sound. Television added sight. Late in the 1948 season, the number
of sets totaling three million, Gillette advertising's Craig Smith
called Red to "beg me" to air the Series. "You're the only guy who
can make this [TV] go," said Smith. Barber finally agreed, despite
the fear that stress would again induce hemorrhage. On Mutual,
Allen drew four times as many people as The Ol' Redhead on
NBC, Barber even glad to reach that total.

A year later, Casey Stengel became the Yankees' skipper, taking
more pennants (a career ten) and Series (seven, tied with "Marse
Joe" McCarthy) than anyone. In the scoreless Series opener v.
Brooklyn, Henrich batted for New York in the ninth. "Going way
back, back, that's the ball game, a [1-0] home run!" Barber cried.
"Look at him grin! Big as a slice of watermelon!" He was warm
on-air—"homespun" a favorite adjective—rewarding a listener: as
Harwell said, "Dodger fans unbelievably loyal." To insiders, this
meant a sublime product but an often-fractured booth.

"Red would often criticize you publicly," said Ernie. "Just
tough to work for." In late 1949, he joined the Giants' less acerbic
Hodges. To replace him, Barber chose Vin Scully, recently out
of Fordham, his initiation a last-day 1950 pennant loss. Two
years later, Barber televised his second Series, the Bums blowing
a 3-2 game edge. Poignant in memory is Duke Snider clearing
the scoreboard in 1952's Game Seven. "Boom! Look out! Look
out!" Red said of his right-field thwack. Finally: "You needn't
look anymore."

Barber's best club was likely the 105-49 '53ers. Before the
Series, he had to salve a wound. Gillette had become rich as
Classic sponsor, yet paid play-by-play men the same piddling two

hundred dollars per game. Most gladly took it. In September 1953, Red demanded the right to renegotiate his fee. Gillette refused. For support, he called Walter O'Malley, unaware that the Dodgers don and Bombers boss Dan Topping had just discussed an extraordinary deal at Toots Shor's Restaurant in New York.

O'Malley raised his glass. "I'll trade you the son of a bitch," he said of Barber.

Topping flushed. "I'll go you one more. I'll give you Allen."

Next morning, sober, they reneged, but the rancor, likely based on envy, endured. When Red phoned about Gillette's intransigence, O'Malley said, "That is *your* problem. I'll nominate Scully [earning a reported $18,000 v. Barber's $60,000] to take your place." Putting down the phone, Red told himself, "Walter, the Dodgers are now *your* problem." His resignation hit Brooklyn harder than losing a double-dip to the 'Jints.

As this chapter attests, the 1940s and 1950s paraded varied soloists. Barber is still revered. Aide Connie Desmond is far less recalled, despite a dreamboat voice. "You felt that Red was Brooklyn's forever," said Harwell, "and that if he left, Connie would take over." Intoxicating, Connie might have become the lead Voice when Los Angeles permanently borrowed the Dodgers. Instead, intoxicated, he snatched defeat from the jaws of victory.

Desmond entered radio in the 1930s with his hometown AA Toledo Mud Hens. "One year, we were eliminated in July," he said. "A month later, they condemned the park." In 1942, the then-Columbus Double-A mic man joined the Yanks. Hearing Connie on the wireless, Red hired him. In 1955, he missed several games, O'Malley axing him before the Series. Wasting another chance, Desmond missed several more next year and never aired another big-league inning. Meantime, Red shocked his industry by joining

Allen, in 1954! A New Yorker with a sense of history might have
been less surprised had Cornwallis joined Washington's senior staff.

At one end of the past decade, Mel and Red still intersected
like veins from a common mine. At the other, sometime in this
era, Allen passed Barber as *SI*'s "most successful, best-known…
most voluble figure in sportscasting, and one of the biggest names
in broadcasting." Mel forever praised his luck. "A guy [Garnett
Marks] says 'Ovary soap' by mistake and gets canned. Arch picks
me and dislikes New York, so I replace him. Everything had to
work for me to get a chance."

It surprised, given life's start. Melvin Allen Israel was born on
February 14, 1913, to Russian émigrés Anna Leibowitz and Julius
Allen Israel of Johns, Alabama, a small town near Birmingham. (In
1940, he adopted his father's middle name, Israel, "not euphonious
enough or easy on the ears," Allen said wryly of anti-Semitism in
radio and television.) Precocious, "Mel spoke sentences at a year,"
said Julius, "and loved baseball as much as speech."

Matriculating at fifteen in 1928 at the University of Alabama,
Allen entered its law school in 1932. Three years later, the regular
Voice of Auburn and Alabama football left town just before the
season. In the lurch, Birmingham's CBS outlet called Crimson
Tide coach Frank Thomas, who said not to worry: Allen was the
Tide's PA Voice—to Thomas, tantamount to play-by-play.

Mel did the game, got a good grade from CBS, graduated
in 1936, passed the bar, and won a university teaching post.
That December, he borrowed Dad's Ford, drove thirty-six hours
nonstop, and took five older classmates to New York "on vacation,"
he said. The trip lasted till his death in 1996.

On a lark, Allen took an audition arranged by CBS's Ted Husing,
who had heard Mel do a 'Bama game. Getting the job, he told his
parents, who bristled. Forget teaching for *this?* Julius also fumed

over the name change, softening when his son hosted *Calling in CBS Foreign Correspondents.* Mel understudied Husing, aired the Kentucky Derby, and was on a plane when the Vanderbilt Cup auto race was scrubbed due to weather. He ad-libbed to fill an hour, his composure—"I'd hardly ever been in a plane before, and now I'm *announcing* from one"—wowing brass.

In 1938, CBS put him on baseball. Allen would go to Yankee Stadium, find a swathe of empty seats at a game, and practice play-by-play. Events soon let Mel leapfrog his age, making him the Voice of the Yankees. Mel loved their park's cachet: the most famed sports site but for the Roman Colosseum. Lengths seemed timeless: 301 feet at the left-field pole to 457 in left-center via 461 feet in center field to 296 feet at the right-field pole. Its core were men for whom public feeling was familial: Phil Rizzuto ("Scooter") and Tommy Henrich ("Old Reliable") and Stengel ("The Ol' Professor," inventing the language Stengelese) and a string of others, including a man who gave baseball's Gettysburg Address.

By 1939, sixty million a week heard Mel voice-over a Twentieth Century Fox Newsreel short in theaters across the country: "This is your Movietone News reporter." That year a tragic rider to an American epic surfaced. Fourteen years earlier, future Yankees captain Lou Gehrig had played his first of a big-league record 2,130 straight games—thus, his moniker "The Iron Horse." In early 1939, tangible decline led manager McCarthy to observe "no coordination. Something was wrong."

On April 30, Lou weighed the symptoms of his yet undiagnosed illness: amyotrophic lateral sclerosis, a fatal neurodegenerative disease ultimately named after Gehrig himself. Next day his club traveled to Detroit. He awaited Joe, saying, "You'd better take me out." Tears filling, McCarthy vainly resisted, Lou presenting his last lineup card. On July 4, No. 4 retired at The Stadium; Lou started a talk few forgot: "For the past two weeks,

you have been reading about the bad break I got. Yet today, I consider myself the luckiest man on the face of the earth." He ended, "I may have had a tough break, but I have an awful lot to live for."

In 1940, visiting the park, Lou told Mel that as a player, he had never been able to hear him broadcast: "But I got to tell you, they're the only thing that keeps me going." Excusing himself, Allen began to cry. Later that decade, another myth was diagnosed with throat cancer. By April 27, 1947—his day in the Bronx— Babe Ruth could barely talk. Mel, emceeing, stood behind Ruth and asked if Babe wanted to speak. He whispered, "I must"— and did, so hoarsely that his end seemed as close as a fastball beneath the chin.

In 1935, Larry MacPhail pioneered night baseball, seeking a time when more demographics could hear or view. In 1946, the Yanks co-owner spent $800,000 to light the Bronx, his club the first with 154-game all-live radio (WINS), TV (DuMont), and team rights ($75,000 to televise). In the war, Allen, as a US Army sergeant, used the Armed Forces Radio Network to speak to troops abroad. By 1947, in a nation of over 140 million people, fifty-six million radios v. seventeen thousand televisions wrote a pinnacle of wireless' primacy. As many as 165,000 radios a month were sold: the undeniable Goliath. But TV's David was slowly gathering stones.

Radio let Mel embody what NBC styled "The World's Greatest Sports Spectacle": the World Series. Before 1942's, Allen thought, as always, of "one solitary fan" he pictured a few feet away. Mel's voice became its soundtrack—to *Variety*, among the world's twenty-five "most recognizable," like Churchill's and Ike's. In 1947–1949, he was heard by twenty-six of thirty-nine million homes with radio. Then, in 1950, "Movietone's own Mel Allen" got a day—"the most unique tribute ever paid to a sportscaster." Gifts included

nine thousand dollars to start a Gehrig and Ruth scholarship fund at Lou and Mel's alma maters, respectively.

In 1951, Allie Reynolds threw a July no-hitter. That September, he got another after Ted Williams popped a foul with two out in the ninth, catcher Yogi Berra dropped it, and "Ted fouled to the *same* spot and Yogi got—a no-hitter again!" said Allen. Eleven days before Reynolds's encore, the Yanks led Cleveland by half-a-game, filling the bases in a one-out ninth. As Joe D. left third base for the plate, Mel said, "He [Phil Rizzuto] lays it down toward the first-base line." Gloving the bunt, Bob Lemon had nowhere to throw as DiMag scored. "The Yankees win it, 2 to 1—on a squeeze play!"

Shortstop Rizzuto knew how to field, hit behind the runner, bunt—and like Berra and Joe D., win. A year later, the World Series title followed its usual path to the Bronx. Ahead for Allen were the darkest night and brightest noon of a man about whom the *Los Angeles Times*' Bud Furillo would write, "If Mel sold fish, he could make it sound as if Puccini wrote the score."

Webster's defines *malaprop* as "the usually unintentionally humorous misuse or distortion of a word or phrase." Byrum "By" Saam knew its meaning well. The man who began his career by saying, "Hello there, Byrum Saam, this is everybody speaking," was introduced by Allen on NBC Radio's 1959 Series as "one of baseball's finest announcers…the amiable, affable, able, the knowledgeable Byrum Saam." Distracted, By said, "Right you are, Mel." By called more losses than *anyone*: 4,395 for the 1938–1954 Athletics and 1939–1949 and 1955–1975 Phillies. Sanity demanded a sense of humor.

Byrum Fred Saam began as Texas Christian University's PA Voice in the mythic Southwest Conference. A local CBS outlet gave him TCU football, often aired on CBS's *College Football Roundup*. It, in turn, was heard by network sports director Ted Husing, who had Saam test for baseball at WCCO Minneapolis despite never calling

it. Hired at twenty, By began Minneapolis Millers play-by-play in
1936 on "the Good Neighbor to the Northwest."

In 1938, a man never wanting to be "too high or too low"
moved to Philadelphia, a city more acquainted with the latter. By
did Temple, Villanova, and the NFL Eagles, many college bowls,
and Wilt Chamberlain's one hundred points in a game. Above
all, he described what meant most to him and generations in the
Delaware Valley—going to the park, not letting interest die, even
when the A's and Phillies had. "Plenty of good seats available,"
Saam rhapsodized, "under a Lehigh Avenue moon."

Listeners felt a bond with "The Man of a Zillion Words." In
1938, the Phils left their half-century-old closet, Baker Bowl, to join
the Athletics at Shibe Park. Their new home was intimate, with a
vast center field and loud critics, of whom By reasoned, "Shrill fans
beat no fans." By 1950, Philadelphia's NW Ayer & Son ad agency
aired its last road re-creation, each local club airing a 154-game
slate live.

By often said, "Here we are, rolling into" an inning. No outlet
could roll through two teams' 154-game schedule, so, as Saam and
the Athletics stayed at WIBG, the Phillies switched to WPEN. By
felt protective toward the elderly A's manager, majority owner, and
patriarch Connie Mack, whose 1950 club placed last as the Phils
took their first pennant since 1915. In late 1954, Mack moved his
club to Kansas City. Next year, Saam rejoined his old National
League team. "I hated Mr. Mack leaving," he said, but perhaps
missed the Phillies more.

The Phils missed the World Series for the rest of the 1950s. In
1959, Saam did not, airing White Sox–Dodgers in the first Classic
west of St. Louis. At the time, sponsor Gillette chose each team's
TV announcer for half of each Series game—here, Chicago's Jack
Brickhouse and LA's Scully. Judged on voice alone—tone, scale,

and ability to fill a register—NBC Radio's may have eclipsed even TV, Saam and Allen among the Classic's all-time best pair of pipes.

From 1916 to 1953, the Bums lost seven straight Series before later upending the Yanks. In LA, they won the pot in year two. "It's a good thing I did a Classic on my own," Saam joked, also airing 1965's Dodgers-Twins. "In the end, I knew I'd never get there with the Phillies." Had they won more—the 1949–1964 Yanks *lost* a pennant only twice—what Neal Poloncarz called By's "eloquence and his mellifluous" tone might have gained a degree of Allen's public. Instead, Saam brooked a year far more awful than any of Mel's Yanks.

The year 1964 proved a test of inner fortitude. Gripping first place since July 16, the Phils led by six and a half games on September 20, a date that could be styled baseball's All-Souls' Day, the club hence dying. Skipper Gene Mauch suddenly adopted a two-man staff, Jim Bunning and Chris Short starting eight of their last dozen games. The first match set the tone, Chico Ruiz swiping home with Frank Robinson at bat to give the Reds a 1-0 shocker. "Given the hitter," said Saam's on-air partner Bill Campbell, "it made no sense," like the ten-day losing streak of locked jaws and pursed lips.

The streak dropped the Phils to third place on closing day, a game behind the Reds and Cards. If St. Louis won, it took the pennant. Yet "[if] we beat Cincy, the Cards lose to the Mets…it's a three-way playoff," By said. St. Louis bombed New York 11-5, voiding Philadelphia's 10-0 romp. In the end, the "Metsies," as '60s skipper Casey Stengel called his team, could not save the Phils' lost year. Somehow Saam's appeal survived it all. So did malaprops as his signature—a response to Mel's "How about that!"

Already on a night game from the West Coast, By had declared, "The double play went 4-6-3 for all you guys scoring in bed." Now Saam gaped of the Houston Astrodome, "What a beautiful night

for baseball. There's no breeze at all." When Ferguson Jenkins beat his former club, the Phils, By said, "Fergie comes from Canada, you know, and his mother died [actually, went blind] in childbirth. So, she never saw him pitch, although she keeps a scrapbook." Saam, a formal man who believed humor belonged *off* the air, inadvertently did his best to keep it *on*.

In 1975, By retired sans title. Next year's Voices Richie Ashburn and Harry Kalas asked him to call the last inning of the NL East Division–clinching game. Said Harry the K: "There's no one in baseball who deserves success more." In 1980, the Phillies, at ninety-seven, won their first World Series. A decade later, Saam rolled into a Hall of Fame reception that evoked his hilarious-without-meaning-to-be charm. Each napkin read, "Right you are!" Ask a Philadelphian. Right By was.

At the other end of Pennsylvania, many cherish another memory as special as Saam's. From 1936 to 1954, Albert K. "Rosey" Rowswell, a 112-pound humorist and lyricist, charted baseball's most ornate vernacular. Ten times in nineteen years, his Pirates braved the second division. Still, year after year, Rosey led the majors in the percentage of area radio sets in use, lauding everything not germane to the score.

A "dipsey-doodle" was a curve ball. A "doozie marooney" meant extra bases. The Pirates became the "Picaroonies." Rosey coined "FOB" for bases "full of Bucs" before Barber adopted it for Brooklyn. Each paled v. his 1938 Oscar-worthy call for a long drive at the Bucs' Forbes Field. Near its apogee, Rowswell barked from the ether, "Get upstairs, Aunt Minnie, and raise the window! Here she [the baseball] comes!"

Simultaneously, he signaled an aide standing on a chair, who then dropped a pane of glass: to a listener, a window breaking. "Oh, that's too bad," Rosey cried. "Aunt Minnie tripped over

a garden hose! She never made it!" One day a plump lass by the name of Minnie entered Forbes in a car for a KDKA TV promotion. Few criticized baseball's Empress with No Clothes. Rosey's successor, Bob Prince, confided: "People knew she was fictitious, and they didn't care."

The pencil-thin Rowswell, a.k.a. "Hercules" or "Muscles," first followed the Pirates as secretary of Pittsburgh's Third Presbyterian Church from 1909 to 1929. His itinerary included tending to parishioners, attending most games at Forbes, and taking Bucs road trips to Boston, New York, and Philadelphia. The 1925 world titlist Pirates gave him a gold watch. In 1936, the club put Rowswell on WWSW, Ripley's "Believe It or Not," noting his speaking rate of four hundred words a minute.

Historically, a local Voice sets the trend for other mic men. Rosey hailed his club, neutrality a sin to "America's [self-described] most partial baseball broadcaster." It wasn't easy. "Oh, my aching back," Rowswell said after each loss. Given Bucs' futility, he sought reprieve through individual success. Lloyd Waner had a .316 average. Brother Paul won a third batting title. No one gave Rosey's back more relief than Ralph Kiner, leading the NL in home runs from 1946 to 1952. One 1948 afternoon, the Pirates' greatest big-wig—at the time, part-owner—Bing Crosby guested behind Rosey's mic.

"I'd like to see Ralph improve a little on his showing so far this afternoon," the crooner said/sang. "Maybe he can do a little better [vs. the Cubs' Doyle Lade]… And he did!" Rosey interrupted, saying, "There goes a long one—open the—it may go in there! Aunt Minnie! [shouting] Boy, it goes clear out over the scoreboard!" Der Bingle, barely audible: "Oh, what a blast…" Rowswell: "Over into Schenley Park, a long homer for Ralph Kiner—his first of the 1948 season!"

Bing resembled an asterisk. "Sounds great," Prince, then a first-year aide, laughed, "but you [Crosby] haven't had the mic for ten

minutes." Stunned, Bob told Rowswell: "My Lord, do you know who you just stole the mic from?" Years later, Bob shook his head. "When you upstage Bing Crosby, you've really pulled the cork."

For a decade, aides dropped panes of glass. Prince's arrival changed Rosey's tack. "Glass got too messy," Bob said, buying a dumbwaiter's tray with bells, nuts, and bolts. In 1954, the Bucs added weekend road TV to WWSW's twenty-affiliate network. Rosey died of a heart attack next February 6. A plaque in their PNC Park press box hails the "Pittsburgh Pirates' first announcer." God bless Aunt Minnie, in memory still searching for her hose.

From 1948 to 1975, a listener to fifty-thousand-watt KDKA Pittsburgh learned enough jargon to last a lifetime. A home run met, "You can kiss it goodbye!" A seismic late-inning rally stirred, "We had 'em all the way!" Bob Prince hexed rival players, identified Bucs by animal names, and was devoted to Tri-State children's charity. "How sweet it is!" he said—and *was*.

As a child, the army brat born in 1916 had a daily word placed under his breakfast cereal dish by mama to be learned by night. Later Bob flunked out of four universities before entering Harvard Law. Nothing took till he recalled how, in the army, "I'd been trained to loaf." Suddenly, broadcasting seemed its cousin. *SI* wrote: "Once…you've heard him, you'd swear the man who invented the microphone had him in mind."

In 1948, Bucs radio aide Jack Craddock resigned. To replace him, Pirates part-owner Tom Johnson touted Prince, who asked Rowswell why he discussed poetry, "crazy sayings," recipes, and the zoo—a "Rosey Ramble." He replied that balls and strikes alone lacked appeal: "It's not just play-by-play that matters. It's what said between the pitches that counts." No Voice ever said it better.

Even before Rosey's death, his successor agreed. After discussing everything *except* the game, Prince footnoted, "By the

way, [Frank] Thomas grounded out, [Bob] Skinner flied out, and that's the inning." Here's to the "Rosey Ramble." Bob danced it to the end.

On May 28, 1956, Dale Long homered in an eighth straight game, a big-league record. As rare was the sangfroid Bob showed next year at the Chase Hotel in St. Louis, ribbing several Bucs about laggard pace. In response, mocking his boniness, Gene Freese dared the college diver twenty dollars to plunge into the hotel pool from his third-floor room. "If he doesn't clear [twelve feet of concrete]," said team trainer Danny Whelan, it "is strictly a blotter job." Prince did.

In 1958, Bob got a new partner, Jim Woods. Enos Slaughter had named him "Possum," saying of his haircut, "I've seen better heads on a possum." Poss now gave Prince a name—"The Gunner"—after the husband of a woman he was talking to in a bar pulled a gun. Jim shrugged at the maverick's past, deciding to "try him on for size." Baseball's Ringling Brothers used only a pencil and scorecard. "We'd do play-by-play or tap dance," said Bob, on the last out crying, *"Booze!"* Like Rosey, they soon led baseball in the percent of radio (also TV) sets in use.

In 1959, the Pirates' Harvey Haddix left Bob almost speechless by pitching the eighth perfect nine-inning big-league game— indeed, "counting his last victory at Forbes Field, [retiring] thirty-eight men in order before a man got aboard, and then only on an error," Bob said in a scoreless thirteenth inning. Joe Adcock then hit a "ball to deep right-center!…It is gone! Home run! Absolutely fantastic!"—Braves, 1-0. The term even better defined a new decade's first year.

The 1960 Pirates drew a team record attendance of 1,705,828. MVP shortstop Dick Groat batted a major league–high .325. Second baseman Bill Mazeroski turned a double play so quickly

the ball seemed radioactive to his glove. Outfielder Roberto
Clemente threw out an NL-high nineteen men. On September 25,
the Pirates clinched their first flag since 1927. The Series opened
at Prince's "House of Thrills." After six sets of "go figure"—three
Pittsburgh close-run things, as Wellington said of Waterloo, v. the
Yankees' bombs-away—Game Seven resembled a blind-folded
tour of an English garden.

Prince and Mel Allen telecast NBC's Series. In the first inning,
Rocky Nelson batted. "There's a drive!" said Bob. "Deep into right
field! Back she goes! You can kiss that one goodbye!"—Bucs, 2-0.
Down, 4-2, Yogi Berra hit in the sixth. "There's a drive hit deep
to right field!" Mel said, calling it foul. He then amended: "All
the way for a home run!"—Yanks, 5-4. In the eighth inning, Bill
Virdon slapped a grounder to Tony Kubek. "A sure double play,"
said the Yanks shortstop, "except the ball hit something, came up,
and hit me in the throat!"

Groat and Clemente singled: 7-6. Hal Smith's three-run
"electrifying homer," read the *Pittsburgh Press*, "turned Forbes Field
into a bedlam": 9-7, Bucs. New York tied the score in the top of
the ninth. In the bottom, Ralph Terry threw a slider at 3:36 p.m.
"There's a drive deep into left field!" said Allen, Berra retreating to
the 406-foot sign. "Look out now! That ball is going…going, gone!
Mazeroski hits it over the left-field fence for a home run. And the
Pirates win it, 10 to 9, and win the World Series!"

Bob spent the final's last inning doing what the game did: go up
and down. With Pittsburgh up, 9-7, he was ordered to do the NBC
clubhouse soiree. Prince took an elevator there, found the score
tied, and returned to the booth as Maz's blast "shook the yard."
An NBCer yelled, "Get back downstairs!" Prince again reached the
clubhouse as reality hit: He had no idea how the Bucs won!

Gunner interviewed "everyone except the one guy in the
world people wanted to see," he said. At last, Mazeroski was
maneuvered to the mic. "How does it feel," Bob asked, "to be a

member of the world champions?" Maz said, "Great." Prince said, "Congratulations." At dinner, Prince asked wife Betty, "By the way, how *did* we win?" Betty said, "You must be kidding. Maz hit a homer." Whatever transcends numbness, Bob felt it then.

The Bucs left Forbes in 1970 for cold Three Rivers Stadium. Another blow was Woods's exit for more money. Both upped Bob's need to promote. In 1966, he popularized a green plastic hot dog–shaped rattle absurdly named the "Green Weenie," fashioned after a rubber hot dog used by Pirates trainer Danny Whelan to supposedly jinx rivals. Huckstering also flowed from sobriquets. Dave Parker became "The Cobra"; Don Hoak, "The Tiger"; Mormon Vern Law, "The Deacon," ordained a priest at seventeen. Willie Stargell owned a fast-food chicken joint in the Hill District, Bob blaring, "Let's spread some chicken on the Hill."

King of Pittsburgh's hill was Clemente, taking four batting crowns and twelve Gold Gloves. One day Bob asked the Spanish word for "let's go." *Arriba,* Roberto said, meaning "rise up" or "arise." It became Clemente's byname, and he and Prince good friends. In 1971, Roberto invited Bob to his native Puerto Rico to receive a silver bat he won in 1961 for his first batting title. Earlier, Game Four of the Bucs-Orioles Series featured the first Classic night set to oblige working people, more than sixty million watching.

In Game Seven, "Here is Bobby Clemente, who has had, if there has ever been a vendetta, this might be it!" Bob said. "And there's a ball hit very deep into right field! Going back for it is Frank Robinson!…It's gone!"—Pirates win, 2-1. Gunner then introduced him on TV as Series MVP. After thanking him in English, Roberto asked his family in Spanish to bless "the most important day of my life." Throughout, Prince used the

Americanized *Bob* or *Bobby*, Clemente loathing it when used by
anyone but him.

In July 1972, 39,035 at Three Rivers on "Bob Prince Night"
hailed the public and private man. On September 30, "Everybody
standing. They want Bobby to get that hit three thousand. Bobby
hits a drive into the gap in left-center field! There it is!"—his
final hit. On New Year's Eve, Clemente died aiding victims of
a Nicaraguan earthquake. Two years later, accusing Prince of
"getting too big for his britches," KDKA owner Westinghouse
Co. dropped the ax. "For many," wrote the *Pittsburgh Post-Gazette*'s
Charlie Feeney, "the baseball world yesterday came to an end."

In 1976, ABC gave Prince the new *Monday Night Baseball*,
curbing his individuality. That June 7, it aired from Pittsburgh, a
minute-and-a-half ovation greeting him. Bob began to cry, bad
reviews and ratings ensuring his ouster. In 1985, Bob had mouth
cancer surgery even as KDKA admitted its decade-old error by
rehiring him April 18. "Other than my family," Bob said, "you've
given me back the only thing I love."

In his first game back, the crowd chanted, "Gun-ner, Gun-ner!"
Bob later entered the hospital, dying June 10. Next year Prince
won the Ford C. Frick Award. In 2001, the Pirates left Three
Rivers for PNC Park, its "Gunner's Lounge" a perfect ode. When
he was fired, Feeney wrote, "There are people in the Tri-State area
who think Prince is irreplaceable." He was.

In 1948, the year of Prince's hiring, another rookie voiced a
Cleveland team that drew a big-league record 2,620,627 and
became the only non–New York City club to win a World Series
between 1947 and 1956. Jimmy Dudley was then thirty-nine, later
recalling the age as "right place, right time."

The fifth child of a large family in Alexandria, Virginia, moved
as a boy to the Blue Ridge foothills. Later, the University of

Virginia graduate with a degree in chemistry was hired by DuPont. He soon tired of the laboratory, whereupon a friend, hearing his voice, suggested radio. Chicago's WIND tapped Dudley in 1942, by then in a world at war. Jimmy soon flew to India with the US Air Force for operations intelligence. Even there, he vowed to re-enter the wireless.

In 1946, Bill Veeck, long touting major league integration, led a syndicate that bought the Indians just as new Commissioner A.B. Happy Chandler was unlocking a big-league racial door. A year later, Veeck moved spring training from Florida to Tucson— "more tolerant," he said. "One afternoon, when our team trots on the field, a Negro will be out there with them. I want to sign him quickly so there won't be much pressure."

On July 5, three days after Veeck bought Larry Doby's contract from the Newark Eagles, the first AL Black player pinch-hit at Comiskey Park. Next year an exhibition game changed the life of another stalwart: "The greatest announcer the team ever had," wrote Joseph Wancho. In 1947, Municipal (a.k.a. Cleveland) Stadium housed a sandlot game. Dudley aired it, having begun doing football and hockey after V-J Day for WJW Cleveland.

At the time, Jack Graney and Van Patrick broadcast the Indians' schedule. WJW would become the club's flagship a year later. Hearing Dudley, the head of sponsor Standard Brewing Co., George Creedon, was beguiled by his sweet, easy rhythm. "That's who I want to do our [1948] games, the guy I just heard on the radio!" he told Veeck, who obliged. No one was more stunned than Jimmy, who felt before the exhibition that he might never see the bigs.

"Get fans interested!" Veeck exclaimed. Dudley tried, despite his team having to play in bare-boned Municipal, built for the 1932 Summer Olympics that Cleveland never hosted. The huge white

elephant was the first publicly funded stadium, far too large for
baseball. The partners' instincts were in tune—to draw, promote.

Special nights feted local groups. When a Lakewood, Ohio,
man wrote that he, "the average fan," merited a night, Veeck,
agreeing, staged "Good Old Joe Earley Night," giving him a boat
and car. Marketing helped set a 1948 AL day, night, and double-
header attendance record. Winning did, too. Lou Boudreau's .355
average and 106 RBI made him the year's MVP. Bob Lemon
topped the league in complete games, innings, and shutouts. Veeck
signed the Negro Leagues' Satchel Paige, forty-two, whose pitching
hurdy-gurdy began with a motion above the head, passed his knee,
and continued till it almost scraped the ground.

Paige finished 6-1, helping Cleveland lead Boston by one game
with one left to play. The Indians then lost and Red Sox won to
force the first AL playoff. On October 4, Fenway Park hosted
Cleveland, the Tigers and White Sox team networks carrying
Dudley's feed. Ironically, his idol was Ted Williams, but Jimmy
was too sheepish to seek an interview. Finally, he found his nerve.
"Jesus, you skinhead," Ted boomed, Dudley bald since his twenties.
"I thought you'd never ask!" Homering twice, Boudreau helped the
Indians to an 8-3 pennant.

Next week a parade down Euclid Avenue hailed the Series v.
the Boston Braves: Indians, in six. By 1949, the Indians' WJW
network had burgeoned from one to twenty-two affiliates in West
Virginia, Pennsylvania, and Ohio. Such fervor didn't prevent a
third-place finish, "Veeck burying the 1948 pennant behind the
center-field fence," said Jimmy, on next year's elimination. He
then sold the team, buying the Browns. In 1953, Dudley aired
MVP Al Rosen's league-high forty-three home run year: five times
Cleveland finished only behind 1951–1956 New York.

A year later, Cleveland's 111-43 record topped even 1927's
Murderers' Row AL-best 110-44, Doby's greatest season tying an

AL-high thirty-two homers and 126 RBI. Municipal hosted the
All-Star Game in 1954, Mutual's Dudley and Al Helfer counting
an 11-9 Americans' homerthon. On September 12, Cleveland
twice beat the Bombers at home before a bigs all-time record of
86,587. Jimmy felt their '50s rivalry exceeded even Red Sox–Yanks,
"crowds mammoth at our place and in the Bronx."

Of the 1954 Series, Jimmy felt that "destiny must have wanted the
Giants," their sweep of the Indians a thunderbolt. Again, he and
Helfer moored Mutual's coverage, Dudley employing his usual
welcome—"Hello, baseball fans everywhere"—and close—"So
long and lots of luck, ya' heah?"

Other jargon included, "The string is out [full count]," "Stay
alive fouls," and "Over to second, one away...back to first, it's a
double play." Nothing stopped attendance from falling to 663,805
in 1958, despite the hiring of ex-football Browns Voice Bob Neal,
whose style was more flammable. Through 1961, they never talked
on-air, seldom off it, and were rarely in the booth at once, proving
that opposites don't always attract.

In 1967, the National Sportscasters and Sportswriters
Association, NSSA—today, the National Sports Media Association,
NSMA—named Dudley Sportscaster of the Year. By then, Neal
had gone to TV, reunited with Jimmy on radio, and ingratiated
himself with Cleveland GM Gabe Paul. In early 1968, Dudley was
axed, too late in the off-season to get a job. A year later, he became
radio Voice of the Seattle Pilots, only to have the franchise move
to Milwaukee as the Brewers in April 1970 and hire local Merle
Harmon—again too late.

In 1976, the longtime Tucson off-season resident did Pacific
Coast League Toros play-by-play. Rumored big-league posts kept
going to a former player or younger Voice. Next year Seattle
rejoined the AL, *TSN* writing falsely: "Rumor has it that Dudley

will be returning" with the expansion Mariners. In 1999, he died at eighty-nine of Alzheimer's disease compounded by a stroke, two years after getting the Frick Award—Polaris in the Indians' stormy sky.

In 1937, recent USC law and University of Detroit graduate Jim Britt arrived in Buffalo to re-create the Triple-A Bisons. Another station did the same game but stayed a half-inning behind should the wire break. Britt finished twenty minutes *before*, his rapid cadence condensing time. In late 1938, Britt's former radio partner Leo Egan helped the Braves and Red Sox hire future Hall of Famer Frank Frisch for the 1939 season.

Frisch proved to be a ragged rookie announcer, ad nauseum crying, "Oh, those bases on balls." By mid-1939, his audience clamored to maroon him in Boston Harbor. That fall, Pittsburgh made the former big-league infielder its manager, saving New England's Yankee Network from axing him. Phoning Britt, Egan told him to come to Boston for an audition.

In November, Britt became the flagship WNAC sports director. On paper, it was a perfect fit: a play-by-play thesaurus in the Athens of America, airing one team in each league. Britt became a baseball *Roget's* of whom a colleague said, "Perhaps no Boston announcer ever better used English." To Boston's two-team schedule, he added the Hub's highest-rated show, WNAC's daily *Jim Britt's Sports Roundup.*

Daily Jim signed off, "Remember, if you can't take part in a sport, be one anyway, will ya'?" In a sense, the 1940–1942 and 1946–early 1950s Red Sox and Braves Voice embodied his broadcast age. No Joe Average, Jim had style.

In Britt's second season, Ted Williams—by consensus, "The Greatest Hitter Who Ever Lived"—bid to be the first .400 hitter

since 1930. On September 28, 1941, the Red Sox played a year-ending twin-bill, No. 9 batting .3995—.400 in the record book. "You got .400. Sit it out," said player/manager Joe Cronin. Refusing, The Kid went six-for-eight to finish at .406. Next year, he won the Triple Crown, topping the league in average, home runs, and runs batted in.

Jim debuted nationally on Mutual in 1942, Lou Boudreau slamming Mort Cooper's second All-Star Game pitch "towards left field!…And it is up in the stands for a home run!" The imminent navy officer then taped an ad teasing his "good sport" slogan: "If you can't take part in a war, buy bonds anyway, will ya'?" In the war, Britt attacked Japanese-held Nauru Island, hit another US plane, and barely made his base. By 1946, he returned stateside, Mutual giving him the Mid-Summer Classic. Williams' same-year return was more hyperbolic, like The Kid.

Ted homered twice, the second off Rip Sewell's softball-like eephus pitch. "I swung as hard as I could, and the wind was blowing out," he said. Jim was less didactic: "I can't believe it. It's *gone!*" Equally improbable was Britt doing the 1946 Fall Classic. "I'm in a war, and now I'm on the Series." In a two-out three-all bottom of the eighth inning of Game Seven v. St. Louis, the Red Sox, if not Britt's, luck ran out.

After Enos Slaughter singled, Harry Walker doubled. Outfielder Leon Culberson then threw to shortstop Johnny Pesky, who turned and—views differ—did or didn't pause before throwing wide of the plate. "He's coming home!" Jim brayed. "The throw! Slaughter scores [a 4-3 run]!" Later, Ted wept. In 1948, the Sox hired a manager he "couldn't wait to play for." Joe McCarthy had made his Yankees wear ties. Aware that The Kid hated them, Joe began spring training in an open-necked shirt. "Anyone who can't get along with a .400 hitter," he said, "is crazy."

In 1948, *TSN* reported Sox and Braves "TV plans [were] indefinite, pending installation of equipment." Channels 4 WBZ and 7 WNAC aired each team, June 15, the region's first TV game from Braves Field. "Ad spots didn't work; the camera missed the ball," said Jim, "but no one complained because they'd never seen coverage"—or such equivalence between the clubs. The Braves, having drawn a record 1,455,439, dreamt of an all-Boston Series—the first in which television might be more than a bit player.

Hurting TV's growth, longtime Mets Voice Howie Rose said, was an inability to preserve content: "Before videotape, a camera had to tape a screen or monitor to record," a process called kinescope: recordings bulky, thus readily discarded. In any case, Britt's milieu was radio, airing Notre Dame and other football, *seven* All-Star Games, and two of his *five* Series, especially 1948's Braves-Indians. To Rose, "Tapping Britt was a stroke of genius." Braves Field looked onto "Fair Harvard, Sommerville, and downtown Boston." Pitcher Johnny Sain "dusted [Ken] Keltner's whiskers." Satchel Paige threw "every possible way but left-handed."

To Rose, Britt's "verbal pyrotechnics" meant Jim could "pick up where he left off a half-century ago and be…accepted" by Sox fandom. If so, many still would be cursing 1949. That April 10, a heel spur shelved Joe DiMaggio. In June, a Fenway night record 36,228 upon his return saw "pyrotechnics" of Joe's own. Britt reported his "drive on the first pitch for a single," then a homer: Bombers, 5-4. Next day No. 5 torched a blast before topping "the wall, screen, and everything," said Pesky: Yanks, 9-7. A day later, DiMag's fourth belt in three games hit a light standard. Joe made the cover of *LIFE* magazine.

Boston took a one-game lead on September 27. Ahead: season-ending October 1-2 at The Stadium. On Saturday, the Sox led, 4-0, before New York rallied a run at a time, winning, 5-4. Phil Rizzuto hit a Sunday leadoff triple, a grounder scoring him. In

the eighth, Boston still behind, 1-0, McCarthy vainly pinch-hit
for starter Ellis Kinder. After Henrich homered off Mel Parnell,
infielder Jerry Coleman swung on a bases-full 3-2 count. "A little
blooper into short right field. [Al] Zarilla comes fast, and he can't
get it!" said Mel Allen: Yanks, 5-3.

On the train home, Kinder slugged an equally soused
McCarthy. Ellis died in 1968, still blaming "the old man. If he
leaves me in, we win." Adding 1949's last/lost weekend in New
York to 1946 and 1948 completed Britt's triune of misfortune.
"Williams never forgot that eighth inning—two [*sic* three] guys
get on, and I knock 'em in," said close friend Coleman. "'What a
rinky-dink,' he'd say. I'd say, 'Ted, you just saw the baseball's cover.
Its core is still in orbit.'" As for McCarthy, he was spared more last-
week pain, in 1950 retiring to his farm near Buffalo.

Britt telecast the 1949 Series, first shown in its entirety east of the
Mississippi over ABC, CBS, DuMont, and NBC. In 1950, he
and Jack Brickhouse televised west to Omaha on three networks,
DuMont excepted. Next year, he and Russ Hodges shared the
first coast-to-coast Series on NBC. To the *Globe*'s Ray Fitzgerald,
Britt was "the biggest name in radio at a time when Boston meant
the game."

Jim's rumored drinking never reached a listener. Instead, said
Leo Egan, "You recall his great depictions"—ill-temper, too. One
day wind reversed a drive. "Jim yells, 'That ball is gone!' But no,
an out." Next inning, a second hitter went long, Britt yelling, "It's
gone!" Again, wind blew it back. Another hitter then unloosed.
"'I don't care what anybody says; it's gone!' But it's *another* out, Jim
berserk. He couldn't admit a mistake," his greatest not preserving
what he had.

Narragansett Brewery had backed each Boston team since
V-E Day. When the Braves and P. Ballantine & Sons Co. left

WHDH for WNAC in late 1950, Britt had to choose. He colossally misjudged, picking the younger Braves. Sox owner Tom Yawkey then made all, not just home, coverage live. The 1952 Braves drew 281,278, a post-war NL low, playing their last game in Boston on September 21.

Next spring, the club arrived at training camp with rumor in the air. On March 18, leaving Britt, it decamped for Milwaukee. "They wanted a local radio team [no TV]," explained Braves successor Earl Gillespie. Colleague Ken Coleman was more graphic. "Britt never recovered from what he'd done to himself. When the Braves left, there was *nothing* left."

Jim joined Ken on 1954–1957 Indians TV. Let go, Britt returned in 1958 to WHDH "haunted by the Red Sox 'what if,'" said Egan, Jim abiding the last straw of having it air the Sox. Dispatched, he moved to various markets, brooking arrests for drunkenness and an eye injury that ended his career. Britt died December 28, 1980, at home in Monterey, California. "Some mistakes," said Roy Hobbs in the film *The Natural*, "I guess we never stop paying for."

Chapter 5

EARLY 1950S: THE WIRELESS GOES NETWORK

In 1951, the World Series rivaled a good play that opened the night after *Hamlet* closed. In this case, Shakespeare was Bobby Thomson. Depending on the generation, people know where they were when the Japanese attacked Pearl Harbor, John F. Kennedy died, and The Flying Scotsman swung. October 3, 1951's "The Shot Heard 'Round the World" conjures Russ Hodges five times crying, "The Giants win the pennant!" Likely never before or since have so many great Voices etched baseball in one place or time as New York City that year.

Red Barber helped make Brooklyn "the only place," said Ernie Harwell, "where people made a *vocation* of being a fan." At twenty-three, Vin Scully made English a sudden magic place. The Yankees were about to win their third straight title, Mel Allen as familiar as any player on the field. The Giants were unsung, hiring a dozen mic men before Russ. Wells Twombly wrote: "While Barber gave his listeners corn-fed philosophy and humor, and Allen told you more about baseball than you cared to know, Hodges told it the way it was."

The Sporting News named Russ the 1950 "Announcer of the Year." In a culture where history means yesterday's visit to the hair salon, several facts explain the longevity of his call. First,

whoever won the best-two-of-three NL playoff made the Series.
Sudden death transfixed: Like *that*, the 'Jints won. Baseball meant
everything to a large part of America, massively covered in print
and on the air. Dodgers-Giants was at high meridian: The two
teams normally played twenty-two games yearly—twenty-five
in 1951—radio/TV running through the city. Finally, while TV
yearly became larger, radio was still huge.

Hodges and Harwell split the playoff between Giants flagship
WMCA and the first coast-to-coast network (CBS/NBC) telecast.
The good friends had flipped a coin in advance—and Ernie got
CBS's Game Three. "I was feeling a little sorry for [Hodges],"
Harwell said. "Ol' Russ [was] going to be stuck on radio." Six
variations of team or network radio/TV broadcast the game. "I
was gonna be on TV, the new craze, and I thought that *I* had the
plum assignment." Ernie laughed his magnolia giggle. "What did
TV give me? *Anonymity*. What did radio give Russ? *Immortality!*"

Born on June 18, 1910, in Dayton, Tennessee, Hodges as a
youth would have settled for serenity: dad a Southern Railroad
telegrapher who moved his clan almost yearly. Entering the
University of Kentucky, Russ broke an ankle playing football,
became a spotter identifying players, briefly went on air, and "was
hooked." After law school at the University of Cincinnati, he
passed the bar but never practiced, lawyers then a victim of supply
and demand.

In 1932, Hodges, having been named a Covington, Kentucky,
disc jockey, soon wanted a five-dollar raise. Station manager
L.B. Wilson said memorably that he could find any alley, shoot
a shotgun, and hit thirty better Voices. Unbowed, Russ started
an odyssey of re-creation: Reds, Cubs, White Sox, boxing, and
Big Ten football, then Class-B Charlotte. In 1942, the gentle
teddy bear of a man joined Washington's Arch McDonald: "No
pennant," Russ said, "but finally games *live* in person!"

Russ Hodges

By 1946, Allen requested Russ in person, impressed by his fellow lawyer's JD degree and Arch's praise. Few aides have faced such pressure. As cited, the Yanks began all radio and home TV live coverage, making the entire schedule appear consequential. Their record 2,265,512 attendance helped the bigs break the all-time high by 80 percent. Players back from World War II were identifiable again, some Bombers acting as if they never left. Spud Chandler was 20-8. Phil Rizzuto welded the infield. For the fifth and final time, Charlie Keller hit twenty or more homers.

The first-year mix of the Yankees' two counselors featured quick thinking on their feet. "Russ and I'd finish the other's

thoughts," said the senior partner, the ad agency starting two-way
and voice ads. At an inning's end, Mel posed a question, Russ
replying at the next inning's start. Once, Allen altered the scripted
question. Hodges gave a scripted answer. "It made no sense,
which was the idea," Mel laughed, at this point earning a reported
$95,000—highest of any big-league Voice.

"Most of the Alabama," read the New York *Daily News*, "has
been trained out of Mel," leaving a proclivity to pun. Once a foul
ball hit the façade, landing near the plate. "From the façade to
the sod, who's soddy now?" said Allen. In 1947, Larry MacPhail
summoned Russ. "Tell Allen to stop ad-libbing. Beginning right
now," said the World War II colonel. That fall, MacPhail sold his
percentage of the club to partners Del Webb and Dan Topping,
whereupon puns revived. At last, Russ had enough, or at least
pretended to. "You just go on and fracture the listening audience,"
he said on air. "I'm going out for a breath of fresh air," and did.

One day in 1948, Allen called a borderline home run "going,
going," then, finally certain, "gone!" He pulled back, leaned over,
and said to Hodges, "Jiminy Cricket, I sounded like an auctioneer."
Shortly letters arrived asking that he always use the phrase. Next
year, Russ left to head Giants radio and help Al Helfer on TV. In
1950, Ernie Harwell left Brooklyn to join him, each later winning
the Frick. "I know darned well I don't have a good radio voice,"
Hodges said. On the other hand, "I know sports well"—enough to
make the rare lasting call that did *not* involve the Yanks.

Unlike baseball, polo was never played at the Giants' Polo
Grounds across the Harlem River from the Bronx. Foul turf
formed a vast semi-circle. The right-field pole stood 258 feet
from the plate, siring the snarky term "Polo Grounds home run."
A twenty-one-foot upper deck overhang made left's 279-foot
line seem closer. Center field (483 feet) mimed a green Sahara.
Russ settled in despite Bell's palsy, paralyzing a side of his face.
Rallying, he did college football, the Kentucky Derby, and many

fights, saying he didn't believe in leaving "a listener on the edge of his seat."

The 1951 baseball season kept the listener there. By late May, Willie Mays had joined the 'Jints, gone hitless his first twelve big-league at-bats, and been consoled by skipper Leo Durocher. "I brought you here [from Triple-A Minneapolis] to do one thing— play center field," the Lip said. "And as long as that uniform says, 'New York Giants,' and I'm the manager, you will be in center field every day"—each game on WMCA Radio, home on WPIX TV.

Fable claims the Dodgers blew the pennant. Fact shows they finished 24-20 v. the 37-7 Giants. Sal Maglie and Larry Jansen were 46-17. Mays batted at .274. On August 11, the 'Jints trailed by thirteen games. By September 20, the deficit had dropped by eight and one-half. Eight days later, the pursuer caught its prey: each 94-58. Next day both blanked the opposition. New York then won a 3-2 final at Boston. Russ phoned the team office on the train back to Manhattan, monitoring the Dodgers at Shibe Park. Despite a cold, he had to shout play-by-play to players.

The eight-all game went extra innings, Jackie Robinson making "an incredible diving twelfth-inning catch," Russ said. He hurt his shoulder, stayed in, and hit a fourteenth-inning homer: Brooklyn, 9-8. A day later, the playoff began: to Hodges, "everything focused on our rivalry." In 1947, America owned about thirty-three hundred radio receivers for every one television. By 1951, ten million TV sets had been sold and another nearly ten thousand bought each day. It had momentum. To others, the kinetic tube seemed transient. Radio had cachet.

The opus opened in Brooklyn: Giants, 3-1. Next day the Dodgers romped, 10-0, at the 'Jints home beneath Coogan's Bluff. That night Russ stayed awake gargling—worse, to test his voice, kept talking into a fictional mic, hurting his throat. "I had trouble breathing, my nose was running, and I was sure I had a fever," he said. Bums public address Voice Tex Rickard later mourned

how the decider was not in Flatbush, where "I'd have introduced Thomson against [relief pitcher Ralph] Branca." Instead, The Flying Scotsman introduced himself.

Had Game Three been in Brooklyn, the Dodgers would have enjoyed last at-bats. Instead, New York did, down, 4-2, in the ninth inning with one out and two on base. At 3:58 p.m., Thomson swung. "Branca throws. There's a long drive!" Russ boomed. "It's going to be, I believe! ...The Giants win the pennant! The Giants win the pennant! The Giants win the pennant! The Giants win the pennant! Bobby Thomson hits into the lower deck of the left-field stands! The Giants win the pennant! And they're going crazy! They are going crazy! Oh-oh!"

Paper of all types fluttered from the stands. Breathing joy, infielder Eddie Stanky wrestled third base coach Durocher to the ground. Hodges continued, somehow sane: "I don't believe it! I do not believe it! Bobby Thomson hit a line drive into the lower deck of the left-field stands, and the whole place is going crazy! The Giants—[owner] Horace Stoneham is now a winner—the Giants won it by a score of 5 to 4, and they're picking Bobby Thomson up and carrying him off the field!"

Since pre-videotape had to use a screen to record, kinescopes preserved little. Brooklyn restaurant waiter Lawrence Goldberg was among few to even have a radio reel-to-reel recorder. In myth, he was a Dodgers fanatic, wanting to savor their triumph. In fact, the Giants fan, leaving for work, had his mom hit record. That fall sponsor Chesterfield cigarettes issued "the most exciting moment in baseball history" on a record. One writer said Russ stood on his chair for two minutes, braying, "The Giants win the pennant!" Future partner Lon Simmons said, "Russ was dramatic, but gave the score, the meaning, who won."

On CBS, Harwell called, "It's gone!" then stopped. Andy
Pafko seemed glued to the left-field wall. "Uh, oh," Ernie thought,
"suppose he catches it." On Dodgers radio, Barber defined
restraint. "Branca pumps, delivers. A curveball belted deep out
to left field! It is—a home run! And the New York Giants win
the National League pennant! And the Polo Grounds goes wild!"
Scully was glad Red called the titan on flagship WMGM: "Then
it would have been too much for me" on a date Brooklyn-born
comedian Phil Foster styled, "D-Day"—"Dat-Day."

Afterward, polarity filled the side-by-side clubhouses behind
center field. Scully told of "the Giants whooping it up at their
victory celebration, [while] in ours it was like a morgue." Few
imagined that such passion would be rewarded six years later by
both clubs crying, "Westward Ho!"

Excluding the Series, 1951 postseason exclusivity was an
incongruity. Beside CBS and NBC TV and 'Jints and Brooks
radio, the networks broadcasting the playoff included the Brooklyn
Dodgers Radio Network, Walter O'Malley's 1950 idea to deepen
Dodgers immersion beyond the local and regional. By 1952, Nat
Allbright knit together 117 outlets, never revealing that he re-
created from a studio in Washington, DC. In time, Allbright aired
some fifteen hundred games. Fueling such growth was "Dat-Day":
the drama, if not result.

Finally, two networks carried the playoff around the country.
As of 1950, Mutual Radio aired a *Game of the Day* six days a week,
lead Voice Al Helfer. A year earlier, Gordon McLendon formed
the Liberty Broadcasting System (LBS), its daily *Game* re-created
for affiliates mostly south of Virginia and west of Illinois. They
competed fiercely, Mutual's *Game* having deeper pockets and
surviving longer. Tellingly, The Old Scotchman—barely thirty—
aired the last month of 1951's regular season live. "From the

bay of Tokyo to the tip of Land's End, *this* is the day," began his
October 3 final. Said Bob Costas, listening much later on tape:
"He's roaring from the first pitch."

Born in 1921 in Paris, Texas, McLendon attended Yale, did
basketball and baseball play-by-play, and hung with classmate and
future actor James Whitmore, each's voice rich and round. World
War II pivoted his career, Gordon interpreting Japanese, having
majored in oriental languages. Returning home, he knew how
Armed Forces Radio had helped troops follow the Pastime—but
also that local big-league coverage only knit a triangle from Boston
via Washington to St. Louis, the rest of the country unserved.

McLendon realized that the Federal Communications
Commission (FCC) wanted local-team outlets beyond that area.
He did, too, Dad buying him station KLIF in Oak Cliff, Texas.
In 1949, The Scotchman formed LBS, *Game of the Day* its jewel.
"Most of America got only the Series and All-Star Game," mused
1962–1978 Mets Voice Lindsey Nelson. "Someone was bound
to say, 'Whoever brings radio baseball elsewhere will get rich.'"
Overnight, precincts limited to the Mid-Summer and Fall Classic
could hear Liberty's three hundred-game schedule: said Nelson,
"daily interest like nothing before or since."

Lindsey was eight when, in 1927, he heard Graham McNamee
call a fight from so near a ring that he could "almost touch the
canvas." The Campbellsville, Tennessee, native spotted football on
WSM Radio, "The Station of the Grand Ole Opry," as a student
at the University of Tennessee. The 1940 graduate joined the
army's Ninth Infantry Division in North Carolina, taught English,
and after Pearl Harbor became a war correspondent and public
relations specialist, helping reporters like Ernest Hemingway and
meeting members of the French Foreign Legion.

In 1945, he met Russian officers the day that US and Soviet
troops drank captured German champagne at the Elbe River.
"We needed interpreters," Nelson laughed. "It prepared me for

Stengel," meaning the 1962–1965 skipper of the Mets. Back in Tennessee, he wrote for a paper, finding that "after Europe, I couldn't get excited about a drunk in city court." For him, Liberty's 1950-1952 *Game* became a tutorial, showing how private enterprise could tie "a minimum of cash and maximum of ingenuity." Each outlet sold ads, paid line charges, and gave The Old Scotchman ten dollars a game.

Gordon's sole cost was salary—plus the $27.50 Western Union charged KLIF for sending a re-created game from a big-league park. With up to 458 affiliates, McLendon made as much as $4,000 a game. Eventually, the series helped build baseball's second-largest network next to Mutual. For Lindsey, it led to NBC, the Mets, and stardom. Years later, the mention of *Game of the Day* was to guarantee his smile.

"A mid-century big-league team only heard *its* team. You were better off in the boonies, getting all the majors with *Game*," said St. Louis-born Robert Blattner, called "Bud" by his father and the public as 1930s teenage world table-tennis titlist, 1940s big-league infielder, and 1950–1953 Browns announcer. Bud became a McLendon Voice, working with, among others, Don Wells; Curt Gowdy, whom we will address; and Jerry Doggett, to become a 1956–1987 Dodgers announcer—Vin Scully's running-mate.

To appear live, McLendon simulated each yard's sound by fusing general and loud crowd noise in studio. He reserved the Bronx Cheer for the Bronx, taped each public address Voice, and fashioned a PA echo by having people put their head in a wastebasket to announce a batter. Re-creating in studio, he once welcomed "the president of the Liberty Broadcasting System"—*himself*—to the booth. In a different voice, McLendon said, "Ah, yes, Washington. At this time of year, the cherry blossoms are

beautiful." The Scotchman seemed older than his age, so riveting that games in person seemed a bore.

A fixed routine fostered listener loyalty: two games daily and three on a holiday. Arresting language helped: The first inning became "the hello half of the home frame," "hope as black as the inside of a cat." Baseball banned outlets within seventy-five miles of a big-league town to protect local radio. Unaffected were two-thirds of the country: to them, said a writer, "Gordon more famous than Edward R. Murrow." Like Lindsey, Doggett "wanted to write about sports, but with no ability, I tried to talk my way through."

In 1938, radio school and a *Broadcasting* ad led him to the East Texas League and eighty dollars a month: "Back then," he said, "it seemed like a million." After three years, Jerry leaped to Dallas in the Texas League. By 1948, rights spun to KLIF. McLendon wanted Dizzy Dean, who had aired the Browns and Cardinals and whose greed now saved Doggett's job. "It was a strange experience," Jerry said. "I wasn't used to a happy end." In 1950, he became *Game*'s travel, schedule, and play-by-play man. On September 30, 1951, Doggett re-created the Brooks in Philadelphia. McLendon aired the 'Jints in Boston live.

"If you wanted to do a game or interview somewhere, Gordon'd say OK," said Jerry. "With broadcasters like ours, I hoped we'd go on forever." In 1951, McLendon was named *TSN* "Announcer of the Year." Next year LBS went to Chapter 11, Gordon having doubled a per-game fee and added non-baseball programming, losing outlets and raising costs. Worse, oblivious to *Game*'s effect, the bigs barred Liberty from major-league parks and cut its lifeline by getting Western Union to stop sending re-creation code even to studios far beyond the seventy-five-mile limit.

LBS vainly sued baseball for twelve million dollars for "illegally hindering and restructuring...commerce." In 1952, a judge denied McLendon's bid for a temporary injunction. *Game* expired that May, its fall even faster than its rise. Gordon forged the "top 40"

musical format, started the first all-news station, and died in 1986, terming *Game* among the "warmest memories of my life." His offspring include the CBS *Game of the Week,* NBC's *Major League Baseball,* and ESPN's (Entertainment and Sports Programming Network) *Sunday Night Baseball.* There are worse ways to be recalled.

Presence is hard to define but relatively easy to discern. In 2019, the Hall of Fame made Al Helfer that year's Frick Award honoree, hailing him for serving in World War II, heading Mutual's 1950s *Game of the Day* as "Mr. Radio Baseball," and scoring New York's broadcast hat trick: the only man except for Connie Desmond to broadcast for each pre-1958 Big Apple team—the Dodgers, Giants, and Yankees.

The six-foot-four, 275 pounder—"They never knew why I was so big"—was born in 1911 to a five-foot-nine dad and five-foot-three mom. Raised twenty-five miles southwest of Pittsburgh, Al took to radio at sixteen, lettered in four sports at Washington and Jefferson, and at eighteen chose the wireless over a pact tendered by Connie Mack. He re-created the Pirates before joining Barber on 1935–1936 WLW and WSAI Cincinnati—an anomaly in an age where most Voices worked alone. In 1937, Al tumbled to WOR New York, Mutual's eastern flagship station, for college football, prime-time variety, and experimental Yanks re-creation.

In 1939, WOR assigned him again to Red, who aired Brooklyn's first year of radio. Through 1941, protective of his place, Barber let Al describe one inning a game. "Brother Al," as Red dubbed him, then took the moniker halfway around the globe to his 1943 signal in the US Navy, launching the Allied invasion of Sicily. Radio's *Cavalcade of America* starred Alfred Drake as Lieutenant Commander Helfer. The war over in 1945, Al joined Bill Slater on the Giants, Yankees, and Mutual's World Series, one survey showing that three-fourths of all men listened to all or part.

The Yankees made Barber a 1946 offer, were spurned, then hired Allen, who dumped Helfer for his old friend Hodges. Al returned to the Cincinnati hometown of his wife, Estrild Raymona Myers, her stage name Ramona, who had performed at Buckingham Palace. Helfer took an ad job, then covered the 1948 presidential campaign for Mutual. In 1949, he joined the now-'Jints Russ on WMCA and WPIX. Yearly it got harder to recall which club was being aired by whom.

Franklin Roosevelt's first Fireside Chat, in 1933 on network radio, claimed, "The country needs and, unless I mistake its temper, the country demands persistent experimentation." Late-1940s baseball experimented, too. Liberty's *Game* angered Mutual, born in 1935 and now with almost seven hundred affiliates. "We had more to offer but more to lose," said Mutual's sports director Paul Jonas. "If we did it, we'd do it right"—live. Would such a regular-season series hurt its Series and All-Star Game? A Mutual *Game of the Day* might cost four million dollars and would be blacked out in every big-league market—to *TSN*'s Hy Turkin, "The biggest broadcasting gamble in history."

In early 1950, Jonas chose Helfer as its principal announcer. Almost thrice his boss's one hundred pounds, Al could lift him with one hand. With St. Louis the majors' farthest extremity to the south and west, Helfer became the sole regular-season announcer for the two in three people without local-team wireless. His series began April 18, Al voicing it through 1954. "Everything *as* it happened from *where* it happened," Jonas said—Main Street's window on the bigs. As Liberty was dying, Mutual lived.

Save Sunday, Helfer boarded a plane once daily, often more, for another big-league city. Late Saturday, the self-styled "Ghost of Hartsdale" returned to his home near New York, got fresh laundry, saw family, and "left before the door shut." Next week: same script,

Mutual caring, Jonas said, about "guys across America who'd
followed baseball in the paper. Now each day they're hearing Al."
A ground ball went "down across the carpet too short." A pitcher
gave "a great big heave and a sigh," then "pumps once, twice,
delivers." It was "sunny at Shibe Park this afternoon, with the
wind…blowing diagonally across the diamond and going out from
behind first base."

Al Rosen batted: "pretty stocky, sort of thick-chested, square
shoulders, stands deep at the plate." A home-run blitz became
"clouting that potato pretty well. This ball is about as live as it
can be." Righthander Bob "Lemon, over his head again, throws.
According to [an] article written in…[The] *Sporting News*, the
harder Lemon works, the more his shirttail flops out. Well, he
must be working this afternoon because he's got enough material
there to put a jib on a sailboat." Brother Al's word picture used the
entire alphabet.

In 1950, Mutual bought 1951–1956 All-Star Game and World
Series TV rights, selling them to NBC before the deal began.
On radio, Helfer did four (1951–1954) All-Star Games and
five (1951–1955) Series on more than 1,490 Mutual, Canadian
Broadcasting Corporation, Armed Forces Radio, and other outlets.
On TV, he aired five (1952 and 1955–1958) All-Star Games and
the 1957 Series with Mel Allen, Al's last network berth—apt since,
except for Mel and Dean, he was baseball's leading 1950s network
heavyweight. Routinely, at least 65 percent of US homes saw all or
part of their Fall and Mid-Summer Classic.

In 1953, New York and Brooklyn staged a fifth Subway Series.
In Game Six, the Yanks up, 3-1, one triumph from a record fifth
straight title, Helfer took the mic from partner and Phillies Voice
Gene Kelly in the ninth. With one out, Duke Snider walked.
Carl Furillo batted. "There's a high fly ball deep into right field!"
Al said. "[Hank] Bauer cannot get it! It's a home run! It ties the
ballgame at three! Well, good people, we have a brand-new affair

at Yankee Stadium right now… Furillo waited for one of the most
dramatic moments in the entire Series to unleash his first home
run!" The Dodgers half of The Stadium shook, teams so close in
proximity that games had a split clientele.

The peak of Al's career penned "a storybook finish to this
fiftieth World Series," he said. In the home ninth, two Yanks
reached v. Clem Labine. The winning run led off second base. The
batter, Billy Martin, "is sort of on a rampage in this Series." Pause.
"Martin swings. It's up the middle for a base hit! Here comes
Bauer, tearing around third! He's in to score!"—his Classic high
twelve hits tying another Martin, Pepper, in 1929. "The Yankees
are world champions once again! The Yankees Series record is now
sixteen and four. Once again, it's the Yankees!"

By 1954, Al had trekked "four million miles" for Mutual, his
doctor telling him to resign. He rejoined Brooklyn in 1955, sang
its season-long goodbye in 1957, and spent 1958 in Philadelphia
doing play-by-play back to New York. "Big mistake," he said. "No
neutral team [Phillies] was going to replace 'em." In 1962, Al
worked the rookie Colt .45s. A last hurrah became the 1968–1969
Oakland A's. Once Reggie Jackson homered with Ted Kubiak
on third base. "And Kubiak will score easily on the play," Helfer
said—no longer touting Main Street or airing the Dodgers, Giants,
and Yanks, but still able to stir up a fuss.

John MacLean succeeded Helfer on Mutual's 1955–1959 *Game*. "It
went everywhere," he said. "I just didn't expect it to die." When
it did, he became the Voice of the 1961–1968 Senators, who died
almost daily: second division each year. He kept his audience by
hailing the loyal opposition—"Mantle, Maris, Rocky Colavito"—
cheered by visitors or recent transplants to DC. In 1972, MacLean
aired the Red Sox before a stroke hospitalized, then killed, him.
His successor as *Game*'s 1960 coda was a Voice who called the

Indians and Tigers and even as a child needed only six hours of sleep a night.

Van Patrick lettered in four sports at TCU, called play-by-play in the Southern Association and Texas, Three-I, and International Leagues, and in 1947, was hired by Cleveland owner Bill Veeck for radio as Larry Doby cracked the American League color line. "It was the first time every Indians game was done home and road," Van said of WGAR, never noting Doby's color. "Back then, you just didn't talk about race."

Veeck had signed the self-styled "The Ole Announcer" partly to launch the Indians' small screen presence. Yet on April 21, 1948, *TSN* said of Cleveland, "No television plan made by club at present time." Irate, Van had the last laugh on NBC TV's Series play-by-play, he and Red Barber reaching almost ten million viewers. That, in turn, led to Tigers TV in 1949, Van impressing with a deep jumbo of a voice, working the mic like a baton.

In 1951, on the eve of the All-Star Game hailing Motown's 250th birthday, Tigers Voice Harry Heilmann died. Patrick replaced him until Stroh Brewery became a sponsor in 1959, deeming Van too much to handle. Patrick himself, said network executive Al Wester, thought "it was time to move" to Mutual as sports head and Voice of *Game of the Day*, Van feeling it an even trade. He never thought of *Game* itself moving on.

In 1960, Patrick visited Fenway Park, Wrigley Field, and Griffith Stadium, sounding as fine as Helfer and MacLean. In 1961–1962, though, the big leagues swelled to twenty clubs. "Suddenly," said Wester, "many [Mutual] *Game* stations switched to the [AL Los Angeles and DC or NL Houston and New York] expansion teams," the series dying in 1961. Van then aired basketball, golf, the Olympics, and Notre Dame and *Monday Night Football*, seldom looking back to baseball, or it to him.

"I was in awe of him," said George Kell, starting Tigers TV
in 1959. Ernie Harwell, replacing Van on 1960 radio, styled him
"flamboyant, intimidating to follow." In 1973, Patrick contracted
cancer, dying the next year in surgery on Notre Dame's game
weekend in South Bend. Without intending to be sacrilegious, it is
hard to imagine the Good Lord finding a speaker whose sermons
were more likely to impress.

This chapter began with Thomson's homer. It ends with the 1951
Fall Classic. For nearly two months, the Giants had played like
extraterrestrials. Could that continue against the Yanks? Helfer and
Allen voiced Mutual, CBC, and Armed Forces Radio. Jim Britt and
naturally Hodges moored NBC TV's Series over sixty-four stations,
including its first foreign outlet in Matamoros, Mexico.

The Series is recalled less for result than foreboding. In Game
Two, playing right field, Mickey Mantle tried to avoid Joe D. on a
fly, stepped on a drain cover, tore knee ligaments, and collapsed.
"I thought he'd been shot," said Jerry Coleman, "the way he
went down." Since it defied sense, the Giants took two of the
first three sets, 5-1: Monte Irvin swiping home, and 6-2, on five
unearned runs.

"We had 'em till the rain came," said Hodges. A storm
postponed Game Four at the Polo Grounds, letting Casey Stengel
rest his tired staff. Starter Allie Reynolds got three, not two, days'
rest: Yanks, 6-2. A day later, their blows caromed around the
oblong yard, 13-1. Back across the Harlem River, the Bombers
entered the sixth set's ninth inning ahead, 4-1, when the 'Jints
scored twice.

"Will history [Thomson] repeat itself?" Britt asked before
pinch-hitter Sal Yvars lined to right field, where Bauer made a
sliding last-out 4-3 catch on the lush Bronx grass. Allen cried,
"Three straight for The Professor! The Yankees win again!"

Playing his last game, DiMag drolly explained his team's success: "It's the cool weather. A clean uniform, a shave, and haircut." It worked if you were No. 5.

Chapter 6

1950s: Local Television's Dawn

The 1950s largely ended the debate over whether televising at least part of a team's schedule was good for business. Lingering was how much should be broadcast, whether home or away, and when. The Pirates resisted video till 1953. The Dodgers and Giants finally televised eleven games from the other's park in 1959 and 1961, respectively. Fatally, Milwaukee was last in either league to allow TV: only fifteen road sets in 1962.

For contrast, recall the Phillies. Most teams settled for one TV flagship station. By 1949, Philadelphia had a big-league record three outlets by necessity—none could possibly air the entire Phillies and Athletics' schedule—and desire—more flagships, more promotion. The channels pooled crew, equipment, and on-air talent. Byrum Saam, Claude Haring, and George Walsh broadcast on TV and WIBG Radio, Saam next year moving to the A's.

By late 1962, "Wanting to liven up their booth," said By, the Phils hired someone who could be excused for deeming life unfair. Bill Campbell's mother had died giving birth in 1923, Dad not telling him till age eleven. Bill lived with him, a traveling paint salesman, then aunts, then Dad again, changing schools six times. Often alone, Campbell tuned to radio's Bill Dyer, Voice of the 1936–1940 A's and Phils. "The sound entranced," he said, "like stories around a fire."

In 1937, at Philly's Roman Catholic High School, Bill told
tales on a fifteen-minute sports show. Next came a small station in
Atlantic City, minor-league Lancaster, WIP Philadelphia—and the
Coast Guard, including convoy duty.

Back from World War II, Campbell became WCAU radio, then
TV, sports director. He hosted daily radio, cohosted a wireless and
TV series with Connie Mack, and aired TV with Stoney McLinn,
once Ty Cobb's ghostwriter, on a program titled *The Kid and the
Old-Timer*.

For "The Dean" of Philadelphia mic men, youth had meant
listening to baseball on the radio. In 1963, it reentered his life,
Bill taking a $10,000 pay cut to air the Phillies. His wife Jo said,
"Baseball is what you've wanted to do your whole life. Follow your
heart." Campbell would.

Biographer Sam Carchidi wrote, "[No sport] came close in [Bill's]
affection," his only limited prior baseball play-by-play re-creating
the 1940s A's: "There's a smash into the hole at short. Eddie Joost
backhands, throws—gets Rizzuto by a step!" In 1963, he joined
Saam and the beloved Richie Ashburn on WFIL Channel 6 and
560 AM for his first daily big-league stint.

As a 1948–1959 Phillie, Ashburn had been a two-time batting
champion. Even in 1962, the thirty-five-year-old hit an expansion
Mets-high .306. The club MVP received a boat and took it on the
Delaware River, where it sank. Next season he traded a jockstrap
for more than a three-decade jockocracy. "This game [baseball]
looks a lot easier from up here," Richie said. Campbell told him it
wasn't—but that easy talk could curb the lulls.

Bill and By shared play-by-play, Richie on "color," through
each year's radio and roughly sixty-game TV schedules. Ashburn
knew what to expect from Saam: "[Outfielder] Bob Johnson
is going back," By said. "He hits his head against the wall.

He reaches down, picks it up, and throws it to second base."
But what of Bill? Richie found that he supplied maturity and
encyclopedic baseball knowledge. Each helped survive a term that
in Philadelphia still stands alone.

As cited, *1964* denotes the Phils' epic plunge after leading
the NL for seventy-three straight days. "There's a *roof-top* job,"
Campbell roared of one blast. "What a *titanic* shot by [rookie
Richie] Allen!" he beamed of another. Later, Bill said, "It was just
great, great baseball every night." At season's end, eight thousand
pallbearers greeted the team at the international airport. Typically,
Campbell accented the first 150 games, not the last dirty dozen.

Had the team not collapsed, Saam would have telecast NBC's
World Series. In turn, Bill's resume would have added network
Classic radio. In December 1970, Campbell arrived home to learn
of his Phillies dismissal from Jo, who heard it over WPEN Radio—
"a shot in the heart," she said, "he didn't even know it." Letters to
the *Daily News* ran thirteen to one on his behalf.

In 1971, Bill briefly joined the Pirates, later doing PRISM
cable play-by-play and WCAU Radio, then back to WIP Radio
for voice-over, gigs, and commentary. Awards lengthened like
1964's losing streak, including two-time then-NSSA Pennsylvania
Broadcaster of the Year. Forty years later, saying he would spurn
sports today, Campbell excepted one. "If they asked me to go back
and cover baseball, I'd go in a minute."

On March 18, 1953, the Braves became the first big-league club to
change sites since 1903. "When we got north from spring training,"
said Earl Gillespie, "a parade reached downtown Milwaukee's
Schroeder Hotel." Burghers festooned a Christmas tree: having
missed the holiday with the team, they pined to celebrate it now. A
nonperson in Boston, the Braves' new embrace became the envy of
every franchise.

In baseball's century-old broadcast past, the poignancy of 1950s Milwaukee lingers. "We packed parks around the league," said Gillespie, its 1953–1963 Voice. The big leagues' smallest city led in '50s attendance for six straight years. "Nobody had what we did," added Earl, his popularity as "Milwaukee's Pied Piper" running through Wisconsin and beyond.

In time, the hoopla showed radio's limit—and why healthy franchises enlist television, using both, not either/or. Neither factored in Gillespie's 1920s youth, Earl and his younger brother sharing a bedroom in the Chicago Depression basement of their immigrant grandparents' home. Lacking even an elementary school certificate, Dad could not find work. "I figured if I could make it in the big leagues and earn $9,000 a year, I'd be happy," Gillespie said.

In 1934, his idol, future Cub Phil Cavarretta, graduated from Chicago's Lane Technological High School. Living across town, Earl took an early-morning streetcar to attend Lane. A first baseman, like Phil, Gillespie hit more than .500 as a senior, signed with the White Sox, joined their lowest-affiliated club, and was sold to a team in the Michigan State League. "I was broke," he said, "and had to hitchhike home."

The wanderer did odd jobs until signing with Class-D Green Bay in 1940. This was *not* how Cavarretta had begun. In 1943, Gillespie joined the Marines, later spending time in Okinawa. He returned home to Class-D, hurt his shoulder, and grasped that, to make the bigs, "I'd need another way." In 1948, hired by WJPG Green Bay, Earl practiced off-hours in an empty studio "screaming into a dead mic," said the station manager. Play-by-play had become his way.

In 1951, Gillespie began his career over. Tapped by the American Association Brewers, he aired Milwaukee's 1951–1952 Little World

Series and AA title, respectively. Miller High Life beer was their major sponsor; the head of the brewery, Fred Miller, brokered Braves owner Lou Perini's 1953 move, saying that *whichever* outlet became the radio flagship would make Earl the Voice.

Like WEMP, fifty thousand-watt WTMJ hoped to do the Braves, so Miller let each carry the team on the same feed: two flagships posting a four-state network. Perini forbid all TV: at home, to protect attendance; away, less sensibly, to protect radio even as the percentage of houses with sets rose. In 1953, Blaine Walsh joined Earl in the booth, having built bridges in Germany and France as a teen in WWII for the 248th Combat Engineer Battalion, and returned to join WTMJ in 1952.

For the next decade, wrote Bob Buege, "The most recognizable voices in the entire baseball-crazy state belonged to them," Blaine's baritone a complement to Gillespie's high tenor. Depending on the team's record, Earl especially stirred a love-hate response. Most mailed "lucky pennies" and sent tiny china cows with halos suspended over their heads—a tribute to his term "Holy cow!" heisted from Harry Caray.

For his part, Walsh used a huge fishnet to snare foul balls, the crowd crying, "Blainer, get the net!" Gillespie threw daily batting practice, Joe Adcock's drive once almost removing Earl's bridgework. "No more BP!" bayed skipper Charlie Grimm. In 1954, Adcock slammed four home runs in a game at Brooklyn and Milwaukee became the first NL city to draw two million. Next year it hosted the All-Star Game, Earl on NBC Radio. In the twelfth inning, Stan Musial batted. "There's a drive to deep right field, back toward that fence," said Earl. "It's gone—the [6-5] ballgame is over!"

Buege wrote: "In stores, on front porches, in open convertibles at stoplights, [Earl and Blaine's] descriptions and accounts of the games were unavoidable"—Milwaukee baseball's *Brigadoon*. The

'57 variety of Braves soldiered to the city's first big-league title, almost making the ex-Bostons an All-Star team. Del Crandall caught. Wes Covington, Billy Bruton, and Henry Aaron formed the outfield. The infield tied Adcock, Red Schoendienst, Johnny Logan, and Eddie Mathews. Pitchers Warren Spahn and Lew Burdette formed a nonpareil pair.

The club drew a final NL record 2,215,404, Aaron lashing forty-four homers as NL MVP. The Hammer faced St. Louis September 23: "A swing and a drive back into center field!" cried Earl. "Going back towards the wall! It's back at that fence…and is it caught or not? It's a home run! The Braves are the champions of the National League! Henry Aaron just hit his forty-third home run of the year!"

Gillespie and Bob Neal did NBC Classic radio. "I wasn't well-known yet," said Earl, "not considered in Mel Allen's league." In the fourth game, the Yankees up, 5-4 and two sets to one, had a chance to seal the Series. Instead, Logan smacked a game-tying tenth-inning double. Mathews then hit. "A swing and a drive into right field! Going back toward that wall! It may be! It is—a [7-5] home run!"

In Game Seven, the Braves led, 5-0, in the ninth inning. The Yanks had the bases full. Burdette threw: "Swung on, lined, grabbed by Mathews, who steps on third," said Earl, "and the World Series is over, and the Milwaukee Braves are the new world champions of baseball!" Next year, the team and Gillespie again made the Series, New York inverting a three-to-one game deficit. Attendance fell below two million for the first time since 1953. The utility of a radio-only policy had begun to dim.

In 1959, Milwaukee and LA contended closely through September, the Braves losing a best-of-three playoff. In 1956, the Braves had

lost the pennant by a game. "With a different last day then and in
'59," said Gillespie, "I'd have been in four World Series in a row."

He never again came close, compensating by accenting the
personal. In 1959, "Logan in fast, up with the ball," Earl said,
"throws to first on a great play by Joe Adcock, and Warren
Spahn has a no-hitter!" In 1961, Spahn won his three hundredth
game, bringing tears to Earl's eyes, Warren his favorite player.
Yet, increasingly, Earl seemed less bent on marketing the club
than protesting what he felt to be a wrong: its rumored move—
to Georgia.

By 1962, attendance crashed to 766,921, putting the franchise
in jeopardy. Excuses, or reasons, mounted. The relocated
Minnesota Twins split the upper-Midwest market. "Perini sold
the club in the early 1960s," Gillespie said, "and the new owners
traded popular players [Adcock, Bruton, and Logan] looking for
a reason to leave." Earl himself resigned to become Milwaukee's
WITI sports director in 1963.

Mostly, Wisconsin now obsessed on the 1961–1962 and 1965–
1966 NFL titlist Green Bay Packers and their stentorian CBS
Voice. "When [Ray Scott] intoned… 'First down. Green Bay,'"
wrote *TV Guide*, "10 million spines would quiver." Barely utilizing
the tube—the Braves never telecast more than fifteen games a
year—they reacted to football's TV ubiquity by pretending it did
not exist.

In October 1964, the Braves conceded they would become the
first franchise to move a second time, court decree delaying a shift
to Atlanta by a year. On 1965's final Opening Day, Walsh stood
behind the mic, reading the 1953 Braves' first-season opening
lineup, each starter running to his position as Blaine said his
name. Since Adcock was still playing with the Angels, a familiar
pinch-hitter, in a lovely touch, was announced: an old Class-D first
baseman named Gillespie.

That September 22 marked the Braves' last game in
Milwaukee. Even when baseball returned in 1970 as the Seattle
Pilots-turned Brewers, "Many of us could not forgive the game,"
said Earl. Walsh died in 1985. Moving to Florida, Gillespie golfed,
kept in touch with his adopted burg, and reminisced about "the
story of, the glory of, the Milwaukee Braves," as he once waxed on
a team highlight film. Earl died December 12, 2003, at eighty-one,
TV reporting it.

From 1950 to 2016, Vin Scully played every note of baseball's
octave, none as musical as his daily invite to "pull up a chair."
Through 1957, his Brooks aired almost every game on TV, Vin
moving fluidly between it and radio. After moving West, the
Dodgers, like the Braves, banned almost all video, Scully, a.k.a. The
Transistor Kid. Later he added network play-by-play. On *Game of
the Week*, America fully grasped what each coast already knew.

The man synonymous with baseball on the air was born
November 29, 1927, in Manhattan: ironically, a fly ball from the
Bronx to a silk salesman and an "Irish, red-haired" mother. In
1932, Vincent Aloysius Scully died of pneumonia, his son barely
knowing him. To cope, Vin's mother, Bridget Freehill, began
renting out two spare rooms, usually for merchant sailors. One,
a British seaman, worked for Cunard Lines. In 1935, he and
Bridget wed.

Scully's favorite place as a child was beneath an Emerson radio
"that sat so high off the ground that I was able to crawl up under
it," putting a pillow on its crosspiece. Each Saturday, he sat with
milk and saltines and heard Ted Husing and Bill Stern do football.
"I shouldn't have cared about a game like Florida-Tennessee," said
Vin, yet got goose bumps from the roar of the crowd.

At eight, the Giants fan wrote a composition for a parish class
about wanting to be a sports announcer. Three years later, Red

Barber arrived at Ebbets Field. Entering Fordham Preparatory, Vin heard him between Latin, English, the newspaper and yearbook, and jobs to pay tuition. By 1946, he had entered Fordham University, joined the navy, and returned to college. A classmate recalls him "everywhere, recording himself," carting a huge tape recorder.

In 1949, the senior sent letters to 125 stations, fifty-thousand-watt WTOP Washington the sole station to reply. The CBS outlet made Vin a summer fill-in. Interviewing at the network, he met its sports director—Red! Busy, Barber told him to leave his name, address, and number. Each week Vin heard *College Football Roundup*, skipping from game to game.

In November, Ernie Harwell was promoted at the last minute to its primary game, creating a void on backup Boston University—Maryland. To replace him, Red recalled Scully and phoned his home, getting Bridget. "Vinny, you'll never guess who called you," she said, opening the door that night. "He wants you to call him." Vin said, "Who was it?" Red Skelton, Mama said.

Barber assigned Scully to the game at Fenway Park, where, coatless on a frigid day, Vin found no booth, only a roof site between home plate and right field. Every time someone threw a pass, he had to race across the roof to report. Since his game was close, CBS moved there after halftime. By the third quarter, Vin fought frostbite, sure he had failed.

That week Fenway brass apologized to Red about the booth. Scully impressed him as a stickler for preparation and for not noting his travail. Two days later, Barber phoned: "You'll have a booth next week—Harvard-Yale." A month earlier, the Dodgers' Harwell had been hired by the Giants. To succeed him, Barber broached an idea to then co-owner Branch Rickey: "Take a

promising young man and train him." Rickey said, "Fine, that is, if you find the right man."

Red phoned Scully to ask, "How would you like to broadcast for the Dodgers?" His reply launched radio/TV's longest same-team and big-league streak: sixty-seven years. Believe it or not, Vin had never entered Brooklyn till the day he went to work. Mom and Pop didn't drive. Train, bus, and trolley seemed impractical, "Ebbets so far away." Braving "on-the-job training," the rookie living with his parents brought Red an early lineup card. "'This man hit third yesterday,' he said. 'Why is he fifth today?' It was the last time I didn't know."

One day Scully, on radio, was left alone at the mic: Barber, to do TV; Connie Desmond, to "get coffee." Tension in the booth was such that The Ol' Redhead would not even say that Scully had been permanently hired until Rickey ordered him to announce it. After October 1951, pressure intensified. Vin never forgot how the fate of a franchise could turn on a swing.

"At the start of the ninth," Scully said, Brooklyn up, 4-1, "I saw a man walking in the lower deck of the Polo Grounds, carrying this great big horseshoe of flowers that you might see at a funeral home." A banner cloaked the horseshoe: "GIANTS, REST IN PEACE." After The Shot, Vin "wondered what did that guy do with those flowers? You can't hide that. You can't just suddenly put that under your coat"—though Flatbush tried for decades to put The Shot out of mind.

In 1953, five of eight regulars hit higher than .300. As noted, Red that fall sought Walter O'Malley's aid to renegotiate his Series TV fee, the owner refused, and Barber resigned. As a courtesy, O'Malley called Desmond, who passed. Next, he phoned Vin, who, heartsick, asked the Redhead and Connie for consent. Barber said, "If there was anyone I'd want to take my place, it'd be you."

"I tried to play it pretty cool," said Vin. The morning of the Series opener, Vin had a fine breakfast with his family "as if it was

just another day. Then I went upstairs and threw up." Future *New York Times* man George Vecsey felt Scully a continuum. "He'd been raw, but we heard Red fuss over and teach him." Much later, Vin called him "a father to me in every way."

To fill on-air time, Scully collected early anecdotes from a park he came to love. A tiny booth hung suspended above boxes: open, previously with no wire before a foul nearly conked Red in the face. "Balls came back and made you aware of individuals," said Vin. Once Dodgers uberfan Hilda Chester brayed, "Vin Scully, I love you!" The crowd cackled at Ebbets' most famous housewife. Flushed, Vin hung his head. "Look at me when I'm talking to you!" she said.

In 1955, the Yanks and Dodgers met again. Five straight Series lost to New York had made failure the elephant in Brooklyn's room. As expected, the Bombers bolted to a two-game lead in the first Series aired on TV in "living color." Pitcher Johnny Podres halted their momentum, 8-3. Brooklyn won twice more before Whitey Ford countered, the Faithful readying for another seventh game.

In the fifth inning, Vin took play-by-play from Mel Allen. Next inning, the Bums took a 2-0 lead on Gil Hodges' second RBI. In its bottom half, Billy Martin and Gil McDougald reached base before Yogi Berra arced toward the left-field pole. Sandy Amoros raced toward the line, helped by being left-handed—nearer the ball— and made a spectacular one-handed catch. In the corner of his eye, Vin saw McDougald stumble, turning second. Amoros threw to Pee Wee Reese, who fired to Hodges for a double play.

Brooklyn held its breath as the Yankees' ninth inning began. It had been this way before. Bill Skowron grounded to Podres. Bob Cerv flied to Amoros. Podres threw a changeup that Elston Howard banged to Pee Wee, who threw to Gil. Said Scully, simply:

"Ladies and gentlemen, the Brooklyn Dodgers are the champions of the world." Today, his words top a giant photo at the entrance to the Dodgers' offices in Los Angeles.

All winter, people asked how Vin remained so calm. According to biographer Greg King, Scully said, "Well, the truth is, I was so emotionally overwhelmed by it all that if I had to say another word, I think I would have cried." Later, the team bus entered the Brooklyn-Battery Tunnel to a borough transformed. The *Times'* John Drebinger wrote: "Brooklyn at long last has won the World Series and now let someone suggest moving the Dodgers elsewhere."

By 1957, jet travel had cut New York–Los Angeles flight time to four and a half hours. O'Malley bought a forty-four-passenger airplane for $775,000, taking a helicopter in 1956 over prime real estate—Chavez Ravine, the site now of Dodger Stadium. Next year the Brooks dealt their Texas League franchise to the Cubs' Pacific Coast League Angels. In exchange, they got Southern California big-league rights and their small-scale version of Wrigley Field as a possible home for the relocated Dodgers. "Walter was looking ahead," said Vin, "in case he couldn't get what he needed to stay."

On May 28, 1957, the NL said, "The Dodgers could move if we eased scheduling by getting another team to California," said broadcaster Jerry Doggett. For a time, the Dodgers kept up the pretense. Clown Emmett Kelly, parodying Willard Mullin's Brooklyn Bum, was hired to "relieve tension." On August 8, the Giants said they were moving to San Francisco in 1958. Next month, they and the Dodgers played one last time at the Polo Grounds, Vin recalling 'Jints patrons or players being pelted in Brooklyn with "beer, coins, whatever fans would find."

"I'd go to the ballpark just hoping no one would get hurt," Scully reminisced on air. This game reflected a different hurt. "You want 'em to take their time," he said, sensing that the crowd hoped

to "holler." The youth in his childhood park wished to mourn. "Boy, it's funny being a kid raised in New York," he said. "You sit here watching this ballgame and looking at the Polo Grounds, and your memories go wild." The Giants won, 3-2. It didn't matter.

On September 24, Ebbets Field held a final service for 6,702 congregants: Bums 2, Bucs 0. Organist Gladys Goodding, "known to take a drink," said Vin, arrived with "a brown paper bag, entered her little booth with the organ, and locked the door." The first song was "My Buddy." Drinking, Gladys "became more sullen; her songs, funereal." Irate, O'Malley sent an usher to tell her to be cheerier. "She had the door locked," Vin said. "Anyway, he couldn't fire her! They were leaving." With each song more nostalgic than before, Gladys reopened the bag.

On October 8, after LA's City Council voted to give three hundred acres of land to the Dodgers for the deed to Wrigley Field and to set forth their commitment to build a fifty-thousand-seat stadium, O'Malley confirmed that his club would move to Los Angeles for the 1958 season. New York must have felt like Gladys Goodding. For the moment, the best solution was to get sloshed.

Like Brooklyn in 1955, the entire decade was a high meridian for the Yankees, who, unlike the Braves, used TV fully: every home match on WPIX TV. In October, coverage was left to NBC. In 1952, two in three Americans watched Dodgers-Yanks Game Seven, a *Gillette Cavalcade of Sports* presentation. The country, wrote sportswriter Heywood Broun, "stopped and paid attention," introduced to the "Look Sharp March," Sharpie the Parrot ("Mister, how ya' fixed for blades?"), and voice-over ("Look sharp, feel sharp, be sharp").

Allen aired NBC's Pre-Game Seven telecast before receding, the custom for a Voice not on balls and strikes: baseball soliloquy, not happy talk. Barber did the first half of play-by-play; Mel,

the second. In the sixth inning, Allen described "the magnificent Mickey" clearing Brooklyn's right-field screen. "That ball is going, going, it is gone! And the Yankees are back out in front, 3 to 2, in the battle of the home runs!"

Casey Stengel was "up and off that bench all day long," Mel said, TV eying each dugout. Bob Kuzava relieved Vic Raschi in the seventh inning: New York, 4-2, two out, sacks full. Jackie Robinson swung. "It's a high pop-up!" The last out seemed secure. Suddenly, "Who's going to get it? Here comes Billy Martin digging hard—and he makes the catch at the last second! How about that!"—the Yanks' fourth straight title.

Once, Allen hailed a taxi at night in Omaha. The cabby, not recognizing him, began to drive. "Sheraton, please," Mel said. Suddenly, the driver, head swiveling, almost drove off the road. Donald Hall, 2006 Poet Laureate of the United States, wrote: "Sometimes I feel I will never stop; just go on forever till one fine morning I…look over at God and say, 'How about that!'" Allen thought "'How about that!' a regional expression" as it became a national idiom, Mel amazed that America thought it his.

Allen aired the Rose and other Bowls, almost every Army-Navy, Blue-Gray, and East-West Shrine game, "All-Star Game, which he did more of [twenty-four] than anyone, and [twenty] Series," said Lindsey Nelson. With local Voices airing the Classic and the 1949–1964 Yanks losing a flag only twice, he covered the 1947–1963 event on network radio or TV every year but 1954. Yankee-haters prayed that laryngitis would silence him forever. Yankee-lovers thought him more theatral than being at the park.

In 1953, re-creating the first "tape-measure" homer, Mel etched Mick's "tremendous drive going into deep left field!" at Griffith Stadium. "It's going, going, it's going over the bleachers and over the sign atop the bleachers," off its sixty-foot-high scoreboard, "into the houses of yards across the street!" Sans tape, Yanks publicist Arthur "Red" Patterson walked its 565-foot length.

"It's got to be one of the longest home runs I've ever seen hit!"
Allen gaped.

Three years later, on Memorial Day, the switch-hitting No.
7 struck the façade above The Stadium's third deck of the
grandstand: nearly the first ball to leave the park fair in a big-
league game. Mantle peaked that year with a Triple Crown fifty-
two homers, 130 RBI, and .353 average, going deep a record third
time left- and right-handed in a game. Said Yogi Berra, "I think
you'd call him amphibious."

By then, Stengel had become an American linguist matching Berra
and on a good day evocative of Twain. Named Yanks manager in
October 1948, Casey only twice in nine prior big-league years had
placed even fifth. At a news conference, he explained seeming a
buffoon. Clowning around was all right in the second division. "But
you don't have to always leave them laughing when you're up there,
and I mean to be up there."

By "up there," The Ol' Professor meant the World Series,
making it ten of his twelve Yankees years. At ten o'clock in the
evening, Sunday, October 7, 1956, Brooklyn's Sal "The Barber"
Maglie appeared on the CBS program *What's My Line*, next day to
oppose New York's Don Larsen in Series Game Five. Panelists tried
to guess his identity. They only needed to wait.

At one o'clock on Monday, Allen and Scully again began play-
by-play. In the fourth inning, Mick whacked the Barber. "There's
one if it stays fair!" Mel said. "It is going, going, gone! Mickey
Mantle achieves his third home run of the Series, his eighth in
World Series play!" The Yanks led, 1-0, as Berra hit. "There's
a drive! The Duke on the run! He dives! He's got it!" An inning
later, the Brooks' Gil Hodges hit to left-center field. "Mantle on
the run!" Allen said. "Going, going! He makes the catch! How
about that!"

Methodically Larsen set the Dodgers down, stilled by his
unusual no-windup motion. Only three batters neared a hit:
Robinson, lining to Gil McDougald; Hodges, robbed by Mick;
Sandy Amoros, hooking foul. Slowly, people awoke to what was
happening. Vin succeeded Mel in the last half of the fifth, neither
having to exaggerate. No one had even thrown a Fall Classic no-
hitter. Here no Dodger had even reached base.

Allen sat, "dying to broadcast," Scully said, as "younger and
thoroughly intimidated by Mel's example," he followed a no-
hitter's code of silence throughout. Scully afterward changed
his approach to pending no-nos. In 1991, however, a kinescope
surfaced of Larsen's jewel, preserving Vin's close: "Well, all right.
Let's all take a deep breath as we go to the most dramatic ninth
inning in the history of baseball. I'm going to sit back, light up,
and hope I don't chew the cigarette to pieces."

Carl Furillo lofted to right fielder Hank Bauer. Roy Campanella
grounded out, Billy Martin to Joe Collins. In the dugout, even to
Stengel, the game lacked reference. What could you compare it
to? With two out, Larsen worked the count on pinch-hitter Dale
Mitchell to one ball and two strikes. "Got him!" Scully cried of
called strike three. "The greatest game ever pitched in baseball
history by Don Larsen!"

"I don't think you or I shall ever see such a thing again," said
Allen, laryngitis shelving him next day, pleasing critics. Vin replied,
"I think we can both just go now," later conceding to feeling
"wilted, like a rose." Six times the Bums and Bombers had met
since 1947—"so often it seemed safe to assume that everything
possible had happened," Stan Isaacs wrote, until now. Brooklyn
won Game Six, 1-0, in ten innings. Robinson's last hit scored its
last Series run. In the final, Berra took Don Newcombe twice over
the right-field screen: Yanks, 9-0.

Postscript: Jerry Coleman was on the bench as the fifth game
unfurled. By the eighth inning, players began talking to each other,

then started counseling Stengel about how to position players. Not liking it, the Yanks skipper finally unloosed: "Damn it. I'll tell you where to play!" It must have worked, marveled the 1949–1957 Yankees infielder and later half-century Voice, because "Casey positioned Yogi Berra perfectly behind the plate to catch Larsen's final strike."

By 1954, Ernie Harwell had left the Giants for the Browns-turned-rookie Baltimore Orioles. Willie Mays left the last two years of military training behind to hit .345. Patrons left Coogan's Bluff, the champion 'Jints drawing 1,155,067 v. 1,600,793 in 1947. "Folks watched on local TV," said Russ Hodges. Around the fraying Polo Grounds, people were getting mugged.

In the 1954 Series opener v. Cleveland, score two-all in the eighth, NBC's Hodges and Jack Brickhouse watched Vic Wertz mug a pitch off the 'Jints Don Liddle. "Way back, back!" boomed Jack on air. "It is—oh, what a catch by Mays! …Notice where that 483-foot mark is in center field? The ball itself—Russ, you know this ballpark [Polo Grounds] better than anyone else I know—had to go about 460, didn't it?" Hodges: "It certainly did, and I don't see how Willie did it, but he's been doing it all year."

After Mays and Hank Thompson walked in the tenth inning, Dusty Rhodes pinch-homered into the right-field seats: 5-2, New York. The Giants swept the next three sets, few imagining they or the Dodgers leaving. The 'Jints needed only a new park to stay. Brooklyn was the only team to have drawn a million people yearly since 1945.

Three years later, Giants owner Horace Stoneham said, "We're sorry to disappoint the kids of New York, but we didn't see many of their parents out there at the Polo Grounds in recent years [post-1946 attendance dropping by a million]." The *New York World-Telegram & Sun* screamed: "It's Official: Giants to Frisco." On

September 29, 1957, "Giants Bow to Bucs [9-1] in Polo Grounds
Finale," the *Daily News* bannered. Russ's home run call fit the day,
bidding the Apple "bye-bye, baby!"

For the next three years, Les Keiter memorably re-created the
team's schedule on WINS New York. On April 15, 1958, baseball's
transplanted tag-team opened in person at the Giants' temporary
22,900-seat home, Hodges calling it "the Polo Grounds, I mean
Seals Stadium." The home team beat LA, 8-0. Three days later,
a league record 78,672 packed the Dodgers' debut at Los Angeles
Memorial Coliseum. In the ninth, Jim Davenport scored the tying
run but was called out for missing third base on Willie Kirkland's
triple, Giants losing, 6-5. The rivalry had traveled well.

Russ's 1957 partner, Jim Woods, had stayed back East, the
'Jints wanting a local to offset Hodges. Lon Simmons grew up in
Burbank. After World War II, he joined the Phillies system, struck
out the side his first inning, tore a shoulder muscle the next, and
then turned to radio, reaching Giants flagship KSFO. "When
you're young, everything means more," Lon said. "You couldn't get
closer to my emotions than the Giants' first years here."

In 1958, the Giants topped .500 for the first of fourteen straight
years. A year later, the Bay had bought more than six hundred
thousand transistor radios—mostly, it was thought, to hear the
team. "[At] a restaurant—they'd have baseball on," said KSFO's
Stu Smith. "With most games afternoon, it flooded offices, cable
cars, bars." Radio's pair bonded, Simmons terming Hodges "'The
Fabulous Fat Man,' more fabulous than fat."

Russ began any game, "How ya' doing, everybody?" Lon once
replied, "Better than your clothes," joking that his tailor had asked
Russ to take the labels out. Known to imbibe, Hodges's first years
out west merited one drink after another. He did NBC Radio's
second 1959 All-Star Game. Willie McCovey became Rookie of

the Year. As late as September 19, the 'Jints led the league. Where would the Series go? Seals was too small, a new park not ready. The Dodgers solved the fix by winning the pennant.

In 1954, San Francisco voters had backed a four-million-dollar park bond issue contingent on getting a team. Opening in 1960, Candlestick Park rose at a point overlooking the bay. Stoneham had insisted: "No cold, no wind, no problems." Instead, he found that a bracing wind blew in from left-center field. "The irony is that O'Malley had convinced Horace to come here—'a gold rush,'" Lon laughed. "Soon [1962] O'Malley had beautiful Dodger Stadium and Horace had this dump."

Writer Bob Stevens suggested that "the trick was to look past the park." Russ aired the first 1961 All-Star Game at Candlestick, pitcher Stu Miller balking in the ninth. Headlines blared he had been blown off the mound. On a more pleasant note, the 'Jints once homered back-to-back-to-back, Hodges thrice crying, "Tell it bye-bye baby!"

Listening in suburban Half Moon Bay, future Giants Voice Jon Miller played a board game, Strat-O-Matic, miming Russ, the PA Voice, organist, and crowd. In 1962, Jon, ten, saw his first game at the Stick. "I had a radio and binoculars, so I could hear and see Hodges. Russ'd say something, then grab French fries. It hit me: 'Hey, this is the life for me!'" With seven games left, LA led by four. The Giants played by day, then Russ re-created the Dodgers at night on KSFO.

On September 30, Willie's last-day blast beat Houston, 2-1, at Candlestick. "Mays hits one a long way! Tell it bye-bye baby! Mays put one into orbit!" Russ beamed. Over the PA system, he then did Dodgers play-by-play, St. Louis winning 1-0. Ahead: a best-of-three series—1951 redux. The teams split the first two sets. In the decider, four ninth-inning runs gave San Francisco a 6-4 victory, Mays flinging the last out into the bleachers at Dodger Stadium.

Like 1951, champagne left one clubhouse for the other—and Russ voiced his last World Series: NBC's 'Jints-Yanks.

New York led Game Seven, 1-0, as Matty Alou singled, two batters fanned, and Mays doubled in the ninth. Hodges and Allen shared a final batter, having partnered their first game in 1946. Like the 1951 playoff, 1962's Series kinescope was destroyed. Preserved: Simmons, on NBC Radio. "Here's a liner straight to [Bobby] Richardson! The ball game is over, and the World Series is over! …Had that ball gotten out of his reach, the Giants would have been the winner! Now, it's the Yankees!"

The 1965–1966 'Jints lost a last-weekend pennant to LA, costing Russ a fourth and fifth Series. Even so, he aired all but two of Mays' first 628 homers. In New York, Stoneham had televised each home game. Now, he showed almost none. In 1968, the A's moved to Oakland, dividing the region. A football makeover curbed the Stick's baseball feel. The team eventually built a new park. Russ would have liked 2010 even more—the Giants' first world title since 1954. At the City Hall salute, Jon Miller cried, "Bye-bye baby!"

Hodges had retired after the 1970 season. Next April, he died, at sixty, of a heart attack. Mays wept: "Russ was like my big brother. I turned to him for everything." For two decades, in a pre-cable and internet world, a Giants fan often did, too. Russ never equaled 1951, but no one else has, either.

From 1948 to 2002, William Earnest Harwell called five major league clubs—most famously, Detroit. A soft-spoken institution, he called his home team "the Tiges" and the Red Sox "the Bostons" and said, "He played every hop perfectly except the last." As author Mitch Albom said, "If baseball had a voice, it would sound just like Ernie Harwell."

Growing up, Ernie used his front porch as a stage on which to learn. "You'd hear about the local banker and beauty parlor operator and who married whom," he said. Then Ernie spoke—as a boy, he stuttered—about the bags, positions, batter, and pitcher. Whatever the play, "Your mouth and brain had to describe it without frills."

The towhead was helped by special elocution—"expression"—lessons he took as a boy at Doc Green's drugstore in Washington, Georgia. A favorite tract was Sam Walter Foss's 1800s inspirational poem primarily read at graduations. Years later, its final passage became Ernie's most famous idiom, "[The batter stood there] like the house by the side of the road" to describe a called third strike. It ended with a phrase, "To be a friend of man." He was.

A childhood friend of mine heard Harwell air the Tigers on WJR 760 Detroit across Lake Erie from Upstate New York. Each day, his wizardry led someone from a different town to fictively grab a foul. "That ball is nabbed by a guy from Alma, Michigan!" he might cry. Bystanders at the park pled, "Hey, Ernie, have someone from Hope [or Detroit or Sarnia] grab one!" Oblivious, my friend told his mother that Ernie must have a lot of friends. He did.

Listing much, biography can tell too little; bestselling author and lyricist, seventy songs; contributor, *Collier's* to *Reader's Digest*; creator, the essay "A Game for All America," to be described shortly. "The wonder of Ernie goes far beyond being great behind the mic," Red Sox announcer Ned Martin said. The musical *Peter Pan* sang, "I've got to crow." Having much to crow about, Ernie refrained.

At five, he was the Atlanta Crackers visiting batboy; eight, author Margaret Mitchell's paperboy; later, sang a duet with Pearl Bailey, spoke at a Billy Graham crusade, and wrote for Johnny Mercer. He was the first sports Voice to telecast coast-to-coast (October 3, 1951), be baptized in the Jordan River, and be traded

for a player (Brooklyn's Cliff Dapper, 1948). You didn't learn it
from Ernie, though.

Harwell's baseball passion began with the Southern Association
Crackers' Ponce de Leon Park. As a child, he sold popcorn there.
At sixteen, Ernie became *The Sporting News* Atlanta correspondent.
At Emory University, he was a newspaper editor and post-degree
WSB Radio sports director and wed Lulu Tankersley, a high
school beauty queen, at twenty-four. About this time, he became
sports editor for the Marines' magazine *Leatherneck*. You heard that
elsewhere, too.

After the war, Harwell began airing the Crackers. By 1947, a
General Mills Wheaties "scout" visited Atlanta to hear him, Ernie
re-creating a twenty-one-inning game. Finally, he entered the lobby
to find the scout. "Then I saw him. For hours he'd been asleep." In
truth, Harwell was so good that, as noted previously, the Dodgers
dealt for him when Red Barber's ulcer burst in 1948. Harwell
took to Brooklyn a manner falling softly on the ear, his anecdotal
style favoring the familiar. A home run was "looong gone";
double play, "Two for the price of one"; called strike, "excessive
window shopping."

In 1950, Ernie left for the Polo Grounds, then Baltimore
in 1954. Next year he composed "A Game for All America,"
translated into six languages. It read: "It's America, this baseball.
A re-issued newsreel of boyhood dreams. Dreams lost somewhere
between boy and man." Baseball, he wrote, "is Humor, holding
its sides when an errant puppy eludes two groundskeepers and
the fastest outfielder. And Pathos, dragging itself off the field after
being knocked from the box." It was "a game for America!" Ernie
ended. "A game for boys and men," girls and women. Still.

In 1960, Harwell, inheriting a bad club, replaced Mutual Radio-
bound Van Patrick in Detroit. Next year, at what Ernie styled

"The Corner" at Michigan and Trumbull, new owner John Fetzer renamed the park Tiger Stadium. Out of nowhere, the '61ers went 101-61 to nearly beat the Maris and Mantle Yankees. Detroit began a September 1-3 series in the Bronx, a game and a half behind, interest "so amazing," said Harwell, that the football Lions postponed an exhibition to avoid conflict with the "Tiges" local TV opener.

Next June 24, a Yanks-Tigers day game crashed primetime TV. It began at 1:31. Jack Reed's twenty-second-inning homer, in a seven-hour then-longest bigs game, beat Detroit, 9-7. Ontario writer: "I've got to leave." Another: "Why are you going?" Answer: "My visa just expired." In 1963, Ernie aired the Series on NBC Radio. Twelve years later, in the film *One Flew Over the Cuckoo's Nest*, Jack Nicholson as a schizophrenic strained to hear him. Ernie joked, "Wish I got a residual [from that and five other films]."

In 1967, rioting in Detroit killed forty-three. Next year, as more than 250 cities burned, "A strange thing happened," Detroit *Free Press* columnist Joe Falls wrote. "The ball club…started winning games. As the streets began to heat up, people began staying in at night to listen to Ernie Harwell on radio." Nightly, he was there, so vivid that a Michigan Harris poll named Ernie its favorite Voice— two years after he retired.

The 1968 season, a.k.a. "The Year of the Pitcher," was The Year of the Tiger, too. MVP/Cy Young Award honoree Denny McLain became the first hurler since 1934 to win thirty games. On September 14, Willie Horton's ninth-inning drive beat the A's, 5-4, "McLain…one of the first out of the dugout," said Harwell. Three days later, a Tigers win or Orioles defeat would clinch a pennant. At The Corner, Don Wert hit "a line shot, base hit right field, the Tigers win it! Here comes [Al] Kaline in to score, and it's all over! …And the Tigers have won their first pennant since 1945!"

Injury had shelved Kaline for much of the year. Skipper Mayo Smith, needing a bat and aware of Al's then sixteen-year Tigers tenure, daringly restored him to right field for the Series, moving outfielder Mickey Stanley to short. St. Louis had a three-to-one set edge till Kaline knocked in the fifth game's winning run. In scoreless Game Seven, Jim Northrup lined to center field with two out and two on in the seventh. "Here comes [Curt] Flood," said Ernie. "He's digging hard. He almost fell down! It's over his head for a hit!"—Tigers win, 4-1. Understating, Ernie called it "worth the wait."

Nearing home run No. 700, Henry Aaron prompted Harwell's song "Move Over Babe, Here Comes Henry" in 1973. In 1981, receiving a Frick, he invoked "a tongue-tied kid from Georgia, growing up to be an announcer and praising the Lord for showing him the way to Cooperstown." Detroit's 1984 troupe was as select: the fourth team to top the league or division daily. Up, three sets to one, it led, 5-4, as Kirk Gibson, accepting a bet from skipper Sparky Anderson in the dugout, bombed "a long drive to right! And it is a home run for Gibson! ...The Tigers lead it, 8 to 4!"

A plebiscite would likely have found Michigan sooner cheering for Ohio State than voting to exile Ernie. Yet in late 1990, Harwell said he would not return after 1991, "fired" by ex-Michigan football-coach-turned-Tigers-head Bo Schembechler. The *Free Press* screamed, "A Gentleman Wronged." A year later, the Tigers were sold to Mike Ilitch, who, rehiring Harwell, axed Bo. In 1999, voice breaking, Ernie said goodbye to Tiger Stadium over the PA mic: "We will remember."

The Detroits unveiled a statue on Ernie Harwell Day. The Pastime never owned but did define him. He would see you "before Opening Day"; a manuscript was due "by World Series time." In 2009, Harwell announced he had inoperable cancer of the bile duct, saying he had "maybe a year or half a year left." His eight

months were not enough. He died May 4, 2010, at ninety-two.
Albom then wrote a smash *Ernie the Play*.

How did Ernie do this—live all these lives: announcer, writer,
family man—with such grace? "Miss Lulu" was his best friend.
Their four children, reading, and exercise kept him young. He
distilled the magic of the American small town. Finally, Ernie's
faith was deep and true. Why did his death light a candle in untold
houses by the side of the road? Deep down, we wanted to *be* him—
the slight figure with glasses, beret, clear soul, and open mind.

In 1955, the year of Harwell's heart-felt essay, a heart attack felled
Cubs radio Voice Bert Wilson. A year earlier, Jack Quinlan had
joined him on the wireless, "Possessed of the firmness of a heavy
handshake, the resonance of a finely tuned harp, the clarity of a
starry night, [and] the quality of a prayer," said WGN Sports head
Jack Rosenberg.

Born in Peoria, Illinois, Quinlan told his mother at five that
he hoped to broadcast the Cubs. Later, he diverted friends with
simulated play-by-play before and after leaving Notre Dame in
1948. In 1951, he was hired to aid Wilson. "Three years out of
[college] and I'm working at Wrigley Field," Quinlan marveled.
He joined WIND in 1953, became top Voice on Wilson's death,
and left in 1958 for WGN.

In nine years, his Cubs never made the first division, their
obscurity not mandating his. NBC Radio gave Jack the 1960 World
Series and first All-Star Game. A great career seemed ahead until,
returning from 1965 spring training golf in Mesa, Arizona, he had
wheels lock on his rented car, skidding nearly two hundred feet
into a semitrailer truck. "It's like Brickhouse says," said 1958–1987
Cubs Voice Lou Boudreau. "'When Jack died, it was like losing a
younger brother.'"

Quinlan grew up with Chicago as radio's capital. In any 1940s rendering, the Second City became television's hub. In 1916—the year the Cubs came to Wrigley, then known as Weeghman Park—the man who became Chi-Town's TV essence was also born in Peoria. "Anybody who could see, knew that television would be important someday," said Jack, becoming Chicago's sportscaster with the largest voice who cast the furthest shadow for the longest time, his famed signature "Hey-hey!"

As a boy, Brickhouse worked after school to pay expenses, Dad dying when he was three. Mom remarried. Jack helped Grandma deliver food trays at a hospital and in 1933 left Bradley University, unable to afford it. In 1934, he took a job as a seventeen-dollar-a-week WMBD Peoria spare mic man and switchboard operator, covering news to barn dances and the Three-I League, impressing the Midwest's surpassing Voice.

Jack arrived in Chicago in 1940 to join and ultimately help Bob Elson air the Cubs and White Sox. Brickhouse later joined the Marines, was discharged due to boyhood tuberculosis, and replaced Elson, who was still serving in the war. In 1946, Bob, now out of uniform, replaced Jack. Next year Brickhouse worked on experimental TV, Chicago having more than one in ten US sets. By 1948, WGN Channel 9 aired each team's home schedule, both never there at once. Since Wrigley lacked lights, "the Cubs were on when kids left school," Jack televising more than five thousand games.

At a time where some clubs shunned TV, "long-term continuity made for lifelong fans," said Brickhouse. His precedents included being WGN's first on-camera face, daily TV Voice, and boxing mic man. Jack especially liked 1951's center-field camera charting the pitcher/hitter shot. "If you worked fourteen hours a day," he said, "it was a breeze." Non-sports events included the 1945 and 1969 presidential inaugural, each major party's 1944 to 1968 quadrennial convention, and one-on-one with four US presidents.

Brickhouse aired 1962's Cubs-Phillies TV from Wrigley in the first satellite broadcast to Europe, the 1950–1953 All-Star Game, and football—"every sport…except for hockey and horse racing. I have enough trouble picking a horse without trying to broadcast it." He also interviewed Leo Durocher and Pope Paul VI—alas, a writer said, not at once. Always, Jack said he was too busy to be tired.

On every Cubs or Sox homer, his calling card, "Back, back, back… Hey-hey!" roused each side of the Second City. On April 11, 1968, Chicago columnist and lifelong Cubs addict Mike Royko's annual Cubs quiz included a Q and A. Question: When a ball goes over the left-field wall, what street does it land on? Answer: Waveland Avenue. But to hear Brickhouse yell, you'd think it landed in his eye.

Jack Brickhouse

As a storyteller, Brickhouse kept sentences lean, narrative expressive. Cubs' mediocrity meant dead air left to fill. "The optimist says the glass is half-full. The pessimist says the glass is half-empty. The Cubs fan asks when the glass will spill," he rued. Even optimists had not foreseen the 1959 White Sox pennant-clinching on September 22 at Cleveland. "Dangerous Vic Power is up," said Jack on WGN. "There's a ground ball. [Luis] Aparicio has it, steps on second, throws to first! The ball game's over! Sox are the champions of 1959!"

WGN broadcast from a United charter bringing the Sox back to Chicago. Brickhouse asked Nellie Fox if he remembered ever swallowing his trademark chewing tobacco. "Remember it?" the imminent MVP said. "I don't even want to think about it." Outfielder Jim Rivera kept saying, "Whatever happened to the Yankees?" The bile between Elson and NBC let Jack add 1959's Series to his 1950, 1952, and 1954's. Since kinescopes were destroyed, no TV play-by-play is believed to exist from 1959's White Sox–Dodgers seen by a record 120 million viewers.

In the opener, the Sox romped, 11-0. LA won three of the next four sets. Back in Chicago, the Classic ended, as it began, with a blowout: Dodgers, 9-3. Jack refused to be depressed. The Sox flag had repaid his faith, as would the Cubs' Don Cardwell's 1960 no-hitter: the first-ever thrown in a first start after being dealt. "Watch it now!" Brickhouse boomed of the last out, "Hit on a line to left! …Come on, Moose [left fielder Walt Moryn]! He caught it!" Later, Jack said, "I like some Gee-Whiz enthusiasm in broadcasting sports." Somehow, we knew.

In late 1960, Don Wells left Pale Hose radio for Los Angeles Angels wireless and TV. On television, Vince Lloyd, a World War II Marine who worked in several markets before landing at WGN in 1949, remained on Cubs and White Sox TV pre-game and play-by-play. On April 10, 1961, the White Sox began their season

in Washington for the traditional presidential opener. On WGN's *Leadoff Man* show, JFK became the first US president interviewed on television at a baseball game.

Lloyd: "Mr. President, have you had an opportunity to do any warming up for this, sir?" Kennedy: "Well, we've just been getting ready here today." Lloyd: "Throwing nothing but strikes? Very good."

Kennedy: "I feel it important that we get, ah, not be a nation of just spectators, even though that's what we are today, but also a nation of participants—particularly to make it possible for young men and women to participate actively in physical effort."

Leaving, Vince asked about Mrs. Kennedy. JFK smiled and said, "Well, it's Monday. She's home doing the wash."

In 1961, another *Leadoff* guest vanished near airtime. "Where's Roger Maris?" Lloyd told Whitey Ford, who grabbed Yogi Berra and Mickey Mantle for an interview. "Holy mackerel!" Vince said, using his signature. "[Now] I've got three great names." Appearing, Maris made it four. "I just got a call from my wife in Kansas City," Roger said, adding, "she gave birth to a son!"

Lloyd aired White Sox television through 1964, adding at one time or another the Bears, basketball Bulls, wrestling, Big Ten football—and 1965 Cubs radio play-by-play upon Quinlan's death. Wireless analyst Lou Boudreau vowed to "quit if I didn't come over [from TV]," said Lloyd, spending the next twenty-three years on radio. Later Vince would say of Lou, "I can't imagine there's ever been a better baseball analyst."

In 1965, only WGN ferried the team on radio. Thirty-five outlets did by 1973. On TV, neither Chicago team broadcast with the other at home till 1968, when Sox owner Arthur Allyn dumped WGN for UHF (ultra-high frequency) WFLD. Livid, owner Philip Wrigley had Brickhouse call the *entire* Cubs schedule. The Hose

missed his cloud nine voice "and enthusiasm that nothing could shake," said WGN's Jack Rosenberg.

On April 8, 1969, Willie Smith pinch-homered an Opening Day ninth-inning 7-6 bonanza for the Cubs. Billy Williams set an NL record: 895 straight games. Baseball's best infield wed Ron Santo, Don Kessinger, Glenn Beckert, and Ernie Banks. Brickhouse was in "Friendly Confines" heaven. By mid-August, the Cubs held a nine-game lead. The Mets then finished 38-11, Chicago ending eight games behind. Even then, Brickhouse did not despair.

Banks faced Pat Jarvis May 12, 1970. "He swings and a drive—a liner, left field! It is—there it is!" said Jack. "Mr. Banks has just hit his five hundredth career homer! He is getting a standing ovation!" Mr. Cub retired a year later. In 1981, the Tribune Company bought the club. Jack did his final game on September 27, a large crowd huddling afterward. "That got to me," he mused. "I was holding out pretty good till then."

In 1983, Brickhouse made Cooperstown, telling how a reporter mused that given Jack's frenetic schedule, even if he didn't make it, his suitcase would. "Fortunately for me," Brickhouse said, "we arrived together." He died August 15, 1998, at eighty-two, of a stroke after brain surgery, having penned a tombstone: "Here lies the guy who could do the best soft-shoe anywhere for 'Tea for Two.'" Today, a bust of him in downtown Chicago hails the man whose "Whew, boy!" and "Oh, brother!" made him one of us, but so much more.

Chapter 7

1950S–1960S: NETWORK TV'S DEBUT

The culture of the 1950s vaunted, among other things, Dwight Eisenhower playing golf, John Wayne at your nearest theater, and entertainment television Voices of a non-elitist lilt. Consensus claimed that few would watch network TV regular-season baseball. "It was all local," said CBS Sports director Bill MacPhail. "Why would Omaha watch Red Sox–Tigers?" Dizzy Dean was why. "In mid-America," he said, "Dean made watching baseball an absolute religion." As Diz would say, "Pod-nuh, you ain't just a-woofin'."

Before 1953, no TV network had aired a major sport's full regular season. That year Ol' Diz's ABC *Game of the Week* began each Saturday, moved to posh CBS in 1955, and added a 1957 Sunday *Game*. To protect box office and local-team video, baseball banned the program within fifty miles of a big-league city. Unvexed, *Game* forged a ten to fifteen rating. "About three in ten Americans were blacked out," said Bill. "In the rest, we had up to four of five sets in use!" Critic Ron Powers evoked Dean's "mythologizing presence," Main Street grateful for his harmony with the small town and rural.

Through its 1965 finale, *Game* evoked Marshall Dillon, Billy Sunday, and Gabby Hayes, Jay Hanna Dean already a Paul Bunyan legend: born in Arkansas on January 16, 1910, traversing the South as a cotton picker's son and as noted, leaving school in second grade. At sixteen, Jay joined the army, Dad falsely saying

he was eighteen. Stationed at Fort Sam Houston in San Antonio, Dean joined its baseball team. His master sergeant lavishly praised him to a Cardinals scout, despite Jay also being his outfit's "dizziest [ever] kid."

Dizzy served a second year, paid the army a hundred dollars to leave, and signed to pitch for Branch Rickey's Redbirds. At St. Joseph, Missouri, of the Class-A Western League, Dean, ignoring curfew, ran into the league president at four in the morning. "So the old boy is out prowling by hisself, huh?" Diz laughed. "I'm not one to squawk. Us stars and presidents must have our fun."

In 1930, Dean won his first big-league game on the final day, then charged the Cardinals $2,700 for bills in next year's spring training, author Joseph Wancho wrote. "He broke team rules and was generally viewed as a pest," yet became the Redbird the public was most enamored of. This set, as lawyers say, a precedent.

Dean spent 1931 in Houston, a 26-10 Texas League MVP. Impressed, manager Joe Schultz worried that Diz was self-impressed. One day each ordered scrambled eggs and bacon at a diner, the kitchen errantly subbing calves' brains for bacon. After cleaning his plate, Dean asked what had been served. "What? I didn't order no brains," Diz said. Schultz replied, "Be quiet; she knows what you need." That June 15, Dean got what he lacked, wedding Patricia Nash, who became his business manager and bookkeeper: married forty-three years with no children, Pat likely feeling that one child in the family was enough.

In 1933, promoted to St. Louis a year earlier, Dean fanned seventeen Cubs in a single game. Next September, he spliced three Dodgers hits to open a double-header, 3-0. In Game Four of the World Series, Jay, pinch-running, was smacked in the head by a throw. "X-Rays of Dean's Head Show Nothing," read papers. Diz

then took an 11-0 final. The institution in the booth above the field was a household name on it first.

In 1937, Jay started for the National League in the July 7 All-Star Game, yielding a home run to Lou Gehrig. Piqued, Diz then fired a fastball which Earl Averill deposited off the hurler's left foot. "Your big toe is fractured," a doctor said. "No, it ain't," said Diz. "It's broke." He returned too soon, pain making his left foot impossible to pivot, pitched "entirely with my arm," and permanently hurt it. Dealt to the Cubs, fastball gone, he vainly tried a new side-arm delivery. In 1941, Diz retired with a 150-83 record and 3.02 ERA, pitching four innings as an attendance ploy in 1947.

By then, Falstaff Brewery had broached Cardinals and American League Browns radio, Diz airing them through 1953. Some Voices swell vocabulary. Dean reinvented it. A batter "swang" and runner "slud." Pitchers stood "confidentially" on the mound. Fielders returned to "respectable" positions. A station offered a gig hosting classical music. "You want me to play this sympathetic [symphonic] music and commertate on them composers?" The St. Louis Board of Education tried to yank Diz off the air, even as *TSN* named him 1944 "Announcer of the Year."

In 1948, Dean gave a speech: "Radio Announcing I Have Did." The Soviet Union controlled Eastern Europe. Diz vowed to "get me a bunch of bats and balls and sneak me a couple of empires and learn them kids behind the Iron Curtain how to bat and play baseball." Joseph Stalin—"Joe Stallion"—could run concessions. "[That way,] he'd get outta politics and get in a honest business." The Kremlin had no response.

In 1950–1951, Diz televised the Yankees on WABD, Channel 4, "The things that he came up with—*sludding* into third—were professional," said Mel Allen. "Once he said *slid* correctly, by

mistake, and corrected himself. But it was too country for New York." Meantime, Dean aired Mutual's 1952–1954 *Game of the Day*, his principal partner Al Helfer—each reviled by the other—or Bud Blattner of Falstaff Brewery's twenty-four outlet Browns network.

Falstaff wanted a national niche, which required TV's still-*nouveau* impact. ABC was the weakest, thus, cheapest, network: "Fewer outlets than CBS or NBC," said ABC aide Edgar Scherick, aware how "crucial paid inventory" was to "paying bills." He also knew a related fact: "Football fans watch regardless of team." On the tube, baseball had always been a regular-season individual-team hit. You watched only if your team was involved.

Scherick touted Dean for a prospective Saturday *Game of the Week* in 1953, reversing baseball's tradition as only a national October smash. A Voice to transcend teams could become the series. Ron Powers styled Diz "a prodigious bubbling kettle of Americana who would keep [people] tuning in even if he did the play-by-play for ballroom dancing at Arthur Murray." Like any revolution, the idea was easier than the execution.

First, Dean had to get on the air. The blackout of any place within fifty miles of a big-league city was a thumbed nose at sponsors and one in three viewers. Worse, each network had to sell each team's rights. Initially, only the A's, Indians, and White Sox bit. "The rest said, 'Save local coverage! Forget national TV!'" said Scherick. *Game* debuted Memorial Day weekend on just eighteen affiliates. "Howdy, *pod-nuhs*, this' Dizzy Dean f'um Cleveland's Municipal Stadium," Powers summarized. By next year Ol' Diz was watched by more than 75 percent of sets in use.

"Had *Game* failed," said MacPhail, "maybe TV sports has a different future." Instead, the response was "stunning," Dean vending, "Falstaff—it's America's premium quality beer!" on more than one hundred outlets. Lindsey Nelson began NBC's Saturday *Major League Baseball* in 1957. After CBS added Sunday,

NBC countered in 1959. Next year ABC's Jack Buck invaded late-afternoon Saturday. Baseball had never been a regular-season network player. Now all three aired five weekend games. "All network coverage," Nelson said in 1988, "stems from Dean."

In A.C. Nielsen ratings, Diz whelped Frick Award honorees Buck, Nelson, Joe Garagiola, and Bob Wolff head-to-head by three and four to one. He weekly sang "The Wabash Cannonball," almost as much a part of televised baseball as "Take Me Out to the Ball Game." At one time or another, Dean dozed, ate catfish, hymned "Amazing Grace," and proudly touted his bulbous weight, cowboy boots, and Stetson—the whole rustic air. Dean read telegrams, left the booth to buy swollen plates of food, and gave mid-America a decent measure of regard.

"We'd get reports from Phoenix, Cedar Rapids, [and] Little Rock, and they'd close down when Dean was on," said MacPhail, businesses shuttered. In Hollywood, Clark Gable played nine holes of golf each Saturday, saw *Game* at the clubhouse bar, then returned to the course. One day a skirmish roiled the field. "That batter shakin' his head down there—he don't know what's goin' on. I don't know what he don't know, but I know he don't know." They had "to be my words," Dean said, "'cause no one else would have 'em."

By the late 1950s, "Dean passed Barber as baseball's biggest broadcast name except Mel," mused Nelson. Auguring schism between elite and regular Americans, many at CBS New York were unaware of Dean's presence, given *Game*'s broadcast ban. His name was once inadvertently raised at a sponsor meeting, a CBSer noting that "We would never have on our network a person as uncouth as him."

"But…he's *on* our network…every weekend," said MacPhail.

Twice a week, he said, Bill watched knowing he "had no control, just wondering what Diz'd say or do." United Airlines backed *Game.* Hating to fly, Dean said on air, "If you have to, pod-

nuh, Eastern is much the best." In 1958, he bleached MacPhail's gray hair. "I don't know how we come off callin' this the *Game of the Week*. There's a much better game—Dodgers-Giants—over on NBC."

"*Syntax?*" Diz said. "Are those jokers up in Washington putting a tax on that, too?" He pardoned so-so pitching: "The ball they're playing with isn't lively; it's hysterical." One day he lashed an umpire, giving English more respect. "That was quite a game," Dean later said. "What a shame you didn't get to see it." Once, Ted Kluszewski, Bob Borkowski, and Fred Baczewski filled the bases. "I was sweatin'," Diz said, "hopin' that nobody's get a hit so I didn't have to pronounce them names."

Alas, the batter hit toward to left-center field. "There's a long drive"—Dean gulped—"and here's [*Game* producer] Gene Kirby to tell you all about it." We leave with a *Peanuts* strip. Charles Schulz once had Lucy quote Diz about an outside pitch: "He shouldn't hadn't oughta swang!"

Dizzy Dean

Blattner knew that Dean loved his image as "the guy who fell off the turnip truck and wandered barefoot into town, saying, 'Fellas, what's it all about?'" Reality differed. Once Diz did the first two innings, his first grammatically sound. During break, he said, "That's enough o' *that*. Now I'm gonna start makin' money." Bud thought that Dean loved humanity, not people, his signet "pod-nuh" a way to convince you that, "My God, Diz remembered me 'cause he called me pod-nuh."

From the first, Bud conveyed fact and strategy. Diz offered everything but score and sanity. "I'd come in," Blattner said, "and give what Diz had missed." He didn't always notice. On September 27, 1959, the Braves and Dodgers forced a best-of-three playoff. Falstaff asked tobacco company L&M to cosponsor, dicey since Diz trashed cigarettes. Refusing, L&M cornered Falstaff, which said,

"L&M won't take Dean. You [Blattner] and George Kell do the
games." Enraged, Diz vowed to quit *Game* if Bud did the playoff.
Afraid of losing Dean, Falstaff pulled Blattner, who resigned.

"Dean couldn't stand that I'd do the games, not him," Bud said,
"never grasping why I left. I couldn't have looked in the mirror if
I hadn't." He resumed St. Louis NBA play-by-play even as honor
cost "the world's best baseball broadcast job"—and returned to
1960–1961 Cardinals TV, began the "Buddy Fund" local charity,
and became 1962–1968 Voice of the Los Angeles, then California,
Angels. In 1967, Blattner and Curt Gowdy did TV's All-Star
Game from Anaheim. Still, "[Wife] Babs and our daughters missed
me. It wasn't home."

In 1969, Bud returned home, named first Voice of the
expansion Kansas City Royals. Leaving due to "burnout" six years
later, he retired to Lake Ozark, Missouri, building a great tennis
complex. "To an extent, staying active may have saved my life." It
couldn't forever, Blattner dying of lung cancer at home in 2009. To
the end, "pod-nuh" was a gentleman.

Blattner's *Game* successor, Harold "Pee Wee" Reese, had 2,170
hits for the Dodgers, anchored Brooklyn's sole world title team,
and made the All-Star team in 1942 and 1946–1954—and
Cooperstown in 1984, arguably the most beloved-ever Bum. Yet
of the countless people queued up to meet him, few mentioned
Brooklyn. "To this day," he said a decade before his 1999 death,
"folks come up and say, 'Baseball hasn't been the same since you
two left.'"

The two were Ol' Diz and Pee Wee—"Two great guys," a
1960 CBS promo went—the latter a marble-shooting son of
a railroad detective found by a Louisville Colonels scout while
playing shortstop in a 1937 church league game. In 1940, Brooklyn
acquired the self-styled "country kid" born near Louisville. "I

get to the city, and it's another planet," he said. Its capital was
Ebbets Field. The then five-foot-nine, 140-pounder began by
being mistaken for the bat boy, ending as the borough's bat, glove,
and heart.

Reese spent 1943–1945 in the navy, returning to baseball in
1946. The next year, Jackie Robinson broke the major league color
barrier, joining Pee Wee in a Dodgers uniform. Reaction both off-
and on-field was at first mixed. Reese felt drawn to him for reasons
based more on right than race. In Cincinnati, an anonymous crank
threatened to shoot Jackie if he played. Reese moseyed over in
warm-ups, joking, "Don't stand so damn close. Move away, will
you?" as if proximity meant risk.

Jackie started laughing, Pee Wee using humor, one player
to another, becoming, as it happened, lifelong friends. In 1955,
Reese at thirty-seven, and Robinson one year younger, finally won
a Series. In LA, he became a coach in 1958, "Like an old fire
horse watching the rest of 'em gallop past." By late 1959, CBS
TV targeted him as Dean's next sidekick. Hesitant, Reese finally
yielded. He had never called a pitch.

In early 1960, he bought a tape recorder, watched footage, and
worked with Gene Kirby: "an exhibition, and I'm sweatin'!" Dean
asked if Pee Wee had a problem. "Boy, no kidding," Reese said.
"Here's all you do," said Diz, singing "The Wabash Cannonball."

For a while, a peaceful easy feeling eluded Reese like a fat pitch
in a batting slump. One morning at breakfast, he learned from
Kirby that with Diz on vacation, next week Pee Wee would do
play-by-play. Reese feigned calm. "You okay?" said Gene. "Sure,"
said the former shortstop. Kirby smiled: "So how come you're
pouring coffee on your pancakes?"

Dean reassured the neophyte. "I loved the big loaf. He
protected me, eased pressure," Reese said. In one commercial
break, Diz said, "Pod-nuh, let me pick this up. You just lost some
sales." Another day Dean left the booth, on air saying, "I'm going

out for a hamburger. Want one?" Pee Wee: "Sure." The next shot
showed the hefty Diz lodged on a narrow ladder below the booth.

In 1966, NBC's *Game*, replacing CBS, named Curt Gowdy,
who refused to work with Dean. Hired as Diz's proxy, Reese found
Gowdy "nice, but worried about mistakes. Diz and I just laughed."
In 1967–1968, Dean did random color on Atlanta's WSB TV
twenty-two-outlet network. Reese lasted through 1968, replaced by
Tony Kubek. "I just wonder what went wrong," he said later. "Did
I talk too much? Didn't I talk enough?"

Pee Wee did TV in Cincinnati, then Montreal, owned a
bowling alley and storm window business, and vended for bat
company Hillerich and Bradsby. In 1985, he retired to Florida a
year after he and Gowdy entered the Hall of Fame: Reese as a
player, Gowdy given the Frick.

Each likely recalled Dean guesting on NBC's first 1973 Monday
Game of the Week with Curt and Tony. Out of the closet came
yesterday once more. "Where did Dean live?" Gowdy asked. Diz
replied, "Why, in Bond, Mississippi."

Where was Bond? Curt said. "Oh, 'bout three miles from
Wiggins," said Dean.

Where was Wiggins? "Oh, 'bout three miles from Bond."

Diz died at sixty-four in July 1974 of a heart attack. Reese was
often asked if he missed the series. "Nah, not the exposure, really,"
he said. "But I sure miss Ol' Diz."

In 1957, NBC outlets convinced the network to start its own
Saturday series, *Major League Baseball*, Lindsey Nelson doing balls
and strikes, and former Giants skipper Leo Durocher, color.
"NBC'd got zero audience [v. Dean]," laughed Nelson, "so we
began baseball against him on Saturday and got almost zero."

Neither network paid rights. Until 1965's ABC pact, CBS and
NBC paid only the teams it wanted to broadcast a certain fee per

game. "Since the Yankees were top draw," Lindsey explained, ruefully, "CBS bought their entire weekend schedule"—by 1964, paying the Bombers five times as much as any other team. "They owned the game," said Nelson of CBS—ironically, the bucolic Dean helping solidify the urban and urbane Yankees as a national team. The network barely noticed when NBC added its own Sunday game in 1959.

From 1953 to 1965, the Bombers' often twice-a-week network TV status was not affixed to another team. "Each week, growing up in Texas," said TBS TV Voice Brian Anderson, "you'd turn on *Game*, and they'd be on." With Vin Scully now in California, the Yanks' every pitch was often called by *each* of baseball's arguably three top radio/TV mandarins—Allen, Dean, and Red Barber. Another contender, Nelson, aired the 1969 and 1973 Series, 1971 All-Star Game, a potpourri of college bowls, and the Amazin' and Miracle Mets.

For half a century, famed bandleader Guy Lombardo welcomed each year over CBS TV from New York's Roosevelt, then Waldorf-Astoria, Hotel. An early 1970s comedian said, "I hear Guy Lombardo says that when he goes, he's taking New Year's Eve with him." Lindsey aired twenty-six Cotton Bowls from Dallas on New Year's Day, his last on January 1, 1986, after which the same could be said of him.

"What didn't you do?" I asked once.

"Rest," Nelson deadpanned.

He was glad to have done it, Lindsey added, not wanting to try it again.

As described, Nelson was an army captain in World War II, trekking to fronts in North Africa and Europe. On May 8, 1945, V-E (Europe) Day, a photo was inscribed to him by the man he

worked for: "A very busy man the day this picture was taken.
Dwight Eisenhower."

The Tennessean came home to post-war print boredom,
Liberty *Game of the Day*, and to a break that can make a career,
and did. Desperate after Bill Stern, known for his voice and drug
addiction, skipped out on a golf tournament in Dallas, NBC sports
director Tom Gallery had a friend suggest Nelson, whom Tom
phoned and promptly flew to Texas. Lindsey soon moved to New
York as his assistant sports director. "Best damned phone call I ever
made," Gallery said.

Like Lindsey, Allen was a Peacock peer, doing NBC's Series,
All-Star Game, and Rose Bowl—its then trifecta. "Ours was a
unique relationship. We were colleagues and competitors," said
Nelson. "I was Mel's boss. I was also his friend." Allen could
overwhelm, like a lead soloist. Lindsey treated you like a neighbor.
In the 1950s, they hosted *Football Panorama*. On play-by-play, they
profited from color analysts: Nelson, Red Grange, Bud Wilkinson,
and Terry Brennan. With luck, a baseball series would, too. "We
had nothing to lose. Our outlets said, 'Without baseball to oppose
Diz, our screens might as well go black.'"

As lead Voice, Nelson had three NBC baseball sidekicks.
Through 1959, Leo Durocher "was the most energetic guy
you'd ever see but had a fear of offending people." He became
a Dodgers scout in 1960, replaced by Fred Haney, just fired as
Braves manager: "Sort of coasting, at the point in his life where
he just wanted to take it easy." In 1961, Haney left to be the
expansion Angels' first GM, which opened *Major League Baseball* to
Joe Garagiola.

Nelson brought a lifelong big-league familiarity, at eight hearing
the Series by radio in his Tennessee public school. Students could
visit the auditorium during recess or a non-class period to listen.
His generation's earpiece was the wireless. The 1950s' was TV,

Gallery vowing that NBC's first-year regular-season baseball would commence by Opening Day. In fact, 1957's began before it: a Dodgers exhibition at Milwaukee. Nelson chose Jim Woods to call it, his voice as bass as a drum.

CBS already owned rights to televise eight of sixteen bigs teams. Said Lindsey: "They tried to squeeze us [out], but missed Milwaukee, which won a pennant." Nelson bought the Braves and Pirates (eleven sets apiece) and Cubs and Senators (two apiece)—all home. "Then it was whether you liked baseball, or [Dean's] song and dance." Diz rarely checked a monitor. Conversely, Nelson wed look and word.

"If a cameraman tipped his lens to a gum wrapper on the floor," a producer said, "Lindsey would say the right thing about the wrapper." Beyond baseball, he dispensed two of football's landmarks. The first was the annual Army-Navy Game, including 1963 when instant replay was introduced on CBS, and Lindsey had to explain repeatedly, "This is not live!" The other: the 1966–1979 Sunday morning *Notre Dame Football*. The Voice-over of the Fighting Irish packaged hours of day-before pre-taped play-after-play material into a ninety-minute fresco of syndicated TV.

During 1957–1961's *Major League Baseball*, Nelson felt local radio/TV to be the Pastime's fillet. "You spend one month in spring training and six afterward [in regular season]. The rest of the year's your own," Lindsey said. In 1962, he joined the first-year Metropolitan Baseball Club of New York—the Mets. Like CBS, NBC baseball had been blacked out within fifty miles of New York. "Many, not knowing that, said, 'Why are they hiring a football guy?'" Lindsey thought their skepticism a hoot. "If this were Broadway, the tryout had run five years."

In 1962, Bob Wolff succeeded Nelson on *Major League Baseball* after fourteen years in Washington. In 1961, the Senators had

become the Minnesota Twins. Wolff had gone but missed the
East, accepting GM George Weiss's late 1961 offer to broadcast
the expansion Mets. The New York *Daily News* pealed: "Wolff
Coming." The offer was premature, the Mets lacking a sponsor
or station.

Time passed. The Twins pressed Bob to reup for 1962. When
Weiss could not commit, Wolff signed with Minnesota, then
watched how George inked WABC Radio, WOR-TV, and Nelson.
"What symmetry!" Bob said. "Lindsey's hired for what might have
been my Mets job, and NBC hires me [the Twins releasing him]
for Lindsey's old job!" In addition, Wolff inherited *Major League
Baseball* analyst Joe Garagiola, a 1961 Nelson holdover.

Greeting Wolff, Joe said, "You work your side of the street
[interviews] and I'll work mine." The new play-by-play man liked
Garagiola's vernacular: "The guy stapled him to the bag" or "A
runner's smilin' like he swallowed a banana peel." Afterward, they
reviewed each pitch. "'Bob, first inning, count 3 and 2, Mantle
up,' Joe'd say. 'The next ball was a foul. You said this, and I said
that, and if you'd said this, I'd have come back with that.'" By next
game, Bob said, "My 'this' jibed with Joe's 'that.'"

From 1962–1964, many viewers changed TV channels each
weekend between networks doing baseball simultaneously. At CBS,
Dizzy Dean's use of rhetoric could gently be called erratic. Wolff
used it as fluently as Jascha Heifetz had a violin, trying to be "the
best announcer I could be," said Bob. Dean tried to be himself:
"Butcher names, didn't know players or score, knowing that people
didn't care."

For three years, the two grammarians clashed, Wolff's perfect
against Dean's fractured English. Bob said, "We were bigger in
cities, but Dean [was] gigantic elsewhere." Wolff also aired NBC
Radio and postseason TV, including the 1962 Giants-LA playoff,
Game Two, a then nine-inning record four hours and eighteen

minutes. "Each half-hour, NBC said, 'This program will not be
seen tonight because of baseball,'" he said. "Another thirty minutes
later, they'd chop another."

Then, in 1965, buying regular-season exclusivity, ABC hired
Wolff for baseball and the anthology series *Wide World of Sports*.
Almost immediately, Madison Square Garden approached Bob
about voicing a new cable TV network. He did as many as 250
MSG events a year—Wolff the first to call the title event of the
four major US sports. However, the animal-lover's favorite affair
was the Westminster Kennel Club Dog Show, where, in coaching
garb, he gave dogs a locker room "pup talk."

The MSG Network was a first-of-its-kind venture. Its site let the
native New Yorker spend the rest of his life in nearby South Nyack,
with his wife Jane and three children, including author and WFAN
New York host Rick. Bob won a cable ACE and multiple Emmy
awards, made MSG's Walk of Fame, and became a six-time New
York State Sportscaster of the Year. Sadly, he did little baseball
for the rest of his life. Yet his enormous volume of prior coverage
enriched its hold on the American sensibility. Let us recall how.

Wolff's baseball ethic began even before he entered Duke on a
baseball scholarship in 1938. Bob rode a train from Long Island to
Yankee Stadium to watch Negro League teams like the Homestead
Grays. Later, he saw them play at DC's Griffith Stadium, Josh
Gibson thrice clearing a wall behind the distant left-field seats.

Wolff hit .583 at Woodmore Academy, broke his leg sliding into
second base at Duke, and in a cast began hosting radio's variety
Your Duke Parade. Pleased, he grew confused about his career. "I've
never seen an arm or leg outlast a voice," coach Jack Coombs
said. In the navy, the Phi Beta Kappa '42 rode his commission
to Harvard Business School, then the Seabees in Camp Perry,

Virginia, and the Solomon Islands, and finally Washington to revise navy supply procedure.

In 1946, Bob became sports director of the *Washington Post*–owned WINX Radio. That year, at twenty-six, he trailblazed as the voice of WTTG-TV Channel 5 on the DuMont Network—DC's first telecaster. "Studio lighting was so brutal, sweat poured from my forehead," he said. Guests got ill. Bob lost ten pounds in a wool suit in an hour on air. Few shared his misery, America's only other commercial station then WABD New York.

"Most people lacked faith in TV," said Wolff, lacking sleep. In 1949, he added WWDC Radio, joining Arch McDonald as lead Voice, doing innings 1–3 and 7–9 on TV and 4–6 on the wireless. "Each day, four pre- and post-game programs, a TV and radio show, column, and the game!" he said. Bob served a DC so starved for decent baseball that after a nine-game winning streak in 1949, it held a parade down Pennsylvania Avenue as if the team had won a pennant.

Nowhere was that fervor more evident than on Opening Day—the star-spangled occasion where the president throws out the first ball. Before baseball's 2005 return to the capital, Bob had aired fourteen First Days, more than anyone, since his tenure spanned most of Truman's and all of Eisenhower's presidencies. An audience, including White House, military, and federal officials, followed him. Often radio aired the rite nationally, the team's 8-6 win-loss record sublime for Washington.

For the Nationals, losing was so *au courant* that, when giving the score, "I didn't need to specify," Bob mused. "Folks tuning in heard me say, '5-3,' '10-4', already knowing who was winning"—not the Nats. When, in 2019, DC won its first World Series since 1924, many toasted the greatest Voice to announce baseball in the capital. Wolff helped keep the Senators from being the Atlantis of the major leagues.

To distract from the score, Bob interviewed in-game "fans in the stands." Hollywood types like Jerry Lewis, Bill Dana, and Jonathan Winters visited the booth. Wolff created the '50s "The Singing Senators." Players Jim Lemon, Albie Pearson, and Roy Sievers sang melody. Howie Devron played accordion. Wolff strung his ukulele. "People liked us, anyway."

A Washington listener enjoyed the "The Singing Senators" records more than records "I called against our team," Bob said. In 1953, Mantle hit the first "tape-measure" homer v. Chuck Stobbs, who later flung the unofficial longest wild pitch that wildly hopped, leapfrogged the backstop, and landed in a concession stand. In 1956, as stated, Mickey almost clubbed the first fair ball in a big-league game out of Yankee Stadium off the Nats' Pedro Ramos.

For a long time, Bob may have set a record trying to prove himself. "I'd say, 'How about [Mutual] network work?'—the All-Star Game or Series," he said. "They'd say, 'If your name gets big enough, we'll put you on.'" Wolff answered, "Put me on tonight, and my name will be big enough tomorrow." On July 10, 1956, he did the All-Star Game in Washington. "I'd worn [sponsor] Gillette out, Plus, I knew the park."

Bob's art peaked in the radio/TV interview, steering direction to a guest, including Babe Ruth, Jim Thorpe, Bob Hope, and Milton Berle. With only three network and few independent or cable outlets, syndicated TV series were much rarer than today. Bob syndicated a different pre-game show for each of eight big-league clubs—a majority of the vast material he donated to the Library of Congress in 2013.

Later in 1956, a good year got better, Bob getting the Series and on October 8 a transcendent story. Airing the second half of Game Five, Bob told producer Joel Nixon he would avoid the term *perfect game*, Don Larsen having retired the first fifteen Dodgers: "I'll use every synonym in the book so that everyone knows what's

happening." Bob liked the tradition of not using it, possibly jinxing the outcome: rather, "eighteen up and down…only Yankees have reached base."

By the ninth inning, New York led, 2-0. "[Dale] Mitchell waiting, stands deep… Here comes the pitch. Strike three! A no-hitter! A perfect game for Don Larsen!" Bob felt "mostly a sore arm. My body had been so tense that I was pitching with Larsen. It took me a week to recover." Next day's game was scoreless till the tenth, with Jackie Robinson working overtime: "[Enos] Slaughter's after it, he leaps! It's over his head against the wall! …Robinson is being pummeled"—describing Robinson's last hit scoring the Bums' last World Series run for their last Classic triumph.

Wolff had said to Gillette, "Put me on tonight, and my name will be big enough tomorrow." Inevitably, though, he reclaimed his day job, Washington a good fit for Bob. He also felt fealty to deceased owner Clark Griffith and his successor, nephew Calvin, the Nats having a mom-and-pop feel. "For some, baseball was a hobby," he said. "For the Griffiths, it was the way to pay expenses." For others, it was a passion, then and now.

In 1957, the Nationals won the first game of a home double-header—itself a rarity. Before game two, Wolff had another visitor in the booth. "Let's play a game," he said to his guest. "Don't say your name until we're finished talking." First, Bob asked about the Nats' first-game victory. "Well, of course," his guest replied, "being a Washington fan, I thought it was great." They spoke for seven minutes.

Finally, Wolff asked, "Are you originally from Washington, sir?" Guest: "No, I'm a Californian." Bob: "What sort of work do you do, sir?" Guest: "I work for the government."

Bob: "Oh, for the government?" His guest said, "Yes, yes. I work for the government." Wolff: "What sort of work do you do,

sir?" "Well, I'm the vice president," said Richard Nixon. The interview led that week's *The Sporting News* and other sports pages.

In 1993, Bob was honored by the Smithsonian Institution. "For him, it was like coming home," said son Rick. Two years later, getting the Frick Award, Bob sang "Take Me Out to the Ballgame," reasonably on-key. In 2002, he released MSG's *Bob Wolff Scrapbook*, based on his 1950's TV series. The Hall of Fame later issued an Ike-era *Legend to Legend* interview. "I think they hold up pretty well," Wolff said, "but I keep thinking, 'Who is that young man on the screen?'" In 2009, the Nationals Park TV booth was named in his honor.

Bob especially enjoyed reliving his early TV days, when cigars and cigarettes eclipsed even beer in paying bills. Once, he waved a cigar under his nose while hyping "the wonderful aroma" of Robert Burns Imperial. "Terrific," said the sponsor. "One suggestion. Next time you praise 'the wonderful aroma,' take the cigar out of the glass tubing first."

In 2017, Bob Wolff died after seventy-eight years of radio/ TV—America's longest/still-running sportscaster. "When I started, I was baseball's youngest Voice," Bob had laughed. Near the end, he was the oldest. It is apt that for years he lectured at Pace and St. John's Universities. Bob Wolff gave so much to like. Thankfully, he had as much to teach.

By the time Joe Garagiola became NBC's *Major League Baseball*'s 1961–1964 analyst and humorist, he had already fashioned himself and a certain best friend who had grown up across the street into his own best subject matter.

Joe was born February 12, 1926, the son of a father who worked in a brickyard and a mother who could not speak English. Like his friend, Garagiola thought baseball "a simple game." Each was also a hoot to hear.

His friend was Lawrence Peter "Yogi" Berra, an institution, arguably baseball's greatest catcher, and the person passing Shakespeare in the last decade as most quoted by US public speakers. Joe was also raised, like The Yog, in the same Italian section of St. Louis known as The Hill.

Early on, Garagiola learned that "Yogi thinks funny and speaks what he thinks." Joe became famed on *Major League Baseball* for poking fun at himself and at Berra for being funny. At first, some accused Garagiola of inventing "Berraisms." Ultimately, they conceded that "no one could create what Mr. Berra coined."

"I'll ask him, 'What time is it?'" Joe would state. "Yogi'll say, 'Now?'" Berra also said, "It's dangerous to make predictions— especially about the future;" "If a guy can't get sick on a [bad] day like this, he ain't healthy;" and, "Always go to other people's funerals. Otherwise, they won't come to yours."

Even more than Berra's friendship, Joe's supposed lack of skill became a trope: "I went through life as the player to be named later." He began by signing a 1942 contract for a five-hundred-dollar bonus with the Cardinals and moving from their Springfield outlet to Class-AA Columbus. Before inking him, the Cardinals hid Joe as a fifteen-year-old from other teams by sending him to Springfield as a groundskeeper and clubhouse boy, doing laundry of team prospects. In 1944, he was drafted, sent to Fort Riley, Kansas, and eventually to the Philippines in the war, then back to the Cards.

In 1946, the rookie got four hits in Game Four of the World Series, hitting .316 for the Classic. In 1950, he braved a shoulder separation; listening to the Redbirds' Harry Caray became a rehab ritual. "My wife was pregnant then, and it made me start thinking, 'Who wants an old ballplayer?'" Joe said. In 1951, he was dealt to Pittsburgh and in 1953–1954 to the Cubs and 'Jints, respectively.

In early 1955, Joe G. said, "I've got a chance to get into broadcasting. I wonder if I should do it." The Cubs' Jack

Brickhouse prophesied, "No. This broadcasting is one tough field."
He entered it by replacing the Cardinals' Milo Hamilton and
saying he was "ready. I used to sit in the bullpen and say, 'Why the
hell doesn't he throw the curveball?'" To become an announcer,
Joe said, all he had to do was to make his language less blue.

By the mid-1950s, the Redbirds had slumped appreciably, Joe a
KMOX Radio and KTVI TV bridge to an age when they were fun
to watch, not inadvertently funny.

As lead Voice, Caray taught him how to use the diaphragm,
working on curbing a sharp, even harsh, voice. "I had a lot of help,
and needed it," Joe said. Inhaling tapes, he developed an avuncular
style, evolving into a heavyweight of the resin bag. In time, millions
awaited the ex-catcher's bits as vaudeville had Sophie Tucker's.

The nature of the game became a favored subject. "It's not like
going to church," Joe said. The '52 Pirates were a sure-fire belly-
laugh, last in nine categories—especially their 42-112 record. "The
most courageous team in baseball," he said. "We had 154 games
scheduled, and we showed up for every one." Garagiola's career
seemed to worsen in each retelling. "I'm an expert on two things—
trades and slumps."

In 1960, Joe penned the bestselling *Baseball Is a Funny Game*,
ghostwritten by Martin Quigley, the book of anecdotes becoming,
noted Warren Corbett, "The rocket engine of his career." That
year, at a campaign event for John F. Kennedy, he put his arm
around former president Harry S. Truman. Aware that Dad, still
skeptical about Joe's new career, would be watching on TV, he said,
"Hey, Pop, I just want you to see who I'm hanging around with."

That year NBC's *Today Show* brought Joe to New York for a
book interview that led to *Major League Baseball.* Nelson styled
him "the single most ambitious man I ever met." Wolff found
Garagiola more considerate: "If I looked out to the pen and

couldn't tell who was right- or left-handed," Joe passed a note, "Smith to the right, Jones to the left," instead of saying on air, "That's Smith, the righty," or "That's Jones, a lefty."

In his first NBC year, Joe aired the second All-Star Game with Red Sox Voice Curt Gowdy at Fenway Park and the Yankees' World Series romp with Mel Allen at The Stadium and Cincinnati's Crosley Field.

In Game Three, the Series and the match tied at one and two, respectively, Mickey Mantle knelt on deck in the ninth inning. "If ever it was pitch-measuring time, it's right now, Joe," Allen mused. Said Joe: "You'd better measure right." Roger Maris did, homering to right.

In 1961, script flashing "ROGER MARIS" on the screen seemed futuristic as Maris rounded third base: the new technology prophetic of today, like Garagiola's style. Most peers then seldom interrupted the other's play-by-play. Joe did, freely. As he often said, "I'm Italian. I like to talk."

Garagiola later did the 1965 and 1974–1975 All-Star Games, but his most memorable Mid-Summer Classic was at 1962's new District of Columbia Stadium with Mel. Joe interviewed President John F. Kennedy, his candidate of choice two years earlier.

That off-season, Joe left the Cardinals to become a *Today Show* occasional regular, a network radio *Monitor* regular, and host of *Joe Garagiola Sports*—"the highest-rated of all sports programs on any network," read a Sindlinger Report. In 1962, he aired his first radio World Series. A year later, Joe's Classic partner, Ernie Harwell, said, "[This was] my first introduction to the transistor craze in Southern California." Even in the Series, "People brought radios. Joe would say something funny, and titters would go through the crowd."

On October 24, 1963, lifetime pal Berra was introduced as new Yanks manager, hustled to the Savoy Hilton for a baseball bubble-gum event, and introduced by Joe. By 1964, writer Til Ferdenzi quoted Garagiola saying, "Boy, I'd like to get the Yankees job." That fall, he got it, Allen, as we will see, axed after a quarter-century in the Bronx. Joe then aired the Yanks-Cardinals Series: to writer Phil Pepe, closing the deal. "He won critical acclaim for… entertaining reporting."

Garagiola also studied comedic timing at nightclubs in different cities. He's "good wit, no hit," said Ferdenzi, and would "salt Yankee baseball with quips, snappy sayings, and maybe an occasional soft-shoe." Manager-turned-GM Ralph Houk lauded Joe's "warm interpretation of the game." The lowly 1964 Mets had outdrawn the Yankees. The new regime started March 21, 1965, from Ft. Lauderdale, on WPIX, Kay Gardella noting, "Garagiola will call the plays" aided by Red Barber, Phil Rizzuto, and Jerry Coleman. Houk expected to match the Mets booth, not for his on-field club to resemble theirs.

The 1965 Yankees fell below .500 for the first time since 1925. A year later, they finished last. A rare beam of light illumined May 14, 1967. "Stu Miller's ready! Here's the payoff pitch by Miller to Mantle," Joe said. "Swung on! There she goes! There she goes! … Mickey Mantle has hit the 500th home run [of his career], and the score at the end of seven complete innings: New York 6, Baltimore 4." At thirty-five, a fading Mick was still the best player on the club.

"With that kind of team," Joe said later, "it was easy to [focus] outside the ballpark." From late 1967 to 1973, he devoted his wit and geniality to NBC's *Today* and guest-hosting *The Tonight Show Starring Johnny Carson*. On NBC or syndication, he hosted shows including *Joe Garagiola's Memory Game* and *Sale of the Century*, 1970s *To Tell the Truth*, and 1980s *Strike It Rich*. It was easy to think incorrectly that Joe had left baseball radio/TV behind.

As teenagers in 1940, Joe and Yogi had played in a Works Progress Administration summer league and served as bat boys or errand boys at their Cardinals tryout camp, "Mostly just hanging around hustling cracked bats." Garagiola died six months after his childhood pal in March 2016, their lives evincing "only in America."

Jack Buck was born August 21, 1924, in Holyoke, Massachusetts, seventy-eight miles from Boston, his father a railroad accountant. He was the third of seven children, but that is only partly correct. Even more than Scully, crawling under the Emerson to hear Bill Stern air football, he was a child of radio.

The Red Sox die-hard daily gravitated to Boston's Fred Hoey, etching the (not yet Green) Monster. To his death, Buck could recite Fred's "He throws to first and gets his man!"—also his standard childhood menu of cereal, soup, and bakery leftovers. The wireless and poverty were the lynchpins of his youth.

In 1939, the Bucks moved to Cleveland, Dad working on the Erie Railroad. Even as a teen, Jack took on a forest of odd jobs. Upon Dad's death at forty-nine in 1940, his son became the clan's bread-winner—even boarding a Great Lakes iron ore boat as porter, painter, cook, deckhand, and crane operator—"anything," he told me, "to pay the bills."

Baseball on radio got what time Buck had left. By day he heard Jack Graney locally and Graham McNamee and Tom Manning "on network." In October, Allen, Barber, and Bob Elson "did the Series. I'd try to never miss a pitch." At night, the Ohio émigré even inhaled games in Spanish from Havana. "And all by radio, inexpensive," he recalled, "the one medium the Depression hadn't crushed."

On July 17, 1941, baseball's then-largest night crowd, 67,468, jammed Cleveland Stadium, Buck seeing third baseman "Ken

Keltner rob DiMaggio twice" to end Joe's hit streak. Two years
later, he became a corporal and instructor with the 9th Infantry
Division. On March 15, 1945, war almost over, Jack took shrapnel
in his shoulder during a fray with Germans, later earning the
Purple Heart.

Ironically, Jack later learned that future peer Lindsey Nelson
was wounded in the same shoulder and on the same day—the only
difference that Lindsey wasn't "dodging bullets carrying a hand
grenade on his chest." Buck spent V-E Day in Paris: material he
later used at countless roasts. "I've always had a fondness for Italian
women. In fact, during World War II, an Italian woman hid me in
her basement for three months. Of course, this was in Cleveland."

Back home, Jack, twenty-two, entered Ohio State University to
major in radio speech, auditing Woody Hayes's class on football.
The three-year graduate called OSU's Buckeyes and Cardinals
Triple-A Columbus on WCOL. The station was then sold. Jack
tried TV but missed baseball. Happily for Buck, St. Louis had
another Triple-A team: the Rochester Red Wings, whose regular
Voice "told a dirty story at a dinner," which ended in Jack replacing
him in 1953. Like millions of GIs, he was making up for lost time.

That August, Buck trekked to the Polo Grounds to audition
for Gus Mancuso's Cardinals job. When Chick Hearn, later of
pro basketball, spurned it, Jack, hired, was given a Harry Caray
tape and told by officials, "Copy him." Buck: "I could no more do
that than with any other guy." Jack was animated but controlled,
getting letters from states whose license plates filled weekend lots:
Iowa, Alabama, Texas. Atlanta one day styled itself "America's
Team." To Buck, such appropriation was unjust, the title rightfully
the Cards'.

A year after the 'Jints and Dodgers' move, Budweiser telecast
forty-four of their sets from Pittsburgh and St. Louis on WNT
New York. Garagiola, a St. Louis mouthpiece since 1955, gave
Anheuser-Busch three in its booth: thus, the freedom to let Buck

peel off and broadcast to the Apple. "I'd do the games, then rejoin
the Cardinals, the reaction so good the Yankees vowed to telecast
their games into St. Louis if we didn't end the broadcast." They did
due to legal threats. For Buck, "It was great, [giving] me entrée to
the market."

Jack would have rejoined the 1960 Cardinals, except that Bud
Blattner had left *Game of the Week* in late 1959 after his blowup
with Dean. Bud returned to St. Louis, doing TV while Caray and
Joe G. handled radio. "I just got squeezed out," said Jack. "I guess
KMOX and the Cardinals weren't as impressed as some others by
the job I'd done for Bud[weiser] that year."

In 1960, eleven times as many households owned at least one TV
set as a decade earlier—nine in ten. For the only time, each network
did baseball—Saturday and Sunday, NBC's Nelson; each day,
CBS's Dean; on Saturday, ABC's Buck, voicing its first series since
1954's *Game of the Week*. ABC's twenty-five-game schedule began at
four o'clock Eastern Time, voided conflict with earlier-afternoon
CBS and NBC, and originated in Kansas City, Philadelphia,
San Francisco, and Washington. "The other two networks never
broadcast from [the Giants'] Candlestick Park or KC and almost
never from Washington, so we had easy pickings getting rights,"
said Jack.

That year marked Candlestick's debut, "so we thought folks
would be interested in what it was," he said—cold and gusty. A
crowded booth let Buck invade New York: apt since his *Game* on-
air partner was beloved in its most populous borough. Brooklyn's
Carl Erskine, a.k.a. "Oisk," was 20-6 in 1953, had a 122-78 career,
and had retired a year earlier. "Carl became a lifelong friend,"
Buck said, "but the series ran into trouble. Dean and Lindsey were
established and didn't need big cities to be a hit. We did. And

because we couldn't go there"—baseball's big-league blackout—"it couldn't work."

As observed, ABC also abided fewer outlets than CBS or NBC, next year debuting *Wide World of Sports* in *Game*'s time slot. Critically touted, *Game* let Jack survive the Redbirds musical chairs, KMOX, and his airing the then-derided American Football League. A 1962 AFL title game photo shows Buck reporting overtime's coin toss. Next year, Jack began NFL coverage of the Bears, Cowboys, Super Bowl IV—and December 1967 Ice Bowl, the temperature seventeen degrees below zero. "Excuse me," said Jack, "while I have a bite of my coffee."

He worked the St. Louis Hawks and Blues and ABC bowling, introduced the Gateway Arch, and emceed dinners, at which Buck excelled. The 1954–1962 Cards six times flunked the first division, his catchphrase, "That's a winner!" heard too seldom. By contrast, since baseball's daily, Jack said, "A good team builds momentum— the best thing in the best sport, unifying a city."

A quarter-century later, the age made Buck wistful: "To broadcast baseball on radio, then TV, is the only thing I've wanted to do." Personality was crucial—"so too putting knowledge above one-liners." Recalling the 1960's fine network Voices, who included, not immodestly, himself, Jack compared them with some broadcasters who felt "hum-drum" toward baseball. Count him, Buck said, "among those wanting Voices with a sense of themselves"—and affinity for the game.

Chapter 8

1960S–1970S: SHINING TEAMS AMID THE NIGHT

In mid-twentieth-century America, Mel Allen and Red Barber were often thought to be baseball's finest voices by network radio/ TV and mass-circulation print, most located in the East. Many in the interior favored others, including Harry Caray and Jack Buck. Individually, they differed. From 1954 to 1969, they formed the Cardinals' truly larger-than-life team.

This chapter describes a number of 1960s and 1970s twosomes and trios of whom, as Aristotle said, "The whole is greater than the [here, considerable] sum of the parts." It also chronicles the twinning of Voice and franchise where visitors became family and others discover, as Dorothy said, "There's no place like home"— each making the other better.

Caray was born in 1914 of an Italian father and Romanian mother, later orphaned and raised by an aunt. It may surprise a reader that he was a bookworm growing up. Raised in a poor part of St. Louis, Harry sold papers by day and devoured books from the library by night. Poverty and bad vision scuttled college and the air force, respectively. Instead, in 1942 Caray eyed a puzzlement.

Harry often trooped to Sportsman's Park. Electric in person, the Cardinals on radio put him to sleep. Was he lucky, seeing only great games—or were Voices that inept at conveying baseball's

lure? It must be the announcing, he felt. Auditioning at giant
KMOX, Harry was told to read a script: "Puccini? Who's he?"
He flopped but intrigued GM Merle Jones, who steered him to
weaker stations. In 1945, Redbirds play-by-play opened. This time,
a Griesedieck Bros. Brewing sponsor lauded another candidate: "I
can listen to him and read the paper at the same time."

Caray leaped from his chair: "You're spending hundreds of
thousands of dollars to sponsor baseball," for what? "You need
someone who's going to keep the fan interested in the game.
Because if they're paying attention to the game, they'll pay
attention to the commercial!" The sponsor phoned the ad director:
"Get over here. I want you to meet our new play-by-play man."
Caray's sidekick was ex-catcher Gabby Street: "The closest thing to
a father I knew, outspoken, great humor," said Harry. Gabby died
in 1951. Two years later, August A. Busch Jr. bought the team to
keep it in St. Louis.

In 1955, the Cardinals signed KMOX, millions learning
baseball over their Anheuser-Busch network from Pocahontas,
Arkansas, to Galesburg, Illinois, including a young Bill Clinton
in Little Rock. Today, a 111-outlet Redbirds hookup still ties
Vincennes, Indiana, and Ripley, Tennessee: Harry's greatest legacy.
Asked which Voice has most loved the game, many would bellow,
"*Holy cow!*—it's him!"

Harry's signature stemmed from a Browns game at Sportsman's
Park in 1942. The Yankees' Phil Rizzuto caught a ball, threw wildly
to second base, and screamed at Gerry Priddy, "Holy cow! You
should have held it!" Seated nearby, Caray heard the idiom and
later used it on the air. Much later, as a Voice, Rizzuto adopted
"Holy cow!" Harry then asked Allen to tell Phil to stop. Mel said,
"I'd be glad to pass on a note," and did, but Phil didn't listen.

To Buck, Harry's appeal sprang from "telling it like it is" a quarter-century before the term—also, from being a self-styled "inveterate fan, who happens to be behind the mic." Credibility was his ace. He reported, and if a player did badly, Caray said, "He gets a bad report."

In 1955–1962, three Frick honorees filled the Cardinals' booth. Caray was inducted in 1989; Buck, 1987; and Joe Garagiola, 1991. Except for Howard Cosell, Garagiola, making bald almost hip, was "the most recognizable person you'd call a sports announcer," said Bob Costas. Buck was always ready with a quip. "The Irish are so relaxed," he said. "If you buy a paper, they say, 'Do you want yesterday's paper or today's?' I say, 'Today's.' They say, 'Then come back tomorrow.'"

The person who never got a "bad report" was No. 6; likely no city loving an athlete as St. Louis did Stan Musial. Raised in Indiana, future Frick Voice Dave Niehaus spent summer nights on the front porch with his dad. "Suddenly from the Zenith radio in the living room comes Caray's voice," he said. "'It might be! It could be! It is! Holy cow!' …Magic is happening in St. Louis!"— Musial homering "a zillion miles away!"

Stan's nickname was penned by partisans at Ebbets Field, wailing, "Here comes that *man* again!" Harry's favorite call was Musial's 1958 "Line drive—There it is!—into left field! Hit number three thousand! A run has scored. MOO-zell around first, on his way to second with a double. Holy cow!" In April 1964, he made a prophecy: "[Pitcher] Roger Craig has hit the left-center field wall! The Cardinals are going to win the pennant!" They did on the final day. "A high pop foul! [Tim] McCarver's there! The Cardinals won the pennant! …Everybody out! Hey! …Mayhem on the field!"

Their 1964 and 1967 World Series titles were the club's first since 1946. Airing the 1968 Classic on NBC TV, Harry never doubted that he would die behind the mic. "With my last gasp, I'd

say, 'Cardinals win!'" St. Louis lost the Series, blowing a three-to-one game lead. A month later, Caray almost lost his life in an auto accident. On Opening Day 1969, he walked on the field, shucking a pair of canes for effect. Given his twenty-five years, "I expected a gold watch." Instead, after the season, "I got a pink slip" due to a supposed affair with the wife of August Busch III. After a year in Oakland, Caray moved in 1971 to the White Sox Comiskey Park.

At Comiskey, Caray sang the only tune he knew as organist Nancy Faust played "Take Me Out to the Ballgame" in the seventh-inning stretch. In 1976, new Sox owner Bill Veeck noticed him, next game hiding a PA mic to raise Harry above the crowd. "[Listening,] I knew any fan knew he could sing better and would join in. A good voice would have intimidated them!" Overnight, Caray became the Maestro of the stretch—"All right, lemme hear ya"—tying one baseball rite to another.

Several years later, the Sox transitioned from free to pay-TV in fewer than fifty thousand homes; Harry worried about "be[coming] Harry Who." In 1981, the Tribune Co. announced that he would voice its new subsidiary, SuperStation WGN TV, soon fusing Caray and the Cubs in more than twenty million homes. The cable audience topped even his Cardinals peak, beamed by satellite from Alaska to Key West. On the road, banners read, "Hey Harry" or "Holy cow!" The tumult was especially notable when the Cards met the Cubs.

On June 23, 1984, St. Louis led *Game of the Week*, 9-8: ninth inning, Chicago's Ryne Sandberg batting at Wrigley Field. "There it goes!" said Harry on radio, local TV banned. "Way back! It might be! It could be! It is! Holy cow! The game is tied!" Next inning, the Redbirds led again, 11-9, as Ryne swung: "Way back! Might be outta here! It is! He did it! He did it again! The game is tied! The game is tied! Holy cow! Everybody is going bananas!" An

inning later, the game ended. "Cubs win! [12-11] Cubs win! Cubs win! Holy cow! Cubs win! I never saw a game like this in my life! And I've been around a long life!"

September 24, 1984: "One more, and it's over. The Chicago Cubs will be the new Eastern Division champs!" Harry crowed. "Hey, it's in there! Cubs are the champions! Cubs are the champions! The Cubs win! …Now our lives are [almost] complete!" The Cubs lost the National League Championship Series (NLCS), missing the World Series. Another loss was 1987's major stroke, slowing Caray's speech, celebs from Bill Murray to Bill Moyers subbing. Returning, Harry at, say, 50 percent seemed more compelling than some at ninety.

Each year, Caray as a "regional Voice" became "[more of] a national cult hero," said Steve Stone, former Cubs and White Sox pitcher turned Harry's 1983–1997 color man. In the 1980s, Anheuser-Busch ran "Cub Fan–Bud Man" ads featuring Harry, clad in black, replete with hat, tie askew, his dancing somewhere between the Rockettes and Arthur Murray. On NBC's *Saturday Night Live*, Will Ferrell's parody of Caray became a regular thing.

"Harry was not always a bed of roses but [was] riveting and usually fun," said Stone, also airing the Cubs in 1998–2000 and 2003–2004. "He taught, 'You have to know when the game can speak for itself, say 3 to 2, and when you have to speak *for* the game'"—a rout and/or action lagging. Harry's advice to ESPN's Rick Sutcliffe should be printed on every announcer's scorecard, "When the game is at its worst, you have to be at your very best."

Caray also famously said, "You can't beat *fun*"—he used the word deliberately—"at the old ballpark." In 1991, his son, Braves announcer Skip, and grandson, Mariners Voice Chip, joined him to become the first three-generation *famille* to do a game. Then, in 1996, the Brewers' Pat Hughes arrived to head Cubs radio,

grasping Harry's core. Harry, at eighty, said Pat, was "still a ten-year-old and a senior citizen."

Late in his career, Caray took to drinking hot tea and eating lemons to renew his throat. Once, he had a tea bag in the cup, voices saying, "Harry, put the tea down! Put your headset on! We're going on the air!" Caray said, "OK, right there!" Then: "Harry, come on!" In Caray's haste, the headset cord and tea bag string tangled. Harry opened WGN's telecast with a tea bag hanging from his left ear: "Hello everybody!" Pat said, "You had to see it to believe it!"

Harder to believe was February 1998. On Valentine's Day, the heart of the Cubs fell while dancing, suffered a heart attack, then coma, and died February 18.

"It might be!"—a funeral that stilled Chicago. WGN TV beamed the service and cortege. Passersby saluted. Flowers deluged the park.

"It could be!"—Harry's statue outside Wrigley had a beer can in its hand.

"It is/was!"—When the Cubs won the 2016 World Series, Anheuser-Busch ran a commercial reprising the classic "Cub Fan–Bud Man." It had aged even better than the Cubs. The dictionary defines *fan*, as derived from the Greek word fanatic, showing "extreme zeal, piety, etc."—almost a religion. Harry loved the game as Joe Fan did. For most, that was far more than enough.

Harry Caray

In 1965, Jack Buck called his first All-Star Game for NBC TV. Next year, Busch Stadium, opening eight blocks from the St. Louis Arch, hosted the Mid-Summer Classic. With Caray's exit, Buck became the franchise, joined in 1972 by former Cardinals third baseman Mike Shannon in a twosome that lasted till Jack's death.

Like the Redbirds public, used to mid-and-late '60s success, Jack was getting restless. In late 1975, he departed for New York, saying he regretted leaving "the best baseball broadcasting job in the United States, but the opportunity to join NBC [Sports] is immensely attractive." His *Grandstand* series put him in the studio

each weekend, knitting five hours of live programming, mostly football. Uneasy in a studio format, he lost the job in 1976 and returned home, still beloved in St. Louis for his vast charitable and community work.

In 1976, an event renewed Buck's mojo: baseball's greatest wireless series in more than a decade. It stemmed from NBC Radio dropping baseball and CBS airing it, including the 1976–1997 Series, All-Star Game, League Championship Series (LCS)—to Commissioner Bowie Kuhn, "baseball's jewels,"—and a new 1985–1997 *Game of the Week.* Voices included Buck, Vin Scully, Jerry Coleman, Curt Gowdy, Ernie Harwell, and Lindsey Nelson. Meeting with candidates, CBS senior VP Dick Brescia recalled, "We went for guys with baseball credentials," who loved the game and could transmit it—guys like Buck, for whom the late 1970s and the 1980s meant rebirth.

Jack called CBS's first event: the 1976 All-Star Game, adding four NLCS and nine World Series. He did the 1982 Series locally, a season starting with all-world shortstop Ozzie Smith arriving from San Diego and ending with Jack's trademark, "That's a winner! A World Series winner for the St. Louis Cardinals!" His yearly workload boasted 215 games on local and CBS Radio and NFL TV. Said sportswriter Bob Broeg, "That's one whale of a trifecta."

In 1985, he authored a whale of an NLCS. In 2,967 big-league at-bats, Smith had never homered left-handed. In Game Five v. LA, score and series tied at two, he uncorked a ninth-inning drive. "It may go!" said Buck. "Go crazy, folks! Go crazy! It's a home run, and the Cardinals have won the game, 3-2, on a home run by the Wizard!" In Game Six, St. Louis on its last out, Jack Clark jacked a flag-taking belt. "A long one into left field! Adios! Goodbye! It may be that's the [7-5] winner!"

The 1988 Series transcended each moment, LA behind Oakland, 4-3, in Game One's last of the ninth, Jack working with ex-Cardinals All-Star Bill White, the first Black broadcaster to air a

Series. With two out and a runner on base, Kirk Gibson, seemingly unable to even pinch-hit with a leg injury, hobbled from the dugout. The duo conjectured if the Dodgers slugger, barely able to swing, could even reach base.

Then: "Gibson swings—and a fly ball to deep right field! This is gonna be a home run! Unbelievable! A home run for Gibson! And the Dodgers have won the game, 5 to 4! I don't believe what I just *saw!*" We did: Buck let us. "*I don't believe what I just saw!*" he resumed. "Is this really happening, Bill?" The radio, like the heart, throbbed.

"One of the most remarkable finishes to any World Series Game…a one-handed home run by Kirk Gibson!" Jack concluded. "And the Dodgers have won it…five to four, and I'm stunned, Bill," like his Greek chorus of a crowd.

On October 17, 1989, Buck was airing his last Series for CBS Radio with White, Sparky Anderson, and Johnny Bench at Candlestick Park when a 6.89 magnitude Loma Prieta earthquake rocked the Bay Area. The quake sent them sprawling. Jack played it cool: "I must say about Johnny Bench, folks, if he moved that fast when he played, he would have never hit into a double play."

To Buck, the next few years affirmed how baseball and football differ—and the effect on baseball when the difference is ignored. In 1990, CBS TV began four-year exclusivity, Jack given play-by-play, grasping that baseball demands word picture, not every-play dissection. "[CBS] knew that football [broadcasting] stars analysts," Buck said, "so they said, 'Let [analyst Tim] McCarver run the show.'" Worse, the new pact slashed regular-season coverage. Buck rued: "We never got a chance to fit"—unlike, for instance, he and Mike Shannon.

Shannon was signed by his hometown Cardinals in 1958, hit a monstrous homer off the top of the Busch Stadium scoreboard in

the 1964 World Series, and played through 1970. Two years later, he joined Buck on radio. Enduring and, to many, endearing, Mike announced in early 2021 that the season would be his last. Already missed: Mike's KMOX Network home run call: "Here's a long one to left/center/right, get up, baby, get up, get up...oh yeah!"

In 1991, the Braves and Twins met in an arresting Series of their own after both placed last a year before. In Game Six, Kirby Puckett hit an extra-inning blast. "Into deep left-center! ... And we'll see you tomorrow night!" Jack said. Minnesota's Dan Gladden reached third base in the final's scoreless tenth, followed by two intentional walks. "[Barry] Larkin is the pinch-hitter... The Twins are going to win the World Series! The Twins have won it!"

Shortly sacked for alleged "poor chemistry" with McCarver, Buck again returned home, braving diabetes, a pacemaker, vertigo, and Parkinson's disease. In 1998, the Cardinals dedicated a bust of him, hand cupping an ear, behind the microphone. Mark McGwire ripped homer No. 60—"Wake up, Babe Ruth! There's company coming"—then targeted Roger Maris. "McGwire's No. 61, Flight 61, headed for Planet Maris! History! Bedlam! What a moment! Pardon me for a moment while I stand to applaud."

On September 17, 2001, six days after the terrorist attack on America, Buck, frail, courageous, read a poem of his at Busch Stadium: "Everyone is saying the same thing and praying / that we end these senseless moments we are living / As our fathers did before, we will win this unwanted war / and our children will enjoy the future we are giving."

Jack endured several surgeries in the months before his June 18, 2002, death. "Buck Dead at 77," blared the page-one *Post-Dispatch*. The team lit his statue. Thousands viewed the casket, lined a freeway for his cortege, and wept. Jack left wife Carole, eight children, and sixteen grandchildren—and a definition of grace.

Some radio/TV Voices are too hip or square for their region's "place, environment, relations," to quote Thornton Wilder. By contrast, the two Voices who defined the Red Sox in their most crucial year of the last century grasped what the Olde Towne Team means. "People mention upsets," Ken Coleman said of 1967's 100-to-1 Red Sox. "They're nothing compared to that." Out of nowhere, The Impossible Dream revived baseball in New England—to many, even after its first world title in eighty-six years, the franchise's finest year.

Coleman was born fifteen minutes from Fenway Park. Ned Martin moved to the Fens in 1961. One night Ned called Ted Williams "Big Guy." The next night invoked *Hamlet*: "Good night, sweet prince, and flights of angels sing thee to thy rest." Wrote Martin: "Over the years, you remember the ups and downs, but above all the excitement of this boundless, confounded team. Remember them and weep, or laugh, or sing. And wrap yourself in this Red Sox thing."

At twelve, Coleman lost an eye to a bb gun. The accident replaced one of his heroes, slugger Jimmie Foxx, with another, mic man Fred Hoey. After high school, he joined the army, served in Burma, and aired Indian rugby, cricket, and soccer on Armed Forces Radio. Back home, he studied oratory, then called Boston University, Ohio State, and Harvard football. In 1952, Ken began voicing the Cleveland Browns 125-outlet network, adding Indians TV in 1954.

Coleman called every 1957–1965 play of running back Jim Brown, who retired in 1966 just as Ken began to revisit the points of his past. First, Red Sox Voice Curt Gowdy left for NBC. To replace him, Sox execs bypassed Martin, the natural heir: first, contacting the Mets' Bob Murphy, who declined; then Coleman, ecstatic on getting Hoey's job. Ken was formal, old-school, and loyal, deserving better than the then sad-sack Sox. "The [team]

atmosphere was awful," said Ned. Some expected friction,
Coleman's hiring "a deep disappointment" to Martin. Improbably,
friendship bloomed.

At nine, Martin saw his first game at Shibe Park. One night, Dad
brought home cocktail coasters autographed by Johnny Marcum
and Jimmie Foxx. "Foxx!" Ned gawked, "He was like God to
me!"—the Athletics his team. Martin entered Duke University in
1941, soon segueing to the Fourth Marine Division. For a long time,
he shunned memory of the Battle of Iwo Jima in 1945, where young
men grew up fast.

A critic wrote, "He never bragged [or] needed praise, and
hated shtick and self-promotion." "I'm not one of the guys that
you see raising the flag," Martin said of the famous monument of
that day. He recalled when word spread that Old Glory was flying
on Mount Suribachi—"Our flag! What a feeling!" Ned returned to
major in English literature, worked on the Pennsylvania Turnpike,
and tried advertising and publishing before conjuring college radio.

By 1956, Martin reached Triple-A Charleston. "I kept sending
tapes to big-league teams, but nothing happened" until Curt
Gowdy, hearing a tape, invited him to audition unofficially on a
1960 Red Sox game in Baltimore. Next January, he visited the
Fens, grasping why "people came to see what it's like. 'You mean
it's [the left-field Wall then 315 feet from the plate] that close?'
Damn right." Here, no lead was safe, or deficit hopeless. "A little
hit, an error, opens a door. A walk, triple maybe down the line,
poof," smooth sailing gone.

Beside 1967, Martin most evoked 1961, starting with the first of
Carl Yastrzemski's 3,419 hits. It ended with Roger Maris needing
a last-day homer to top Babe Ruth's sixty. In pre-game, Ned asked
the Sox starting pitcher, "How do you feel about number 61?"
Tracy Stallard said, "I'll throw him the fastball. More power to him

if he hits it." In the fourth, he did. The average baseball fan has heard Phil Rizzuto's call of Maris' homer. Martin's depiction was not even taped.

Ned looked on, conflicted: "a kid when Ruth played," but aware of Roger's niche. "What a climax for an amazing year," he said. As Al Jolson said, "You ain't seen nothin' yet."

After The Kid's 1960 goodbye, a writer wailed, "What are we going to write about now?" By 1966, owner Tom Yawkey had ceased trying to buy a pennant. Instead, his farm system buoyed a region where, as the *Globe*'s Mike Barnicle wrote, "Baseball is not a matter of life and death, but the Sox are." The 1967 home opener drew only 8,324. Then, on April 14, rookie Billy Rohr began his career in the Bronx, no-hitting the Yankees through one man out in the ninth.

"On the threshold," Ken said on WHDH TV. "Eight hits in the game, all of them belong to Boston... Fly ball to left field! Yastrzemski is going hard, way back, way back! And he dives— and makes a tremendous catch! Everybody in Yankee Stadium on their feet roaring as Yastrzemski went back and came down with that ball!" One batter later, Elston Howard singled, Tony C. (Conigliaro) catching "it on the first hop. No chance."

Slowly, hesitantly, as Ken voiced on the WHDH program "The Impossible Dream," the "fans began to sense it. This year was not quite the same." One day, "Base hit to right, here comes Tony! Here comes George [Scott]! And the Red Sox have won it, 11 to 10." Another day, after Reggie Smith hit a scoreless tenth-inning triple, a listener refused to enter the Sumner Tunnel until he heard the outcome. Hundreds of drivers backed up, listening, too.

In mid-July, Boston won four straight at Fenway, took the next six on the road, and returned to Logan Airport to find "ten thousand people waiting for you," the pilot said. "They seem

happy with what you've done." In late August, two and a half games divided five teams, at which point a gentle game turned hard. The Angels' Jack Hamilton's pitch caused Conigliaro's batting helmet to fly off, a grotesque wound around his left eye.

A day after the beaning, the Sox won, 12-11. Next day, Boston, down by eight runs in the second game of a double-header, theatrically tied the score. Infielder Jerry Adair then hit a "ball deep into left-center field, and it is…a *home run!*" Ken cried. "Jerry Adair has hit his second home run of the season…and the Red Sox, who trailed, 8 to 0, are now leading in the eighth inning, 9 to 8!"

Four miles away, Adair's poke sired "one crescendo after another" from one hundred thousand at Revere Beach, most listening to Sox radio. "To his [2003] death," shortstop Rico Petrocelli said, Ken thought "that reaction symbolized the year." Hope fell back on Yastrzemski, whose .326 average, forty-four homers, and 121 RBI took a Triple Crown. By Thursday, September 28, the Twins led by a game with two left at Fenway, Boston needing to sweep to win or force a playoff.

On Saturday, score two-all in the last of the sixth, "Scott hits one deep into center field!" said Coleman. "This one is back! This one is gone!": 3-2, Sox. Next inning Martin, on radio, more fully etched Yaz's last regular-season blast: "Hit deep toward right field! This may be gone! It's outta here!" Pause. "If you've just turned your radio on, *it's happened again.* Yastrzemski's hit a three-run homer, and it's now 6-2, Red Sox"—final, 6-4.

A day later, Detroit, needing to sweep a twin-bill for a playoff, won its opener. In Boston, Minnesota up, 2-0, Sox starting pitcher Jim Lonborg bunted safely to trigger a five-spot. "Boston is out in the sixth inning," Ken eventually said, "but what a sixth inning it was!" With two out in the ninth, the Twins' Rich Rollins batted.

"The pitch is looped toward shortstop. Petrocelli's back; he's got it! The Red Sox win [5-3]! And there's pandemonium on the field!" Ned said. "Listen!"

As Rico clutched the ball, hundreds on the field became a wave, rocking, Lonborg hoisted by the crowd. A radio lit the Sox clubhouse: no ESPN, cellphones, or internet, simply listening to Ernie Harwell on the wireless from Detroit. In the ninth inning, Dick McAuliffe, not hitting into a double play all year, promptly banged into a 4-6-3. The next-day Boston *Record American* cover blared: "*Champs!*"

In 1972, Ken moved to Red Sox TV, then to Cincinnati three years later, the Reds making the World Series—ironically, against the Sox. In 1979, he returned for a last decade on Boston radio. Martin died in 2002, at seventy-eight, a year before Coleman at the same age. In 2003, the Boston *Herald*'s Kevin Convey recalled 1967: "There will be other summers. And I will listen to other announcers. But I will never stop hearing Ken."

As observed, in 1961 the Washington Senators moved to Minneapolis-St. Paul to become the Twins. The sound of their Voice fused John Huston's and Morgan Freeman's, magisterial and deep. It is true that from 1956 to 1974, Ray Scott defined pro football." Yet when son Preston was later asked Dad's preference, he said quickly, "My father said baseball, no contest, was his favorite." The choice said much about it, and him.

For a long time after Ray's 1919 birth in Johnstown, Pennsylvania, baseball so dominated that even Pittsburgh's now-Steelers were named the Pirates. By 1947, Scott aired each Steelers exhibition, pro football still so small-timey that he was lucky to have a seat and spotter. Then, in 1953, Ray went uptown on Saturday night's *The NFL on DuMont* Network. Former Yale coach Hermann Hickman did color.

In 1955, DuMont died, and Scott joined ABC. On January
1, 1956, the famed Bill Stern arrived at game time for the Sugar
Bowl incoherent, due to painkillers, said backup Ray: "No way
he could go on." Scott did, adeptly and spontaneously, making
his reputation. That September, he joined CBS for its first year
of national pro football coverage: same time and channel, each
Sunday, live.

At the time, every NFL club was assigned a Voice: Ken
Coleman, Browns; Chris Schenkel, Giants; Chuck Thompson,
Colts. CBS *apologized* to Scott for "sticking me with the small-
market Packers." Then, in 1959, Vince Lombardi was named
coach; Green Bay becoming football's Mayberry, a.k.a. Titletown.
By the time Ray added his favorite sport, his cachet was almost as
large as that of his city.

As the Senators became the Twins, Scott was asked to join
Washington holdover Bob Wolff and local writer Halsey Hall
on WCCO Radio and WTCN TV. Ray remembered airing
only one late-1950s game on NBC's *Major League Baseball* from
Pittsburgh, where he lived. Yet, "I loved baseball," he said later.
"I probably attended more Pirates games than any other non-
broadcasters here."

Buying radio/TV rights, the Hamm Brewing Co. convinced
Scott to move his wife and five children to Edina, a Minneapolis
suburb, Ray musing that he "wouldn't have moved my family
if I wasn't sold on baseball for the future." Having struck NFL
gold, Preston said, "The irony is that he was ready to give it all up
for baseball."

The Twins opened April 11, 1961, in the Bronx, beating the
Yanks, 6-0. Ten days later, 24,606 watched their home opener
at a 30,637-seat triple-deck cantilever, past and present meeting:
Metropolitan Stadium, a.k.a. the Met, had a small-town baseball

feel. "His football style was simple: 'Starr. Dowler. Touchdown. Green Bay,'" said Wolff. "It took a while to grasp that baseball, especially radio, needs more."

As Scott adapted, the region "cut him slack," said publicist Tom Mee. His celebrity made people patient. The 1955–1960 Senators lured 2.7 million stragglers. The '61ers wooed almost 1.3 million. When Wolff left for NBC in 1962, owner Calvin Griffith felt no need to shop for a successor. Segue to July 11, 1965: until their 1987 world title, the high noon of Twins emotion. After fourteen pennants in the last sixteen years, the Yankees trailed by thirteen and a half games, Minnesota in first place.

New York played the Twins the day before the All-Star break. "This game completed a four-game series, huge crowds," Scott said, but the Yankees led the final, 5-4. Harmon Killebrew faced Pete Mikkelsen in the ninth, two out and one on. "Oh my, and imagine the season's only half over. One after another of games that go right down to the wire," Ray said on air. Then, suddenly: "A line drive to left! Way back! It's a home run! The Twins win!" As it happened, the dynasty was dead, Killer's blast its punctuation.

September 26 united new team and old town. "The Twins have won 98 games," Ray said in the capital. "Number 99 means the pennant. Here's the windup—and the pitch! Strike three! He struck him out! The Twins win! …Final score: the Twins 2, the Senators 1. The Twins have won the American League pennant!" Zoilo Versalles was named MVP. Mudcat Grant finished 21-7. "In the Upper Midwest," said Scott, "it was the season of light."

He and the Dodgers' Vin Scully called the first Series of transplanted clubs, trading streaks. Minnesota won the first two sets, LA taking the next three at home. Game Seven swung on ex-Flatbusher Jim Gilliam's third-inning two-on heist of a line drive down the third-base line. "If he doesn't rob [Versalles], we score twice, Zoilo has a triple," said Ray, "and Sandy [Koufax] leaves."

Instead, Koufax won, 2-0. Ray himself left the Twins after 1966 for CBS football and golf, not having time for the baseball and network overload. Eventually, he aired the 1970s Senators, Twins, and Milwaukee Brewers "because it keeps me in the game." Sadly, Scott was fired by CBS for "[speaking] out against the growing tendency to focus on the announcer, not event," he said. In time, Ray, banished by the networks, called baseball, golf, and college football on cable TV. Scott died in 1998, his own man in an age of company men, still a surpassing Voice.

Unlike Scott's, the Twins' Herb Carneal's voice didn't command a room. Instead, it mimed a region: dependable and credible. In 1962, he joined baseball's then-northernmost franchise. Carneal's legacy is as much felt as seen—loyalty he fueled over three fifty-thousand-watt stations: WHO Des Moines, WOW Omaha, and flagship WCCO Minneapolis, "The Good Neighbor to the Northwest."

Such flagships in size and number helped bolster a 110-outlet eight-state network—then largest in the league. "Not to mention," Herb would attest, fifteen more each weekend in the Rocky Mountain region. On TV, WTCN also keyed a far-flung seven-state fifteen-affiliate hookup, airing fifty games: Carneal berthed that, too, as anchored in 10,000 Lakes.

In the Twins weekend parking lot, you saw license plates from Nevada to Missouri and north into Canada. In 1993, the Colorado Rockies were born, dimming the team's regional panache. Minnesota may never match its 1960s status as a baseball vortex—but then, few other teams have or are likely to. Especially at night, voice heightened by the atmosphere, Carneal became mic man as metaphor, saying "Hi, everybody" at the start of each game.

Born in Richmond in 1923, Herb followed the nearby Senators. Future stops included WMBG Richmond, Triple-A Syracuse, and

Springfield, Massachusetts. In 1954, he aired Philadelphia's final two-team year. In 1957, Carneal left for Baltimore, where Ernie Harwell "[took] me under his wing," instructing him to paint a picture and shun caricature. Among other things, he etched Hoyt Wilhelm's 1958 no-hitter and 1960 "Baby Birds" near-flag. When Hamm Brewery lost O's rights in late 1961, Herb lost his job just as Bob Wolff left his for *Major League Baseball.*

"Time is the great physician," said Benjamin Disraeli. With Carneal, exquisite timing also helped, replacing Wolff in 1962 as Scott became boss. "We worked six years and never had a disagreement," said Ray. "No pretension, down to earth. Herb knew the game, no screaming—a must for the area." It helped that Carneal had a 1960s team whose talent almost said it all.

Two days after Scott called Killebrew's 1965 Yankees-killer, Minnesota hosted the All-Star Game. Herb manned NBC Radio. "There's a high drive to left field! It is really hit! …It's…5 to 5 on a tremendous home run way back into the left-field stands by Harmon Killebrew!" The Twins then began a voyage of "wait till next year": losing a seven-set Series, a last-day pennant, and two LCS through 1970. "The outcome left something to be desired," said Carneal, "but great names all the way."

Rod Carew won seven batting titles. Killebrew led the AL in home runs in 1959, 1962–1964, 1967, and 1969. César Tovar played each position in one game in 1968. Carneal eschewed each's limelight. In 1967, similarly modest Voice Merle Harmon joined the booth. Having called the Jets and Steelers, Merle felt football's key "preparing weekly like a prayer." Baseball required a greater art of "finding something interesting as you say the pitcher throws the ball."

In 1967, as noted, the Twins were among five teams cloistered for the last two months in a spectacular AL race. Merle aired

Minnesota through 1969, working with Herb and a man who
loved his name in lights. Former *Minneapolis Tribune* columnist
Halsey Hall munched cigars, ate green onions, and claimed to have
bayed "Holy cow!" before Caray. Former *Tribune* sports editor Sid
Hartman said, "He loved baseball, he loved radio, and he loved the
fact he was able to drink for free on the road."

In 1982, the Twins entered the Hubert H. Humphrey
Metrodome—plagued by gray-green AstroTurf obscuring balls
and sound levels that required player earplugs during their
victorious 1987 Series. Minnesota won another Classic in 1991.
Five years later, the Hall of Fame gave Herb the Frick Award. At
eighty, he signed a new contract, his wife Kathy having died in
2000. "The booth gives me something to do."

In 2004, the Pavek Museum of Broadcasting's Hall of Fame
inducted the NSMA's record twenty-time Minnesota Sportscaster
of the Year. Herb died of congestive heart failure on April 1, 2007,
at eighty-three. The Twins dedicated the season to him by wearing
sleeve patches to honor the heartland's *real* good neighbor.

"After the Dodgers and Giants left in late '57, you could see soccer,
hoops, midget auto racing, and boxing," said the New York *Daily
News'* Dick Young of the Polo Grounds. "Just no baseball." To fill
the void, lawyer William A. Shea chaired a citizens committee. A
1959 threat of a proposed third eight-club big league—the Branch
Rickey-led Continental, with player raids and anti-trust suits—
made the National League expand to ten teams, the Houston Colt
.45s joining the New York Metropolitans in 1962.

The Mets would be run by ex-Yankees headliners Casey
Stengel and George Weiss as manager and GM, respectively. A
new home, Shea Stadium in Queens, was expected to open in
several years. Until then, the Polo Grounds was gussied up by
$250,000 in city cash. In the 1961 expansion draft, New York

chose old Dodgers like Roger Craig and Gil Hodges "who excelled on paper," said Lindsey Nelson, "but paper doesn't play." Largely unresolved was who would talk above the field.

When last we left Nelson, he was leaving a 1957–1961 stint as Voice of NBC's *Major League Baseball* to head Mets radio/TV, bringing play-by-play panache. Weiss felt the second broadcaster should be a "steady professional." The third Voice was to be an ex-player—preferably a recent NL star.

To find a "steady pro," Weiss consulted, among others, Curt Gowdy. He recommended an ex-Marine master technical sergeant who had returned from war to study petroleum engineering. Bob Murphy then switched to radio, airing basketball, Sooner football—and minor-league baseball at Muskogee and Oklahoma City.

In 1949, Bob had replaced Gowdy when Curt left Oklahoma City for the bigs. In 1954, Murphy too left there to join Curt at Fenway Park. Seeing himself in the Okie greenhorn, Gowdy drove Murphy hard. "We got work to do," he said, "Let's announce like we're friends, just talking to each other." Bob added, "With Curt's support, I did a lot to clean up."

In 1960, Murphy became lead Voice of the Orioles. "I know you love it here in Boston," Curt said, "but you can't *not* go." In September 1961, the Birds' Jack Fisher faced Roger Maris in the at-bat that helped make Bob a Met. "It's number 60!" Murphy cried on WBAL Radio. "He's tied the Babe!" for Ruth's single-season home run mark. Next month, the O's dumped their beer sponsor. Feeling "lost in the shuffle," Bob sent the Maris tape to Weiss.

"George liked Bob's distinctive voice that filled the air," said Nelson, "in addition to the good things he'd heard from Curt." By now, the Mets broadcast trilogy lacked only an ex-player. They found someone distinctive in the extreme.

When Ralph Kiner was four, his father died. Mother and child
left New Mexico for California, where he played softball and
developed an upper-cut swing. Kiner took it to the Pirates, signing
on graduating from high school in 1941. Next came Eastern League
Albany, briefly International League Toronto, and most of World
War II as a navy pilot in the Pacific Theater, where he "barely
touched a bat," Ralph said.

In 1946, the Pittsburgh rookie hit as many home runs as his
age: An NL-high and club record twenty-three. In all, the Pirates'
Special K led the league in homers seven straight years. As we have
seen, in 1952 the Bucs finished last despite Kiner's thirty-seven
blasts. Then-Pirates GM Rickey suggested a pay cut. When Ralph
objected, Branch said, "Son, we can finish last without you"—and
did. Kiner retired with 369 homers. In 1961, the Pacific Coast
League Padres GM joined White Sox radio, re-creating the AL by
day if Chicago played at night.

Next March, the Mets convened in St. Petersburg for a
first spring training. Only Casey's humor made the initial year
tolerable, inviting the press to "come see my amazin' Mets, some
of which has never played semi-pro before." Opening Day's first
inning set the tone, Roger Craig's balk helping score a St. Louis
run: Cardinals, 11-4. The home opener was Friday, April 13, as
if the league knew the nightmare that was in store. Uncertainty
towered about who would pay. Many, as it occurred. The Mets
drew 922,530, improbable for such a cellar club.

A chant arose—"Let's go, Mets!"—as they lost nine straight,
seventeen in a row, then sixteen of seventeen. Said Stengel: "If we
can make losing popular, I'm for it." The Mets strove to please,
finishing a wretched 40-120. "I never ask how we lost 120. I ask
how we won 40," said Casey. The season ended with Joe Pignatano
as the only big-leaguer to hit into a triple play in his final at-bat. It
was a feeling with which a Mets fan could empathize.

Perhaps the Mets' greatest shock was shellacking the Yankees' radio/TV ratings: akin, said Murphy, to "Mr. Ed beating Man of War." Fifty-thousand-watt WABC aired each game; WOR Channel 9, 128 sets road and away. Bob had to unlearn Gowdy's tutelage. "Lindsey was straight ahead," not liking chit-chat. He also understood that self-promotion could be self-preservation—the reason for Nelson's signature garish plaid sport coats. Said Lindsey: "It pays to advertise."

The Mets agreed, styling their public "The New Breed." Patrons scribbled messages on sheets. Placards caught the camera's eye. Perhaps the best promotion was the post-home game *Kiner's Korner*'s debut in 1963: soon the *New York Post*'s Phil Mushnick's "best bad show in TV history." *Korner* now seems a period piece, "Then it was revolutionary: anecdotes, interviews with big shots," forging "a cult-like" clientele.

Lindsey aired NBC TV's 1964 All-Star Game at the new Shea Stadium: NL, 7-4. On May 31, New York lost the second set of a twin-bill to the Giants, 8-6, in twenty-three innings: a Mets triple play accenting the bigs' seven-hour and twenty-three-minute longest game until 1984. Each season seemed longer than its predecessor: the Mets last or next-to-last every year through 1968.

Then, on April 8, 1969, the Mets began a most improbable year by losing to another expansion team, the Montreal Expos. Meanwhile, Willie Smith pinch-homered a 7-6 Cubs victory, the two teams entwined all year like vines around a trellis. An eleven-game Mets win streak began in late May. On July 9, Tom Seaver retired the first twenty-five Cubs before Jimmy Qualls' "line drive into left-center field!" said Murphy. "And the roar goes up from the big [50,709] crowd! A roar of disappointment!" Seaver recouped, 4-0. Qualls didn't, getting one hit in 1970 and retiring two years later.

On August 16, the Mets trailed Chicago by nine games.
Ten days later, they had crept up to within three and a half. On
September 8, the Cubs arrived, just two and a half games ahead.
The Mets won a 3-2 series opener. Next night, Seaver romped,
7-1. A day later, Ken Boswell's hit beat the Expos, 3-2. "The
New York Mets, seven years and four months, for the first time
in their history, have gone into first place in the National League
race!" Ralph said. The crowd heaved, "We're number one!" On
September 24, joy jumped over the moon.

That night, the Mets led in the ninth inning, 6-0 at Shea, on the
cusp of clinching the NL East. Murphy sang, "Ground ball hit to
shortstop! [Bud] Harrelson to [Al] Weis! There's one! First base!
Double play! The Mets win! The Mets win! It's all over! Oh, the
roar going up from this crowd! Oh, the scene on the field! Fans are
pouring out on the field!" Manager Gil Hodges was asked later,
"Tell us what this proves." Hodges sat back, spread his hands, and
laughed, "Can't be done."

The 100-to-1 Mets met Atlanta in the first League
Championship Series—a new pathway to the Series, winning twice
in Georgia, then moving to Shea. In Game Three, ninth inning,
Mets 7-4, Tony Gonzalez at bat, Kiner said, "The pitch, a curve,
chopped out to third. [Wayne] Garrett has the ball! The throw to
first! And the Mets are the National League champions!" The AL
titlist Orioles looked on, bemused, unaware that New York's last
laugh lay ahead.

Given its 109-53 regular-season record, Baltimore's demolition
seemed a snap. Nelson and NBC's Gowdy handled TV; Kiner and
NBC's Jim Simpson, radio; and the O's Bill O'Donnell, both. The
Birds won a 4-1 opener. Next day, the Classic swung, 2-1. In Game
Three, Simpson said, "Hit high and deep to center field! [New
York's Tommie] Agee…pulled around to right, goes over with his

speed… He's got it!" Later, Agee encored. "Fly ball to right-center field! Deep in right center! [Art] Shamsky with Agee! Agee dives, and he makes the catch!"—Mets, 5-0.

Next day, Seaver led, 1-0, in a one-out ninth inning. With a man on third, Ron Swoboda's diving catch of Brooks Robinson's liner kept the score tied. In the tenth, an errant Orioles throw hit a runner and bounced away, letting Rod Gaspar score the winning run. Down, three games to one, Baltimore led a day later, 3-0, before Donn Clendenon's two-run blast, Weis's first homer in five years at Shea, and two eighth-inning doubles and errors gave New York a 5-3 lead.

At 3:16 p.m., the Birds' Davey Johnson swung. "There's a fly ball out to left!" said Gowdy. "Waiting is [Cleon] Jones! The Mets are the world champions! Jerry Koosman is being mobbed!" Leaving the booth for the victory celebration, Nelson was struck by "the whole enormity of the thing." He mused, "The Mets may last a thousand years, as Churchill would say. They may win a dozen championships. But they can only do it the first time once, and the first time was incomparable."

Kiner entered the Hall of Fame as a player in 1975. Nelson and Murphy won a Frick in 1988 and 1994, respectively. "The early Mets had trouble turning two. Here we are, three for three!" Bob said at Cooperstown. The '73ers waved another flag, Nelson again telecasting the Series in the year his wife died. In 1979, wanting to be near his daughter in California, he left the Mets to air the Giants. Lindsey later returned to his alma mater to lecture, write a memoir, and do CBS Radio's *Game of the Week.* He spent the last decade of his life fighting Parkinson's disease, dying in 1995—to many, the Mets' forever sound.

Increasingly, Murphy seemed "the voice of all things Mets," wrote Marty Noble. A word he often used—*marvelous!*—defined having a home phone number with the last four digits 6-3-8-7

(Mets) and the radio booth named in his honor at Shea and in
2009, at Citi Field. Retiring in 2003, he received an American
flag that flew over Iwo Jima. At Shea, a giant card was presented,
reading, "Dear Bob, Wishing you all the best in your retirement.
The Mets family." Thousands signed, then mourned his next-
year death.

At that point, only Kiner remained from 1969, famed for
malaprops—"We'll be back after this word from Manufacturers
Hangover," went one. Another: "If Casey Stengel were alive today,
he'd be spinning in his grave." He trails only Vin Scully and Jaime
Jarrín for consecutive years voicing a club: 1952 through 2013, a
year before his death. Mets 1983–1998 Voice Tim McCarver, who
revived Ralph's career on cable TV in the 1980s, observed that
"Mr. Kiner's ways are wondrous." In memory, they remain. The
Mets TV booth is named after him, and a zillion other Kinerisms
endure to this day.

Of the two new teams admitted to the National League in 1962,
the Mets, as seen, flaunted contempt for moderation of any kind.
Meanwhile, the new Colt .45s for a long time showed an inability to
scale a peak—unusual in a state which proclaimed itself can-do.

Houston's 1962–1986 Voice was Gene Elston: more Plains than
Southwest, he moved from Iowa radio via the navy in World War
II to baseball at several small outlets and finally WIND Chicago
in 1954, where lead Voice Bert Wilson died after the 1955 season.
The Cubs kept losing, owner Philip Wrigley saying, "We have a
defeatist attitude." The attitude was well-earned.

The 1955–1957 Cubs bumbled to a second-division dead end.
They then fired Elston, not the team. Gene bounced to Mutual's
Game of the Day, analyst Bob Feller's fastball unable to save the
series. "Texas had the most affiliates on *Game,* and when it died in
1960, that paid off," Gene said, also airing 1961's last season of

the minor-league Houston Buffaloes, a.k.a. the Buffs. Next year he leaped to the Colt .45s, seemingly a Voice at odds with the state's persona.

"America has rolled by like an army of steamrollers," James Earl Jones mused in *Field of Dreams.* "It has been erased like a blackboard, rebuilt, and erased again. But *baseball* has marked the time." Texas has in a similar sense—specifically, the Texas of filmmaking's Old West: then already more than half a century old, but ageless, timeless: from Jimmy Stewart through John Wayne to the genius of director John Ford.

When Gene Elston arrived in 1961 Texas, film's Old West Texas still lived physically, tangibly. To a small-town Iowan, its impact could be, as Elston said, "Overwhelming." Texas should be grateful that Houston's first big-league Voice met it on his own terms.

It was easy to be mistakenly impressed by the 1961 Mets NL expansion draft: an aging household-name roster. By comparison, Houston GM Paul Richards stressed youth. The early 1960s Colt .45s had Dick (Turk) Farrell, who put snakes in lockers and got an out after a drive hit his head, caroming to outfielder Jimmy Wynn. At a summit on the mound, first baseman Rusty Staub said, "I'm charging the plate. Whatever you do, throw home." Pitcher Hal Woodeshick promptly threw to first, nearly hitting him in the ear.

On the one hand, sorrow stalked the infant franchise. Al Heist broke an ankle in the first inning of the first exhibition game. Jim Umbricht and later Walt Bond died of cancer. On the other, Richards signed a young Joe Morgan, Larry Dierker, Dave Giusti, Mike Cuellar, and John Mayberry. All augured the bright future envisioned by former Harris County judge and Houston mayor, now Colt .45s president, H. Roy Hofheinz. This meant that 32,601-seat Colt Stadium would not long be their home.

Colt was a.k.a. "Mosquito Heaven," huge insects bombing the
public, the grounds crew regularly spraying between innings. In
1965, the franchise got a buffer: the Space City's space-age home,
the Astrodome, "The Eighth Wonder of the World," which was
the first air-conditioned, all-purpose domed stadium and had been
built for $35 million. It opened April 9 with a night exhibition v.
the Yanks: 47,878 gaped. President Lyndon Johnson stood in his
box high above center field when Mickey Mantle slammed the
Dome's first homer. Early trouble, though, soon arose.

The roof, originally clear, was painted to reduce glare, but lack
of daylight killed the grass field. St. Louis's Monsanto Company
had a solution—artificial grass (in Houston, AstroTurf), a first. The
vast indoor park—lines 340 feet away; alleys, 375; center field,
406—also led to a panoply of unique rules. A ball hitting a foul
speaker was out if the fielder caught it. The PA speaker was in play
117 feet up and 329 feet from home plate.

On April 27, 1965, the Mets' first visit, Lindsey Nelson did
play-by-play in a gondola suspended over second base. "What if
the ball hits my man Lindsey?" Casey Stengel said. Looking up,
umpire Tom Gorman shrugged. "Well, Case," he said, "if the ball
hits the roof, it's in play, so I guess if it hits Lindsey, it's in play."
Later, Stengel said, "That's the first time my man Lindsey was ever
a ground rule."

In 1968, Houston hosted the All-Star Game, Elston and Curt
Gowdy splitting balls and strikes. Gene then returned to his far-
flung thirty-five radio and fifteen TV outlet networks, respectively,
from the Panhandle to Baton Rouge. Sidekicks included Al Helfer,
Harry Kalas, Bob Prince, Dewayne Staats, and Dierker. Above all,
Loel Passe lent a down-home sound from his 1940s Birmingham
radio and 1950s Buffaloes, he and Gene airing the 1961 Buffs and
1962–1976 Astros née Colts.

In a 1971 *SI* profile, Passe said he preferred TV to radio, but,
"When you love baseball the way I do and broadcast major league

games from the great cities of the country—man, that's living."
More partial than Gene, Loel coined, "Hot ziggety dog and good
ol' sassafras tea," "He breezed him one more time," and, "Now
you're chunkin'." Few Spanish-speaking games were then aired
live, so Voice René Cárdenas listened to English play-by-play, then
interpreted. Loel, though, spoke "words so strange," said René,
"that I couldn't translate them into Spanish."

Houston Post writer Mickey Herskowitz styled, "Loel...the
entertainment, but Gene the key. Solid, trustworthy." Theater
spoke for itself, "What if?" its core: Nolan Ryan, braving a 1980
LCS defeat to Philly; José Cruz, a 1986 playoff bow to the Mets;
Craig Biggio, bounced in three straight National League Division
Series (NLDS). The worst was 1980. Houston took a 2-1 game
then-best-of-five LCS edge, next day led, 2-0, but lost another
run as Gary Woods left third base early on a fly. It cost a pennant:
Phils, in ten innings. In Game Five, the Astros lost in extra innings.
Nail-biting was getting old.

"Being from Iowa," Elston hadn't known if his style "would be
accepted." He was proud that it had, teaching essentials to an
area bereft of a big-league past. On September 25, 1986, Houston
pitcher Mike Scott no-hit the Giants to clinch the NL West. On
'Stros wireless, Milo Hamilton drew a picture. TV's Gene said,
simply, "There it is!" letting sight and sound hold sway. "You
have a picture in front of you. Don't say what is going on," Elston
warned. "[On radio] I tried to put myself in the fans' seat to tell
them what I thought they wanted to know. I wanted to do the actual
scene at the ballpark."

Both Elston and longhorn culture respected a job well done.
Gene made the Texas Radio and Texas Baseball Hall(s) of Fame
and became a four-time Texas Sportscaster of the Year. He called
Houston's first sixteen hundred games, including eleven no-hitters.

Particularly special: September 26, 1981, when Nolan Ryan broke
Sandy Koufax's record for no-nos, Gene saying, "Two balls and no
strikes to Dusty Baker. And a ground ball to third! Art Howe! He
got it! Nolan Ryan! No-hitter Number 5!"

As baseball's Jack Webb—the character who said, "Just the
facts, ma'am," on TV's *Dragnet*—Elston knew he was not for
everyone, especially in an age where style increasingly trumped
substance. In 1985, Hamilton arrived from Chicago. After the
next season, new General Manager Dick Wagner fired the
team's original Voice. "If they want somebody to phony up some
excitement, I can't change my personality," Gene said, shuffling
to CBS's *Game*, where he was appreciated, as in Western film, in
which Jimmy Stewart was thought superb, not unfairly compared
to John Wayne.

Elston's last play-by-play buoyed three straight (1995–1997)
NLDS for CBS. He left broadcasting, braved a stroke, and got the
Ford C. Frick Award in 2006. By then, the Astros had moved into
their current home, Minute Maid Park (née Enron Field) with its
left-field porch and 1860s locomotive and steel tender—almost as
fine as Houston's first world title, in 2017. Sadly, Gene died two
years earlier, at ninety-three, having long ago called Texas home.

Think of San Francisco's cable cars, drop-dead skyline, and Golden
Gate Bridge. It also has birthed the most Frick honorees of any
franchise. Of forty-five recipients, a team-high eleven have aired
the Giants: in order, Mel Allen, Russ Hodges, Ernie Harwell, Jack
Brickhouse, Lindsey Nelson, Arch McDonald, Lon Simmons, Jon
Miller, Tim McCarver, Al Helfer, and Al Michaels. Their radio/
TV continuum also includes recent Voices like Hank Greenwald,
Mike Krukow, and Duane Kuiper, prizing not solemnity but mirth.

Born in Detroit, Greenwald was raised in Rochester, New
York, and attended Syracuse University, where he joined campus

radio. Hank aired the 1979–2005 Giants, Yankees, A's, and CBS
Radio. Humor bridged them: "In Montreal, when you ask for a
nonsmoking section, they send you to Buffalo," Hank said, turning
fifty in 1985. "It's funny," he said of the then-toxic Giants. "When
the season started, I was only forty-three."

Hank did the 'Jints from 1979–1986 and 1989–1996. For a
long time, they drew poorly at Candlestick Park. One night, a
foul landed in a sea of empty seats. Greenwald gave the section
number, adding, "Anyone coming to tomorrow's game might want
to stop and pick it up?" In 1985, a game of the 62-100 Giants
drew 1,632. "Sixteen thirty-two!" Hank blared. "That's not a
crowd. That's a shirt size." In 1987, he returned east to air the
Bronx Bombers, finding, "It's amazing how a couple of years with
the Yankees can validate your career."

Greenwald then crossed the continent again to find the
Giants much improved. In 1993, they barely lost the NL's
Western Division, winning 103 games. What hadn't changed was
Greenwald's funny bone. One night, he taped an open: "Good
evening, everybody. I'm Hank Greenwald, along with Duane
Kuiper. We're here at Three Rivers Stadium." The producer told
Hank to shorten it. The open was still too long. The Voice obliged:
"Good evening. I'm Hank Greenwald, along with Duane Kuiper.
We're here at Two Rivers Stadium."

In the 1980s, Greenwald covered two men who later as
broadcasters provided comic relief. Kuiper was a 1982–1985
Giants infielder who also hosted a radio show on flagship KNBR.
His playing time overlapped Krukow's, a 1983–1989 'Jints righty
who won twenty games in 1986 and first worked for the station
in 1990. For the last third of a century, their "Kruk and Kuip"
affiliation has regaled the baseball public.

"I could say Krukow and Kuiper work Giants games, except
that it doesn't seem like work," said MLB Network's Matt
Vasgersian, praising their "ex-teammate clubhouse-prankster

sensibilities." Before a night game at Candlestick, Kruk and Kuip
added paper shredding to pre-game preparation. First, they tore
paper into quarters for fifteen minutes, as if discarding notes.
When the wind crested—after all, it was Candlestick—they tossed
the paper from their booth, knowing it would blow "two booths to
the right into the visitor's: a ticker-tape parade."

"They made a mess," said Vasgersian, "but had better aim
than some Giants pitchers"—excluding Krukow, in 1999 chosen
by Bay Area media as the 'Jints 1980s starting right-handed hurler.
Ultimately, they defined baseball merriment. ESPN's Tim Kurkjian
called Krukow, born in Long Beach, California, a "character."
One day, a baseball lodged in the webbing of Terry Mulholland's
glove, the pitcher throwing his glove to first baseman Bob Brenly
for the out. "You blew it," Mike told teammate Brenly. "You should
have whipped it around the infield."

Born in Racine, Wisconsin, Kuiper made the bigs via
Centerville (Iowa) Junior College, Southern Illinois University,
and the 1972 amateur draft—the Indians giving him an eight-
thousand-dollar signing bonus. In 1974, he replaced injured
second baseman Jack Brohamer. At bat, the singles hitter once tied
a big-league record by lashing two bases-loaded triples at Yankee
Stadium. The defensive whiz often made skipper Frank Robinson
"[stand] up in the dugout and applaud plays Duane made." In
1981, Kuiper joined the Giants, next year setting a then–San
Francisco Giants high with fourteen pinch-hits.

From 1986–1992, he did KNBR commentary. A year later,
the 'Jints rumored about to move to Florida, Duane became the
first-year Colorado Rockies Voice. One day, Kuiper aired their
last game of the year in Philadelphia when suddenly the Phillie
Phanatic mascot crashed through the back of the broadcast booth
between Duane and partner Charlie Jones, threw their notes in
the air, climbed over the ledge outside, and sauntered around the

stadium. Perhaps traumatized, Kuiper retired to the Bay in 1994, rookie Krukow supplying color after a 124-117 career record.

"People respond to them because they're totally natural on the air," Jon Miller said. "Kruk and Kuip" sired "Kruktionary" phrases like "Grab some pine, meat" after a strikeout and "Just another, ha ha ha, laugher!" after a cardiac set. In 2007, Kuip said, "[Barry] Bonds hits one high! Hits it deep! Outta here! 756! Bonds stands alone," breaking Hank Aaron's home run record. His greatest call was 2010's "swing and a miss! …The Giants, for the first time in fifty-two years, the Giants are world champions! You can't help but think that this group is celebrating for the Say Hey Kid, for Will the Thrill [Clark], celebrating for No. 25 [Bonds], and celebrating for all you Giants fans!"

Like Krukow, Kuiper is a seven-time Emmy Award winner, each hoisting 'Jints World Series titles in 2012 and 2014 and doing daily pre-game commentary in addition to the game. "I speak Spanish to God, Italian to women, French to men, and German to my horse," said Charles V, Holy Roman emperor. Kruk and Kuip speak a language that helps to paint the Bay's verbal landscape: among the best ex-athletes increasingly speaking baseball radio/ TV—in 2021, an estimated 40 percent of all Voices. Many find that just fine.

Chapter 9

1960S–1980S: NETWORK TV BLOOMS

In 1961, Congress sanctioned for the first time TV contracts between a network and professional sports league, letting the NFL negotiate with CBS or another network—revenue divided equally among all teams, tiny Green Bay no less than metropolitan New York. Two years later, each NFL club received $329,000. By comparison, baseball TV revenue accrued to each team separately with no regard for another.

In 1964, the Yankees earned $550,000 from CBS's *Game of the Week* for each home weekend game. The White Sox, Indians, Braves, and Pirates each netted $125,000 from NBC for the right to broadcast from their park. A majority of the twenty major-league teams received no network cash. Enough of social Darwinism, owners cried: Let us share the wealth! In response, baseball forged ABC TV's 1965 *Major League Championship Baseball*, a game each Saturday and Independence and Labor Day.

The Phillies' new local pact barred that year's network involvement. The Yanks were wed to a final year of CBS's renamed *Yankee Game of the Week*. Every other team received $300,000 from a $5.4 million pot. Weekly, Voices Keith Jackson, Chris Schenkel, and Merle Harmon divided three regional matches. Unlike CBS's Dizzy Dean, barred in big-league burgs, ABC entered every city. "We felt like a trailblazer," said Merle.

"Coast-to-coast, no blackouts." *Major League Championship Baseball* has remained baseball's national TV test pattern ever since.

Ironically, the 1965 *Yankee Game* clobbered ABC from Boise to Buffalo. Fatally, ABC's pact did not outlaw same-time local TV. "We'd go into Chicago with the Mets and Dodgers," Merle said, "and at the same time, local stations featured the White Sox and the Cubs. Try building network ratings that way." Vainly, Harmon did. To its credit, ABC proved willing to innovate, its greatest reform hiring the pioneer who broke baseball's on-field color line. In March 1965, the *New York Times* reported that Jackie Robinson would break an off-field line. (See Chapter 11 for more.)

ABC baseball ended that October. Merle was released from the 1967–1969 Twins when the Seattle Pilots moved to Milwaukee in 1970. "They knew what [Milwaukee] meant to me," said Harmon, having broadcast the 1964–1965 Braves. Airing the renamed Brewers through 1979, he found that they would not soon contend—and the Braves' desertion for Atlanta still stung.

That year, Merle inked a multi-year NBC TV pact to air, among other events, the 1980 Moscow Summer Olympics. He did the 1980 Series and backup *Game of the Week* but not the Games, boycotted by America after the Soviet Union invaded Afghanistan. "A great letdown," Harmon said, braving another when NBC axed him in 1982 for Bob Costas, less costly at twenty-nine.

As 1982–1989 Rangers TV play-by-play man, Merle aired Nolan Ryan's five thousandth strikeout. Retiring in 1995, he left an array of firsts: voice heard on WFAN New York; originator of the then-largest US sports souvenir retailer "Merle Harmon Fan Fair;" and 1965's precedent-busting series. The Mormon lay preacher stoically bore a heart attack and the bankruptcy of "Fan Fair," dying in 2009, at eighty-two. "As good a broadcaster as he was," said son Keith, "he was just a greater man."

For almost two decades before and during 1965, a Who's Who of Voices televised network baseball. That October 19, NBC bought 1966–1968 exclusivity for the All-Star Game, World Series, and *Game of the Week*, choosing one man to narrate the entire package: a self-effacing small-town boy airing its big-city coverage.

Curt Gowdy's style was home-style—to John Updike, "with its guileless hint of Wyoming twang"—viewed on NBC's thirteen World Series, twelve All-Star Games, and a decade of *Game*. Born in 1919 and raised in Cheyenne—hence The Wyoming Cowboy—he and his father would have thought Yankee Stadium the moon. "He'd say, 'Someday I'd like to see a big-league game,'" recalled the son, who entered minor-league radio after college.

To Curt, the minors were a workshop for "the sporting broadcast business—ads, production, play-by-play—in one." He aired the Texas League Oklahoma City Indians, auditioning with the Yankees' Mel Allen in December 1948. Mel on-air razzed Curt's mark-down sports coats. To his endearing garb, the rookie added courtesy, respectability, and pluck. The Red Sox noticed, in 1951 offering him radio/TV. The Cowboy knew, "This was my chance to be number one. I also loved New York."

Finally, he accepted, only to have Boston start with two losses, earning telegrams—"Go back to New York, Yankee lover"—inanely assigning blame. Worse, Gowdy mucked up pronouncing regional burgs—Ipswich, Worcester, Swampscott—Sox owner Tom Yawkey even hiring a speech tutor. Back at Fenway, the student found that Yawkey wanted to see him. Shaken, Curt walked from the field to his office. "I just want to welcome you to the Red Sox," Tom said. "I followed you in New York and liked it."

In Gowdy's fifteen years in Boston, the team grew worse, yet interest lasted, fixated on its franchise Gibraltar. Ted Williams, now forty-two and quietly planning retirement, wanted to finish at Fenway. On September 28, 1960, Ted reportedly had a chest cold:

thus, missing that weekend's final road series. Curt, curious, asked him, "Are you [retiring after today]? The Kid said, 'Yeah, but don't mention it till the game starts.' No one knew."

Before the game v. Baltimore, Ted's No. 9 was retired. He made out three times at bat, then faced Jack Fisher. Gowdy said, "Fenway Park, Boston, Ted Williams' last game in a Red Sox uniform." In the eighth inning, "There's a long drive to deep right-center! It could be! It could be! It is!" said Curt, incredulous. "It's a home run! Ted Williams has homered in his last time at bat in a Red Sox uniform!"

Gowdy's Sox tenure ended due to ABC baseball's end, NBC adding it in 1966. Curt, NBC's football Voice since 1964, was hired to do both. As color man, sponsor Falstaff Brewery hyped Dean and former pod-nuh Pee Wee Reese. Gowdy said of Dean, "I can't do *Wabash Cannonball.* Our styles clash." Falstaff settled on Reese.

Under NBC's new pact, Curt aired half of each Series game. Before 1969, *Game* had loftily ignored the lowly Mets. By September, it showed them weekly. Upon the Classic's last out at Shea Stadium, Gowdy said, "Look at this scene!"—evoking the wonder that he felt when Dad vowed to take him to a "big-league game."

For The Cowboy, 1975 became a bigs last hurrah. Unexpectedly, his Red Sox won the pennant and LCS. Ahead, three sets to two, Cincinnati led Series Game Six, 6-3, as two eighth-inning Sox reached base. "[Bernie] Carbo hits a high drive!" said Curt on NBC Radio, "Deep center! Home run!" The old pro stilled. Then: "Bernie Carbo has hit his second home run of the Series! ...And the Red Sox have tied it, 6 to 6!"

Next inning, Fred Lynn lofted a bases-full no-out fly. "It is caught by [George] Foster," Curt said. "Here's the tag. Here's the throw! He's out! A double play! Foster throws him out!" Score still even, the Reds' Joe Morgan batted in the eleventh. "There's a long

shot! Back goes [Dwight] Evans—back, back! And what a grab!
Evans made a grab and saved a home run on that one!" At 12:34
a.m., Carlton Fisk arced a twelfth-inning pitch toward Fenway's
left-field wall, using hand signals and body English to force the
ball fair.

Said Gowdy: "They're jamming out on the field! His
teammates are waiting for him! And the Red Sox send the World
Series into Game Seven with a dramatic 7 to 6 victory." The
seventh game drew a record 75,980,000 viewers. Nonetheless,
NBC Sports head Carl Lindemann shortly traveled to Curt's
Emmy Award-winning *The American Sportsman* series being filmed in
Maine to tell the age's network paradigm that he was through.

In 1972, Wyoming officially named Curt Gowdy State
Park—"My greatest day," said the avid conservationist. In 1998, he
narrated "Casey at the Bat," with the Boston Pops, at Tanglewood,
calling it "my greatest thrill"—both symbols of his core, The
Cowboy dying in 2006, at eighty-six.

In 1973, Garagiola won a Peabody Award for broadcast excellence:
notably for his fifteen-minute *The Baseball World of Joe Garagiola* on
NBC's Monday *Game of the Week*. Still, *Game* play-by-play bewitched.
In retrospect, his getting it seems ordained. Curt's ratings had
slumped. Joe pitched for Chrysler Corp., baseball's network TV
angel. He even had Commissioner Kuhn's support.

In 1976, Garagiola, as lead Voice, inherited Tony Kubek as
analyst. Joining *Game*, Joe changed it. The two ex-jocks spent much
of each *Game* gently sparring. A pitcher throws errantly to first base
on a bunt. Tony: "The catcher's fault." The ex-receiver responded:
"What? Who made the throw?" Kubek knew his job was to
illuminate; Garagiola's, to orchestrate.

Like 1975, the 1977–1980 Series pulled a 50 percent-plus
audience share, including 1978's Dodgers-Yanks still-record

32.8 rating, Game Two a Joe G. apex. LA led, 4-3, ninth inning, two out and on. New York's Reggie Jackson fouled four pitches before reliever Bob Welch "Struck him out! Ballgame over! …A marvelous performance!" said Joe. Originally, NBC felt that Garagiola's devotion to the idiosyncratic might restore *Game*'s bloom. Producer Scotty Connal recalled how "Saturday had a constituency, but it was hard to boost."

Same-time local-team TV split *Game*'s audience, NBC ratings dropping from 1974's 7.3 of each hundred sets to 1981's 6.3. By 1982, ABC broadcast a sporadic yearly schedule, CBS had no yen to do the sport, but cable's SuperStations had begun to rise. Seeking to swell its footprint, NBC, shifting Joe to color, that year hired a man of letters.

Joe Garagiola, center, with Stan Musial, left, and Yogi Berra

Winning every honor from a Lifetime Achievement Emmy to a star on the Hollywood Walk of Fame never changed Dick Enberg.

"Baseball," he said late in life, "has been in my DNA since I was
in diapers."

Born in 1935 in Mount Clemens, Michigan, Dick teethed on
a bat as a four-year-old in the days he spent in his grandfather's
grocery store. "I remember him saying, 'Dickie, come in here.
If you can answer this baseball question, you can pick out some
Superman bubble gum,'" said Enberg. "I studied my baseball
because I knew Grandpa would give me some free bubble gum."

Raised on a farm, Dick followed baseball on the air and begged
Dad to drive him to Detroit when the Red Sox were scheduled
to watch *his* Superman, Ted Williams, hit. In the late 1950s, Dick
worked as a one-dollar-an-hour student janitor and public address
Voice at Central Michigan University's radio station, leaving to get
thirty-five dollars a game to announce football and basketball and
receive two degrees at the University of Indiana.

At twenty-six, hoping "to be the best professor around," Dick
took his doctorate and began teaching and coaching at a school
now named Cal State Northridge. Ultimately shedding academia,
Enberg began Angels radio/TV play-by-play in 1969. By 1975, he
had made it big with TV's syndicated *Sports Challenge*, starring ex-
athletes-turned-panelists. Dick produced PBS's award-winning *The
Way It Was*, aired the game show *Battle*, and replaced Gowdy on
NBC college basketball and the Rose and Super Bowl—also calling
the Breeders' Cup, Olympics, and Wimbledon.

In 2000–2011, Enberg added pro football and golf for CBS,
scheduling by stopwatch as much as calendar. A frantic schedule
meant leaving the Angels in 1978: "Here I am, doing other
network sports," Dick said, "and I don't have time for my favorite."
In 1982, he finally called the *Game*, LCS, and Milwaukee-St.
Louis World Series. Enberg was warm, kind, and fair, unlike some
network dynamos. Two months after his Series, NBC altered a new
Game cast.

Spurned by NBC, Dick resumed Angels TV. Friends asked why. "I miss the game," he said. In 2010 he began to broadcast the Padres. Five years later, Enberg received the Frick. "I sank to my knees when I learned of this award," he said. "I've tried them all, and baseball is the best announcer's game." Dick died in December 2017, six months before his book, *Being Ted Williams*, was released. From teething on a baseball bat to a life of photographs and memories, first loves rarely die.

When Enberg was removed from *Game* in 1982, he said, "There was no room for me at the end." Scully, a good friend, replaced him: NBC's new $550 million 1984–1989 pact required return on investment. Vin would do play-by-play; Joe G., color. The backup arrangement featured Kubek, dropped from the primary *Game*, with Costas. Skeptics wondered if the mixed styles would work. "Some people were hoping we'd be…always sniping at each other," said Scully later. "But they forgot that Joe and I are two old pros."

In *Game*'s 1984 first year of exclusivity, its Nielsen rating climbed from 5.9 to 6.4. What's more, Series coverage, wrote the *Boston Globe*'s Jack Craig, was "a pinnacle for televised sport." One moment, Joe likened Ruppert Jones' stance to "a hula dancer on a Don Ho record." Another, he predicted a pitchout. "How did you know that?" gushed Vin. "The fist," Garagiola said. The pitchout sign hadn't changed since before the war. "Uncanny," NBC director Harry Coyle said.

In 1988, the pair ferried its last Series, CBS buying 1990–1993 exclusivity as Garagiola left NBC for the 1990 Angels, 1998–2012 Diamondbacks, and 1994–2002 Westminster Kennel Club Dog Show on USA Network. Despite Joe's blizzard of past programming, he laughed, "People come up to me and say, 'I love you [best] on Westminster.'"

Garagiola earned the Hall of Fame's 2014 Buck O'Neil Lifetime Achievement Award for opposing smokeless tobacco and founding the Baseball Assistance Team to help indigent former players and others. He is recalled as no ordinary Joe on the field, and extraordinary off it.

In 2009, Tony Kubek became the Hall of Fame's thirty-third Ford C. Frick Award recipient. It was a historic pick—the first analyst-only honored—and improbable, given how many 1954 "bonus baby" teams were ready to break the bank to sign the "painfully shy" eighteen-year-old.

Kubek's father, an ex-Triple-A Milwaukee Brewer, knew better where Tony's future lay. "Forget a big deal," Dad said. "Their rules make you stay with the [parent] club." He wanted his son to mature in the bushes. Agreeing, New York gave him just three thousand dollars to sign. "If not for him," Tony said of Dad, "I'd have never signed with the Yanks." Without them, he likely would never have made TV.

Instead, in 1957, Kubek made the parent club, became Rookie of the Year, and homered twice in World Series Game Three in his family's home—Milwaukee. Next year Tony played shortstop, third base, and the whole outfield in a Series game. Skipper Casey Stengel prized his versatility. Ralph Houk, Casey's 1961 successor, wanted stability, naming Tony shortstop, "Period." The 109-53 Yankees won the Series his way.

Tony married, was drafted, entered Army Reserve, and returned in August 1962 to go deep in his first at-bat and help the Yanks win again. Voices Allen and Red Barber regularly invited him on post-game TV. Once he accepted, regretting it. Hard to believe: the red light made Kubek sweat. "Nobody would ever have thought of me on the air," he said, except for an inadvertent plus: After the 1960 Fall Classic, most Americans knew his name.

October 13, Game Seven, Forbes Field, Yanks up, 7-4. The
bottom of the eighth inning began with a Pirates single. A Bill
Virdon ground ball was hit to Kubek: "A sure double-play until the
ball hit something and hit me in the larynx." Tony fell, grabbed his
throat, choking and coughing blood. The gamer wanted to stay in,
but as Allen said, "Casey is saying, 'This is no time to be a hero.'"
With Kubek in a hospital, Bill Mazeroski hit a 10-9 game-winning
blast. The "Beat 'Em Bucs" had.

Tony struggled offensively through 1965, when doctors found
he had broken his neck, likely from Virdon's grounder or a neck
injury playing touch football. A collision could paralyze. Retiring,
Kubek, thirty, readied to fly home and "sell [Laughing Cow]
cheese." Instead, an NBC official cornered him at a Manhattan
bar. The Peacocks had just acquired *Game of the Week*, he explained.
Would Tony audition as a backup analyst?

Incredulous, Kubek laughed but was hired. Curt Gowdy and
Pee Wee Reese did the primary "A" game—say, Cubs-Dodgers—
seen everywhere but there. Blackout rules gave Tony and Jim
Simpson the "B" Backup game—Tigers-Indians—seen only in
Chi-Town and LA. When an "A" game was rained out, Simpson's
sub was "thrilled." Not Tony. Thirty minutes before the game,
no Tony. Fifteen, no Tony. Finally, Tony. "Where you been?" said
Charlie Jones. "Throwing up," said Kubek. "I'm not ready to
go national."

By 1968, he was. That fall, Curt and Pee Wee on play-by-play
and color, respectively, NBC made Kubek a Series field reporter
about to dislodge another ex-shortstop. "I wasn't bitter," said
Reese, axed for Tony but not told why. Stuttering and talking
too quickly, NBC's new backup analyst had to partly make
himself over.

Buying a recorder, he read poetry aloud for twenty minutes a
day: Curt's idea to enhance delivery. To Tony, the designated hitter
was a "dumb rule." The "union guy" said replacement players

"would have to be called scabs." Call Kubek baseball's Diogenes, being and seeking an honest man.

Who was this new guy, anyway? Not Wisconsin's tongue-tied teen. Between 1966 and 1989, he did ten All-Star Games, fourteen LCS, and eleven World Series. In 1972, Oakland's Bert Campaneris was knocked down and threw his bat at Detroit's Larrin LaGrow in the LCS. Tony called it "justified," the pitch aimed at Bert's legs–thus, his health and career. When Motown's Chrysler, Kuhn, and NBC asked him to apologize, Kubek refused. To *TSN*, he had "really no sense of humor, speaks a little too often, and may be too much in love with his sport. Still, one listens," as in 1975.

In Series Game Three, the Reds' Cesar Geronimo reached first in a five-all tenth inning. Boston catcher Carlton Fisk threw Ed Armbrister's bunt into center field, Kubek saying plate umpire Larry Barnett failed to call Ed out for interfering with an attempted force out. In turn, Joe Morgan plated the 6-5 winning run. Next month, Barnett held Curt and Tony "responsible" for death threats to Barnett and his family. Kubek got a thousand letters calling him a Boston shill.

In 1977, Kubek was hired by Canada's The Sports Network, "[educating] a whole generation of Canadian [also American] baseball fans without being condescending or simplistic," said the *Toronto Star*. In 1989, he went back to a future he never expected: baseball sans NBC. On September 30, Kubek aired the network's 981st and last *Game*, from familiar terrain, Toronto's SkyDome.

In 1990, he joined the Yanks' Madison Square Garden Network. Four years later, the Yanks atop the AL East, a 232-day work stoppage canceled the Series for the first time since 1904. Upset at the game's "greed, the nastiness," Tony scrapped a final $525,000 MSG year and walked away. Kubek had made enemies.

In 2009, he also made baseball's birthplace as a Frick honoree. It was a trade he was glad to seal.

"Historically, we shall be proven right," Walter O'Malley said of leaving Brooklyn. Scully looked on, torn yet relieved when Walter, ignoring advice to hire West Coasters, told Vin that he would remain the Dodgers Voice.

After considerable debate, O'Malley chose to play in the Los Angeles Memorial Coliseum, its configuration foreign to baseball's. The last row of bleachers lay seven hundred feet from home plate. Binoculars became the rage, as did the transistor radio, used by Angelenos to hear Vin call plays they could barely see. "The Portable Vinnie," wrote Rick Reilly, "made LA a transistor town."

In Flatbush, O'Malley telecast each home game. In LA, he aired none. To see the ex-Bums, you paid cash, a change putting the spotlight on Scully. By the early 1960s, Vin was a Southland ubiquity in a way he had never been in New York. A joke, wrote Steve Bisheff, "and the...park would erupt in laugher, often startling players on the field." On a freeway, Scully's language "drifted up from every traffic jam and outdoor cafe."

The Coliseum closed September 20, 1961, succeeded next April 10 by five-tier 56,000-capacity Dodger Stadium. On June 30, Koufax became the first Dodgers lefty to hurl a no-hitter since 1908. The club drew a bigs record 2,755,184. In 1963, Vin aired Mr. K's coming-out: a 25-5 record and NL-record 306 strikeouts. Sandy K'd a record fifteen in the Series opener v. the Yanks. In Game Four, he completed the 2-1 sweep—"If you had any connection to the Dodgers," Scully said later, "probably the sweetest moment in their history."

For Koufax, life was as sweet on September 9, 1965, Scully phoning flagship station KFI to have it record Sandy's last half-inning. Three times earlier, he had "walked out to the mound to

pitch a fateful ninth-inning" no-hitter. This was "the toughest":
No Cubs had reached base. After Sandy fanned the last six batters,
Vin mused how "when he wrote his name in capital letters in the
record book, that *K* stands out even more than the *O-U-F-A-X.*"

Next month, LA won another title, Vin viewing each game
as an empty canvas: "You get your paints and brushes, and you
mix the paints. Afterward, on radio and TV, you say, 'OK, that's
the best I can do.'" Upon Koufax's final out, he said: "On the
scoreboard in right field, it is 9:46 p.m. in the City of the Angels."
Looking ahead, Scully was already eying the clock.

Vin's vitae tied twelve All-Star Game and twenty-five Series; every
major radio/TV Hall of Fame; Lifetime Achievement Emmy;
Presidential Medal of Freedom; even Dodger Stadium's address
renamed 1000 Vin Scully Avenue. One reason is he never grew
smug, hosting a network quiz show *It Takes Two* and CBS's *The Vin
Scully Show* and adding network tennis, golf, and football. Baseball,
however, towered, nowhere more than in 1974, Vin leaving
the booth on Hank Aaron's 715th homer, finally returning and
admiring: "A Black man is getting a standing ovation in the Deep
South for breaking a record of an all-time baseball idol."

In 1976, Dodgers fans voted Scully "the most memorable
personality in [LA] franchise history." Next year, baseball's new
four-year pact with NBC gave ABC its "first Series. They wanted
their own guys," Phil Mushnick said, citing a network niche as
being crucial to a postseason job. Vin did CBS Radio's late-1970s
and early 1980s All-Star Game and Series, yet needed TV for
more people to appreciate his vivid tints and bold pastels.

In 1982, Scully got a Night at Dodger Stadium, a star on the
Hollywood Walk of Fame, and Frick Award. At Cooperstown,
he said, "I would like to pray with humility and with great
thanksgiving." NBC Sports President Arthur Watson knew that

for the next baseball pact to work in 1984–1989, *Game* required
Vin's benediction that avoided the cross of "too many guys
using statistics the way a drunk uses a lamp post—for support,
not illumination."

Vin Scully

All decade, Scully's take on history became baseball's history.
In 1986, the then ill-starred Red Sox lost a 5-3 tenth-inning lead.
"Three and two to…[Mookie] Wilson! …Little roller up along
first…behind the bag… It gets through [Bill] Buckner! Here comes
[Ray] Knight! And the Mets win it!" Vin cried, voice throbbing,
then hushing. It is how millions still remember him.

Others invoke the 1988 Classic opener, the favored 104-58 A's
up, 4-3, in the ninth. The Dodgers injured slugger was supposedly
unavailable even to pinch-hit as Scully scanned the LA bench.
"The man the Dodgers need is Kirk Gibson, and he's not even in
uniform," said Vin. Icing a knee in the locker room, Gibson heard
him and, irate, got into uniform. With two out and one on, Scully,
eyeing a monitor, said, "And look who's coming up!"

Limping to the plate, Gibson barely fouled four balls, then
swung at a 3-2 pitch. "High fly ball into right field! *She is gone!*"

Vin exclaimed. Sixty-seven seconds later: "In a year that has been so *improbable*, the *impossible* has happened!" Again, Scully fled the mic, deferring to the viewer. A good painter knows that less is often more.

Vin's post-*Game* age fused message and messenger: impossible to replicate Gibson's deed, or forget it. Scully retired in 2016. In 2020, the Dodgers won their first World Series since Gibson's blast, asking Vin to narrate their highlight film. Emmy Award-winning Aaron Cohen wrote the script. "It was daunting," he said. "[At ninety-three!] what comes out of his mouth naturally is pitch-perfect and better than anyone could ever write."

We leave Scully on May 7, 1959, professional baseball's then-largest crowd, 93,103, lauding Roy Campanella, paralyzed a year earlier in a car accident, at a Yanks-Dodgers exhibition game. After the fifth inning, lights dimmed as Pee Wee wheeled Campy across the first-base line toward the mound, each person there asked to light a match. "The lights are now starting to come out, like thousands and thousands of fireflies," Vin said of the silent tribute, "starting deep in center field, glittering around to left, and slowly the entire ballpark"—then unforgettably, "a sea of lights at the Coliseum."

"Let there be a prayer for every light," said Scully, for "on his last trip to the mound, the city of Los Angeles says hello." Vin's genius never said goodbye.

As noted, in baseball's 1976–1979 first dual network contract since 1965, NBC and ABC were to televise every other year's All-Star Game, League Championship Series, and World Series. ABC assumed prime-time coverage, retitled *Monday Night Baseball:* up to eighteen games yearly, including a stray Sunday afternoon.

"Baseball can succeed," ABC Sports President Roone Arledge vowed. "It'll take something different in primetime to work." ABC knew the sport's lull between pitches, stately tempo, and triangular shape on a rectangular screen—and its twist *was* different. It briefly employed Bob Prince, sprinkled heavily with Bob Uecker's wit, and prescribed ample doses of "Humble Howard," an ironic pseudonym for Howard Cosell.

Throughout much of its baseball affiliation, ABC also used Keith Jackson as lead Voice to replace Prince. Jackson was a Georgian and ex-Marine who graced 1965's *Major League Championship Baseball* but defined college football to his 2018 death at eighty-nine—"*Whoa, Nellie!*" a synonym for the sport. Keith became a bubbling mouthpiece to the public, intelligent far beyond his persona as a good ol' boy—and to some, a Voice doing baseball with a football soul.

In 1986, Keith rejoined ABC for a baseball farewell. In LCS Game Three, the Mets, Lenny Dykstra swung in the ninth: Houston up, 5-4, runner on. "Hit to right!" Jackson chimed. "Going back! It's gone! The Mets win!" Game Six became a sixteen-inning epic. Down 7-6, the Astros hit with two out and on in their last ups. "Kevin Bass swings and misses and strikes out on three breaking balls! The New York Mets have won the 1986 National League pennant!" Said the *Daily News*: "It was about as lovely as the most lovely sport in the world can be. Rapture!"— Jackson's voice never lovelier.

In 1783, Edmund Burke rose in the House of Commons to praise a colleague. "He may live long," Burke said, "he may do much, but here is the summit. He can never exceed what he does this day." Al Michaels did much in a third of a century of baseball, especially becoming ABC's first true 1980s big-league Voice. His summit, however, was a hockey game from the 1980 Winter Olympics,

affirming, "Do you believe in miracles? *Yes!*" His true love, though, is baseball.

The 2021 recipient of the Frick Award grew up in 1950s Brooklyn, his real school Ebbets Field. Each weekend his family walked to the park to seats high behind home plate, where, looking down, Michaels eyed Red Barber and thought, "Can you imagine seeing every game for *free?*" At nine, he heard Vin replace Red. In 1958, five years later, Scully and the Bums vamoosed—to Michaels, "Two best Voices, and I get 'em both." By quirk, his father took the clan to LA the year of the Dodgers' move.

A decade later, the Arizona State University radio/TV graduate started PCL Hawaii Islanders play-by-play, re-creating from a Honolulu hotel. In November 1970, Michaels accepted an offer from Cincinnati to air the Big Red Machine. Begun in 1969, two of the first three NLCS ended prematurely. An aberration was 1972's Reds-Pirates, going the five-game max. Pittsburgh led the final, 3-2, Johnny Bench up in the ninth. "Hit in the air to deep right!" said Michaels. "Back goes Clemente!"—playing, no one guessed, his final game—"At the fence, she's gone! Johnny Bench, who hits almost every home run to left field, hits one to right! The game is tied!"

With two out, the pennant led off third base. "In the dirt—it's a wild pitch!" Al yelped. "Here comes [George] Foster! ...Bob Moose throws a wild pitch, and the Reds have won the National League pennant!" Michaels telecast NBC's four Series sets at Riverfront Stadium. In 1974, relations with GM Dick Wagner strained, Al joined the Giants, using humor hidden in Ohio. Estimating crowd size: "1,967. That's a...great year for Inglenook Wine. Not so good for the Giants." The score at the end of "six: San Diego 9, the Giants 9. Unfortunately, the Giants are playing in German."

In 1976, Al joined ABC TV's *Monday Night Baseball*, yearly
pining to supplant Jackson, "A football guy on baseball! It was
no secret that Al was miffed," said *TV Guide*. They shared the
1979 and 1981 Series. In 1983, Michaels was promoted, calling
Monday with Cosell and ex-Orioles skipper Earl Weaver, the latter
surprisingly bland after a career of Oscar-worthy blowups. A year
later, Arledge hired "A" analyst Jim Palmer, a Valentino released
by the O's and whom "ABC finds an irresistible prospect," wrote
Jack Craig.

By 1984, Al called the All-Star Game, "[presenting]," said *TSN*,
"a rare chance…to see ballplayers known ordinarily via box scores.
ABC [primarily] wants the sport for October, anyway." Every
network wanted the Olympics, especially after America's 4-3 upset
of the Red Army hockey team in the February 22, 1980, Winter
Olympics semifinal at Lake Placid, New York.

The Friday US-Soviet game was tape-delayed for primetime,
Al employing his famous line. Earlier, millions heard "The Miracle
on Ice" live by radio, horns honked in joy: the globe's best team
losing to our *kids*. To find a phrase worthy of such emotion in only
his second TV hockey game defines a summit. Michaels' second of
nine Olympics also defined his career: "I can't think of anything
that would ever top it," he said, not even Sunday's final, America
beating Finland for the Gold.

In October 1986, *Newsweek* wrote: "It leaves you breathless," Al
airing the ALCS. A strike from tying it, Boston lost Game Four,
4-3. Next day it led, 2-1, when Dave Henderson "knock[ed] Bobby
Grich's ball over the wall for a two-run homer!" By the ninth, up
5-4, the Angels an out from a flag, a hit batter preceded Donnie
Moore's pitch: "[Brian] Downing goes back!" Al said. "And it's
gone! You're looking at one for the ages here!" Boston won, 7-6,
and took the LCS.

On October 17, 1989, clear and warm—earthquake weather—
Michaels hosted ABC's A's-Giants Series pre-game. At 5:04 p.m.,
PDT, he yelled, "I'll tell you what, we're having [7.1 Richter scale]
an earth—" The feed cut as Al, Palmer, and Tim McCarver hit
the floor. ABC restored audio fifteen seconds later, with Michaels
joking, "Well, folks, that's the greatest open in the history of
television." Parts of the Nimitz Freeway and Bay Bridge were
destroyed. At Candlestick Park, generators revived the TV picture
before the crowd filed out.

The three-time NSMA Sportscaster of the Year won his first
news category Emmy, relaying quake reports to Ted Koppel at
ABC's DC bureau. Al's highest peak involved life and death:
sixty-seven perished. After a ten-day delay, the Series resumed at
Candlestick, reaping an all-time low Classic rating. Losing baseball
in 1990 to CBS ended Michaels' niche as a regular big-league
Voice, "Tough to accept because baseball at ABC had come such a
long way."

At contract's end, CBS chose not to renew, NBC and ABC
siring the 1994–1995 "The Baseball Network [TBN]": a format
that began in July, sans day or national exposure, but let Michaels
and Costas split 1995 Series play-by-play. Fox, NBC, and ESPN
then inked a 1996–2000 pact with the Pastime. Al's only later
baseball was on ESPN in 2003—and with Costas for 2011's
Giants-Mets match on baseball's new in-house MLB Network.

Add eight World Series, six Super Bowls, the Walter Cronkite
Award for Excellence, a star on the Hollywood Walk of Fame, and
the Frick—to the Kid from Brooklyn, perhaps the best of all. Once
wanting to be Red Barber, he had reached the summit as himself.

In late 1976, Al airing the NLCS, Roone Arledge gave the Yanks-
Royals ALCS to Jackson, Bob Uecker, and Howard Cosell, of

whom Curt Gowdy said, "I'm not Howard. I don't think every ex-jock's a bum."

For years, the tale of Howard Cosell was told by Howard Himself: his Brooklyn youth, the Dodgers, Phi Beta Kappa at New York University, and law school degree. At war's end, he began a legal practice and a 1950s ABC Radio Little League show. An improbable rise ensued from the early ABC wireless series *Speaking of Sports*, TV boxing, and Mets pre/post-game radio, with Arledge "impressed" by "Howard [having] more access to athletes than anyone" despite ABC airing fewer major events than CBS or NBC.

By then, Roone suggested, Cosell had been arguably "blackballed for five years" for arrogance and/or anti-Semitism. In 1965, Arledge responded, grafting Howard onto the network by having him interview big-leaguers on Saturday. It led to *Wide World of Sports*, ties to Muhammad Ali, and *Monday Night Football*. Howard became a barometer of baseball's health: having revered it, as the Dodgers moved, 1960s swirled, and he and Casey Stengel bickered, Cosell termed the game "odious."

When ABC reacquired baseball in the 1970s, Kuhn wanted Cosell barred from coverage. Arledge refused, but Howard eased criticism, ensuring a regular- and postseason role: Cosell ideal for primetime drama. For a time, détente lived. In 1978, NBC carried *Bob Hope's Salute to the World Series*: the bigs first nightly special in fifteen years. Memorable was a comic biblical baseball interpretation of the game by Howard, rediscovering the Pastime's lure.

Sadly, Cosell could not leave well enough alone. In 1985, on the eve of ABC's World Series, Howard released a book, *I Never Played the Game*, savaging almost anyone he had ever worked with— especially Michaels. Wrote *SI*: "ABC was afraid of an on-the-air scene" between them. Accordingly, Howard was cashiered. Had

he helped redeem Arledge's vow to make baseball in primetime "work"? Yes, and no.

In 1973, NBC primetime baseball averaged a 12 AC Nielsen rating, ABC's later 12.6. Yet in primetime, Roone's approach *did* work for major events—the kind he spun for football. In 1976–1986, ABC beat NBC's All-Star Game and LCS, 24.2 to 22.1 and 17.5 to 15.7, respectively. Only the Series, a longtime Peacock monopoly, favored NBC, 28.7 to 27.4. Arledge's big-name glitter—read: Cosell—worked best on a big-event stage.

Many resented it, and him. For the 1977 Dodgers-Yankees Series, Arledge, choosing Voices, relegated Vin Scully to almost a walk-on part, which he declined. Conversely, wrote Larry Stewart, "He went to great lengths to use Cosell, who admittedly does not like baseball and obviously doesn't know much about it, on the Series... The public is outraged that" Cosell was on and that Scully "is not behind the mic with [his] Dodgers."

Milo Hamilton, reminiscing, said Bob Elson believed people tuned in to hear the game, not him: "With the coming of Cosell and his merry men, that attitude became regarded as kind of quaint." Cosell may never have been called quaint, but he was likely called everything else.

By 1983, as Michaels became *Monday Night*'s first real baseball Voice, Bob Uecker had left the series to further his image as the comedic sap who symbolized Everyman's "memories of being rejected, of someone stomping on us," said sponsor Miller Brewing Co.

"The man's bigger than the game, he's bigger than the team, he's bigger than the league, he's bigger than the sport," Cosell said of Uke. "They talk about a new commissioner. If I had my pick, it would be you, Bob Uecker." Bob, overbooked, said, "Howie, I wish I had time."

Peter Ueberroth got the job in 1984, but Uke survived nicely as "Mr. Baseball," Johnny Carson's sobriquet. *SI* hailed "the funniest man in broadcasting," emerging as a stand-up comedian, movie and TV avatar, and 1976–1982 *Monday* and post-1970 Milwaukee Brewers star. His memoir reflected his past vocation with the Braves, Cardinals, and Phillies: *Catcher in the Wry.*

Uecker's humor was deadpan, gently mocking, impromptu, and biographical, often leaving a listener to wonder what was fictive—and real. Born in Milwaukee in 1934, he mined his script from as far back as boyhood: "As a kid," Bob said, "I learned boxing. The way I played ball, I had to defend myself." In 1956, the Braves inked Uke, traversing the minors before making the main stage six years later. In 1964, he joined the Cardinals, who lost the first game Uecker appeared in, then won the next five.

St. Louis won the pennant, Bob shagging fly balls in a tuba before a Series game. Uecker batted .200 lifetime, but .400, he jested, off Sandy Koufax. That alone, Uke said, should have kept Sandy out of Cooperstown. (In fact, he hit .184.) Through 1967, the reserve prepped for the future, "Sitting in the bullpen talking into a beer cup" and plotting script. "It was discouraging," he said, "when, as a hitter, I'd look at the third-base coach, and he'd turn his back—and the other catcher, instead of giving a signal to his pitcher, would just yell out what he wanted."

Much of Uke's humor was later heard on *Monday Night*, his spot-on timing honed on a job he had after joining the transplanted Atlanta Braves. As a "goodwill ambassador," wrote Eric Aron, Bob wowed crowds doing what he called "stand-up, weird, and ignorant stuff about my career—anything for a laugh." Anyone who saw him play, Uecker said, knew he had "plenty of material."

Once Uke performed at friend Al Hirt's Atlanta night club. Success led in 1970 to the first of about one hundred guest spots on Carson's *The Tonight Show*. That same year, Milwaukee Brewers owner Bud Selig hired Bob as a scout. "Worst I ever had," Selig said. "[GM] Frank Lane comes raging into my office asking what kind of scout I hired. The report was smeared with gravy and mashed potatoes."

Next year, Uke did the Brewers on WTMJ, his manner barely resembling stand-up. Uke repeated count and score. "Remember," he said, "I'd never done play-by-play unless you count…beer cups in the bullpen." Trying not "to wisecrack my way through it," Bob evinced his emigrant parents' work ethic. By 1982, he succeeded Merle Harmon as Voice of the Brewers: as broadcast director Bill Haig said, "People who know him through his comedy expect him to be like that, and they're surprised when he's [not]."

Also unexpected was *Monday*'s lackluster showing. Beyond talent, ABC had trouble simply keeping up. "Baseball is terrifically difficult to televise," said NBC director Harry Coyle. "The action's not all in one spot like football. You have to anticipate"—and to have continuity. In 1976, ABC went cold turkey from April to June—and in 1978 missed four Mondays in a row.

By comparison, though, unlike NBC, ABC liberally promoted *Monday*. Baseball frequently graced the network's *World News Tonight*. A 1960 ABC in-house memo said, "ADD SHOW BUSINESS TO SPORTS." Arledge could not have said it better. Postseason starred household names: Lou Brock, Reggie Jackson, Seaver, Palmer, and McCarver—above all, Uke's humor.

Increasingly, Bob transcended baseball: starring in the ABC comedy series *Mr. Belvedere*, hosting *Battle of the Network Stars*, and playing boozy play-by-play man Harry Doyle in *Major League I, II*, and *III*. By the time Bob left *Monday*, Miller Brewing spots had begun starring him and other ex-jock Miller Lite All-Stars. Uke's wed caricature and naivete, parodying his perks as a "big leaguer."

In one spot, Bob heads for a box seat, bragging about getting "freebies to the game. [I just] call the front office—*bingo!*" Told he's in the wrong seat, he assumes an upgrade. We next see him in the upper deck, shouting to those nearby, "Good seats, eh, buddy?"

Actor or announcer? In 2003, the five-time Wisconsin Sportscaster of the Year got the Frick. This Uecker had never had a contract, shaking hands before each Brewers season. Bob aired a 1982 pennant, called Robin Yount's three thousandth hit, and did three All-Star Games, eight LCS, and five Series on 1976–1998 ABC or NBC.

The other Uke was "make-believe." In 2001, the Brewers left County Stadium for Miller Park, where 106 obstructed one-dollar seats in the upper-grandstand level above plate were named "Uecker seats." A Uke Miller spot says, "Ah, those fans, I love 'em." Across baseball, the feeling is reciprocal.

Born fifty-two days before Pearl Harbor, Tim McCarver was a fine 1959–1980 major-league baseball catcher—among only seven modern-day four-decade players. He then arguably became baseball's finest 1980–2013 television analyst, working for four teams and as many networks. For a long time, many tried to postpone his retirement. We miss him, even now.

McCarver announced his retirement after Fox TV's 2013 World Series—a record twenty-fourth. He also did that year's LCS, *Game of the Week*, and his twenty-second All-Star Game—a virtue of network exclusivity. Add three Outstanding Sports Personality-Sports Event Analyst Emmys, seven Telly Awards, tenure on each major TV network, and six books on the sport.

As much as any TV analyst, Tim knew the game and more. He could clarify how a slider differs from a curveball—and why it took forever after D-Day for Montgomery to take Caan. A viewer rarely left his telecast without learning something new, surprising

since Tim's "first love" was high school football in his native
Memphis. Baseball became "my final love" after St. Louis signed
him in 1959. Tim and then-pitcher Steve Carlton were later dealt
to Philadelphia, so synergistic that McCarver said they would be
buried in the same cemetery sixty feet and six inches apart, the
distance between home plate and the pitcher's mound.

In 1964, the Cardinals took their first pennant in eighteen
years. In the World Series, Tim's Game Five tenth-inning parabola
v. the Yankees gave St. Louis a 5-2 victory and leg up on its then
seventh title. In 1967, he, Lou Brock, and Orlando Cepeda rode
the neologism "El Birdos" to another crown. In 1978, the now-
Phillie began cohosting an HBO series, *Race for the Pennant*, while
playing. Two years later, he retired with ninety-seven homers and a
jumbo for a catcher fifty-seven triples.

Discarding his glove, Tim did NBC backup *Game of the Week*
and joined Philly radio/TV with Harry Kalas and Richie Ashburn,
quickly learning that "When you retire, you're an outsider, not
player. Broadcast like one." His 1983 move to the Mets became a
career-maker, Phil Mushnick writing, "He has rekindled hope that
sophisticated baseball has a place in New York."

McCarver worked at Shea Stadium for sixteen years, helping secure
ABC's regular- and postseason coverage. At a time of nascent
cable, he hosted the syndicated *The Greats of the Game*. "Three
things explain his rise," said Merle Harmon. "Timing, talent, and
territory." Jack Craig called McCarver's "praise" with the Mets
"much better than being lauded in Kansas City or Houston because
the networks are in New York, and so are their decision-makers."

As noted, in 1985, Howard Cosell's scathing book sired his exile
just before the Series. Tim replaced him at the last minute, saying
of St. Louis pitcher John Tudor, "He's just like a surgeon. The only
difference is that when he takes the heart out of a team, he doesn't

replace it." McCarver and Al Michaels thrived. "I just felt the 'fit' was there," said Al. "It was like working a jigsaw puzzle and finding all the pieces."

From 1983 to 1998, Tim found them locally with the Mets. His longest stay with a team began on cable TV, he and Ralph Kiner defining chemistry. Once Kiner called him MacArthur. Tim: "Ralph, you're probably thinking of General MacArthur." Kiner: "What did I say?" "Tim MacArthur." Ralph: "Close enough." Mets lose, 9-1. Post-game, Tim noted the general's line, "'Chance favors a prepared man.' Obviously, the Mets weren't prepared tonight." Kiner: "MacArthur also said, 'I shall return,' and we'll be right back after this."

One inning, Tim noted Harry Truman throwing "pitches left-and right-handed." Another day, the Broadway junkie referenced Stephen Sondheim's "The Little Things You Do Together." Tonight, McCarver said, "It was the little things the Mets did together." Fox's Ken Rosenthal said, "I heard him say so often, 'I have never heard that term before.'"

Occasionally, McCarver was asked what baseball meant to him. He said it had done *to* him, physically, and *for* him, cerebrally. Catching pitchers for twenty-one years left his "left thumb twisted and torn. Fastballs and sliders are the jackhammers of the catcher's life." As Michaels has described, in 1989, *fate* almost did to them, McCarver toppling to the ABC TV booth floor during the Earthquake World Series.

In 1996, the Yankees won their first world title since 1978 and first of four in five years—the night after the brother of manager Joe Torre received a heart transplant. For Fox's first Fall Classic, McCarver uncorked a classic line: "Frank Torre is on the second day of his second heart. Joe Torre is in the fifty-sixth year of his first one. Both are overflowing." In 1999, the Mets traded Tim's

$500,000 salary for Tom Seaver: "A decision so small," wrote the New York *Daily News*' Mike Lupica, "it could fit inside a batting glove." McCarver's fit pleased the Yanks, whom he joined.

Next year, Tim buoyed *another* first: the only Apple "Subway Series" since 1956. A year later, in 2001, New York led, 2-1, in Game Seven, Arizona loading the bases in the ninth. Mariano Rivera needed two outs for a fourth straight title. The *New Yorker*'s Roger Angell wrote how McCarver noted that "Rivera throws inside to left-handers, and left-handers get a lot of broken-bat hits to left, into the shallow parts of the outfield." Pitched inside, Luis Gonzalez swung, broke his bat, and hit the ball into short left field"—D-backs win, 3-2. To Angell, Tim's became "The Call of Calls."

In 2002, Yanks TV welcomed cable's YES Network, McCarver decoupling for the Giants and then exclusively for Fox. He extended the syndicated *The Tim McCarver Show*, helped to briefly revive Fox's *Game*, aired a record fourteenth straight Series with Joe Buck, and got the 2012 Frick Award. In time, Tim left Fox to call the Cardinals on Fox Sports Midwest. In 2020, he opted not to work at seventy-nine, his doctor citing Covid-19 travel safety and viewers bidding McCarver an affectionate farewell—having learned and laughed from the quintessential baseball analyst.

As a 1956–1969 pitcher, the Dodgers' Don Drysdale became noted for beanballs, spitballs, and a certain haughty charm. "I've got one way to pitch righties"—pause—"tight." As a 1970–1993 broadcaster, he had manners Miss Manners would envy. In the late 1970s and early 1980s, Don stabilized an ABC TV baseball ship unsure how to navigate. "I'm not bigger than the game," said "Big D," "just part of it."

The six-foot-five pitcher hunted heads. The later Voice was content not to turn them. His duality began in Van Nuys, a

farming town in California's San Fernando Valley. In the early 1950s, teenage Don and friend Robert Redford worked outdoors and forged an abiding will not to lose. Later, the Pirates' Dick Groat said: "Batting against Drysdale is like making a date with a dentist."

By 1952, Drysdale played on Van Nuys American Legion Post 193, moving eastward and upward through Triple-A Montreal to Ebbets Field. Like the franchise, he then moved west, leading the league in 1959 strikeouts, shutouts—and hit batsmen, Don beaning a career record 154. At one time or another, Big D had a 2.15 ERA (1968), hit seven homers (1958 and 1965), and opened the 1965 World Series, Sandy Koufax declining to pitch on Yom Kippur. LA trailed, 7-1, when skipper Walter Alston pulled Drysdale. "Bet you wish I was Jewish," Don said.

In 1968, he threw a big-league record six straight shutouts and fifty-eight and two-thirds straight scoreless innings. Next year, Drysdale tore a rotator cuff, his playing career over. The owner of a ranch near Los Angeles could have returned to raise and race thoroughbreds. Don, though, was enamored of radio and TV, having "listened for years to different styles, how they enunciate, and so forth," he said.

Drysdale left California in 1970 for English CBC-TV, training daily with a recorder and airing the Expos that year and next. Big D spent a year in Texas, then aired the Angels, White Sox, and 1988–1993 Dodgers, coming home. After he did NBC's 1977 ALCS, ABC found him not unduly edgy or stagy on *Monday Night*, *Superstars*, *Wide World of Sports*, the 1979 World Series, and five All-Star Games and LCS.

In August 1988, LA's Orel Hershiser began a bigs-record fifty-nine straight scoreless innings. On September 28, he topped Don's record, Big D taking the field to hug the pitcher, saying, "Oh, I'll tell ya, congratulations. At least you kept it in the family." Next month, he did the World Series on Dodgers radio, Kirk Gibson

batting: "Here's the 3-2 pitch… A drive into right field [almost
losing his voice]. Way back! This ball is gone! [two minutes of dead
air] The crowd will not stop! They can't believe the ending! And
this time, Mighty Casey did *not* strike out!"

The Dodgers title concluded Don's first year back. "He'd
never been happier," said wife, Ann Meyers. "Working where
his memories were, with Vinny, away from network TV, his life
picture-perfect." On July 3, 1993, Drysdale, fifty-six, had a fatal
heart attack in Montreal. Shaken, Scully opened that night's game
from Olympic Stadium. "Never have I been asked to make an
announcement that hurts me as much as this one. And I say it to
you as best I can with a broken heart." It is a small consolation, but
to many, he remains "picture-perfect" in their mind.

Chapter 10

1970S–1990S: CABLE AND COMPANY

In 1972, businessman Ted Turner bought rights to air Braves games for his fledgling Atlanta station, WTCG, broadcasting on an Ultra-High Frequency (UHF) band with limited access. Renamed WTBS (Turner Broadcasting System) in 1976, Turner gained FCC permission to distribute programs nationally to regional cable providers for the first time.

Enabling this were newly available satellites letting regional companies offer programs from all over the globe. Turner's success fueled a barrage of national cable networks, including his own Cable News Network (CNN), made available to local markets via subscription.

Dubbed a "SuperStation," WTBS fused national cable and the Braves, the franchise Ted bought in 1976. "[This will] sell us a world from Georgia," Turner vowed even before his club won its first thirteen games in 1982—to Braves Voice Ernie Johnson, "The 'two-by-four' that hit America right between the eyes."

Ted's pioneering venture turned the cable business into a multi-billion-dollar national industry. In the 1980s, many big-league teams tried, with varying success, to launch similar SuperStations and/or regional networks, all offspring of what Turner called "America's Team." Let us look at Johnson, his life intersecting baseball and the then-rise of big-league programming in almost every US home.

More than a decade before Turner bought the Braves, the 1964 Dodgers offered baseball's first pay-per-game cable subscription, TeleVision (STV). Cable channels charged by length of time. "TBS [Turner eventually dropped its "W" to denote national] had been just one of many dozens of offerings," said Johnson. The name "SuperStation" was Ted's idea to signal size across the country. In 1982, it had something besides a name—Atlanta's first division title since 1969.

Other SuperStation Voices emerged about this time—especially WGN's Harry Caray, New York WOR's Tim McCarver, and WPIX's Phil Rizzuto—but the Braves were *primus inter pares:* "first among equals," Johnson, Pete Van Wieren, and Harry's son Skip rousing TV interest time zones away. "The Braves had been just one team among many," said Ernie. "Then '82 happened, and suddenly they weren't."

Born in 1924, Johnson was the youngest of three children of Swedish parents who immigrated to rural Vermont. In 1942, the high school senior tossed three straight near-no-hitters, threw batting practice to Paul Waner and Ernie Lombardi, signed with the Boston Braves, and braved the invasion of Okinawa as a US Marine. Discharged, Johnson came home to finally make the Braves, relocating to Milwaukee in 1953.

"Dad liked to self-deprecatingly joke about his career, but [he] was a pretty darn good relief pitcher," said son Ernie Jr., a longtime TBS announcer. By 1960, Senior had been released by Milwaukee and Baltimore and signed with the Indians, only to hurt his arm. "Here's how bad I'd become," he said. "[Braves catcher] Del Crandall said to forget a spitter because 'It's so slow, it's dry by the time it hits the plate.'"

Ernie returned to Milwaukee, hosting a post-retirement TV show called *Play Ball.* Like many Voices, he could instantly haul anecdotes from the shelf. "Two little ladies entered the park about

the fifth inning and sat down behind a priest," Johnson said on radio. "'What's the score, Father?' they said. The priest said, 'Nothing-nothing.' One lady told the other, 'Oh, good, we haven't missed anything.'"

Later, a pinch-hitter batted for the home team. "He makes the sign of the cross before stepping into the box. The little old lady leaned over and said, 'Father, Father, will that help?' The priest turned around and said, 'Not if he can't hit.'"

In the Braves' strange 1965 interregnum—with the team in Milwaukee, but Georgia-bound the next year, Ernie aired "a tease for the club coming down": seventy radio/TV games on WSB Atlanta. Next year he, Milo Hamilton, and Larry Munson utilized thirty-six radio and nineteen TV outlets. Increasingly, the franchise relied on Henry Aaron on the field and off, inertia gripping the franchise after No. 44 passed the Babe with home run No. 715.

In 1975, Ernie became lead Voice, invoking pops "that bring rain" and "giving that one a blue star"—a paladin of a play. He often lacked crowd noise, with one game drawing only 737 people and Braves fan attendance the NL's second-lowest. Their future was Turner's belief in cable, even when few knew precisely what it was. By 1982, Atlanta lured a record 1,801,985, a letter to *TSN* thanking TBS for "getting baseball back in the hearts of rural America," previously limited to one network game each week.

A general-interest channel for those who did or might like baseball, TBS beamed as many as 150 of each year's 162 sets, many replayed in the early morning. Ernie, Skip, and Pete's 1976 booth got mail from Maine to Hawaii, the early on-field team a comic foil. Once San Diego's Gene Richards tried to steal second base, catcher Biff Pocoroba's throw bouncing off pitcher Buzz Capra's head almost a hundred feet in the air. Buzz then collapsed. "Capra was a friend," Skip said, "and I was afraid he might be

dead"—he wasn't—"but it was so typical of our team that I
couldn't help laughing."

The late 1980s Braves' awfulness bookended the 1970's. Yet
radio/TV's triumvirate stirred a oneness with the region. In 1976,
Caray welcomed Johnson by saying, "Here with the play-by-play,
the [new] Voice of the Braves." During break, Ernie said, "If you
don't mind, we're all the Voice of the Braves." Such an egalitarian
pulse let Braves announcers laugh with and at each other—as
Casey Stengel said of bunting, "Not too hard, not too easy"—
telling stories in a casual way that put an audience to ease.

In 1989, 41,020 hailed Ernie Johnson Night, the three-time
Emmy honoree and Georgia Broadcaster of the Year retiring.
Later he rejoined Ernie Jr. on the regional cable outlet Sports
South, laughing, "People tell me, 'I thought you'd retired! What
are you going to do? Give back all your gifts?'" The other Voices
hadn't left: Van Wieren a.k.a. "The Professor" for his likeness of
author and ex-bigs pitcher Jim Brosnan—and Caray, the *Atlanta
Journal-Constitution*'s Mark Bradley styling him "the one" of the trio
that "we thought we knew best, the funny one…the snarky one."

Van Wieren forged an Upstate New York state of mind: born
in Rochester and graduated from Cornell University, he moved
from several radio outlets and the *Washington Post* to Mets Triple-A
Tidewater and in 1976, the untenured bigs—"a double whammy,"
handling Braves radio and travel. Pete did Flames hockey, Falcons
football, and Hawks and other pro basketball on TBS and TNT,
his "best baseball things" still ahead.

League-worst in 1990, next year's club was first by a game over
LA on the next-to-last day. "Stretch by [John] Smoltz," Pete said.
"A high fly ball to right field! …Back goes [David] Justice! He's
got it! And the magic number for Atlanta is down to one! The
Braves have clinched a tie for [NL West] first!" Later, Atlanta lost
to Minnesota in a seven-set Series, including a ten-inning 1-0 final.

Three games went extra innings. Five were one-run: "as they say in
the South," Pete said, "'as close as fuzz on a tick's ear.'"

For Atlanta, 1991 convened an age that Turner said would make it
"the team of the decade." Would the laugh be on him, or last laugh
his? Skip Caray had encountered each for being "Harry's Kid," as a
boy hearing Dad nightly say, "Let's pause for station identification.
Good night, Skip. This is the Cardinals Baseball Network." He knew
Pop to be a two-edged sword. "I might not have got a job" were it
not for Harry—but "because of that, I'd have to be even better."

Raised in and near St. Louis, Junior wanted to play sports till
hurting his knee. Overnight, radio glistened. At the University
of Missouri, Skip worked summers at KMOX Radio. To shake
Dad's ghost, he left for out-of-town Redbirds outlets. In 1968, the
St. Louis Hawks moved to Atlanta, Caray as team Voice soon less
"Harry's Kid" than radio/TV celeb. Pop could empty a distillery.
Junior twitted "cocktail hour" in Atlanta. Harry boomed. Skip
barbed. Both scored umpires, Junior lashing Ed Vargo's "worst call
by a major league umpire in fifty years."

In 1992, Atlanta's LCS foe was previous-year's Pittsburgh.
Behind, 2-0, in the last inning of Game Seven, Terry Pendleton
doubled. Atlanta scored, loading the bases with two out. Reliever
Stan Belinda then faced pinch-hitter Francisco Cabrera, Justice,
and leaden Sid Bream on base. "A lotta room in right-center field,"
Caray began. "If he hits one there, we can dance in the streets.
Swung on, line drive, left field! One run is in! Here comes Bream!
Here's the throw to the plate! Braves win! Braves win! Braves win!
Braves win! Braves win!"

Then: "They may have to hospitalize Sid Bream!"—buried
under mates at the plate as people began pounding Skip on the
back. "I didn't feel it," he said later. "My fixation calling the play
was total. All I knew was Frank's hit meant the pennant." In

the Series, Ernie Sr. broadcast three innings on radio. "Nothing like completing the resume," he said, turning humor on himself. Atlanta tried to complete *its* resume: by 1995, thirty-seven years without a title. That season the team became the first to win it for three cities: Boston, Milwaukee, and Atlanta.

In the ninth, ahead of Cleveland, 1-0, in Game Six, Ahab caught Moby Dick: "Fly ball, deep left-center!" Skip pealed. "[Marquis] Grissom on the run! Yes! Yes! Yes! The Atlanta Braves have given you a championship! Listen to this crowd!" Despite sublime pitching—Smoltz, Greg Maddux, and Tom Glavine, among others—Atlanta has not won another, although making the postseason—a player lockout erased 1994's—a nonpareil fourteen straight years.

In 2001, Ernie made the Braves Hall of Fame, joined in 2004 by Pete and Skip. Van Wieren wrote two books, including *Of Mikes and Men: A Lifetime of Braves Baseball,* with Jack Wilkinson, and was proud of two precedents from 1995: first of eleven straight years Atlanta won its division and first franchise to win a Series from south of the Mason-Dixon Line.

Ultimately, TBS became available in sixty-three million homes. To Skip, a small crowd became "a partial sellout." In attendance were "Sam Scoresby and Linda Yavnov," the scotch and vodka, respectively, of the Braves lounge bar. In August 2008, the younger Caray died of a heart attack nine days before turning sixty-nine. The *Journal-Constitution* read: "Braves Lose the Voice That Made Us All Fans." Two months later, Van Wieren retired, dying in 2014 of cancer.

Given how Braves radio/TV often felt like a sleepover, family is a fine note on which to end. In 1993, Ernie Johnson was asked by his son to share each Wednesday's Braves game on Sport South TV. "No matter what happens in his broadcast career," a friend

of Junior's said, "the highlight will always be the [four years] he
spent with his father" in the booth—something that Senior knew.
Dad kept it unassuming, then retired for good to his Crabapple
farm, near Atlanta, where a US Marine Corps' flag—"Next to
family, there's nothing I'm prouder of"—flew from a pole in the
front yard.

Thereafter Junior pictured Dad and Mom in front of "their
[set]" while working a game. For a time, he used Dad's signoff
when the Braves won a telecast—"and on this winning night, so
long everybody"—borrowed without Pop's permission "but with
his blessing and my love." In 2011, Senior died at eighty-seven.
One letter among hundreds sent of sympathy especially moved
the son: "When you heard Ernie Johnson do a game, it was like
summertime would never end."

When in 1968, White Sox owner Arthur Allyn began daily coverage
of Chicago's first UHF TV outlet (WFLD)—baseball's first free
cable carrier—many wondered if *pay* cable was near. Its success
was stop and start. In 1982, *TSN* bannered, "Cable Explosion Near
In Baseball." Big-league flagship stations and their outlets aired
more than two-thirds of their 2,106 games on free TV. Eight clubs
had some form of subscription or pay TV. Others were "drawing
up plans."

In the 1980s, momentum from free TV to cable seemed
irreversible. The White Sox Ken "Hawk" Harrelson, Don
Drysdale, Joe McConnell, and Early Wynn launched Sports Vision
subscription. In Detroit, Larry Adderley, Hank Aguirre, and Norm
Cash voiced ON-TV. On Pirates Action TV, Bob Prince and Ray
Scott twinned legendarily. Phillies PRISM-TV boasted Harry
Kalas, Richie Ashburn, and McCarver. Some teams sank, some
zig-zagged, others rode cable's wave.

From 1980 to 1990, cable subscriptions spiraled from sixteen million homes to nearly seventy. By 1987, smaller SuperStations existed, based on size, like Boston's WSBK. Five were labeled major. By 1982, TBS subscribers had leaped from twenty to thirty million. The Cubs were on WGN in twenty million households, swollen by Harry Caray, profiled earlier. Tim McCarver, also depicted, helped the Mets enter twelve million. The Yanks and Rangers entered five and three million, respectively.

"Between the fees cable operators [Cablevision or Comcast] would pay to include superstations…and the advertising fees the stations could bring in, superstations became huge revenue streams," wrote Jack Moore in *The Hardball Times*. "They made baseball accessible in rural areas, some for the very first time. You will find Braves fans in rural pockets not just around Georgia and the Southeast, but in places like where I grew up in western Wisconsin, hours away from both the Twins and Brewers."

Across America, viewers watched *irrespective* of team—the Pastime gaining long-term good as well as short-term profit. "We *were* [today's] MLB Network," said Glenn Diamond, heading TBS productions for twenty-two years until 2007. Out west, denizens would brave rush hour, reach home, and sit down to watch baseball. "A lot of people would watch the Braves at four o'clock while they were waiting to watch the Giants or the A's or the Dodgers or the Angels."

Bob Vorwald held a similar job as WGN Sports head of production for as long as Diamond, airing the age's other SuperStation giant. "To me, we were creating baseball fans. Not just Cubs fans, but baseball fans," he told *Yahoo! Sports'* Mike Oz. The Cubs "had probably the greatest baseball salesman in the history of the game with Harry Caray," seen and beloved everywhere that people knew baseball and probably in some areas where they didn't.

Always, Vorwald was aware of their ubiquity. "[The Cubs were] on in every big-league clubhouse," he said. "It was us against the soap operas," Wrigley Field sans lights until 1988. The Cubs were even better since they were aired earlier for most of the country. "You'd hear [pitcher] Kerry Wood talking about being a kid in Texas and watching the games on WGN," Caray's lifeline to America and beyond.

Even the smallest major SuperStation served baseball's clientele. For the decade after 1985, Dallas/Ft. Worth independent station WKVT had rights to distribute its signal across the Southwest. Numerous Voices, including Merle Harmon, Steve Busby, and Bob Carpenter, did TV. Two men who called video *and* radio are noted here. One, Eric Nadel, still does the wireless. The other, Mark Holtz, brought capacity and stability to play-by-play.

Holtz was a homebody who lived out his favorite film, *It's a Wonderful Life*, the Illinois native paying his way through Wartburg College in Iowa. His trek through the minors ended with Denver's 1976–1980 Bears. In 1981, Mark joined Rangers cable, worked WBAP Radio, then keyed KTVT's five-state TV network. A deep, velvet tone, passion for baseball books and statistics, and fueling interest when the season ended before July made him "a fan that loved baseball...and had the ultimate voice for the game," GM Tom Grieve said.

In 1989, a group led by George W. Bush bought the franchise, attendance breaking two million for the first time. On August 22, Nolan Ryan got his five thousandth career strikeout. Later, Holtz spied him on the clubhouse stationary bicycle, amazed that "you're not out celebrating!" Smiling, Nolan said, "If I don't ride this bicycle, I won't get ready for my next start." Couldn't he relax once? No, Ryan said. "Got to ride a bike for forty-five minutes after everybody leaves the day I pitch."

In 1993, the Rangers lost their last game at Arlington Stadium, an original minor-league park. A year later, The Ballpark at Arlington opened, merging aspects of old parks like Ebbets Field, Wrigley Field, and Tiger Stadium but lacking a retractable roof to stem area heat and humidity. On July 28, 1994, Texas lefty Kenny Rogers pitched a perfect game there, Holtz crooning his final out: "Two out, ninth inning, perfect game, Kenny Rogers for the Rangers against Gary DiSarcina... And the pitch, swung on, lined to center, [Rusty] Greer is there, he's calling. He's got it! Hello perfect game!" Holtz said, a derivative of his "Hello win column!" said after each Texas triumph. "Kenny Rogers mobbed on the mound! Twenty-seven up, 27 down! ...the first perfect game [score: 4-0] in Texas Rangers history! ...What a scene in the first year of The Ballpark in Arlington!"

At the time, wife Alice recalled, "He was copacetic, the losing about to end" before an August 12 player strike ended the first-place Rangers' year. In 1996, Holtz voiced their first-ever postseason. Usually, off-season gave the homebody a chance to tend his dog, friends, Alice, and daughter Cindy. "My life totally revolves around family," he said. "When Alice was diagnosed [in 1989, of cancer], I thought I would be left alone." Now Mark himself was diagnosed with leukemia, a bone marrow disease.

"His blood-forming cells don't function normally," Alice said. "He takes medication, but the pain is awful." In February of 1997, Mark began blood transplants and hormone injections, his illness shocking the Dallas-Ft. Worth metroplex and Rangers radio/TV network. Holtz started each home Rangers broadcast by booming, "It's baseball time in Texas!"—a phrase still used around the team's new park, retractable roofed Globe Life Field. It is hardly the sole evidence of his rapport.

Mark Holtz Lake, a wide spot in Johnson Creek north of The Ballpark, is named in his memory. When Texas beat Tampa Bay in the 2010 Division Series Game Five to take its first postseason

series, Nadel exclaimed, "Hello win column!" on Rangers radio—
the first time he had used the term since Holtz's leaving. Before
each game at Globe Life, ebullient public address Voice Chuck
Morgan still proclaims, "It's baseball time in Texas!"

On May 22, 1997, the eight-time Texas Sportscaster of the
Year called his finale. "I'd give anything to have another game,
but I know my situation. It's over," he said. Holtz entered Baylor
University Medical Center for a bone marrow transplant. "Mark
took care of me all those years," said Alice. "Now I'm taking care
of him." She died in 1999. Holtz preceded her, on September 7,
1997, having lived a wonderful, if abbreviated, life.

On occasion, a career can seem ordained at birth. Eric Nadel was
born May 16, 1951, in Brooklyn. He was—of course—a Dodgers
fan who revered Vin Scully. In 2014, Nadel got the Frick Award for
broadcast excellence, the first principal Voice of the Rangers to be
honored by Cooperstown and third of the Lone Star State's Voices,
succeeding the Astros' Milo Hamilton and Gene Elston in 1992
and 2006, respectively. His home run call, "That ball is history!" is
history itself.

Nadel joined the Rangers in 1979, his "career path different
from many Voices in baseball," he said. From Hilda Chester to the
Dodger Sym-phony Band, Brooklyn's big-league baseball history
had been idiosyncratic. True to form, by 1978, Eric had broadcast
minor league hockey at several stops and the Dallas Diamonds of
the Women's Professional Basketball League. "That July, Rangers
broadcast head Roy Parks asked if I'd done baseball." Loving the
game, Eric creatively embellished.

Nadel told Parks that he had aired baseball at Brown University.
Fine, said the Rangers domo: Send a tape. Not having one, Nadel
had played baseball in college and possessed "a decent command
of the game's history and phraseology," going forth to tape a four-

game series at Arlington Stadium. It was "my tryout," Eric said, and it was enough.

"Roy Parks figured that by 1979 I could do baseball without embarrassing him. If you like baseball on skates, hear my awful early tapes. With so much cash at risk, today, my hiring could never happen." Nadel often thinks what he would have missed—in particular, the then fifty-year-old Rangers née Senators franchise's first pennant in 2010, ending a North American professional sports franchise record for playoff futility.

Nadel especially liked parks heavy with individuality. Tiger Stadium was "the only place I've worked where I could see the spin of the ball on its way to home plate." Eric still shudders at Texas catcher Geno Petralli once tying a bigs record of six passed balls, trying to catch Charlie Hough's knuckleball. Seeing the late break, he "felt for Geno each time he chased another knuckler to the screen, almost directly beneath our booth," his frustration more audible.

Eric outlasted Hough, Petralli, and David Freese's homer that kept Texas from taking the 2011 World Series: now his franchise's longest-running Voice. Like Holtz, Nadel was inducted into the Texas Hall of Fame, also twice winning the Associated Press award for best play-by-play in the state and writing four books, including *The Texas Rangers: The Authorized History*. In 2020, he inked a two-year contract extension keeping him on the air through at least 2022. Eric belongs to a select list of Voices airing baseball for forty or more years with a single club.

Phillies announcer Scott Franzke likes to relate growing up in Dallas hearing Nadel and Holtz tell their inside jokes, "The Rangers flagship outlet [then WBAP] playing its silly theme, its Texas twang pitching Panhandle Slim shirts." In 1991, his freshman year at Southern Methodist University, Scott and two friends decided to see spring training. Next day, driving all night, they arrived at the Rangers' Port Charlotte, Florida, camp.

On a lark, Scott sent a note to the booth on a napkin from the concession stand—all he had to write on—asking Holtz and Nadel "to say hi to Dallas." Improbably, they did, "Even mentioning our *names* on the air, followed by a crack about mustard on the napkin," said Franzke. "Nothing beats baseball for making simple, small connections with fans, day after day, many with mustard-stained napkins of their own." Nadel continues to connect. Looking back, Brooklyn to Cooperstown was a natural evolution.

Since 1951, WPIX New York, more often than not, has been the Yankees free TV flagship. In the 1980s, it became the club's SuperStation, announced by, among others, arguably the team's most beloved-ever Voice, Fiero (Philip) Francis Rizzuto, a trolley car conductor's son.

Born in Brooklyn in 1917, Rizzuto acquired a lasting moniker from minor-league teammate Billy Hitchcock. Eying the five-foot-six shortstop, Billy said, "Man, you're not runnin', you're scootin'"—ergo, Scooter. In 1941, he made the big club, Red Ruffing, Bill Dickey, and Joe DiMaggio, among others, giving Phil the cold shoulder. Hurt, he approached another star. "Relax, they're not snubbing you," Lefty Gomez said. "They just haven't seen you yet."

As a player, Phil won or made the 1950 MVP award, five All-Star teams, nine pennants, and seven world titles. "My best pitch," said Vic Raschi, "is anything the batter grounds, lines, or pops in his direction." By 1956, Scooter had devolved into a .231 batter with no extra-base hits. One day, GM George Weiss told him that the club had a chance to acquire Enos Slaughter from Kansas City. "What do you think?" he asked. Phil: "Boy, getting him would be a help."

Scooter was released on August 25—Old Timer's Day—replaced by Slaughter on the roster for the season's final month. As

a player, Rizzuto, at thirty-nine, was through. "I couldn't believe it," he said, shocked. "The pinstripes meant so much to me then. It was something to live up to and live for." Mel Allen had him call a half-inning here or there. Baltimore offered a broadcast post, but Phil wanted to stay in the Bronx.

Jim Woods, a Yankees mic man since 1953, was dispatched that fall, Peter Lyon wrote, so that Phil could "become the junior member of the team that broadcasts all of the Yankees games with Mel Allen and Red Barber, the country's best-known sports announcers." To his credit, Scooter knew the score: "Can you picture a thorn between two roses? I wouldn't have hired myself!" In the end, shortstop's loss was New York's radio/TV's gain.

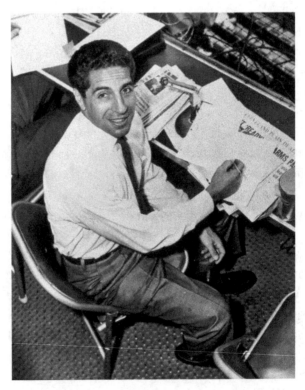

Phil Rizzuto

Rizzuto may have known how to play "small ball"—get on base,
then score runs methodically—as well as any player of his time. As
a broadcaster, he was at first a boat without an oar. Stealing a sign,
Phil interrupted to tell the audience—"Oh, my God! He's going to
steal home!"—as Allen called a pitch. Mel and Red at first resented
the interloper. One day, they left the neophyte by himself behind
the mic—"outside the booth if I messed up, but I was alone"—
trying not to mangle language or abide dead air.

"Philadelphia Ath-a-letics," Phil would say. "No, it's Athletics,"
Allen corrected him, *on* air, frosting Scooter's mother. In private,
Mel held a session of dos and don'ts. Among the latter may have,
should have, been not to leave before the final pitch. For a while,
Phil did two innings daily. "He'd finish after the seventh or eighth,"
said Allen. "Red and I'd complete the game."

In 1957, a game went into extra innings. Mel said on air, "And
now to take you into the tenth, here is…here is"—not Rizzuto,
already on the George Washington Bridge, going home to "my
bride" Cora, a phrase he used till death. Even when Rizzuto
stayed, "You'd hear him hook the mic into the stand announcing
the final score," said Allen. On June 24, 1962, Phil got his most
jarring reminder that baseball is at least a nine-inning game—
often more.

That day, 35,368 gathered in Detroit to see the Yankees play
the Tigers. Leaving in the seventh inning, Phil flew to LaGuardia
Airport, headed to New Jersey, and turned on the radio. It was
seven o'clock. The 1:30 game should have ended by four. "I drop
my jaw; Red's starting the nineteenth," Scooter said. Mel had TV.
"I'm on the bridge and say, 'What am I gonna do?'" Phil arrived
home, kissed his "bride," and turned on WPIX TV. There Mel
was, in red-faced living color. As we have seen from Ernie Harwell,
the game finally ended after seven hours: Yanks, 9-7.

A year earlier, in 1961, the more play-actor than play-by-play
man had called Roger Maris' sixty-first home run of that season
to pass Babe Ruth's sixty. On October 1, Red Sox pitcher Tracy
Stallard took his "windup. Fastball, hit deep to right! This could be
it! Way back there! Holy cow, he did it! Sixty-one for Maris! Look
at 'em fight for that ball out there! Holy cow, what a shot! Another
standing ovation for Roger Maris… One of the greatest sights I've
seen here at Yankee Stadium."

"Holy cow!" was, as noted, the signature Scooter borrowed
from Harry Caray. By now, Phil had also developed a unique way
of keeping score. One day, Bob Costas probed Scooter's scorecard.
A slash bespoke a "K." "WW" seemed to mean a single and
sacrifice. Puzzled, Bob said, "I've seen a lot of ways to keep score.
What's 'WW'?" Rizzuto: "Wasn't watching."

For a time, Phil followed a traditional path of play-by-play: balls
and strikes, a stray story now and then. This changed after Allen
and Barber were axed in 1964 and 1966, respectively, Phil now
the true Voice of the Yankees, forming an intensely personal style
unlike any other then or now.

To the *Times*' George Vecsey, a typical Scooter inning tied
"birthday greetings, movie reviews, golf tips, war memories"—
he had served in the Philippines and Australia—"frequent
psychosomatic broodings, fearsome predictions of rain, sleet, snow,
thunder, lightning, tornadoes, waterspouts," and allergies and
insects, a dragonfly shooing Phil from the booth. One viewer wrote
a letter "beefing about that holy cow," he said. "He said in India
the cow is sacred, and I shouldn't say such a thing." If it's sacred,
Phil mused, what's wrong with "Holy cow"?

In 1964, the Yanks won their then-normal pennant. Normality
finally returned with a 1976 pennant and 1977–1978 first World
Series title since 1962. By then, Phil and former All-Star first
baseman Bill White had forged a duo some likened to Abbott and
Costello. Once the camera spotted a lovely teenage girl. "White,"

said Rizzuto, "she reminds me of the old song, 'A Pretty Girl Is
Like a Memory.'" Bill said: "Ah, Scooter, I think that's 'melody.'"
Phil: "Really? How do you know her name is Melody?"

Critiquing his appeal, columnist Will Grimsley said Phil
"attracted a broader spectrum of the audience, non-baseball
people who might otherwise [not] be watching." In 1994,
Cooperstown's Veterans Committee finally put him in the Hall
of Fame. That fall, Phil and Cora got a trip to Europe from the
Yankees. At the Vatican, Pope John Paul II changed his schedule
for an audience. "I'll tell you," said Rizzuto, "that's as close to God
as you can get."

In 1996, Rizzuto retired. Next year, the *Times*' sports media
critic, Richard Sandomir, wrote, "Where are you, Scooter? The
[Yanks] Phil-free games miss his mirth." In 2007, Phil died at
almost ninety, making baseball a far less joyous place.

By 1982, the growth of SuperStations in full bloom, a Harris
national poll reported that baseball had reemerged as America's
favorite sport, leading football, 23–20 percent, others trailing.
Of the reasons for the Pastime's edge, it seems likely that cable
television played a major, perhaps crucial, role. Yet many in
baseball doubted that was necessarily so.

Several years later, new Commissioner Peter Ueberroth said
that "the SuperStations come into certain areas and achieve higher
ratings than the local club on television. It is a basic unfairness."
Successor once-removed Fay Vincent agreed: "SuperStations
restrict the viability of local broadcasts because they diminish the
attraction of the local games and divide the advertising market."
Sandomir expressed a more neutral view. Baseball's goal, he said,
was to sanely manage a flood of cable games—and affect "how
those games are distributed."

WGN distributor Gerald Weaver said, "Baseball wants to be rid of us [SuperStations]." Baseball said it merely wished to curb competitive disparity. In January 1985, Ueberroth got Turner and other SuperStation clubs to pay tax into a central fund proportional to the number of households *beyond* their local markets—and the number of games. Next month, Turner agreed to pay $30 million over five years to prevent local owners from acting either by lawsuit or through Congress.

Moreover, baseball wanted Congress to continue to black out SuperStations when they opposed local networks for the same game. In 1996, merging with Time Warner, TBS became a basic cable channel, letting it collect subscription fees from a cable operator, "[Marking] the end for regular national broadcasts of individual teams," wrote Jack Moore in *The Hardball Times*. Braves yearly telecasts dropped from 150 to ninety-six games "to placate national networks like ESPN and Fox," worried about their "games losing value" if matched daily against the Braves.

In 2014, WGN too became a basic cable channel. Perhaps coincidentally, it also dropped sports programing. Today, almost all clubs air local TV via a regional sports network—and "nearly all of baseball's postseason is broadcast through cable," said Moore. In Chapter 12, we will look at current cable and other technology that succeeded the SuperStation, making baseball more accessible. First, however, the game has become more welcoming in another sense, irrespective of race, sex, or creed.

Chapter 11

1950S–TODAY: OPENING DOORS

Vin Scully once named Sandy Koufax best all-time pitcher; Willie Mays, "best all-around"; Jackie Robinson, "fiercest competitor." As proof, he recalled an incident from 1951 at the Catskills resort Grossinger's, where No. 42 was hosting a seminar.

For the heck of it, the ex-hockey forward Scully decided to ice skate. Jackie and wife Rachel, "Large with child," Vin said, asked to go along. Tying laces, Robinson told him, "I'll race you for five bucks."

"Gee, Jack, I didn't know you skated," Scully said.

"I've never been on skates in my life," said Jackie, ankles turned in.

"Jack," said Vin, trying to be fair, "there's no way you can beat me."

A photo shows them, knees bent, facing the camera. "Maybe you'll beat me, and that's how I'm going to learn," said Robinson. Later, Scully recalled, "That's what made him great. To Jackie, his competitive spirit would overcome how he had 'never been on skates.'"

In 1965, the first Black man to break the major league color barrier became the first to describe baseball as a network television commentator, Jackie showing the same desire to learn and defiance toward defeat. He knew that equality had been too long delayed above the field, not just upon it—especially for Black,

Hispanic, and later women Voices calling baseball play-by-play and analysis. In 2021, big-league baseball still has few Black or women announcers. A higher percentage are Hispanic, likely miming their niche as America's fastest-growing minority.

In March 1965, Robinson met reporters to discuss his role as commentator on ABC's new *Major League Championship Baseball*. Jackie brought the same insistence as he had at Ebbets Field on courage without blinders and a future without fear.

Then chairman of a Harlem bank, Robinson said he had announced "a couple games" and been a Little League analyst. "I do not intend to pull any punches. Neither do I intend to have a chip on my shoulder," he said, adding the self-evident, "I've never been afraid to talk out loud." Next month, he addressed truth's double edge on the eve of the series debut: Thanking the network, Jackie said it was still "a tragedy it has not happened before."

The new ABC series began April 17. Eastern, Central, and Mountain time zones saw football Giants Voice Chris Schenkel and former skipper Leo Durocher on Giants-Mets from Shea Stadium. New York eyed Red Sox v. Orioles, with Merle Harmon and Robinson, "Sending Jackie to where the [media] focus was," said Harmon. Howard Cosell, not yet famous, did his first weekly pre-game show. The West got Keith Jackson and ex-Yanks outfielder Tommy Henrich on Braves-Cubs at Milwaukee. The three largely Big Apple–centric pairs mixed play-by-play and color men.

On May 8, another precedent fell: "TV Invades the Dugouts," the *Chicago Tribune* said of ABC placing a camera in each DC Stadium dugout, violating their sanctity. By then, the novelty of Robinson's hiring had yielded to learning a craft. "Broadcasting was new to Jackie, and this was also the first year that I had earphones linking me directly to the producer [Chuck Howard] in the booth," said Merle. "He talked to us as we were talking to the

audience." Once Chuck spoke to Jackie, who said "OK" on air, likely confusing it.

Jackie adjusted. "For me, working with him was a marvelous experience," said Howard, noting his "high, stabbing voice, great presence, and sharp mind." On October 19, 1965, NBC bought baseball exclusivity from ABC. Braving diabetes, Robinson aired color for the 1972 Montreal Expos, dying that October at fifty-three. "He had a lot of broadcast potential," said Harmon. "All he lacked was time."

Jackie Robinson

Memory. Mention a name, then define its meaning.

If you love baseball statistics, Joe Morgan may mean the man who hit a then–second base record 268 home runs—the first man at that position with two hundred homers, two thousand games, and two thousand hits.

If you like awards, Joe may mean being named 1975–1976 Most Valuable Player, earning five straight Gold Gloves, making ten All-Star teams, and having *The New Bill James Baseball Abstract* call him the "greatest-ever second baseman, ahead of Eddie Collins and Rogers Hornsby."

If you prize imagery, you recall him flapping his bat like a chicken wing—a timing mechanism suggested by Houston then-teammate Nellie Fox—or Joe's glove, as small as a Little Leaguer's, or how the ball seemed to pass through it on a successful 6-4-3.

If you love the Hall of Fame and Museum—Joe did long before his 1990 induction—you prize how he enriched it on the 1994 Board of Directors and as Vice Chairman from 2000 until his 2020 death.

However you remember "Little Joe"—likely the greatest oxymoron in baseball history—there was a lot to like. Author James also calls Morgan the "greatest percentage player in baseball history," referencing fielding percentage, stolen base percentage, walk-to-strikeout ratio, and walks per plate at-bats.

Looking back, No. 8 called his career "a salute to the little guy," meaning his five-foot-seven, 160-pound frame, Morgan arguably getting more out of less size than any player ever—but in fact, he was the ultimate big-gamer. Ask American League teams in Boston and New York, whom Joe demolished in the 1975–1976 World Series.

"Ours is a quick gratification society. I like deferred," he said, a grand attitude for baseball; its long season making you prove yourself each day. Growing up in Oakland, he told his mother

that "if she let me enter baseball, I'd get my degree." She did—and he kept his word. Witness Joe's BA degree from California State–Hayward.

Retiring in 1984, he then entered broadcasting. As a player, he had been a chatterbox. On TV and radio, he learned to parse. "What I try to do is act like I'm on the bench and you're sitting with me. Hopefully, I'll think of the questions before you ask." From 1990 to 2010, he and Jon Miller aired ESPN's *Sunday Night Baseball*. In memory, they remain a celebrated team.

Morgan was born in 1943 in Texas, moved to California at five, and was later spurned by scouts: too small, they said. He played baseball at Oakland City College before being signed by the Houston Colt .45s in 1962, getting a mere three-thousand-dollar signing bonus and a five-hundred-dollar-per-month salary. In 1963–1964, Morgan briefly played at Colt Stadium. Next year, the renamed Astros moved inside.

In 1965, Joe led the league in walks, replaced idol Fox at second base, and became *The Sporting News* Rookie of the Year. In late 1971, Morgan went to Cincinnati in a multi-player deal, Reds skipper Sparky Anderson telling his GM, "You have just won the pennant." He was prophetic, Joe making the 1972–1979 All-Star team, being the first NL second baseman voted back-to-back MVP, and his Big Red Machine taking the 1972–1973, 1975–1976, and 1979 division, league, and/or world title.

If you like baseball, you had to prize mid-1970's October. In the 1975 Series, Game Six tied at six, Morgan pulled to right—a tenth-inning triple or homer—till Dwight Evans turned, caught the ball, and began a double play. "I thought I'd done it," Joe said. Next night he did, plating the winning 4-3 run. In next year's Classic, he homered and hit .333, the Reds first to sweep

the LCS and Series. Each season he led baseball in OPS: on-base percentage plus slugging average.

The 1976 Reds may be the finest team of post-war America: Cincy led both leagues in eleven separate categories. The key was Morgan. "I have never seen anyone, and I mean anyone, play better," Anderson said. Daily Joe worked out, punched a speed bag, used handgrips—and played dominoes. The result, mate Pete Rose said, was "coincidence. Where Joe plays, you win." Released in 1980, Joe returned to help win Houston's first division. In 1983, he reunited with Rose and Tony Pérez in Philadelphia, the Wheeze Kids making the Fall Classic. A year later, he finished up at Oakland, where he began. What next?

For the cerebral Morgan, it was a question posed daily. Managing was out: "You're hired to be fired." Joe started a beer company, opened three fast-food restaurants, and aired the 1985 Reds and 1985–1988 ESPN college baseball. He was in the TV booth when Rose's 4,192nd career hit broke Ty Cobb's record. In 1986, Joe began a nine-year Giants gig, finding that he preferred being an analyst to play-by-play. That year, ESPN hired him to call the College World Series. For ABC, he worked 1988 *Monday Night Baseball* and 1989 *Thursday Night Baseball*, the 1988 ALCS, and as field reporter on the 1989 World Series.

In 1987, Joe's uniform No. 8 was retired. From 1994 to 2000, he helped to call three World Series, three of each league's LCS, and four All-Star Games on NBC. He was everywhere. Morgan began an ESPN.com column, wrote *Baseball for Dummies*, and went "where the game takes me." Increasingly, it took him to postseason double duty. One week, he traveled twelve thousand miles: "Every night, different airport, different motel."

On ESPN's *Sunday Night Baseball*, Morgan hoped to educate. "I'm in the business to help the viewer," he said, knowing the

downside: Strategy can put asleep. "Chemistry takes a while," said his partner, Miller. At first, Joe mused, "What you see is the end of something. When we first started, we didn't always see eye-to-eye." Jon came from radio, Joe TV. Miller adjusted. Morgan relaxed. In time, most liked Jon's lore and Joe's game within the game. The long-running twosome is how many recall Morgan best.

Joe's *Sunday Night* reached its end after twenty-one years, for causes unclear. In 2010, Morgan returned to the Reds as an advisor for baseball operations, including community outreach. Next year, he began a one-hour general sports talk program on Sports USA Radio Network. Joe helped enable the Baseball Assistance Team for indigent ex-players. In 2013, a statue of Morgan was dedicated at Cincy's Great American Ball Park. Then, in 2015, he was diagnosed with myelodysplastic syndrome, which became leukemia. In October 2020, Joe died in California, at seventy-seven. Only death could separate him from The Game.

From 1971 to 1988, Bill White became the first Black man to air big-league play-by-play. In 1989, he became National League president. In 1994, White retired from office three years before the Pastime retired Robinson's No. 42 on the golden anniversary of Jackie's debut. "At each step," Bill said, "I thought of what he faced along the way."

As a teen, White left Florida to attend Hiram College in Ohio. He hoped to practice medicine, envisioning baseball as a means, not end, "making some money only for my pre-med courses." In a 1952 tryout, he ricocheted hits all over Forbes Field's gaping alleys and enormous center field. Giants brass had seen enough, inking him to a pact with Carolina League in Danville, Virginia. Soon the first baseman had enough of the "colored only" restrooms and segregated hotels. Like a refugee, he roomed with Black families on the road.

Inner-directed, White turned anger back on tormenters. "The more vicious the reaction, the more I turned to baseball—and the harder I hit the ball." He was also handy with the mitt, leading the NL in 1956 and 1966 in putouts and assists. Drafted, Bill quit his local army baseball team, thinking it bigoted. The Giants' 1958 move to San Francisco may have enhanced others' tolerance, but not his luck: Orlando Cepeda blocked him at first base. A deal to St. Louis then made things worse. At the time, the incumbent at that position was legendary Stan Musial. Nonetheless, from 1960 to 1966, White yearly won the Gold Glove for fielding, four times knocking in a hundred runs.

Bill also got the 1961 Cardinals to leave a segregated Florida hotel—and helped players' wives start a color-blind day school and kindergarten. It now seems elemental. Then some found it radical. In 1969, White retired with a career 202 homers. Next year he hosted a nightly segment on Philadelphia's ABC TV outlet. Hearing him call basketball, Howard Cosell phoned Yankees head Michael Burke, who offered Bill play-by-play. White knew that failure might hurt other Black mic men. "My first year [1971], I was terrible. I had no style. The next year, I was a little less terrible. The Yankees could easily have fired me." Instead, Bill's work ethic helped him keep his job.

The 1971–1973 Yankees finished three games over .500. Commuting two hours each day from Bucks County, outside Philadelphia, White critiqued the taped segments of every game he did on radio, "Something I never did when I started," said the Yankees' Frank Messer. Slowly, White improved. A cause was affinity. Tim McCarver renewed Ralph Kiner. Phil Rizzuto unlocked White's wit. In turn, Bill—to Scooter, always "White"—became Rizzuto's gentle duelist.

"Phil made me laugh," said White. Once Scooter recalled putting grits in a pocket his first time South. "It looked like oatmeal. I didn't know what to do." Another day, he began a broadcast: "Hi, everybody, this is New York Yankees baseball. I'm Bill White. Wait a minute! I swear to God I didn't." The Apple chortled at Phil's constant use of his partner's surname. "How'd you like to work eighteen years with a guy," Bill said, "who never learned your first name?"

White fueled Black analysts and play-by-play men like Tony Gwynn, Torii Hunter, David Justice, Harold Reynolds, Ken Singleton, and Dave Sims—African American Voices on network/local radio/TV. In 1976, baseball's four-year ABC/NBC TV pact let networks pick Classic mic men—inevitably their own—leaving network radio to local-teamers like White. Thus, in 1977 he crossed another bridge—the first Black broadcaster to call a World Series on network wireless, airing Games Three to Five from Dodger Stadium. The Yanks took a 3-2 set edge over their ancient foe, then won the Series, their first in fifteen years, White back on local radio for Game Six from New York.

A year later, the Bombers trailed Boston by fourteen games in the AL East. New York surged, tying for the flag. October 2 broke crisp and light—the first AL playoff since 1948. At Fenway Park, the Yanks trailed, 2-0, in the seventh, the wind blowing out. Bucky Dent swung. "I saw Yaz [Carl Yastrezmski] looking up," said Sox catcher Carlton Fisk, "and I said, 'Oh, God.'" On WPIX, White described and disbelieved. "Deep to left! Yastrzemski will not get it! It's a home run! A three-run homer by Bucky Dent! And the Yankees now lead by a score of 3 to 2!"

The Bombers won, 5-4, then took a third straight LCS. The 1978 Series plot v. the Dodgers had a familiar end: Yanks, in six. "Popped up behind the plate!" said White, for the second straight year on Series play-by-play. "Coming back, [Thurman] Munson! Throws the mask away! ...The Yankees have won their second

straight world championship!" A decade later, now-scout Dent smiled sadly. "Stupid us. We just thought we'd keep winning." Instead, the Bombers' next title kept until 1996, nearly the end of Bill Clinton's first term.

For Bill White, strains parted, then reconnected a decade after the 1978 Series. Dodgers owner Peter O'Malley led a search committee to find an NL president, one owner saying, "It's his [White's] if he wants it." Ultimately, he did, becoming the major leagues' first Black president. "One part of Robinson would be proud," said Dodgers announcer Jerry Doggett. "The other would have wondered what took so long."

If it were possible for Robinson and White to discuss Black broadcasting, they would likely wonder what took so long to be alarmed about its present state. In 2007, Dave Sims was hired as Voice of the Seattle Mariners. He is currently among only three Black play-by-play men in big-league history—the others, Rob Ford, joining Houston in 2013 from Kansas City, and White.

A minor-league study shows only a handful of Blacks broadcasting the game. Jeff Lantz, senior communications director for minor league baseball, does not dispute the tally. Play-by-play man James Verrett blames the problem on making ends meet. "It's the search for the Holy Grail. You may be out there in the desert for a long time." Low wages are an old story. The dearth of play-by-players has been a story not discussed. How to address it? Like the 1996 film *Jerry Maguire* intoned, "Show me the money!"

Adam Giardino is white—also lead announcer of the Triple-A Scranton/Wilkes-Barre RailRiders. He, Ford, and Sims, former minor-league broadcasters Darius Thigpen and Jay Burnham, and Iowa Cubs Voice Alex Cohen have forged The Black Play-by-Play Broadcaster Grant and Scholarship Fund to try and collect

"enough money" to allow prospective big-league Voices to stay the course, waiting for a job that may never come.

Ford grew up in the Bronx, graduated in 2001 from Syracuse University's S.I. Newhouse School of Public Broadcasting, and did minor league play-by-play in Binghamton, New York; Yakima, Washington; and Kalamazoo, Michigan. He aired the pre-and post-game show for the Royals, moved to Houston in a similar role, and in 2013 became the Astros lead Voice, replacing Brett Dolan, Dave Raymond, and the retiring Milo Hamilton.

Sims is a Bethany College graduate who joined the New York *Daily News*, then segued to WCBS, WFAN, XM Satellite Radio, and ESPN TV Big East and Radio *Sunday Night Football*. In 1993–1994 and 2005–2006, the two-time Emmy recipient did ESPN baseball. In 2012, he aired Fox's broadcast of Philip Humber's perfect game. In 2018, 2019, and 2020, he was named the National Sports Media Association Washington State Sportscaster of the Year.

In Seattle, Sims has a view not seen in his native Philadelphia: Elliott Bay, Mount Rainier, and sunsets from Albert Bierstadt. The view of major-league Black broadcasting is dire, requiring what impressed Vin Scully about Robinson: "his maturity and responsibility" and even anger, Vin calling Jackie "the only player I ever saw who could steal better when he was mad."

In contrast, Hispanic baseball broadcasting, airing games in Spanish, has steadily grown during the past half-century. Its founder, Buck Canel, was "for generations…the voice of the World Series as heard by the collective ear of Latin America," wrote Jerry Izenberg in the *New York Post*. "Kids who played their baseball" in the Dominican Republic, Venezuela, Nicaragua, and Puerto Rico "listened to the voice of a dream." Until Fidel Castro seized power in 1959 and closed his nation, the dream of playing baseball in

America glowed brightest in Cuba, tying "the island in the sun and America's Game."

Throughout the Western Hemisphere, Canel used radio and later television to cover the Pastime from 1937 to 1972 retirement. "The shame is that the average American knows little about him," said *Sports Illustrated*'s Robert H. Boyle. He led "a double life" as the father of Cuban play-by-play—"the George Washington of Spanish-speaking baseball announcers," said *SI*—and as "The Voice of America, one of the great figures of the age."

Born in Rosario, Argentina, in 1906, Eloy B. Canel—Buck, derived from his middle name, Buxo—moved with his family as a boy to New York, where he learned English, worked for the *Staten Island Advance*, and inherited a love of language from grandmother, playwright, and novelist Eva Canel. After his father's death, Buck, graduating, went to Cuba to live with grandma—and manage a winter league team that starred outfielder Oscar Charleston, named by Bill James the fourth-greatest player of all time.

At twenty-five, Buck joined Associated Press in Havana as it swelled Latin American coverage. In 1935, returning to New York, he joined the worldwide French wire service, Havas, as Latin American news editor and learned that NBC Radio meant to start shortwave broadcasts to Latin America in Spanish. Getting Havas's approval, he began his "double life" with the wire service and as a Voice—Frick Award Class of 1985, baseball's first Spanish-speaking announcer.

In 1937, Canel voiced the Giants-Yankees World Series—his first of a record forty-two. A Hispanic-speaking record, twenty-one, involved the Yanks. NBC's Red Network carried Canel's vision, the *Gillette Cavalcade of Sports*, on more than two hundred US and Latin American stations, then TV, once Cuba became wired. The series featured such Spanish speakers as Pancho Pepe Cróquer and Rafael

(Felo) Ramírez. The latter coanchored *Cavalcade of Sports* with Buck, aired forty Caribbean World Series and the 1993–2017 Miami (née Florida) Marlins, and received a Frick Award in 2001.

In 1951, Ramírez aired his first World Series at Yankee Stadium. A foul ball started rolling down the net, and Felo reacted like a prototypal fan, reaching out from the booth and snatching it. He looked over to see "an immortal next to me: Humphrey Bogart," who "just laughed. Even then, getting a baseball was a real big thing." Throughout the hemisphere, a big thing was Felo booming his hallmark *Esstrike!* warning, "If you have cardiac problems, back away from your radio now!" and baying *Estan Ganado, Los Marlins!*—"The Marlins are winning!"

"I have two different personalities," Canel told Boyle in 1963, "one Spanish, the other English. If Héctor López gets a hit, I lead with that in Spanish. In English, I write that Whitey Ford pitched a shutout for the Yankees." A decade later, *TSN* columnist Bob Broeg called Canel "one of the most interesting men behind the scenes in sports." *TIME* styled him "the Graham McNamee of the Caribbean." Buck replied: "Graham McNamee was the Buck Canel of the United States." To Broeg, he was "a trained reporter who just happens to broadcast on the side."

During World War II, Buck's NBC Red Network series, *El Juego de Hoy* [Today's Game], lit its twenty-four-hour Latin American division. "A slice of a game" was aired from Canel's re-creation earlier each day. After the war, the man who lived 24/7 before the term was used did 1954–1957 Yankees home games, often simulcast in Latin America, on then-Spanish station WHOM in New York to more than two million Latin residents. A *TSN* 1955 "Voice of the Fan" letter hailed him as an aficionado from Cuba, saying that listeners "should hand an orchid to the…swell guy who broadcasts the major league games to us, the Spanish-speaking people."

About this time, wrote Boyle, Canel's "double life" resurfaced as a war correspondent in Havana for "the Spanish version of the Gillette Cavalcade of Sports for NBC." According to Izenberg, with Juan Batista overthrown, Castro, a great admirer of Canel's, was one 1959 day advancing with his army. Buck was watching the procession when "he heard the familiar voice shouting above the noise: 'Buck…Buck…Buck.'" A regular listener, Castro leaped from the jeep to hug him, likely miming his trademark in Spanish: *No se vayan, que esto se pone bueno!*—"Don't go away, this is going to get good!"

Canel had first suggested that "the course of history might have changed had a mediocre college pitcher named Castro ever learned to throw a decent curve," wrote Izenberg. Now he asked about US baseball history. A year before, Castro had heard Buck announce the Yankees-Braves Series. Fidel now demanded, "Buck, why [Milwaukee skipper] Fred Haney did not pitch [Warren] Spahn instead of Lew Burdette in Game Seven?"—Burdette losing, 6-2.

Sadly, such curiosity did not ensure baseball would remain on the imprisoned isle. After a time, the Triple-A Havana Sugar Kings left for Jersey City. "Soon after, Castro strongly recommended that Cuban players for the off-season stay home," wrote Boyle. He nationalized the sport, players staying in Cuba as amateurs. As for Buck, he had winter-league games in Puerto Rico videotaped and flown to New York, where he aired play-by-play in Spanish and English. "Last year," he crowed, "we had a higher rating than the Mets."

Jorge Iber was born in Havana, Cuba, raised in the Little Havana neighborhood of Miami, and is an author and Associate Dean and Professor of History at Texas Tech University—an expert on Hispanic broadcasting.

Iber notes a 2018 recent study showing that "Latinos comprise slightly less than one-third of Major League Baseball [players] and about one-half of Minor League Baseball rosters." Since the 1950s, Hispanic play-by-play has grown from a prick on the big-league map to twenty-one of thirty teams airing games in Spanish in 2021. The Dodgers were the first major league team to pay attention to the Spanish-speaking market and broadcast bilingually. Three Hispanic Voices (Canel, Ramírez, and Jaime Jarrín) have now received the Frick.

Born in Cayambe, Ecuador, Jarrín migrated at nineteen to Los Angeles to become a newscaster who later covered President Kennedy's funeral and Winston Churchill's memorial service. In 1959, he began re-creating the Dodgers—los *Esquivadores*. In 1973, Jarrín debuted their Spanish Network, relishing 1980s Fernandomania; the 1981, 1988, and 2020 World Series; and making Cooperstown in 1998.

Other Voices have fueled Hispanic radio/TV's rise. Eduardo Ortega started radio at twenty, was hired by the Padres, and is in his thirty-fifth season. Juan Angel Avila broadcast the Pads from 1998 to 2014, doing the World Series his first year. Uri Berenguer joined the Red Sox as a Hispanic Voice in 2003—at age twenty-one, among the youngest full-time broadcasters in major league history—becoming lead announcer in 2005.

René Cárdenas used radio to build a large Astros née Colt .45s following in Mexico, the Caribbean, and rest of the Americas. Orlando Sanchez-Diago joined the club in its first year, 1962. Francisco Romero and Alex Treviño now air Houston play-by-play and analysis, respectively. Amaury Pi-González left Cuba in 1961 at seventeen, cracked radio/TV, and has aired the A's, Giants, Mariners, or Angels almost continuously since 1978. Others include the Giants Erwin Higueros and Tito Fuentes, Twins Tony Oliva, Mariners Alex Rivera, Royals Jose Ramón Muñoz, and Yankees Beto Villa.

As a child, Luis Rodríguez-Mayoral moved from Puerto
Rico to Panama, where his dad, a military officer, was stationed.
Hearing Canel on the Series hooked him on baseball. Rodríguez-
Mayoral became a founder of the Latin American Players' Day
and the Roberto Clemente Memorial Award. Finally, Joe Angel,
born in Colombia, retired in 2019 after airing ESPN and other
clubs in English and often Spanish for forty-two years, including
nineteen for the Orioles. His *hasta la vista pelota!* crossed Baltimore's
bilingual divide.

Each Voice would grasp how having arrived here in 1955,
Jarrín had never heard of baseball. "I unpack just in time for the
Dodgers-Yankees Series, and can't believe the interest. I'm like,
'Wow, what *is* this game?'" The Spanish phrase *Mi casa es su casa*
means, "My house is your house." Increasingly, that house is full.

Perhaps never did the musical matter more to America than post–
World War II—as Suzyn Waldman, born in 1946 in the Boston
suburb of Newton, knows. Millions heard Broadway scores on
a newly bought TV, sang songs played on their newly invented
transistor, and subscribed to the Columbia Record Series—$2.98
per record and worth every penny.

Damn Yankees starred the Pastime in every way: witness "You've
Gotta Have Heart." In barely a decade, Mary Martin lit *Peter Pan*,
The Sound of Music, and *South Pacific.* Julie Andrews immortalized
My Fair Lady and *Camelot.* By any measure, Ethel Merman was
born to break chandeliers, as in *Annie Get Your Gun* and *Gypsy!* What
Irving Berlin said about *Get Your Gun* was true of the Merm. Was
the musical old-fashioned? a critic asked. "Yes," said the lyricist
and composer. "A good old-fashioned smash."

A youth when Broadway meant almost as much as baseball,
Waldman loved each. One moment she took voice lessons;
another, studied Ted Williams, easy to do since her family held

season tickets at Fenway Park: "At three, I could reach out and touch Ted from where we sat." After Simmons College, Suzyn set upon crashing The Great White Way. For fifteen years, she acted and sang in stock musicals, off-Broadway, and as Dulcinea in Broadway's *Man of La Mancha*. She often sang the National Anthem at The Stadium—and Game Seven of the 1986 ALCS. Baseball became her greatest hit.

In 1949, Merman joined Cardinal Spellman, Mel Allen, and Yogi Berra to stage "Joe DiMaggio Day" in the Bronx. Half a century later, Suzyn brokered a summit at The Stadium that ended a fourteen-year deep freeze. In 1985, George Steinbrenner had GM Clyde King fire Berra as skipper, breaking his word and spurning a face-to-face meeting. Yogi, in turn, vowed to avoid The Stadium as long as George owned the team. By 1999, Suzyn helped persuade The Boss to go to Yogi's home to apologize, ending the feud. That July 18—"Yogi Berra Day"—No. 8 caught a pre-game toss from Don Larsen, his pitcher in 1956's Perfect Game. Yogi then gave his glove to Yanks catcher Joe Girardi, who used it to catch David Cone's Perfect Game.

Suzyn played another role at three o'clock on July 1, 1987. New York's WFAN became America's first twenty-four-hour all-sports radio station, Waldman its first live voice heard. Beats included the Yanks and a daily mid-day talk show. "I was there [Yankee Stadium] all the time and demanded to be taken seriously," she said. Steinbrenner was sympathetic, saying cryptically, "One of these days I'm going to make a statement about women in sports, and you're it. And I hope you can take it," referencing the debate over women being allowed to enter a male locker room. Meanwhile, Toronto outfielder George Bell refused to speak to Apple media, saying they had cost him the 1986 MVP award. After a Blue Jays victory in New York, he changed his mind, Waldman and other writers hurrying to his locker.

At this point, Bell began screaming at her in English and Spanish. "There was deathly silence," she said, aware that some resented women in the clubhouse. Suzyn readied to leave, "a little less tough than I am now," she added later, until outfielder Jesse Barfield asked another writer, "What's her name?" He then called, "Suzyn, I went three for four today! Don't you want to ask *me* any questions?" In 1994, Steinbrenner made his "statement," Suzyn becoming the first woman to do daily TV play-by-play. Sadly, her stay was short; Waldman was diagnosed with breast cancer. Chemotherapy precluded daily TV, yet she still reported for WFAN.

Fighting and beating cancer—still in remission—Suzyn's "pipes," work, and talent earned a slew of curtain calls, including 1996 New York Sportscaster of the Year, 2015 Alliance for Women in Media Life Achievement award, and its prestigious Gracie Award in 2016. In the 1989 World Series, her poise under pressure peaked in live reporting from Candlestick Park on the San Francisco earthquake. Waldman won that year's International Radio Award. *Radio Ink* magazine has named her among radio's most influential women.

From 2002 to 2004, Waldman doubled as Bombers beat reporter on the team's network, the Yankees Entertainment System (YES)—one pioneer, on another. Also in 2002, the talented Michael Kay, formerly of the *New York Post* and *Daily News*, MSG Network, and ESPN Radio, became the Yankees' Voice, meriting Mel Allen's self-description: "partisan, not prejudiced."

In 2005, radio's Charley Steiner left the Yanks for the Dodgers, Suzyn so admired that she was hired by WFAN Radio to bring anecdote and analysis to the club's game coverage. In 2016, she and John Sterling, her popular play-by-play partner—to the media, "Ma and Pa Pinstripes"—were inducted into the New York State Broadcasters Hall of Fame.

Airing the Bombers since 1989, including 5,060 straight games into July 2019, Sterling has made his game-ending mantra, "Ballgame over! The-eh-eh-eh Yankees win!" an Apple institution. For her part, Waldman remains a pathfinder in a once all-male profession where women's Voices are still too rare.

Suzyn Waldman

Waldman's success was partly facilitated by several predecessors. In 1978, *SI* reporter Melissa Ludtke won a lawsuit forcing major-league baseball to open its clubhouses to female journalists.

By then, Betty Caywood had become perhaps the first woman big-league Voice to provide "color commentary." Born in Chicago, she had moved to Kansas City, graduated from Marymount College, and become a weather reporter back on Chi-Town television. On September 16, 1964, Athletics owner Charles Finley hired her to provide what he called "a women's perspective" on A's radio. Forty-four years later, Caywood, now known as Betty Caywood Bushman, briefly returned to the game on WHB Radio for the independent baseball team, the Kansas City T-Bones. She died on September 3, 2020.

Another maverick owner, Bill Veeck, hired the first full-time female play-by-player. Born in 1945, the daughter of a semi-pro baseball player, Mary Shane was a University of Wisconsin graduate and high school teacher. In 1975, her career makeover began covering the Brewers on WRIT Radio in Milwaukee. One night at County Stadium, Harry Caray, surprised to see a woman in the press box, had her do some play-by-play. Well-received, Mary broadcast again next night and on the next Sox visit.

In 1977, flagships WMAQ Radio and WSNS TV hired her for Caray's broadcast team. For Mary, things went more roughly the second time around. Before the season closed, she was not renewed, with some citing her voice; others blamed what Sox analyst Jimmy Piersall termed "built-in prejudice… She never had a chance. Even a bad baseball player gets at least one full season." Mary became a sportswriter for the *Worcester Telegram* in central Massachusetts, covering the basketball Celtics and dying in 1987 of a heart attack at age forty-two.

The next step up equality's ladder ended more happily. A three-time Emmy honoree in New York and Boston, Gayle Gardner worked for ESPN in 1983–1987, then NBC through 1993. That August 3, she became the first woman to televise baseball play-by-play on ESPN's Rockies-Reds. It seemed a natural evolution for

the first weekly female sports anchor on a major network program: ESPN's *SportsCenter*. She also aired college bowls, the Super Bowl, NBC's 1988 and 1992 Summer Olympics, and its 1979–1989 pregame show, *Major League Baseball: An Inside Look*.

Gardner later worked on the Food Network, wrote a screenplay, and returned to anchor with Stuart Scott a special 2004 "old school" edition of *SportsCenter* on its twenty-fifth anniversary. Ethel Merman, mentioned earlier, was asked if Broadway had been good to her. "Yes," she chimed, "but I've been good to Broadway." That truism applies to Suzyn Waldman and other pioneers in this chapter, too.

Chapter 12

1940S-TODAY: TECHNOLOGY MEETS THE SANDLOT KID

"Technology is just a tool," said Bill Gates, "the teacher [here, the Voice] is the most important thing." During the past one hundred years, baseball broadcasters have embraced the tech of their time, conveying baseball's essence—balls and strikes—while stirring its alchemy of look, sound, and feel. This chapter examines technology's effect on baseball—an historical perspective on how we have used it to enhance our enjoyment of the game. We will also look a final time at some of the Voices, the grown-up Sandlot Kids, without whom this book would be incomplete.

Eighteen years after Harold Arlin inaugurated baseball on the wireless at KDKA, Bill Stern announced its first televised game. On May 17, 1939, Princeton edged Columbia, 2-1, at Baker Field, to a handful of TV sets in the New York area. In the stands were about five thousand people. The person with the worst view there had a better glimpse than the best view at home, NBC's W2XBS (now WNBC) using a single camera fifty feet from home plate— "woefully lacking," said the *New York Times*.

The effect reflected the impact of inferior technology. One camera at one site "does not see the complete field. Baseball by television calls for three or four cameras," wrote the *Times*. The primitive look belied NBC's $150,000 van, which must have

seemed more Rube Goldberg than Goose Gossage, relaying images to a transmitter atop the Empire State Building, then picked up by local outposts.

Another problem was a poor-quality picture. One nine-by-twelve-inch screen's "outset was blurred, with reproduced faces dark," said the paper. The ball was rarely seen. Players resembled "flies." At least the viewer didn't suffer long. The ten-inning game took two hours and fifteen minutes. That August 26, as noted, Red Barber announced the first major league game on television, with similar equipment, from Ebbets Field.

Since then, baseball's technological world has made itself over.

Over time, local and network TV technology has helped make baseball infinitely easier to watch and hear. Late 1940s: Home television sales exploded. WPIX and WOR New York put the baserunner and close-up cameras near each dugout and above first and third base. In 1951: WGN coined the center-field camera, and color TV debuted: Brooklyn at Boston. In 1952: The World Series unveiled a split-screen. Videotape later made a recording almost instantly airable. In 1956: CBS's IFB—Interruptible Feedback or Foldback—earpiece tied the announcer, director, and producer, smoothing on-air flow.

On July 17, 1959, baseball crossed a dividing line upon which it never doubled back. Chicago's Jim McAnany's ninth-inning single ended New York's Ralph Terry's no-hitter. On a whim, Mel Allen asked if his Yankees could reshow the hit. The first replay took five to ten minutes to produce. Ultimately, *instant* replay evolved—and technology became more precise.

In 1962, Major League Baseball's first satellite telecast emanated from Wrigley Field via Telstar Communications. In 1971, NBC's Curt Gowdy and Bob Prince aired the first World Series Game at night, thirty-six years after ballparks were first lit

when Franklin Roosevelt threw the ceremonial switch from the White House.

By 1976, no radio network had daily or even weekly broadcast regular-season baseball since Mutual's 1950–1960 *Game of the Day*. The Pastime paid a price, especially in terrain far from local coverage. NBC Radio had broadcast the World Series and All-Star Game since 1957 but with decreasing energy and success. Only an ad-hoc network of local stations carried the LCS.

Dick Brescia, whom we have already met, was CBS Radio's vice-president of sales when, in early 1976, NBC Radio decided to abandon baseball's ship. "They'd gone to an all-news format, deciding sports were not a good fit," he said, telling Bowie Kuhn that it would no longer carry baseball, effective that year. In shock—no Series on the wireless?—the commissioner phoned CBS Radio head Sam Digges.

"They wouldn't charge us much, but would we do these events?" Brescia paraphrased Kuhn. Both sensed that NBC was not a fair gauge of interest. The CBSer also knew that sports on radio were an easy sell to sponsors and listeners locally but might nationally be throwing good money after bad. "It would be a gamble," he said. At last, CBS decided to roll the dice, knowing that to do baseball right meant doing it big.

The new 1976–1979 deal included the Series, LCS, and All-Star Game. It began in the wake of the 1975 World Series, the *New Yorker* writing that winter, "Even now its colors still light up the sky." The problem was outlet skepticism. The solution, Brescia felt, was commitment. CBS's $32-million pact ensured exclusivity; its potential result swelled by the number of—more than two hundred—affiliates. "You can be anywhere in the country," said Kuhn of radio, "and not miss a single pitch."

CBS hoped to use momentum to create an attitude about the game. It bought full-page ads in *TIME*, *SI*, and *TSN*, aired baseball features, placed spots on its NFL coverage, and prized

play-by-play. "The main announcer is the show," said Brescia, mentioning Gowdy, Ernie Harwell, and the Phillies' Harry Kalas, his voice a sonic boom. This left, among others, Jerry Coleman, who had to be doing something right, gracing seventeen LCS. All would be enlisted in a common cause: to make radio/TV baseball come alive.

When Kuhn became commissioner in 1969, baseball's only national forum was Saturday's *Game of the Week*. It lacked any other high-profile weekly TV programming to promote the game. By contrast, pro football boasted such regular highlight shows as *This Week in the NFL*, *The Men Who Played the Game*, and *NFL Week in Review*. Said Kuhn about marketing, especially to youth: "We were being killed."

The next decade forged, as a 1979 *SI* cover story said, "A Golden Age…of popularity and prosperity." As Chapter 13 observes, 1977–1996's syndicated *This Week in Baseball*, airing on more than 150 affiliates, became an enormous hit. It was complemented by another syndicated weekly: the multi-Emmy Award-winning *The Baseball Bunch*, an American educational children's show starring Johnny Bench, Tommy Lasorda, and the famed San Diego Chicken.

In April 1978, Ford C. Frick died, coinciding with this surge in big-league appeal. The former sportswriter, 1934-1951 National League president, and 1951-1965 baseball commissioner had strongly advocated for the Hall of Fame's creation and a place for the wireless in the pastime's orb. Aptly, the Frick Award began as CBS Radio charted a course which caused regular-season exposure to expand.

Ultimately, CBS Radio's *Game of the Week* featured a fifty-set Saturday, Sunday, and holiday schedule and starred a dozen Frick honorees from Marty Brennaman and Gene Elston via Bill King

to Bob Murphy and Lindsey Nelson. Fledglings Gary Cohen, Jim Hunter, Ted Robinson, and Joe Buck, Jack's son, leavened the lions. A special favorite was the series' fifth or "Home Team Inning," presenting a local-team Voice heard beyond his local market, introduced to an audience far larger and more dispersed.

By 1990, *Game* rights doubled, CBS building the bigs' largest network since Mutual. Yet, shockingly, ESPN Radio, only five years old at the time, outbid it for 1998–2002 exclusivity by an estimated $40 million—"In the end," said Brescia's successor, Frank Murphy, "money counting for more than our promotion." It then approached Vin Scully, CBS's 1989–1997 Series Voice, and ESPN TV's Jon Miller about sharing the 1998 Classic. The idea went about as far as a sacrifice bunt.

"I still love the challenge of informing and entertaining," Vin told the *Times*, "but all I do on the road is go to my room, to the ballpark, and back to my room… I'm saying, 'The meter is running.'" To Scully, the fall occasion meant "two weeks away, where I don't want to be." In 1998, Vin retired from network radio, Miller his replacement in the public mind. Let us examine how Jon's ESPN emerged and why.

Since cable's birth, a conundrum had faced baseball: should it supplement, or supplant, network TV? In 1989, NBC TV killed *Game of the Week*, Kuhn's successor, Peter Ueberroth, an accomplice. "Ueberroth could'a kept us and another network," mused the Peacocks' Costas, "but he cared more about cash." Paying $1.06 billion for 1990–1993 exclusivity, CBS, valuing baseball's postseason more than *Game*, would not carry more than sixteen sets in the regular season's twenty-six weeks. No longer would Saturday hinge, as Scully said, on "pull[ing] up a chair."

Game had been available everywhere. The new peewee schedule made it far less of a TV habit for the four in ten homes sans local-

team and/or cable. At the same time, ESPN inked a 1990–1993 $400-million-dollar pact to originally include a six-game-a-week schedule, its flagship *Sunday Night Baseball*—also a daily *Baseball Tonight* and yearly *Home Run Derby.* The effect of its and CBS's new arrangement was to slash exposure for non-cable homes.

"We got baseball because CBS didn't want a *Game*," said Miller. "The weekend's over, you're back from the beach, and there we are." ESPN forecast a 5.0 rating (one point equals 1 percent of TV homes: seven million of 140 million homes), but lured just 3.0. A viewer liked miking players and new MaskCam, BatTrack, and KZone technology. Unpopular was cable America getting too much coverage—the rest, not enough. By 1993, forty million fewer viewers saw all or part of CBS's Series than NBC's in 1980. Sans regular-season visibility, postseason interest ebbed.

Growing up in Northern California, ESPN's future lead Voice came of baseball age in the 1962 Giants-Dodgers pennant race. In the last week, Jon listened to Scully live on LA's KFI. "I'm thinking, 'Gee, this guy's not very good compared with Russ [Hodges]!' I'm sitting in a car, on a hill to help reception, switching back and forth." The 'Jints took the Yankees to Game Seven of the Series, Miller in a dentist's chair when Bobby Richardson caught Willie McCovey's Classic-ending drive. "Given the pain," he said, "how appropriate that I almost bit my dentist's finger."

In 1974, after attending the College of San Mateo, Miller signed with the Oakland A's. A decade later, Jon joined the Orioles after stints at Texas and Boston, working O's radio while Chuck Thompson did TV. In 1991, Miller won his first of two Cable ACE Awards for ESPN, feeling undeserved. "What am I?" he asked the audience. "I go to games, and my best lines are, 'low, ball one,' or probably the line I'm most proud of—'line drive, foul.'" Don't talk money. "I'm an *artiste*, you know."

Miller announced ESPN's trifecta: All-Star Game, LCS, and Series radio. In 1997, the Voice of the Orioles challenged the

idiom of trying to go home again, returning to the Bay after a
public squabble with O's owner Peter Angelos. On either coast, he
was a brilliant mimic, aping Harry Caray, Thompson, and Scully
in English, Spanish, and Japanese, and a natural comic. He also
had the good fortune of running smack-dab into history.

On October 4, 2001, Barry Bonds whacked his Mark
McGwire–tying seventieth home run. Next day he faced Chan
Ho Park at then Pacific Bell Park. "There's a high drive deep into
right-center field! To the big part of the ballpark! Number 71!"
boomed Miller. "And what a shot! ...And Barry Bonds is now the
home run king! Number 71!" Six years later, he called another
blast—No. 756. "Bonds now has more home runs than anyone
who has ever played the game!"

Then in 2014, Madison Bumgarner retired the final batter in
Game Seven. "And the Giants have won; they have won the World
Series for the third time in five years," etching "[Madison's] name
as one of the greatest World Series pitchers the game has ever
seen!" In 2010, Miller won the Frick Award and emceed a rally for
the Giants' first title since 1954: a tribute to the franchise's post-
1957 "whole panorama."

An ESPN official once said, "In Bristol [Connecticut's ESPN
center], Jon means the game." In 2010, that network inexplicably
canned him and partner Joe Morgan. Miller opted for 2011-Giants
radio over *Sunday Night* wireless—an *artiste* still.

Jon Miller, Joe Morgan, and baseball writer Peter Gammons

By the early 2010s, many walls had fallen between print and electronic media, the internet a radio/TV tool. Each big-league team had an official website linked to programs like baseballlibrary. com, ESPN.com, Fastball.com, and SABR.org. Millions subscribed to SiriusXM Satellite Radio for a fee, hearing each team. "Entertainment options" included Gameday Audio on MLB.com, DirecTV—and the Major League Baseball (MLB) Network—a tour de force of all things baseball.

The idea of a network airing baseball programming every minute of the year had been discussed by big-league owners as early as 2004. By 2007, forty-seven million cable and satellite households were potential subscribers, twenty million more than any previous cable launch. The league owned 66.6 percent of the MLB Network when it began. These statistics would have impressed even those, like Dizzy Dean, who mocked them as *statics*.

In 2007, MLB Network executive vice president of business, Tim Brosnan, prophesied that its success would rely less on games covered than on "[our] non-live event creativity." A year later, CBS's five-time Emmy Award winner Tony Petitti became

MLB Network's president and CEO. In mid-2008, he entered an abandoned TV studio in Secaucus, New Jersey, to set up shop. *Bloomberg Businessweek* reported that the Harvard Law School graduate lacked a staff, working studio, and advertisers. He did have a launch date for baseball's $75-million investment: six months away, on January 1, 2009, at six o'clock.

As usual, advertising came first, Petitti hiring "175 full-time employees and probably another 175 freelancers." One hire was Matt Vasgersian, a child actor who did Padres TV, aired five Olympics, and was humorous on and sans command. In 2009, Bob Costas, having nearly retired the National Sports Media Association's Sportscaster of the Year award, winning it eight times, joined the MLB Network to do "historical pieces, documentary-style programming, interviews, and play-by-play—and it's all baseball."

MLB Network's first rehearsal occurred on December 27, 2008. Four days later, it debuted with an episode of *Hot Stove*, followed by the original telecast of Don Larsen's Perfect Game v. Brooklyn. Like most, Costas had never seen the broadcast, interviewing Larsen and catcher Yogi Berra in-studio through the show. Studio 3, in honor of Babe Ruth, now houses all studio programs, including *High Heat, Intentional Talk, MLB Central, MLB Now, MLB Tonight, Quick Pitch*, and *Rundown*. Other series include the documentary *MLB Network Presents*, live game *MLB Network Showcase*, and the formerly named *Diamond Demos* in Studio 42, named for Jackie Robinson.

In addition to Costas and Vasgersian, personalities included: Greg Amsinger, Fran Charles, Mark DeRosa, Robert Flores, Brian Kenny, Harold Reynolds, Alanna Rizzo, Ken Rosenthal, Christopher Russo, Lauren Shehadi, John Smoltz, and the ageless Jim Kaat. Baseball's last original Washington Senator, Kaat had a 283-237 pitching record, won sixteen straight Gold Gloves, then

became an equally successful Yankees, ESPN, CBS, and then MLB Voice.

Each year MLB airs about 150 spring training games, 150 regular-season games, and postseason—in addition to highlight, talking head, and archive since the 1920s. Today baseball's cable channel households top seventy million. In any studio, by any name, the network remains a keeper of the big-league flame.

Like any good Baby Boomer, Costas grew up feeling that baseball was all-important, airing it since with art and verve. In 1989, a tide over which he had no control carried him from his first love to a future he had not envisioned. Later, another unexpected tide let him reach his boyhood shore—first to MLB TV and then to Cooperstown.

Growing up on Long Island, Bob followed baseball by radio or black and white TV. In 1957, at five, he went with his dad to Ebbets Field. "I walk in," Costas said, "and see this green diamond, like the Emerald City." Two years later, he sat with a cousin at Yankee Stadium. Each inning, they crept closer to the field.

In 1960, the family left for California, baseball its escort. "In Ohio, we'd pick up Waite Hoyt on radio, later Earl Gillespie, then Jack Buck and Harry Caray." Nevada spawned Vin Scully. "Dad said, 'That's the Dodgers. We're almost there.'" The Yankees in that year's World Series made LA seem like home. Bill Mazeroski's Game Seven blast retired Costas to his room, eyes welling, "As I take a vow not to speak until Opening Day 1961." Bob did keep mute for a day—"protesting this injustice."

At ten, he was "good field, no hit, and you know what they say about guys who can't even hit their weight," Bob said. "That was me, and I weighed 118 pounds." He carried a dog-eared 1958 Mickey Mantle card in his wallet, feeling "you should carry

a religious artifact with you at all times." Costas graduated from
Syracuse, worked at KMOX, and moored the '80s backup *Game
of the Week*, his tiara June 23, 1984's Cardinals-Cubs. Down, 9-3,
Chicago rallied, Ryne Sandberg homering twice to the "identical
spot. The same fan could have caught it." *Game* shook, like
Wrigley Field.

"That's the real Roy Hobbs because this can't be happening!"
Costas cried. (*The Natural* had just been released.) "We're sitting
here, and it doesn't make any difference if it's 1984 or '54—just
freeze this and don't change a thing!" For many, "The Sandberg
Game" is still the baseball moment to which Bob is most
connected. In 1988, he showed why no network ever treated a
sport with more respect than NBC did the Pastime in the 1980s.

That October 15, Kirk Gibson jaw-dropped his ninth-inning
thunderbolt to win the World Series opener. NBC's next-day
pre-game likened him to Hobbs' Robert Redford. Two network
producers got that film, "stayed up all night at Paramount Studios,
then took our piece by police escort to Dodger Stadium," said
Costas, ad-libbing script. "Look at that and tell me what's wrong
with baseball on TV when it's done by people who care."

In December, CBS TV's exclusive 1990–1993 contract ended
sports' longest-running TV series, stunning Bob. "Whatever else I
did, I'd never have left *Game of the Week*," he said then. Costas was
"ready to do baseball on a full-time basis anywhere, even if I have
to give up everything else." Ironically, under the law of unintended
consequences, *Game*'s 1989 end crushed before freeing him.

In 1993, Jack Buck called Bob "history's most successful
sportscaster." Costas transcended his multiple Olympics and
Emmys and other awards by airing *Dateline* and *Later with Bob Costas*
and *On the Record* and *Costas Now*, finding the wider world's water
fine. With NBC's coverage of the Pastime sporadic, then extinct, to
some, Bob's baseball lineage dimmed, albeit only momentarily.

Receiving the Frick Award in 2018, Costas said, "For me, baseball has always come first. And so...this day, and this honor, will always come first, too." That day he joined Mel and Red and Vin and Harry and others that tens of millions knew on a first-name basis. In *Julius Caesar*, Shakespeare writes about "all the voyage of their life." With a sense of symmetry, Bob's voyage had arrived where it belongs.

Since that first broadcast on KDKA, the Great American Pastime has been ferried by radio, television, and now cellular and digital formats, evolving from large boxes as living room furniture to small screens almost incidentally telling time. Regardless of how we heard them, we remember the familiar voice, face, story, a gracious invite, a signal call—talk from a friend still crucial to baseball broadcasting as we celebrate the first century of baseball on the air. What follows is to make this celebration complete: brief spots of past or current broadcasters, including each Frick honoree not heretofore detailed, all making us feel close enough to our favorite game to reach out and touch the field.

Ken Harrelson, the 2020 Frick recipient, dubbed "Hawk" by Dick Howser for a nose broken in six places, has always followed his own drummer. He joined the Athletics in 1963, was released in 1967, quickly signed with Boston, later retired, tried golf, and as a Voice aired NBC's 1984–1989 backup *Game* and bred his own language on Red Sox, Yankees, and 1982–1985 and 1990–2018 White Sox TV. The Pale Hose were "us," he said. The "good guys" might smack a homer. "Put it on the board!" he beamed. Viewers put the five-time Emmy honoree on theirs.

Hawk stirred things up during mid-1960s batting practice after finding that thirty-six holes of golf had caused a hand blister. "Suddenly, I remember my golf glove," Harrelson said. He put it on, homered twice, and began a trend, Mickey Mantle having the

Yankees club house man buy golf gloves for his team. The Hall of Fame credits Ken with introducing the batting glove in the regular season. He also popularized the one-handed catch: "With bad hands like mine," he said, one hand was better than two—"Yes!" his attitude and catchphrase: Hawkspeak still unique, like him.

Color Jerry Coleman another original. He was a patriot, flying 120 bombing missions in World War II and Korea. "Bob Feller and Ted Williams were right," he said. "What you do for America counts most." A teammate: The infielder's Yanks flew eight flags in his 1949–1957 career. Finally: An incandescent Voice who once worried about "Colemanisms" like Jesús Alou is "in the on-deck circus." Now, he said, "I figure they add to my sex appeal." Fete Jerry's fifty-three years as a Voice—the last forty-three with the Padres. Said the 2005 Frick recipient, "Sometimes big trees grow out of acorns. I think I heard that from a squirrel."

Chuck Thompson learned baseball at his grandmother's boarding house, Connie Mack, a tenant. From 1946 to 2000, the 1993 honoree aired the Phils, A's, and Senators—and the Orioles for twenty-nine years. When Fred Manfra became a Voice, Thompson said, "You have a special privilege. People take you to baptisms, confirmations, on the beach. You're part of them." A listener heard two jewels, in particular. One was "Go to war, Miss Agnes!" borrowed from a golfing neighbor who never swore and used it when he missed a putt. The other, as former broadcast partner Brooks Robinson knows, was: "Ain't the beer cold!" Plus, that neighborly voice. Jon Miller says he never cared what Chuck said, as long as Chuck said it.

A writer once said that Marty Brennaman squabbled with partner Joe Nuxhall "like an old married couple" on WLW's six-state network. Fortunately for Cincinnati, their yarns had a long shelf life. From 1974 to 2019, Brennaman said of a Cincy victory, "This

one belongs to the Reds." The 2000 Frick honoree also authored Marty-speak. "Frog strangler" meant tense game; "Grand Tour," home run; "hit of the two-base variety," double. The Reds became "Redlegs"; Mets, "Metropolitans"; Astros, "Astronomicals." Through 2004, Nuxhall added of a Reds drive, "Get, get up, get *outta here!*" Each one's mantra complemented the other, like Morgan and Bench.

Dave Van Horne's home run phrase was "'Up, up, and away!'—a line I stole from the Fifth Dimension song." Voicing the Marlins since 2001, he still reveres calling the Expos' first game and baseball's first outside America on April 8, 1969, at Shea Stadium: Montreal 11, Mets 10. "This was much bigger to every Canadian…than I had anticipated," said the Frick 2011 honoree. Dave started each broadcast with, "Hi everybody. Glad to have you aboard for today's game." Sadly, the Expos capsized, leaving for Washington in 2005.

Frick 2013's Tom Cheek was the first Voice of the Toronto Blue Jays, Canada's other team. In 1992, he became a Canadian citizen, retired in 2004, and died of a brain tumor a year later. To then-Rays Voice Paul Olden, Cheek practiced "old-style broadcasting's" subtle fact and humor. In a 2004 interview, "Tom spoke freely about his condition, chemotherapy, and letters by listeners," said Olden. "The style was like his play-by-play, giving a listener time to consider information," substance topping even his engaging style.

Harry Kalas, the Frick 2002 recipient, was noted for a signature, "Long drive! It's outta here! Home run!"—and his radio/TV friendship with Richie Ashburn, their vocal alloy lasting twenty-seven years until Ashburn's 1997 death. Kalas was "George Burns to Richie's Gracie Allen," the *Philadelphia Inquirer* said. The 1979 Phillies thudded a distant fourth. "What are they going to name their highlight film?" said Harry. Richie: "How about, the game's not so easy." The Richie Ashburn-Harry Kalas Foundation

now makes summer even better by hosting free baseball camps for children throughout the Philadelphia area.

In the Bay Area, Bill King's persona tied a handlebar mustache, Van Dyke beard, and term "Holy Toledo!"—in 1958, joining Russ Hodges and Lon Simmons in the 'Jints booth. Each was a Frick alumnus, Bill from 2017. From 1981 to 2005, King set a record for most years aired by an A's Voice since radio baseball began in 1938 Philadelphia. Denny Matthews starts each Royals game: "Hi, everybody, and welcome." The Frick 2007 honoree movingly quoted Jack Brickhouse in his speech: "Today, I feel like a man sixty feet, six inches tall." Remote cities and small towns hear Matthews on the Royals' far-flung network, including land once worked by his grandfather on the Chicago & Alton Railroad.

Denny has defined the Royals since their 1969 debut. A last Frick honoree of note is '92's Milo Hamilton, who broadcast for fifty-seven years, worked in a record fifty-nine big-league parks, and called baseball's most famous non–Bobby Thomson home run. On April 8, 1974, Milo aired a record-breaker, Henry Aaron "sitting on 714. Here's the pitch by [LA's Al] Downing...swinging... There's a drive into left-center field! That ball is gonna be...outta here! It's gone! It's 715. Listen to this crowd. There's a new home run champion of all time! And it's Henry Aaron! ...Listen to this crowd!"

We still are.

Finally, internet technology has helped each announcer, network, and club swell their clientele. It blossomed during 1998's Mark McGwire–Sammy Sosa homerthon, both striving to break Roger Maris' single-season mark of sixty-one. Today, we can see it all on YouTube. Then, we almost waited for Voices to document an event before we accepted it as real.

That September 8, Mac lashed Steve Trachsel's first pitch.
"Drives one to deep left—this could be—it's a home run! Number
62 for Mark McGwire! A slice of history and a magical moment
in St. Louis!" said Cubs Voice, Pat Hughes. Fox's Joe Buck used
a disparate "Down the left-field line! Is it enough? There it is, 62!
Touch first, Mark. You are the new single-season home run king!"
Same moment, variant call: The Voice is the difference.

In 1975, viewers relied on a sports segment of the evening
news to see Carlton Fisk's home run. By 1998, No. 62 was
replayed instantly around the globe. Yet then, like now, replay was
insufficient: personality is baseball's key. Technology reveals it in
the booth (think Bob Uecker, or Harry Caray) and beyond (Fisk
leaping, hoping his drive was fair). Pollster John Zogby says, "In the
end, life always comes back to Little League." Why did we fall in
love with baseball? Largely, the Sandlot Kids behind the mic and
the wonder they describe.

Dodgers Voice Charley Steiner tells of a fungo game from
youth. One day, a friend of his, Donnie Sorensen, "an experienced
veteran of eight or nine," ordered him to hit the ball, then run to
first base (elm tree), second (towel), third (another elm), and home
(cardboard). Steiner was nothing if not literal, racing to the tree,
towel, tree, and "home. I mean *home*. All the way to my *house*,"
Charley said, not grasping why everyone was yelling and "chasing
after me" as he ran "the wrong way" home.

There is no wrong way to run home in baseball. Technology
helped lead us there. For a century, its Voices have helped
keep us there.

Chapter 13

A SONNET SUNG UPON THE HEART

On May 22, 2014, President Barack Obama became the first president in office to visit Cooperstown since Martin Van Buren—and the first sitting president to enter America's best-known Hall of Fame and Museum in America's best-known small town.

The president, an ardent White Sox fan, began his remarks by saying that the day's "timing could not be better"—three weeks before the Hall's seventy-fifth birthday—and that he had kept his vow to former Chicago slugger Frank Thomas to "check the place out before he is inducted in July."

A. Bartlett Giamatti had even greater affection for the game. Baseball's seventh commissioner, for whom the Hall's Research Center is named, once likened Fenway Park to "Mount Olympus, the Pyramid at Giza, the nation's Capitol, the czar's Winter Palace, and the Louvre—except, of course, that it is better than all those inconsequential places."

Giamatti's view may be even more valid of Cooperstown, a place that embodies baseball's sonnet sung upon the heart—and likely shared by the pilgrims from places all around the world who gather on Main Street each year to celebrate the Pastime.

In 1936, the Baseball Writers' Association of America chose the first class of five inductees. Three years later, in a rite overseen by Commissioner Kenesaw Mountain Landis, the Hall of Fame opened to the public, its number having swelled to twenty-five

members. If thousands saw it in-person, millions heard Mel Allen and Arch McDonald broadcast the ceremony over CBS Radio.

Since 1978, one Voice a year has received the Hall of Fame's Ford C. Frick Award. It recognizes each announcer's "commitment to excellence, quality of broadcasting abilities, reverence within the game, popularity with fans, and recognition by peers."

As noted in Chapter 4, the sole exception was the first year when Allen and Red Barber were honored jointly. They spoke in alphabetical order, Mel demurring, "The Ol' Redhead was the greatest. He should have been here first." Barber noted how "broadcasters made fans out of more people. We brought baseball into the home." Ralph Kiner introduced Allen, saying, "[His] greatest day was a twenty-two-inning Yankee game, because it was the first time he had enough time to explain the infield fly rule."

Sports Illustrated named another Frick honoree, Ernie Harwell, the radio Voice of its all-time baseball dream team in 1991, nineteen years before his death. Ernie and I often discussed *what* and *who* best expressed play-by-play, for as *TIME* magazine noted, its pioneers and progenitors had "*made it up*, created and perfected an American art form." I took from Harwell four common denominators about what an artist was—and is.

First, he believed in simplicity—give the score at least once a minute. Second: With today's three-hour-average game, keep rhetoric casual and personal—never begin a story you can't complete by break. Third: The culture has changed, which means informing denotes performing. Fourth: As Dutch Reagan mused, "Tell the audience fifteen facts and one story well-told, and it's the story they recall." Of all sports, baseball is the most enriched by stories at centerstage.

When last we left the first Frick honoree, Allen in the early 1960s was near his apex. NBC's Tom Gallery thought that Mel

"brought a special drama to the occasion," his life acquiring a
special drama of its own. Allen's doctor began prescribing pills to
sustain a manic schedule, the patient's speech devolving. He never
grasped the change, even as it occurred. In 1964, Movietone News
ended domestic production. That year, Mel was dropped by the
Yankees and NBC TV. Each declined to say why.

Lacking any "[explanation]," *SI* wrote, "Allen became a victim
of rumors. He was supposed to be a drunkard, a[n] illegal drug
user. Neither rumor was true, but he couldn't fight them. It was as
if Mel had leprosy"—blackballed for more than a decade, life as
he defined it gone. Then, in 1977 he was hired to host and voice-
over the magical syndicated Saturday *This Week in Baseball (TWIB)*,
ultimately sport's highest-rated serial.

"For years, he was a forgotten man," William Leggett wrote,
"but it has all come back to him in abundance"—his last twenty
years a cycle of rise, ruin, and rebirth. "Kids knew him from *This
Week*, wowing a new generation," said executive producer Geoff
Belinfante. "Older folks remembered the salad days. Everyone
had a frame of reference." Having all, he lost all and, against
likelihood, came back.

From 1954 to 1964, Mel and Red Barber peacefully coexisted
in the Bronx. Like Allen, Red had no inkling of his demise. On
September 22, 1966, the day Michael Burke became Yankees
president, 413 fans packed The Stadium for a makeup game. On
WPIX TV, Red, thinking it "the perfect place for Burke to start,
nowhere to go but up," asked director Don Carney to pan the
stands. No shot. He vainly asked again, the team's radio/TV head
telling aides not to show the seats.

Uncowed, Barber said, "I don't know what the paid attendance
is today, but whatever it is, it is the smallest crowd in the history
of Yankee Stadium…and this smallest crowd is the story, not the
ballgame." A week later, the Yanks finished last for the first time
since 1912. Red expected a new contract, but Burke axed him,

too. In hindsight, Barber felt liberated. "I'd become a servant to the microphone. On my own, I'd have gone back for who knows how long."

Like Mel, the last innings of Red's life brought a renaissance. Barber wrote six books and, starting in 1981, reached a new generation through Friday conversations and commentaries with Bob Edwards—to Red, affectionately, "Colonel Bob"—on National Public Radio's *Morning Edition*. "Red's notion was that education continues, no matter what your age," said Edwards, Barber earning broadcasting's Pulitzer, a personal George Foster Peabody Award, in 1990. He died in 1992, four years before Allen.

"History is not the past but a map of the past, drawn from a particular point of view, to be useful to the modern traveler," said historian Henry Glassie. Just as Allen and Barber reemerged to lure applause, so the twenty-first century's two epic "curses" continued to fascinate even those rooting for another team—the Red Sox and Cubs.

In 2004, the Olde Towne Team won its first World Series since 1918. In Game Four of the World Series v. St. Louis, Boston led in sets and score, 3-0. With two out, a "one-oh, pitch," said Joe Castiglione. "Swing and a ground ball! Stabbed by [reliever Keith] Foulke! He has it! He underhands to first! And the Boston Red Sox are the world champions! For the first time in eighty-six years, the Red Sox have won baseball's world championship. Can you believe it?"

Joe's path to Fenway led from a Mantle-Maris youth in Hamden, Connecticut. Hired by the Red Sox in 1983, Castiglione would "waft softly through New England summers, a steady soundtrack on the radio," said David J. Halberstam. "No nicknames, no shtick, no hype, and no gloom, always sunny and easy-going"—a perfect antidote for the region's fear that the sky

was always falling. In 2015, Joe broke Ned Martin's record of thirty-two straight years on Red Sox radio and/or TV, Ned's most memorable patch being 1974–1978, paired with Jim Woods as superbly as the "Possum" had with Bob Prince.

Daily, Martin and Woods completed each other's sentences, communing on-air by "a hand gesture, shrug, raised eyebrow," wrote the *Boston Globe*. After a game, "broadcasters, writers, and the coaching staff [gathered] during which Martin and Woods would be spellbinding with their baseball tales." Jim called Ned "Nedley." Martin kidded Woods about Prince at Pittsburgh: "Did Budweiser sponsor you, or did you sponsor Budweiser?" Poss died in 1988. In 1992, Martin retired to Virginia for the last decade of his life.

In 2016, the Sox, having smashed their curse, the Cubs expunged theirs, ending North America's 108-year longest professional team futility. In Game Seven of the Series, up, 8-7, Pat Hughes became the sole Voice to call a Cubs crown, radio not with us in 1908. "A little bouncer slowly toward [third baseman Kris] Bryant," he said. "He will glove it and throw to [Anthony] Rizzo. It's in time! And the Chicago Cubs win the World Series! The Cubs come pouring out of the dugout, jumping up and down like a bunch of delirious ten-year-olds! The Cubs have done it! …And the celebration begins!"

A day later, a parade began in Chicago before an estimated five million people. Hughes then acted as emcee at a rally, introducing players, pols, and other notables, each hailing a time that most likely felt would never come. Some undoubtedly thought of Pat's beloved sidekick, Ron Santo, who had died in 2010. The Cubs Voice, Rick Wolfe, and Ron Santo Jr. later wrote a book, *Ron Santo: A Perfect 10*, his number—exactly how Ron would have ranked 2016.

From the Cubs to the Red Sox, the Miracle Giants of 1951 to
the Miracle Mets of 1969, one Yankees and Cardinals dynasty to
another, and the 1955 Champion Brooklyn Dodgers to the 2020
titlist Los Angeles Dodgers, each involved a Voice—a storyteller
sharing our game.

Dave Niehaus, the Hoosier native who listened on his front
porch as a boy to Harry Caray describe Stan Musial, was the
Mariners' long-running first Voice. "My, oh, my!" was his leitmotif.
A homer "will fly away!" When the 2008 Frick honoree died in
2010, at seventy-five, ex-M's outfielder Jay Buhner called it "the
saddest day of my life."

If Seattle was the Emerald City, Niehaus was its jewel—exactly
what Cooperstown was to him. Dave loved it. "Really no place like
it, like Disneyland, except that you don't have to pay for rides." He
called the Frick Award "the biggest honor in my life: our Oscar,
the Academy Award. You can't go anywhere from here." In early
2008, Dave visited the village for the first time and was enchanted
by how, as James Fenimore Cooper wrote in *The Deerslayer*, "Here
all was unchanged."

Niehaus began his tour at Doubleday Field, "just the name
causing goose bumps on your arm," he said, looking at "church
spires in a distance. Youngsters who play the game they love. To
think that they've played there for 150 years is unbelievable." What
struck him on the four-hour ride from New York City was how the
region around the Hall of Fame "is like an old *The Saturday Evening
Post* cover, a Norman Rockwell painting."

Later, he toured the Hall's basement. "Like going to Fort Knox,
you wear doctor's gloves, hold a bat by my hero, Ted Williams. It's
like finding the Holy Grail." Leaving and entering the town, Dave
was struck by a sign reading, "Village of Cooperstown." To him,
it evoked a favorite film, *Polar Express*, "where everything is built
on belief."

A boy, Tom—the actor Tom Hanks plays five key parts—goes to the North Pole, where Santa Claus gives him a gift—a bell. Tom returns home, goes to bed Christmas Eve, and wakes up, said Niehaus, to find "the bell's not there." He goes downstairs, "thinking last night a dream, and then he sees a box under the tree." In the box was the bell.

"It's all there if you believe it," Dave noted, referencing the "Village of Cooperstown" sign. Niehaus was a perceptive man with a profound sense of what baseball means to America. "Seeing that sign," he said, "I believe."

Appendix:

FORD C. FRICK AWARD

The Ford C. Frick Award is presented annually by the National
Baseball Hall of Fame and Museum to a broadcaster for "major
contributions to baseball." The award, named after the late
broadcaster, National League President, Commissioner, and
Hall of Famer, has been presented annually since 1978. Frick
was a driving force behind the creation of the Hall of Fame in
Cooperstown and helped foster the relationship between radio and
the game of baseball.

The annual Frick Award ballot is created by a subcommittee
of the voting electorate. An updated three-year election cycle
was introduced starting with the 2017 Award, rotating annually
between three different broadcasting categories: *Major League
Markets* (team-specific announcers), *National Voices* (broadcasters
whose contributions were realized on a national level), and
Broadcasting Beginnings (early team voices and pioneers of baseball
broadcasting). To be considered, an active or retired broadcaster
must have a minimum of ten years of continuous major league
broadcast service with a ball club, network, or a combination
of the two.

The Frick Award electorate is comprised of the living Frick
Award recipients and four broadcast historians or columnists who
are asked to base their selections on each candidate's "commitment

to excellence, quality of broadcasting abilities, reverence within the game, popularity with fans, and recognition by peers."

Mel Allen, the legendary "Voice of the Yankees," and Red Barber, who called games from the "Catbird Seat" for the Cincinnati Reds, Brooklyn Dodgers, and New York Yankees, were chosen as the first two recipients of the award in 1978. A single winner has been selected in each year following.

Frick Award Recipients

- 1978—Mel Allen, Red Barber
- 1979—Bob Elson
- 1980—Russ Hodges
- 1981—Ernie Harwell
- 1982—Vin Scully
- 1983—Jack Brickhouse
- 1984—Curt Gowdy
- 1985—Buck Canel
- 1986—Bob Prince
- 1987—Jack Buck
- 1988—Lindsey Nelson
- 1989—Harry Caray
- 1990—By Saam
- 1991—Joe Garagiola
- 1992—Milo Hamilton
- 1993—Chuck Thompson
- 1994—Bob Murphy
- 1995—Bob Wolff
- 1996—Herb Carneal
- 1997—Jimmy Dudley
- 1998—Jaime Jarrín
- 1999—Arch McDonald
- 2000—Marty Brennaman
- 2001—Felo Ramírez
- 2002—Harry Kalas
- 2003—Bob Uecker
- 2004—Lon Simmons
- 2005—Jerry Coleman
- 2006—Gene Elston
- 2007—Denny Matthews
- 2008—Dave Niehaus
- 2009—Tony Kubek
- 2010—Jon Miller
- 2011—Dave Van Horne
- 2012—Tim McCarver
- 2013—Tom Cheek
- 2014—Eric Nadel
- 2015—Dick Enberg
- 2016—Graham McNamee
- 2017—Bill King
- 2018—Bob Costas
- 2019—Al Helfer
- 2020—Ken Harrelson
- 2021—Al Michaels

Bibliographic Note

I have spent much of my career researching and writing about baseball, especially its union with the broadcast and media world. That juncture lies at *Memories from the Microphone*'s heart—an extensive, if not comprehensive, history of baseball broadcasting focused on the Voices themselves. This is the first book to address a century of baseball on radio and TV—in particular, the men and women who have helped make the Pastime such a major part of America's life.

From its start in 1921, the baseball broadcaster became a Rubik's Cube of actor, writer, director, cameraman, and salesman. To tell their story, I have employed past research, historical context, and anecdote, using the tales of past and present announcers. They reflect the hundreds of stories and other musings told to me, many recorded, that illustrate the drama and comedy of baseball broadcasting itself.

I began interviewing major league Voices in the late 1970s as a twenty-something who had spent a good piece of my childhood hearing and watching local-team radio and network TV. My conversations occurred by phone, tape, letter, and in-person, interviewing Mel Allen, Harry Caray, Bob Costas, and sixty-four other broadcasters. The result—my 1987 book, *Voices of The Game*—was an exhaustive and first of its kind chronicle of baseball radio/TV history.

In 1993, a year after Simon & Schuster updated *Voices of The Game*, I was fortunate to host a *This Is Your Life*–style series on the book at the Smithsonian Institution, interviewing eleven great Voices in nine two-hour evening programs: Allen, Jack Buck,

Caray, Costas, Joe Garagiola, Curt Gowdy, Ernie Harwell, Al Michaels, Jon Miller, Chuck Thompson, and Bob Wolff—each a Ford C. Frick Hall of Fame honoree. The book also became the source of a 1994–1995 three-part primetime ESPN TV series.

For my 1995 book, *The Storytellers*, I sent cassette tapes to current and past broadcasters, inviting them to "just turn on the tape recorder and start talking." I received hundreds of tales about the booth, teams, partners, and related subjects. Sixteen years later, I updated that collection with newer Voices, including ascendant Hispanic broadcasters. *A Talk in the Park* contained the largest collection of stories told by radio/TV Voices—116 announcers— for any baseball book.

Much of the material in *Memories from the Microphone* evolves from more than three decades of my writings for journals, newspapers, websites, blogs, and broadcasts, in addition to the above and other books and, moreover, my personal conversations with the Voices themselves. The reader will note that some of this material was quoted in various chapters.

As a longtime member of the Society for American Baseball Research (SABR), much of my extensive research has occurred at the National Baseball Hall of Fame and Museum, the Library of Congress, *The Sporting News* then in St. Louis, and many websites. I have contributed to more than a dozen SABR books and to their website. Some brief excerpts in this book are from material SABR published online, and from material contributed to the National Hall of Fame, also published on their website.

Sources and Further Reading

Allen, Mel, and Frank Graham, Jr. *It Takes Heart.* New York:
Harper and Brothers, 1959.

Angell, Roger. *Five Seasons: A Baseball Companion.* New York: Simon
& Schuster, 1978.

Asinof, Eliot. *Eight Men Out.* New York: Ace Books, 1983.

Barber, Walter (Red). *1947—When All Hell Broke Loose in Baseball.*
New York: Doubleday, 1982.

__, *The Broadcasters.* New York: Dial Press, 1970.

Bartlett, Arthur. *Baseball and Mr. Spalding.* New York: Farrar, Strauss,
and Young, 1951.

Bealle, Morris A. *The Washington Senators.* Washington, DC:
Columbia Publishing, 1947.

Borelli, Stephen. *How About That! The Life of Mel Allen.* Champaign,
IL: Sports Publishing, 2005.

Buck, Jack. *That's a Winner!* With Rob Rains and Bob Broeg.
Champaign, IL: Sagamore Publishing, 1997.

Caray, Harry and Bob Verdi. *Holy Cow!* New York: Villard
Books, 1989.

Castiglione, Joe. *Broadcast Rites and Sites*, with Douglas B. Lyons.
Lanham, MD: Taylor Trade Publishing, 2004.

Coleman, Ken. *So You Want to Be a Sportscaster?* New York:
Hawthorn Books, 1973.

Corbett, Warren. "Red Barber." *Society for American Baseball Research
(SABR).* accessed March 2021. sabr.org/bioproj/person/
red-barber/.

Cosell, Howard. *Cosell.* New York: Playboy Press, 1973.

Costas, Bob. *Fair Ball: A Fan's Case for Baseball.* New York: Random
House, 2000.

Creamer, Robert W. *Babe: The Legend Comes to Life.* New York:
Simon & Schuster, 1974.

D'Agostino and Bonnie Crosby. *Thorough a Blue Lens: The
Brooklyn Dodgers Photographs of Barney Stein, 1937–57.* Chicago:
Triumph, 2007.

Durso, Joseph. *Yankee Stadium: Fifty Years of Drama.* Boston:
Houghton Mifflin, 1972.

Gammons, Peter. *Beyond the Sixth Game.* Boston: Houghton
Mifflin, 1985.

Garagiola, Joe. *Baseball Is a Funny Game.* New York: Bantam
Books, 1962.

Giamatti, A. Bartlett. *A Great and Glorious Game: Baseball Writings of
A. Bartlett Giamatti.* Edited by Kenneth S. Robson. Foreword by
David Halberstam. Chapel Hill, NC: Algonquin Books, 1998.

Gowdy, Curt. *Cowboy at the Mike.* With Al Hirshberg. Garden City,
NY: Doubleday, 1966.

___, *Seasons to Remember: The Way It Was in American Sports, 1945–60.*
With John Powers. New York: HarperCollins, 1993.

Greenwald, Hank. *This Copyrighted Broadcast.* San Francisco:
Woodford Press, 1999.

Halberstam, David. *Summer of '49.* New York: William
Morrow, 1989.

Halberstam, David J. *Sports on New York Radio: A Play-By-Play History.*
New York: McGraw-Hill, 1999.

Holmes, Tommy. *The Dodgers.* New York: Rutledge Books, 1975.

Honig, Donald. *Baseball's 10 Greatest Teams.* New York:
Macmillan, 1982.

Hughes, Pat. *Harry Caray: Voice of the Fans.* Naperville, IL: Media
Fusion, 2008.

Hynd, Noel. *The Giants of the Polo Grounds.* New York:
Doubleday, 1988.

King, Greg. "Vin Scully." *Society for American Baseball Research
(SABR)*. accessed March 2021. sabr.org/bioproj/person/
vin-scully/.

Korach, Ken. *Holy Toledo: Lessons from Bill King: Renaissance Man of
the Mic*. Soquel, CA: Wellstone, 2013.

Loverno, Thom. *Home of the Game*. Dallas: Taylor, 1999.

McNeil, Alex. *Total Television: A Comprehensive Guide to Programming
from 1948 to 1980*. New York: Penguin Books, 1980.

Mead, William B. *Baseball Goes to War*. Washington, DC: Farragut
Publishing Company, 1985.

Miller, Jon. *Confessions of a Baseball Purist: What's Right. And Wrong,
with Baseball, as Seen from the Best Seat in the House*. With Mark
Hyman. New York: Simon & Schuster, 1998.

Miller, Randy. *Harry The K: The Remarkable Life of Harry Kalas*.
Philadelphia: Running Press, 2010.

Montville, Leigh. *Ted Williams: The Biography of an American Hero*.
New York: Doubleday, 2005.

Morris, Willie. *North Toward Home*. Boston: Houghton Mifflin, 1967.

Nelson, Lindsey. *Hello Everybody, I'm Lindsey Nelson*. New York:
William Morrow, 1985.

Nowlin, Bill and C. Paul Rogers. *A Team That Time Won't Forget:
The 1951 New York Giants*. Phoenix: The Society for American
Baseball Research, 2015.

Okrent, Daniel, and Harris Lewine, eds. *The Ultimate Baseball Book*.
Boston: Houghton Mifflin, 1979.

Oliphant, Thomas. *Praying for Gil Hodges: A Memoir of the 1955 World
Series and One Family's Love of the Brooklyn Dodgers*. New York:
Thomas Dunne Books, 2005.

O'Neill, Terry. *The Game Behind the Game: High Pressure, High Stakes in
Television Sports*. New York: Harper & Row, 1989.

Patterson, Ted. *The Golden Voices of Baseball*. Champaign, IL: Sports
Publishing LLC, 2002.

Plimpton, George. *One for the Record: The Inside Story of Hank Aaron's Chase for the Home Run Record*. New York: Hachette Book Group USA, 2016.

Powers, Ron. *SuperTube: The Rise of Television Sports*. New York: Coward-McCann, 1984.

Rickey, Branch (with Robert Riger). *The American Diamond: A Documentary of the Game of Baseball*. New York: Simon and Schuster, 1965.

Ritter, Lawrence S. *The Glory of Their Times*. New York: Macmillan, 1966.

Robinson, Jackie, with Alfred Duckett. *I Never Had It Made*. New York: Putnam, 1972.

Ruth, George Herman, with Bob Considine. *The Babe Story*. New York: Dutton, 1948.

Shaughnessy, Dan. *The Curse of the Bambino*. New York: Penguin Books, 1991.

Silva, Tony. *Fathers and Sons in Baseball Broadcasting*. Jefferson, NC: McFarland, 2009.

Smith, Curt. *A Talk in the Park*. Washington DC: New York: Potomac Books, 2011.

___, *The Presidents and the Pastime: The History of Baseball and the White House*. Lincoln: University of Nebraska Press, 2018.

___, *The Storytellers*. New York: Macmillan, 1995.

___, *Voices of The Game*. New York: Simon & Schuster, 1992.

Thompson, Chuck. *Ain't the Beer Cold!* With Gordon Beard. South Bend, IN: Diamond Communications, 1996.

Thorn, John, Pete Palmer, and Michael Gershman, eds. *Total Baseball: Seventh Edition*. With Matthew Silverman, Sean Lahman, and Greg Spira. New York: Total Sports Publishing, 2001.

Uecker, Bob, with Mickey Herskowitz. *Catcher in the Wry*. New York: Jove, 1982.

Vecsey, George, ed. *The Way It Was: Great Sports Events from the Past.*
 New York: Mobil Oil and McGraw-Hill Book Co., 1974.

Veeck, Bill. *Veeck—As in Wreck.* New York: New American
 Library, 1962.

Vincent, Fay. *The Last Commissioner.* New York: Simon &
 Schuster, 2002.

Wallop, Douglass. *The Year the Yankees Lost the Pennant.* New York:
 Norton, 1954.

Wancho, Joseph, "Dizzy Dean." *Society for American Baseball Research
 (SABR).* accessed March 2021. sabr.org/bioproj/person/
 dizzy-dean/.

Wolff, Bob. *It's Not Who Won or Lost the Game, It's How You Sold the
 Beer.* South Bend, IN: Diamond Communications, 1996.

Zminda, Don. *The Legendary Harry Caray.* Lanham, MD: Rowman
 & Littlefield, 2019.

INDEX

ABOUT THE AUTHOR

 Curt Smith is an author whom *USA Today* terms "the voice of authority on baseball broadcasting"—and Chicago Cubs announcer Pat Hughes dubs "simply one of the best baseball historians, ever." He also wrote more speeches than anyone for former President George H.W. Bush. *Memories From the Microphone: A Century of Baseball Broadcasting* is his eighteenth book.

In 1998, Smith joined the University of Rochester faculty as Senior Lecturer of English, where, teaching Public Speaking and Presidential Rhetoric, he etches how US presidents from Calvin Coolidge to Joe Biden have communicated through language. As an Upstate New York *Messenger-Post* columnist, he analyzes politics, culture, and sportscasting through what pollster John Zogby calls "his mastery of language."

Smith's career began as a Gannett Co. reporter, *The Saturday Evening Post* senior editor, and as a speechwriter for several cabinet members of the Reagan presidency. As a 1989–1993 Bush White House speechwriter, Smith wrote the "Just War" Persian Gulf speech, the address on the USS *Arizona* memorial site on Pearl Harbor's fiftieth anniversary, and later Bush's 2004 emotional eulogy to Ronald Reagan.

In 1992, he released the updated version of *Voices of the Game*, the history of baseball radio/TV that *Publisher's Weekly* called "monumental." It became a Smithsonian Institution series that *The Washington Post* styled "a mesmerizing memory lane" and then three-part ESPN TV series. Since then, Smith has hosted other Smithsonian, National Baseball Hall of Fame and Museum, and XM Satellite Radio series, and a decade-long National Public Radio Upstate New York series *Perspectives*.

Smith's most recent book is *The Presidents and the Pastime*. Others include *Pull Up a Chair: The Vin Scully Story*, *George H.W. Bush*, *The Storytellers*, *A Talk in the Park*, *What Baseball Means to Me*, and *Windows on the White House*. He has contributed to the *Cambridge Companion to Baseball* and more than a dozen books of the Society of American Baseball Research—and addressed, among others, the White House Historical Association and Cooperstown Symposium on Baseball and American Culture.

Smith has written about baseball or politics for *The Boston Globe*, *Newsweek*, *The New York Times*, *Reader's Digest*, *Sports Illustrated*, *The Sporting News*, and *The Washington Post*. He has appeared on network radio/TV programs including ABC's *Nightline*, Armed Forces Radio, BBC, CNBC, CNN, ESPN, Fox News Channel, History Channel, Mutual Radio's *Jim Bohannon* and *Larry King*, and Radio America.

Born and raised in Upstate New York, the State University of New York at Geneseo graduate was elected in 1993 to the Judson Welliver Society of former White House speechwriters. A member of the Baseball Hall of Fame's Ford C. Frick Award committee, Smith lives with his wife Sarah and two children in Upstate New York.

About the National Baseball Hall of Fame and Museum

The National Baseball Hall of Fame and Museum is an independent not-for-profit educational institution, dedicated to fostering an appreciation of the historical development of baseball and its impact on our culture by collecting, preserving, exhibiting, and interpreting its collections for a global audience as well as honoring those who have made outstanding contributions to our National Pastime. Opening its doors for the first time on June 12, 1939, the Hall of Fame has stood as the definitive repository of the game's treasures and as a symbol of the most profound individual honor bestowed on an athlete. It is every fan's "Field of Dreams," with its stories, legends, and magic shared from generation to generation.

Visit baseballhall.org and follow us on @BaseballHall on Twitter, Facebook, and Instagram for all the latest Hall of Fame news and fascinating stories from the National Pastime.

Mango Publishing, established in 2014, publishes an eclectic list of books by diverse authors—both new and established voices—on topics ranging from business, personal growth, women's empowerment, LGBTQ studies, health, and spirituality to history, popular culture, time management, decluttering, lifestyle, mental wellness, aging, and sustainable living. We were recently named 2019 *and* 2020's #1 fastest-growing independent publisher by *Publishers Weekly.* Our success is driven by our main goal, which is to publish high quality books that will entertain readers as well as make a positive difference in their lives.

Our readers are our most important resource; we value your input, suggestions, and ideas. We'd love to hear from you—after all, we are publishing books for you!

Please stay in touch with us and follow us at:

Facebook: Mango Publishing
Twitter: @MangoPublishing
Instagram: @MangoPublishing
LinkedIn: Mango Publishing
Pinterest: Mango Publishing
Newsletter: mangopublishinggroup.com/newsletter

Join us on Mango's journey to reinvent publishing, one book at a time.

CPSIA information can be obtained
at www.ICGtesting.com
Printed in the USA
JSHW050149180721
16991JS00001B/1